Theatre Institutions in Crisis

Theatre Institutions in Crisis examines how theatre in Europe is beset by a crisis on an institutional level and the pressing need for robust research into the complex configuration of factors at work that are leading to significant shifts in the way theatre is understood, organised, delivered, and received.

Balme and Fisher bring together scholars from different disciplines and countries across Europe to examine what factors can be said to be most common to the institutional crisis of European theatre today. The methods employed are drawn from systems theory, social-scientific approaches, economics and statistics, theatre and performance, and other interpretative approaches (hermeneutics), and labour studies.

This book will be of great interest to researchers, students, and practitioners working in the fields of performance and theatre studies. It will be particularly relevant to researchers with a specific interest in European theatre and its networks.

Christopher Balme is professor of theatre and performance studies at LMU Munich, Germany.

Tony Fisher is a reader in theatre and philosophy and Associate Director of Research at Royal Central School of Speech and Drama, UK.

Theatre Institutions in Crisis
European Perspectives

**Edited by Christopher Balme
and Tony Fisher**

Routledge
Taylor & Francis Group
LONDON AND NEW YORK

First published 2021
by Routledge
2 Park Square, Milton Park, Abingdon, Oxon OX14 4RN

and by Routledge
52 Vanderbilt Avenue, New York, NY 10017

Routledge is an imprint of the Taylor & Francis Group, an informa business

© 2021 selection and editorial matter, Christopher Balme and Tony Fisher; individual chapters, the contributors

The right of Christopher Balme and Tony Fisher to be identified as the editors of the editorial material, and of the authors for their individual chapters, has been asserted in accordance with sections 77 and 78 of the Copyright, Designs and Patents Act 1988.

All rights reserved. No part of this book may be reprinted or reproduced or utilised in any form or by any electronic, mechanical, or other means, now known or hereafter invented, including photocopying and recording, or in any information storage or retrieval system, without permission in writing from the publishers.

Trademark notice: Product or corporate names may be trademarks or registered trademarks, and are used only for identification and explanation without intent to infringe.

British Library Cataloguing-in-Publication Data
A catalogue record for this book is available from the British Library

Library of Congress Cataloging-in-Publication Data
A catalog record for this book has been requested

ISBN: 978-0-367-26610-3 (hbk)
ISBN: 978-0-429-29416-7 (ebk)

Typeset in Times New Roman
by Apex CoVantage, LLC

Contents

List of contributors viii
Preface xii
Acknowledgements xv

Introduction 1
CHRISTOPHER BALME AND TONY FISHER

PART 1
Publics 25

1 Struggles of singularised communities in German theatre: the 'culture war' around the Berlin Volksbühne 27
PETER M. BOENISCH

2 Public (re)assembly and crisis dramaturgy 41
SHANNON JACKSON

3 Re-enacting the crisis of democracy in Milo Rau's *General Assembly* 56
RAMONA MOSSE

4 Fugitive transformations of performance practice in landscapes of crisis 69
GIGI ARGYROPOULOU

PART 2
Funding and labour 81

5 Justifying theatre and its funding after 2008 83
JOSHUA EDELMAN

6 Dutch theatre politics in crisis? 93
QUIRIJN LENNERT VAN DEN HOOGEN

7 Crisis in funding policies: the paradox of National Theatres and the dilemma of evaluating theatre in Italy 105
LIVIA CAVAGLIERI

8 The theatrical employment system in crisis? How working conditions are changing in theatre and elsewhere 119
AXEL HAUNSCHILD

PART 3
Post-socialism 131

9 Crisis? Czech theatre after 1989 133
RADKA KUNDEROVÁ

10 Artistic freedom—state control—democracy: Oliver Frljić's theatre work in Croatia and Poland as an indicator of repressive cultural policy 143
DANIJELA WEBER-KAPUSTA

11 Creating new theatres during the economic crisis: the case of Estonia 153
HEDI-LIIS TOOME AND ANNELI SARO

12 Cultural struggles in Slovenian institutional and independent theatre 166
MAJA ŠORLI AND ZALA DOBOVŠEK

PART 4
Independent theatre scene 179

13 Promises and side effects: the Frankfurt theatre crisis of the 1990s—a case study 181
LORENZ AGGERMANN

14 Potential, need, risk: on control and subjectification in contemporary production networks 194
GEORG DÖCKER

15 Theatre crisis, local farce, or institutional change? The controversy surrounding the Munich Kammerspiele 2018 from an institutional logics perspective 206
BIANCA MICHAELS

Index 222

Contributors

Lorenz Aggermann studied theatre-film and media studies and European ethnology at Universität Wien and Freie Universität Berlin. He was part of the research project 'Theater as *Dispositif*' at JLU Giessen and is currently investigating the self-representation of Roma in performing arts (funded by DFG). His publications include *Der offene Mund* (2013); *Beograd Gazela* (2008); and further articles on the socio-political aspects of theatre, theatricality of everyday life, and contemporary music theatre.

Gigi Argyropoulou is a researcher, curator, theorist, and director working in the fields of performance and cultural practice based in Athens and London. Gigi has initiated public programs, interventions, performances, conferences, festivals, exhibitions, and cultural projects both inside and outside institutions. She holds a PhD from Roehampton University focused on space, politics, and performance, and her work has been published in journals, books, and magazines. Gigi is editor (with H. Vourloumis) of the special issue of *Performance Research*, 'On Institutions'.

Peter M. Boenisch is Professor of Dramaturgy at Aarhus University and part-time Professor of European Theatre at the Royal Central School of Speech and Drama, University of London. His books include *Directing Scenes and Senses: The Thinking of Regie* (2015), *The Theatre of Thomas Ostermeier* (2016), the 30th anniversary edition of David Bradby and David Williams's *Directors' Theatre* (ed., 2019), and *The Schaubühne Berlin under Thomas Ostermeier: Reinventing Realism* (ed., 2020). He leads the research project *Reconfiguring Dramaturgy for a Global Culture: Changing Practices in 21st century European Theatre*, funded by the Aarhus University Foundation.

Livia Cavaglieri is Professor in Theatre Studies at the University of Genoa. She has been a research fellow at Université Sorbonne Nouvelle (IRET). She is Co-Director of the project *Ormete*, a digital collection of oral sources for the performing arts. Her publications include books and essays on four research areas: history of economics and organisation in theatre and opera, social history of theatre, direction and staging, and oral history and theatre.

Zala Dobovšek is a freelance theatre critic and theatrologist. In 2019, she completed her PhD at the Academy of Theatre, Radio, Film and Television of the

University of Ljubljana (AGRFT UL) with the thesis 'Theatre and War: Basic relations between performing arts and the wars in the area of the former Yugoslavia in the 1990s'. She is a postdoctoral assistant of dramaturgy and performing arts (Theatre Review) at AGRFT and a member of the Association of Theatre Critics and Researchers of Slovenia. She also works as pedagogue, selector, and practical dramaturg.

Georg Döcker is a PhD student at the University of Roehampton, London, and the recipient of PhD stipends from the University of Roehampton and TECHNE Consortium. He was a researcher for the DFG research project 'Theatre as *Dispositif*', Justus-Liebig-Universität Gießen (2015–2018). Publications include *Performance Philosophy Journal* 6.1 (forthcoming autumn 2020, edited with Eve Katsouraki and Gerald Siegmund) and 'Control Performance' in *Technologien des Performativen*, edited by Maren Butte, Kathrin Dreckmann, and Elfi Vomberg. Bielefeld: Transcript, forthcoming 2020.

Joshua Edelman is Senior Lecturer in Contemporary Arts at Manchester Metropolitan University. He is Co-Convenor of the Performance, Religion and Spirituality Working Group of the International Federation for Theatre Research and a founding member of the Project on European Theatre Systems. His is a co-author of *The Problem of Theatrical Autonomy* (Amsterdam UP, 2017) and a co-editor of *Performing Religion in Public* (Palgrave, 2013), and his articles have appeared in journals including *Performance Research, Amfiteater, Nordic Theatre Studies, Ecumenica*, and *Liturgy*. He is one of the founding editors of the new journal *Performance, Religion and Spirituality*.

Axel Haunschild is Professor of Work and Employment Studies at Leibniz University Hannover. He held visiting professorships at Royal Holloway College, the University of London, and the University of Innsbruck, Austria. His research interests include changing forms of work, employment and organisation; cultural industries; sustainability from an industrial relations perspective; organisations and lifestyles; and organisational boundaries. He has published in journals such as *Human Relations, Journal of Organizational Behavior, British Journal of Industrial Relations*, and *Organization & Environment*.

Quirijn Lennert van den Hoogen, PhD, teaches art sociology and arts policy at the University of Groningen. His research interests include evaluation of cultural policies and the relevance of art and culture for peripheral regions. He co-edited *Cultural Policy in the Polder: 25 Years Dutch Cultural Policy Act*, an English volume on Dutch cultural policies. He is a member of the Project on European Theatre Systems (STEP) and the Research Centre for Arts in Society (www.rug.nl/research/arts-in-society/). For more information, see www.rug.nl/staff/q.l.van.den.hoogen/.

Shannon Jackson is Hadidi Professor of Rhetoric and of Theater, Dance, and Performance Studies at UC Berkeley, where she is also Associate Vice Chancellor for the Arts + Design. Her publications include *Public Servants: Art and the Crisis of the Common Good* (2016), *The Builders Association: Performance*

and Media in Contemporary Theater (2015), *Social Works: Performing Art, Supporting Publics* (2011), *Professing Performance* (2004), and *Lines of Activity: Performance, Historiography, Hull-House Domesticity* (2000), as well as the online glossary of keywords, In Terms of Performance, co-produced with the Pew Center for Art & Heritage.

Radka Kunderová is Principal Investigator of the EU Marie Skłodowska-Curie Grant 'Redefining the Agency: Post-1989 Crises of Czech and Former East German Theatre' conducted at the Freie Universität Berlin. She worked as the Head of the Institute for Theatre Research and an assistant professor at the JAMU Theatre faculty in the Czech Republic. She has published studies on the discursive shifts in the Czech theatre during the Perestroika period, on hierarchies among the national theatre discourses during the Cold War, and on artistic research.

Bianca Michaels is Managing Director of the School of Arts at LMU Munich. She holds master's and PhD degrees in theatre studies from the Universities of Mainz and Amsterdam (NL), respectively. Her latest area of research explores institutional aspects of theatre and its social and political legitimation. She is currently leading the research project 'Of City Projects and Civic Theatre: Re-Formatting as a Symptom of Institutional Change in Contemporary German Public Theatre' within the research group Configurations of Crisis: Institutional Transformation Processes in Contemporary Performing Arts' (German Research Foundation).

Ramona Mosse is visiting faculty at Bard College Berlin and a former fellow of the International Research Center for Interweaving Performance Cultures at the Free University Berlin. She is co-editor with Minou Arjomand of Erika Fischer-Lichte's *The Routledge Introduction to Theater and Performance Studies* and has published widely on contemporary political performance, intermediality, and modern tragedy. Ramona also works as a dramaturg and is a core convener of the Performance Philosophy Network.

Anneli Saro is Professor of Theatre Research at the University of Tartu (Estonia). Saro has published articles and books on Estonian theatre history and system, performance theory, and audience research. Currently, she is working on two projects: a comparative analysis of amateur theatre fields in small European countries and the poetics of playing.

Maja Šorli is Research Fellow at the Academy of Theatre, Radio, Film and Television of the University of Ljubljana (AGRFT UL) and a freelance dramaturg. In 2014, her monograph *Slovenska postdramska pomlad* (*The Slovenian Postdramatic Spring*) was published by MGL Library. She is a member of the international research group the Project on European Theatre Systems (STEP) and the Feminist Research Working Group at IFTR, as well as the Association of Theatre Critics and Researchers of Slovenia.

Hedi-Liis Toome is a lecturer of theatre research at the University of Tartu (Estonia). Her research interests are in theatre sociology, functioning of theatre, and audience and reception research. She is also curating a national theatre festival.

Danijela Weber-Kapusta is a research associate at the Department for Theatre Studies at LMU Munich. Her publications include *Personentransformation. Zur Konstruktion und Dekonstruktion der Person im deutschen Theater der Jahrtausendwende* (2011) and Dialectic of Identity: Croatian and German Drama between Post-communism and Multiculturalism (2014).

Preface

As this volume was in its final stages of production, the most severe crisis to affect the performing arts since the Second World War took hold. By the middle of March 2020, the world was in the grip of an unprecedented lockdown to prevent the spread of the coronavirus Sars-Cov-2 and its associated illness, COVID-19. As we write, most theatres and, indeed, cultural venues of any kind are still closed and will probably remain that way for many months. Although the immediate impact is clearly economic as the whole workforce employed in the performing arts sector was effectively laid off, the longer-term effects will be much wider. The structural crises affecting European theatre studied in this book have been overridden by what institutional theorists call 'exogenous shocks'.[1] These are usually caused by a significant change in the law or a technological innovation that suddenly transforms the rules of the game and accelerates institutional change. The exogenous shock caused by the coronavirus is of a completely different order, however. Instead of some players being better positioned to profit from a change, suddenly the whole game has been called off—for everybody. Most expect the long-term effects of such severe disruption to lead to fundamental transformations of a kind we are as yet scarcely in a position to imagine.

To take the example of the UK: concert halls, theatres, multi-modal performance centres, opera houses, and fringe venues—no matter how prestigious—warn of imminent disaster;[2] from the Royal Festival Hall to the Royal Court, the economic effects of the pandemic have exposed the profound structural fragility of the financial model underpinning the existing performing arts industry. The weakness of state subsidy in the UK—with venues reliant on self-generated income through private donation and ticket sales—has left it woefully exposed in the present crisis; even as we await the results of a government-led 'Cultural Renewal Task Force', it is likely to experience some of the most profound transformations seen in Europe, where even publicly funded venues receive a bare minimum of government support (the Royal Opera House, for example—one of the better-supported venues—receives approximately 20–25% state subsidy,[3] compared to equivalent venues in Germany, where levels are around 80%). This is to say that the consequences of the corona crisis already pose significant challenges to the neoliberal model of arts' funding: it will either necessitate a significant step-change in levels of government subsidy, unravelling the economic logic

Danijela Weber-Kapusta is a research associate at the Department for Theatre Studies at LMU Munich. Her publications include *Personentransformation. Zur Konstruktion und Dekonstruktion der Person im deutschen Theater der Jahrtausendwende* (2011) and Dialectic of Identity: Croatian and German Drama between Post-communism and Multiculturalism (2014).

Preface

As this volume was in its final stages of production, the most severe crisis to affect the performing arts since the Second World War took hold. By the middle of March 2020, the world was in the grip of an unprecedented lockdown to prevent the spread of the coronavirus Sars-Cov-2 and its associated illness, COVID-19. As we write, most theatres and, indeed, cultural venues of any kind are still closed and will probably remain that way for many months. Although the immediate impact is clearly economic as the whole workforce employed in the performing arts sector was effectively laid off, the longer-term effects will be much wider. The structural crises affecting European theatre studied in this book have been overridden by what institutional theorists call 'exogenous shocks'.[1] These are usually caused by a significant change in the law or a technological innovation that suddenly transforms the rules of the game and accelerates institutional change. The exogenous shock caused by the coronavirus is of a completely different order, however. Instead of some players being better positioned to profit from a change, suddenly the whole game has been called off—for everybody. Most expect the long-term effects of such severe disruption to lead to fundamental transformations of a kind we are as yet scarcely in a position to imagine.

To take the example of the UK: concert halls, theatres, multi-modal performance centres, opera houses, and fringe venues—no matter how prestigious— warn of imminent disaster;[2] from the Royal Festival Hall to the Royal Court, the economic effects of the pandemic have exposed the profound structural fragility of the financial model underpinning the existing performing arts industry. The weakness of state subsidy in the UK—with venues reliant on self-generated income through private donation and ticket sales—has left it woefully exposed in the present crisis; even as we await the results of a government-led 'Cultural Renewal Task Force', it is likely to experience some of the most profound transformations seen in Europe, where even publicly funded venues receive a bare minimum of government support (the Royal Opera House, for example—one of the better-supported venues—receives approximately 20–25% state subsidy,[3] compared to equivalent venues in Germany, where levels are around 80%). This is to say that the consequences of the corona crisis already pose significant challenges to the neoliberal model of arts' funding: it will either necessitate a significant step-change in levels of government subsidy, unravelling the economic logic

for arts' funding that has dominated the UK cultural sector since the 1990s, or it will double-down on its market-driven ideology as recessionary impacts take hold, leading to the sacrifice of a substantial number of venues, many of which are located in economically challenged regions outside the cultural capital, historically devastated by the end of the manufacturing industries and economically depleted by the effects of a decade of Tory-imposed austerity measures.

Although the contributions in this volume were written prior to the corona crisis, we suggest that the fundamental observations contained in them provide a roadmap for the post-corona situation. Institutional theory suggests that exogenous shocks exacerbate and accelerate pre-existing structural problems as we have just touched on briefly in the case of the UK. Our analysis of structural crises as a complex of interrelated elements may, indeed, provide a perspective on the 'historical future' (to use Reinhart Koselleck's term).[4] Several scenarios are possible:

- According to the logic of path dependency, the various theatrical 'systems' are re-started at all costs without any profound changes.
- The already-existing structural problems will be further intensified and accelerated, which could lead to a decline of theatrical activity, as well as widening inequalities of provision, especially in the independent scene.
- On the reception side, theatres might initially be avoided because the older target audience, which is overrepresented above all in opera and classical music, is at greater risk. The theatres will make the necessary adjustments and make their offerings more suitable for young people.
- The presumably unavoidable cost-cutting measures will lead to a return to the 'essentials', with an emphasis on the mainstream and little appetite for experimentation.
- The 'neoliberal paradigm' will be questioned, and the importance of public funding will be strengthened.
- A transnational comparison of systems will intensify, in which those with high levels of public funding will prove to be particularly crisis resistant (although this model is also vulnerable to austerity measures and increases in government borrowing rates).
- Formats and spatial concepts developed in the corona period will have a lasting effect on the future design of performance schedules and the development of new audiences—led, for example, by new combinations of digital and live media—and a departure from traditional venues in response to social distancing measures.

That some of these scenarios appear to be self-contradictory is entirely commensurate with the degree of uncertainty surrounding the current situation. It is quite possible that—post-pandemic—the remaking of the sector will open up opportunities for systemic change to address much wider inequalities, exclusions, and biases. What is more likely, however, is that we will witness, as a result of the pandemic—and as its economic costs are counted—an intensification of 'cultural

inequality' across the regions of Europe as governments respond in different ways to the economic fallout of the crisis—a reminder, perhaps, that the fate of culture is in the final instance dependent on political choices and that the institutional crisis of the European theatre cannot be separated from wider crises of culture and its democratisation.

Christopher Balme and Tony Fisher

Notes

1 Jeanette Colyvas and Walter W. Powell. "Roads to Institutionalization: The Remaking of Boundaries between Public and Private Science." *Research in Organizational Behavior* 27 (2006): 305–53, here 343.
2 See, for example: "The Guardian View on UK Theatre: On the Brink", Editorial, *The Guardian*, May 20, 2020. www.theguardian.com/commentisfree/2020/may/20/the-guardian-view-on-uk-theatre-on-the-brink?CMP=Share_iOSApp_Other.
3 See trustees' report and consolidated financial statements, 52-week period ended August 30, 2009. https://webarchive.nationalarchives.gov.uk/20110120013718/www.charity commission.gov.uk/ScannedAccounts/Ends75/0000211775_ac_20090830_e_c.pdf.
4 Reinhart Koselleck, 1988. *Critique and Crisis: Enlightenment and the Pathogenesis of Modern Society*. Translated by Thomas McCarthy. Cambridge, MA: MIT Press, p. 127.

Acknowledgements

This volume resulted from a fortuitous constellation of elements. Planning for a conference on Systemic Crises in European Theatre was conducted during Christopher Balme's tenure as a Leverhulme Visiting Professor at the Royal Central School of Speech and Drama in 2017 and 2018. Our thanks go to Maria Delgado, Director of Research at Central, who provided unflagging support for this project. Thanks also to Katrin Sohns, Head of Programming at the Goethe-Institut, London, for hosting the conference. A special word of thanks to Chris Dercon (president of the *Réunion des Musées Nationaux* in Paris), who joined the conference immediately after stepping down from the directorship of the Berlin Volksbühne.

Support for the conference and publication was provided by the DFG Research Unit: Configurations of Crisis: Institutional Transformation in the Contemporary Performing Arts (FOR 2734), the Royal Central School of Speech and Drama, and the Leverhulme Trust.

Introduction

Christopher Balme and Tony Fisher

The Chinese word for crisis, *wēijī* (危机), is composed of two words or characters: *wēi*, meaning 'danger', and *jī*, which can be translated as 'chance' or 'opportunity'. In this idea of a 'dangerous opportunity', we find an ambiguous tension in the concept of crisis that signals impending danger while at the same time pointing out that avenues to productively use such risks to overcome the crisis. Etymologically, a crisis (Gr. κρίσις) refers to a turning point in an illness, of which the outcome is either the patient's recovery or death. A crisis is therefore peripeteian, and most definitions recognise it as a moment of dramatic intensification, at which alternative courses of action are demanded. Its semantics shift from the narrowly medical and legal to the more broadly historico-philosophical during the Enlightenment. German historian Reinhardt Koselleck argued that crisis is intimately bound up with a new way of conceptualising futurity that arose during the 18th century and the French Revolution:

> It is in the nature of crises that problems crying out for solution go unresolved. And it is in the nature of crises that the solution, that which the future holds in store, is not predictable. . . . The question of the historical future is inherent in the crisis.
>
> (1988 [1959], 127)

The key idea here is that crises are a productive way to think about the future, or as Koselleck argues, European culture redefines in this period its conception of the future away from an eschatological model and towards a secular one in which the future can be planned for and in some way controlled. To think in terms of crises is to plan the future.

The often-critical relationship between theatre and the society hosting it caused Heiner Müller to remark that crisis is synonymous with theatre: 'It [theatre] can only function as critique and crisis, otherwise it has no relationship whatsoever to society outside the theatre' (Müller 2003, 342). While Müller had mainly the products of theatre in mind—the plays and productions enacted on its stages—the theatre crises examined in this book are less artistic than institutional and refer to significant challenges and transformations, usually brought on by a combination of factors: demographic changes, media and technological innovations, political

interventions (with legal, juridical consequences), movements in the public sphere, and shifts in aesthetic tastes and moods. Their function is nonetheless critical in a sense shared by Koselleck and Müller. Theatre crises on an institutional level can be brought about by exogenous factors, such as severe funding cuts, or by endogenous ones, in which a radical aesthetic may meet with rejection by the public or conflicts in governance can affect the running of a particular organisation. Whereas the latter are usually only temporary, the former can have long-lasting structural consequences such as in the neoliberal reforms of the Thatcher years in the UK, when power was transferred from producers to consumers, producing an economic crisis (Kershaw 1999, 272).

This volume draws on a selection of papers presented at a conference held at the Goethe Institut, London, in April 2018.[1] The conference was, from the outset, overshadowed by two crises at prominent German theatres: the Berlin Volksbühne and the Munich Kammerspiele, where both artistic directors (Chris Dercon in Berlin and Matthias Lilienthal in Munich) had been subjected to intense criticism accompanied by major debates about the future of the much-admired German municipal theatres. Beyond these specific German examples, we argued at the conference that theatre in Europe is indeed beset by a crisis on an institutional level and that there is a pressing need for robust research into the complex configuration of factors at work that are leading to significant shifts in the ways theatre is understood, organised, delivered, and received. This volume brings together scholars from different disciplines and countries across Europe to examine factors that are common.

One way to think of crisis is in terms of a structural configuration or constellation of factors, each of which is subject to dynamic transformation. On a systemic level, crisis can be analysed in relation to four such factors, all of which are subject to or are themselves agents of such transformational change:

- Enculturative breakdown, whereby patterns and practices of theatregoing are no longer passed on through inner-familial or ingroup transmission. These are precipitated by demographic changes, including both the age pyramid and migration.
- A reorganisation of the public sphere through the proliferation of social media on the one hand and increasing restrictions on freedom of expression on the other.
- Increasing heterogeneity in models of labour, especially the precarity effects of economic neoliberalism on patterns of work and employment.
- The emergence of new aesthetic techniques and production processes entailing new formats that do not fit the older models of the theatre as a medium for staging pre-written works.

We argue that these factors can be generalised as a way of investigating the crisis of theatre in Europe from a comparative perspective.

A key issue to be explored in the volume is the relationship between theatre and the state, the latter represented primarily through public spending on theatre

but also, increasingly, through political control. Public support of the theatre was one of the achievements of post-war Europe that united both sides of the Iron Curtain. With the increasing dominance of neoliberal thinking, this consensus has begun to unravel, and the consequences are making themselves felt across the continent. The growing political ambivalence towards supporting the arts has created a legitimation crisis, in which public support of the theatre is framed in the context of welfare economics and austerity. It is one of the ironies of recent developments that a self-proclaimed 'illiberal democracy' such as Hungary is re-investing public money in state-run theatres, especially opera, to counter the years of liberal austerity while at the same time steadily expanding its administrative and artistic control.[2]

Another key question to be addressed is what do crises *produce*? Rather than seeing crisis just through its negative or detrimental effects, the issue here is to also understand in what way a crisis might have a 'positive' effect—namely, how crises induce institutional transformation—whether incremental, more radical, or even revolutionary. To what extent might a crisis be grasped as a question of institutional historicity at the level of its structures of permanence and traditions, which enable it to subsist as an identity through time and to possess 'continuity'? The factors that precipitate institutional change in theatre institutions include technological innovation, changes in artistic practices such as the proliferation of independent groups, and the rise of festival networks. Such social, economic, and cultural transformations can, in turn, engender various crises of legitimation for theatre institutions themselves.

Modalities of crisis

In order to address these questions, we would first like to provide a critical framework within which to locate the contributions to the volume—to offer what Michel Foucault described as a 'grid of intelligibility': an analytic grid by which we might begin to develop an understanding of the discursive construction of 'crisis' as it is applied to contemporary theatre in Europe. In the first instance, this indicates the specificity of the methodological approach we adopt in this introduction: our concern is not so much to offer a definitive way of defining the term *crisis* as to map out some of the key coordinates by which crisis discourse articulates itself, produces its diagnoses, creates explanatory narratives, and constructs the 'reality' of whatever it is that constitutes a given 'state of crisis'. In this sense, we follow the lead of Janet Roitman, elaborated in her book *Anti-Crisis*, in which she suggests that the task today, given the ever-proliferating crisis narratives that are circulated in the public sphere, is to understand how 'crisis is constituted as an object of knowledge' (2014, 3). To focus on the discursive construction of crisis is to highlight the epistemological ambiguity residing within crisis discourse, which Roitman explains as follows:

> [T]he term 'crisis' serves as a primary enabling blind spot for the production of knowledge.... [C]risis is a point of view, or an observation, which is itself

not viewed or observed [thus] . . . does not account for the very conditions of its observation.

(2014, 13)

This is not to suggest that crisis discourses are thereby false or incorrect or, indeed, contrive to produce the very thing they claim to identify—thus, are in some way fraudulent. As Roitman puts it, there is 'no reason to claim that there are no "real" crises' (2014, 94). But it is, on the other hand, to highlight a certain ambiguity lurking within how the 'reality of crisis' is identified—how crisis is produced as an object of knowledge—which suggests that, behind the constructions of crisis discourse, there lies a more profound 'truth' about the nature of the social world in which we operate. Roitman designates crisis, in fact, a 'non-locus for signifying contingency' (2014, 93). In other words, the very term *crisis* functions as a place-holder for the effects of contingency on social structures and institutions that seem (in 'normal' times) to be necessary, even immutable—crisis exposes that which appears to be otherwise necessary or unassailable or unchallengeable to the underlying and aleatoric eventualities of the social world. The epistemological ambiguity of crisis discourse, then, arises from two of its key tendencies: firstly, the way it seeks to explain the relation of the symptoms of crisis and their effective cause—in other words, to construct a metaphysical basis to explain crisis—while, secondly, excluding itself from the influence of the crisis it has diagnostically exposed, in order to arrive at an 'objective' evaluative standpoint. This ambiguity is particularly evident in the great 'Philosophies of History' analysed by Koselleck, such as can be found in Hegel or Marx, where rational or 'voluntative' history (1988 [1959], 133) acts as a form of historico-philosophical insurance against forces as capricious as they are volatile. What these post-Enlightenment crisis discourses construct is, in fact, a ruse for overcoming crises by constraining their antagonistic effects through a logic of 'contradiction', in which rationality always wins out (for example, through the dialectical reconciliation of opposites). The task that crisis discourse thus assigns itself, Roitman suggests, is to 'apprehend these systems or deeper structures from a vantage point that is not itself determined by them . . . to [read off] surface contingencies as symptomatic of a totalizing secular prime mover' (2014, 93)—such as capitalism, the economy or productive forces in Marx, or 'world spirit' in Hegel.

The second point to make with respect to our discourse-oriented approach is that such a methodology aims at what we designate a 'modal' interpretation of crisis. In other words, we distinguish within crisis discourse a number of different modal possibilities by which crisis is discursively constructed as an object of knowledge or as a means of generating knowledge about the world. The significance of this becomes clearer once we consider the mode of analysis favoured by the contributors to this volume, which we indicated earlier through the term *structural configuration* of the 'elements' of crisis. If we designate this mode of analysis as a structural mode, which has constituted a significant line of argument in crisis discourse since the 1960s—enabling, among other things, the analyses of institutional crises at issue here—it is because we thereby wish to distinguish

ours from other modalities of analysis: historical, dramaturgical, and subjective (or 'existential') modes of crisis discourse. However, before we elaborate on what distinguishes these various modalities in greater detail, it is perhaps important to state why we believe it is of value for theatre studies to pursue a structural mode of crisis analysis (where, in fact, it has been more typical to pursue the other modalities). To highlight the relevance of our approach, let us briefly consider an earlier attempt that covers a territory similar to that of the essays in the present volume—Maria Delgado and Caridad Svich's edited collection *Theatre in Crisis? Performance Manifestos for a New Century* (2002). On the face of it, Delgado and Svich's volume is concerned with the same topic as our own volume—not just with the (as it then was) 'current' state of theatre practices, but also with the underlying issues that influence it, such as economics and new technological innovations, as well as issues related to socio-political concerns around identity and representation. In their introduction, Delgado and Svich define their approach to crisis in the following way:

> The word 'crisis' is used here both provocatively and seriously. [Theatre] is, after all, an art created under duress, under economic circumstances both trying and not, and within the often combustible environment of a rehearsal hall. It is also an art that has seemed to reach yet another break point in its identity, mode of presentation, and structural efficacy, given the rise of more popular forms of entertainment and instructions like film, television, and the internet. Theatre artists and scholars dedicated to advancing theatrical discourse have been placed in a position of having to struggle for not only the continuing growth and effectiveness of the form, but also its very importance in a society that has made theatre, especially the kind of theatre made by experimental artists, an increasingly elitist form. This climate has created a crisis of practice.
>
> (2002, 6)

What we discover here both illuminates the similarities to and also points to important differences between our approaches. In the first instance, crisis is understood in a multi-faceted sense as afflicting theatre from a number of potential sources—both intrinsic (theatre practices, its social relations and forms of organisation) and extrinsic (the effect of competitor industries such as television and film that may induce what we term 'enculturation' crises, thereby transforming theatre audiences with unpredictable consequences for the future of the theatre industry). Delgado and Svich point, for example, to the increasingly 'elitist'—that is to say, educated and specialist—audiences that contemporary 'experimental' theatre production specifically cultivates at the expense of appealing to more 'popular' or 'traditional' audiences. The principal difference lies in the way Delgado and Svich's approach then refocuses a concern for these numerous systemic sources of crisis onto the various theatre practices that respond to them—in particular, by soliciting the responses and reflections of key practitioners. Thus, the object of analysis becomes clarified as the 'art which uses the condition of crisis as its

essential trope' (Delgado and Svich 2002, 6). This is in no way to devalue the insights and frequently brilliant analyses that we find in *Theatre in Crisis?* or to dispute their relevance to our own efforts, but rather, to pinpoint the methodological distinctness of our own approach to the question insofar as it constitutes a different point of departure. Indeed, what Dragan Klaic's essay title 'Theatre in Crisis? Theatre of Crisis' in Delgado and Svich's book reveals, perhaps most explicitly, is the subtle methodological slippage that moves the question away from what is meant by 'theatre crisis' to a broader concern with what the 'theatre of crisis' looks like and how theatre(s) can find ways of responding to crisis. The benefits of doing so are palpable in the essays of that volume, but this comes at the cost of leaving us little the wiser as to what exactly is really meant by the 'crisis' of the theatre. Our problematic is, by contrast, limited to penetrating the nature of 'crisis' as such—the term *crisis* as it may be applied, analytically, to theatre understood as a cultural institution. The originality of our approach derives, we believe, from the elaboration and application of methodological tools that are not typically employed within theatre studies, deriving from philosophy, conceptual history, and the social sciences. That said, claims to originality are, of course, only relevant to the extent that the results of the analysis have wider value within the field. Thus, if what we propose here does indeed offer a distinctive way of revealing what is intended in talk of the 'crisis' of contemporary theatre, then it must be demonstrated in the various analyses offered by our contributors. It will be for the reader to discern their merits or otherwise, but it is for us to at least provide the reader with a clear indication of how to make that assessment viable on the basis of the terms from which we set out—i.e., recommending a 'structural mode' of approaching (theatre's) crisis discourse and its forms of critical analysis.

Let us return now to the problematics of 'crisis discourse' as such. We have already said that crisis discourse is essentially 'diagnostic'. But it also has, as Koselleck once observed, a 'predictive meaning' (1988 [1959], 161), in the sense that wherever there is an attempt at diagnosis, there tends to be a subsequent attempt at some form of prognosis, which will be discoverable on its basis. This is not surprising given, as already noted, that crisis discourse originates within the Hippocratic tradition of medicine, where it indicates the 'critical phase' of a disease in which a decision over the survivability of the afflicted victim is called for. If the rhetorical structures of crisis discourse have a diagnostic character, it is because they seek to delimit its causes, to specify the underlying conditions of the pathology—discerning the 'progress' of the crisis by tracing the development of its symptoms—and to expose its hidden logics: again, often understood on a temporal and teleological basis as a series of unfolding and developmentally communicable stages. It thus seeks out inner reasons for the crisis, where the irrational appearance of the symptom gives way to, or is resolved within, an underlying but ultimately rationally apprehended process. As a diagnostic form, in other words, crisis discourse tends to read crisis symptoms as indicators of systemic, structural, or even metaphysical problems located elsewhere—in a dimension whose contours would (were it not for the evident irruptive disorder of crisis itself) otherwise remain inaccessible and imperceptible. Moreover, insofar as it views crisis as a

structural pathology, visibly exhibited by the dissemination of its symptoms, it is always a discourse concerned with the problem of mediation: just as the general practitioner discovers an ailment by relying on the experience of the patient—the inner knowledge of the symptom belongs precisely to the patient's experience—so crisis discourse seeks to elaborate the apparently indiscernible relationality that conjoins symptomatic effect (subjective experience) and underlying cause (pre-subjective phenomenon—for example, the irruption of a pathology located in the depths of the body, its cellular structure, its tissues and organs . . . in short, its hidden recesses). And it is through its mediating function that crisis discourse critically assesses the *meaning* of the crisis—in fact, it *produces* that meaning.

Yet how those mediations result in specific articulations of meaning will depend, we argue, on the *mode* of the crisis discourse and the kind of narrative it thereby develops. Already in Koselleck's analysis, it becomes clear that crisis discourses can be, as he puts it, 'semantically' distinguished in at least three ways. First, there is a semantics of crisis that understands its object as a 'world-immanent trial' (Koselleck 2002, 241), in which history is interpreted as permanent crisis: historical experience is akin to the experience of a 'trial' in which history will be the 'judge'. Koselleck here points to Schiller's famous dictum: 'World history is the judgment of the world' (cited 2002, 241), in which history is conceived as a Subject who 'enforces justice' (2002, 241). Second, crisis is understood as a means of delimiting distinct historical periods—it signifies the 'crossing of an epochal threshold'—for example, the French Revolution signalled a fundamental and irreversible 'break' in the course of European history that saw the end of the absolutist monarchical state. Now, crisis is a periodising concept: it distinguishes particular moments of historical articulation—'turning points'—moments of emergence and surfacing that see the old order eclipsed by the advent of the new. Examples of this kind of crisis discourse can also be found in economic history, which is constructed around periods of economic stabilisation punctuated by intermittent crises of capital, such as supply and demand crises, recessions, and 'boom and bust' cycles. Depending on the nature of the discourse, such crises are narrated as either 'iterative', in the sense that crises are seen to be produced through repetitive processes—almost compulsively, in Freud's sense of trauma—or 'progressivist', where crisis is seen to act as a generative engine for the emergence of 'higher' stages of history or development: crisis is the initiator of advances in progressive history. A third way in which crisis discourse unfolds is in relation to the narration of the conclusion of the crisis situation; what matters in this version is how everything is 'resolved'. Crisis, in this sense, signals the '*terminus ad quem*' of teleological time: it is a moment of final reckoning, often couched in the apocalyptic terms of a 'final decision' or 'Last Judgement'. One finds examples of this both in the Christian tradition of salvation history and in its secularised form: for example, in Marx's understanding that a final crisis of capitalism will announce the imminent arrival of a utopian 'end of history'.

Now, granted the scope of Koselleck's analysis limits itself to an understanding of the role crisis discourse plays in the development of conceptual history, we can nonetheless locate in these three 'semantic models' the essential components that

characterise the three modes of crisis discourse mentioned earlier: the historical, the dramaturgical, and the subjective. To borrow again from medical terminology, the first two can be broken down roughly by a narrative of either 'chronic' time, in which the genesis and unfolding of the crisis result in a longstanding disorder, or, by contrast, that of an 'acute' crisis, whose temporal effects are sudden, immediate, and severe. For the former, crisis is understood as a 'condition' of existence; it is irreducible to those 'joints' that articulate 'time' but are experienced as 'out of joint', as Hamlet would have it—as 'crises' induced by historical moments of significant change. They are permanent states that, however intolerable, are lived with on an ongoing basis, requiring constant scrutiny and management. Modally, this crisis narrative is profoundly undramatic: it speaks of the *longue dureé* and of a protracted temporality. With the acute crisis discourse, however, the opposite is the case. What we have termed the 'dramaturgical mode' of crisis discourse narrates crisis as an *event*. It thus signifies the domain of 'conjunctural' history, where crises are 'played out', but also where radical transformation is prepared. It is dramaturgical in the sense that it sees no difference between 'crisis' and 'event'—they are one and the same thing: moments of theatrical 'anagnorisis'. In the startling language of Walter Benjamin, they provide the means to 'explode' the historical 'continuum'—requiring a 'leap in the open air of history' (1999, 253). It is at this point that we can see how the dramaturgical mode of crisis narrative, whose focus is on the evenemential break in history, coincides with the subjective mode of crisis discourse, in which attention is not placed on the event so much as on the moment of decision.

In his extended essay of 1973, *Legitimation Crisis*, the German philosopher Jürgen Habermas also wrote of the 'dramaturgical concept of crisis', in which—in classical aesthetics—a crisis both represented a turning point in the plot and was also grasped as a 'fateful process that . . . does not simply impose itself from outside and does not remain external to the identity of the person caught up in it' ([1973] 1976, 2). Crisis, in other words, importantly, has an objective and a subjective dimension. Hence, Habermas writes, 'the contradiction, expressed in the catastrophic culmination of conflict, is inherent in the structure of the action system and in the personality systems of the principal characters' (1976 [1973], 2). To be sure, Habermas also locates dramaturgical crisis concepts in relation to what we have described as the historical mode of crisis discourse—and, indeed, it is important to note that crisis discourses often operate in hybrid ways. Thus, in Marx, the attempt to provide a socio-scientific treatment of history also deploys dramaturgical conceptions of crisis. It also, of course, incorporates aspects of the subjective mode that leads Marx, like Hegel before him, to attribute 'agency' either to history as such or to its class protagonists, the proletariat. Viewed in terms of the subjective mode, however, crisis reveals itself most fully at the moment when the subject is called upon to make a decision. Hence, the subjective mode can be found in a number of subjacent categories of crisis discourse. For example, it is central to Carl Schmitt's influential notion of political crisis as revealed by the problem of the state of emergency, in which the 'sovereign' makes his appearance through the very act of declaring the need for emergency

powers to resolve the crisis he has named: 'He decides when there is an extreme emergency as well as what must be done to eliminate it' (2005 [1922], 7). In the tradition of Aristotelian poetics, the crisis is likewise also only truly revealed at the moment when the hero is called upon to make a decision, but it is also a moment requiring profound insight—precisely, an *anagnorisis*—in which, as Hans-Thies Lehmann notes, the 'entire dramatic *situation* is revealed in a new perspective. . . . [The] logic hidden until now appears in full view and determines the shape of everything else, the sense in its entirety' (2016, 165; emphasis in the original). *Anagnorisis* permeates crisis discourse in its 'tragic' form, but, above all, it is a discourse that subjugates the eventual dimension of the play to the moment of insight on the part of the hero in a 'kind of affect-laden illumination that occurs in a flash' (2016, 165). Crisis seizes the tragic-heroic subject, constituting them as the exemplar of action around which the whole crisis situation is thereby constellated. Crisis—in its subjective mode—is not just a call to action; it is already an action that coincides with the moment of authentic seeing—on the part of the hero—of the situation as it 'really is'.

But there is also a structural ambiguity here, noted by Lehmann, that is key to understanding the subjective mode of crisis discourse and what is problematic about it. Since the crisis situation is one in which the subject is centrally implicated, it appears that the moment of insight reveals to the hero not so much the truth of their situation, but precisely the truth of their prior non-understanding of the situation. It is this ambiguity that provides a central insight into the existential limitedness of the subject but also, we believe, consequently brings into question the viability of the decisionistic dimension of the subjective mode of crisis discourse: crisis reveals the subject, but not as a hero who can act, for he always comes to his moment of vision after the fact, occupying instead the interstitial space between knowing and not knowing. This ironic take on the tragic paradigm, of course, heavily inflects Lehmann's understanding of post-dramatic theatre, in which the dramaturgy of crisis is reconfigured around the 'lightning . . . realization of something that escapes understanding' (2016, 168)—particularly for audiences, where the lesson is that insight arrives but it is always already 'too little, too late'.

There is, however, a fourth mode of crisis discourse that we have not yet examined, and it is most important for understanding the aims of this volume—and that is the *structural* mode. It is this mode of analysis, we argue, that is best suited to understanding the way crisis discourse produces a critical interrogation of theatrical institutions. And, while it is not indifferent to the three other modes of analysis surveyed earlier, the structural mode provides a means of avoiding some of their pitfalls—decisionism in relation to the subjective mode, the metaphysical assumptions that underpin the historical mode, and the reductivism of the dramaturgical mode (in which a crisis is always the 'disjointed' time of an event). What the structural mode of crisis discourse offers is an analysis of crisis phenomena *as they appear* at a 'pre-subjective' level; it is at this level, we argue, that those elements of crisis can be identified that help reveal how institutions function—the various systems that they rely upon: for instance, economic systems, systems of

production, cultural (aesthetic and reception) systems—and their normative character and systems of control. It is this integrated ensemble of systems, networks, control and coordination mechanisms, norms, and values that constitute institutions and also limit them. Those limits are revealed when problems arise within one institutional domain that begin to have adverse effects on other domains producing, eventually, institutional 'crisis'. Crisis is invoked in institutional terms when the 'crisis effect' is registered by the diagnostic discourse in terms of challenges it identifies regarding specific structural elements of a system such that they impede, threaten, or collapse the ability of the institution overall to fulfil its 'proper' functions: i.e., to achieve its strategic goals.

Now, to the extent that the structural mode aims at describing 'pre-subjective' crisis phenomena, we differentiate it in opposition to the subject mode of crisis discourse. This should not be taken to mean, however, that it is therefore indifferent to the level of subjective experience, nor that we are suggesting an overly scientific approach—a kind of indifferent objectivism. To borrow from the phenomenology of Edmund Husserl, in his analysis of the 'crisis' of European sciences, it is rather a matter of understanding various 'life praxes' in relation to what he termed the *Lebenswelt*, the life-world, which is the 'grounding soil [*der grünende Boden*] of the "scientifically true" world and at the same time encompasses it in its own universal concreteness' (1970, 131). The structural approach, in other words, brackets out the 'decisionistic' element of the subjective mode of crisis discourse in order to focus on the material conditions of crises. It is here that crises can be identified in the complex interplay between institutional praxes and life-world contexts. One of the most significant advances in terms of developing this kind of approach is found in a work by Habermas, mentioned earlier, on 'legitimation crises', and it is worth highlighting, albeit acknowledging that Habermas is examining socio-political crises of advanced capitalism, some of the broad themes of that analysis that might usefully apply here. Influenced by systems theory, the work of Jean Piaget, and the evolving science of cybernetics, Habermas sought to displace the traditional role played by the subject in theories of crisis in order locate it, instead, within the context of social systems and institutions. (We would argue theatre is one such institution.) A social system is responsive to both environmental influences and (life-world) demands and constraints and the institutional processes of socialisation that are required to mould the behaviour of individuals operating within it, such that they can coordinate their actions according to the 'goal values' and 'norms' they have agreed to abide by. Essential to the function of a social system is what Habermas describes as its 'steering mechanism'—its capacity to respond to problems that may arise by learning from them and adapting itself accordingly. For instance, the economy is a principal steering mechanism of government (1976 [1973], 21). Every social system aims at ensuring stability through both 'systems integration' and 'social integration'—the first, broadly, refers to institutional contexts and the second to life-world problematics. But they are, of course, intrinsically connected; thus, when we speak of social integration—as Habermas observes—we mean the 'system of institutions in which speaking and acting subjects are socially related

(*vergesellschaftet*). Social systems are seen here as life-worlds that are symbolically structured' ([1973] 1976, 4).

What begins to emerge on this basis is a complex picture of how institutional crises emerge through a structural mode of crisis analysis. If we take the case of theatre, understood as an institutional form, for instance, what we are seeking to bring into view is a complex social structure that combines a variety of control or 'steering' mechanisms (governance and administrative structures, policy directives, literary management objectives, financial decisions, etc.), goal values and 'system imperatives' (the realisation of theatrical production, outreach and audience development, etc.), and a range of operational elements that articulate its strategic aims in practical form through processes of production. And here we encounter most explicitly the 'social' and 'relational' dimension of institutional structures—for instance, its reliance on forms of cooperation, socialisation, and the embedding of individuals in shared values, goals, and norms. Institutional crises, seen in such structural terms, arise from complex conjunctions of elements, in which institutions are confronted with either internal or external pressures. Indeed, the complexity of institutional and social forms is such that it is far from clear when the ascription of the term *crisis* should be invoked since they necessarily operate within what Habermas terms a 'range of tolerance' or variation, aimed at anticipating or mitigating pressures that might otherwise critically endanger their existence. There are two points, however, when crisis situations clearly emerge: first, when the range of tolerance allows for no further variation but existing challenges remain unresolved due to the inability of institutional steering mechanisms to cope with them—at this point, a process of dissolution threatens systemic collapse—and second, when the institutional responses to challenges are so radical that they jeopardise the identity of the social system to the point that it becomes unrecognisable. Habermas writes, 'Social systems too have identities and can lose them' ([1973] 1976, 3), indicating that social institutions possess a narratable self-conception—what Habermas terms an 'interpretative system'. Applied to theatre institutions, one might think here of the example of Emma Rice in her brief tenure as artistic director of the Globe Theatre, the incommensurability of her vision for the theatre—introducing contemporary sound and lighting techniques—and the 'identity' it had established for itself as an experiment in respecting early modern conditions in theatre performance, leading to her exit from the theatre.[3] Other examples, examined more fully in this volume, are those of Chris Dercon at the Volksbühne and Matthias Lilienthal at the Munich Kammerspiele (see chapters 1 and 15). The continuation and optimal functioning of any institution requires the 'guarantee' of its identity, and when the 'social interpretative power' upon which institutional systems are founded collapses, then again crisis conditions emerge. In objective terms, institutional 'identity problems' derive ultimately not from 'identity crises' but from the 'fact [of] unresolved steering problems [*Steuerungsprobleme*]'—in short, from a loss of 'control' (1976 [1973], 4).

If systems integration crises emerge from a failure of institutional steering or control mechanisms—in short, from administrative or economic problems—then another source of crisis derives from 'beneath', so to speak—from its relation

to the life-world system. In other words, the sustainability of social institutions is not simply a matter of optimising what Habermas terms 'the specific steering performances of a self-regulated system' (1976 [1973], 4); they are also indebted to 'their dependency on functions of social integration' (1976, 4–5). All social institutions stand in a nuanced relation to the normative structures that underpin the wider socio-cultural environment in which they are ultimately located. Thus, when contradictions emerge between the operational and non-normative aspects of institutional control systems and wider societal motivations, then what can 'break out' is a 'questioning of the norms that still underlie administrative action' (1976, 69). For example, when governmental administrative decisions provoke economic downturns, as they did in 2008 with the global financial crisis, they provoke a substantial challenge to the 'norms' upon which those administrative decisions rested—manifest, politically, in the form of the dissolution of the consensus that once existed around neoliberal economics. Once that point has been reached, Habermas says, the 'penalty for . . . failure is a withdrawal of legitimation' (1976 [1973], 69). In short, the failure of the steering mechanism results in the loss of 'mass loyalty', producing a 'legitimation crisis'. Once again—and without, we hope, straining the analogy too far—one can see how enculturation crises can be understood in terms of the crisis of legitimation that so many theatres confront today: a crisis whose structural contradictions can be mapped as the non-alignment of theatre institutions with the life-world system upon which they rely.

While much more could be said here, let us conclude this section by drawing out some principal aspects of the discussion of crisis discourse thus far together in the form of a basic 'schema' for understanding what distinguishes a structural mode of analysis.

1 *Crisis: subject and institutional conjuncture.* A crisis of the conjuncture tends to indicate political crises: crises that are situational and that lead to emergency decrees and actions. They are not simply predicaments or quandaries but, rather, crossroads—turning points invested with transformative and kinetic energy. As such, they can be determined, according to the earlier analysis, as dramaturgical crises (insofar as they are 'evental'). But they also indicate the subjective dimension of crisis; as noted earlier, a political crisis determined as 'acute' invokes issues of individual authority and sovereign power: what is invested in them becomes a matter of personal standing, status and 'character'. In extremis, such crises converge on the figure of the charismatic personality. But viewed in terms of a structural modality, conjunctural crises must be examined in terms of conditions that exist prior to the determination of the subject of action; it speaks of impersonal circumstances that belie historical claims to heroic individualism as Tolstoy pointed out in *War and Peace*, when he wrote that 'it was not Napoleon who directed the course of the battle, for none of his orders were executed and during the battle he did not know what was going on before him' (2010, 842). Here, the state of the crisis situation is organic. Its appearance is not subjective but constitutive to the extent that one might reverse the Schmittian logic of sovereign

subjectivity and say that the subject appears, within conjunctural crises, not in order to resolve the crisis, but as an onlooker, as in Tolstoy's description of Napoleon. A subject of crisis is, in fact, divested of 'powers of agency'. Viewed in structural terms, we can thus understand 'conjunctural' crises as assailing theatre institutions in relation to any number of congregating factors that encroach on them at a particular moment, whether these are due to enculturation breakdown, difficulties within the public sphere, new labour practices, or advances in technology. (Or, as has happened since our first writing this introduction, an epidemiological emergency that has 'locked down' the theatre industry with potentially catastrophic economic and cultural consequences.) Each constitutes a source of institutional 'steering' mechanism problems.

2 *Crisis: historicity and temporality.* In crisis discourse, the effects of crisis are manifested in terms of an afflicted 'present time'—where the present forms the 'juncture' of the event, as in the dramaturgical conception—but it also appears as a permanent, 'chronic', and ongoing condition, as in the 'historical' mode of crisis discourse. Again, if we are to interpret the 'chronic' crisis phenomenon in structural terms, it becomes necessary to consider its temporal character in its pre-subjective form as a problem of synchronism and diachronism: it concerns functional questions of coexistence and extension. In institutional terms of crisis, coexistence is threatened when the 'unity' of institutional time is assailed by dysfunctionality and a failure of governance. At this point, 'things' no longer work 'together' in ordered sequences. Rather, the capacity to sequence institutional time becomes disrupted, affecting the transactional powers that institutions rely on to realise their 'goal values'. Protracted institutional crises are crises of temporal dysfunction that constantly bring into question the continuance and capacity of institutions to persist over time but which are nonetheless 'managed' (for instance, crises of underfunding are quite typical in the subsidised theatre sector, which, while at times acute, are more frequently persistent: i.e., such crises construct the funding 'environment' as a chronic condition). On the other hand, however 'resilient' an institution may be, drawing on mitigations and forms of 'crisis management', no institution or structure is imperishable—for that reason, chronic conditions must be considered as 'crises'. Moreover, chronic crisis conditions (whose immediate appearance is always 'presentist'—that is to say, they afflict the 'now' of institutional operations) nevertheless constantly bring into play the dialectic of preterition (i.e., of retrospective time—a glance back to how things were prior to the emergence of an interminable crisis-ridden present) and futurity (prospective time—if only the institution can 'weather the storm' and is able to adapt itself such that it can 'meet' the future). Thus, while crisis is always experienced in the 'conjunctural' terms of the present, in the case of chronic crises, the institutional present is shot through with temporal and historical logics—with institutional memory and strategic plans that seek to combat the constant drag of the 'present' on its ambitions.

3 *Crisis: change, newness, and opportunity*. Crisis discourse need not always deal in catastrophism. As we noted at the outset, crises present institutions with unforeseen opportunities to transform themselves. Crisis can offer openings for innovation but, equally, provide instructions for a 'return' or 'restoration' to some former state (to 'return to basic values'). Either way, the success of the transformation must be measured in relation to how successful the institutional form is in adapting itself to meet conjunctural contradictions. At the same time, no transformation can be entirely free of the risk that, in undergoing change, the institution becomes 'other' to itself, and the radicality of the change leads to crises in the 'interpretative system' that underwrites the institutional identity. That said, depending on the depth and scope of the crisis scenario, it is likely that institutions are always systemically transformed by the challenge of meeting conjunctural problems. Thus, even where a theatrical institution is able to recuperate its 'past' in the sense that it reinstates its forsaken authority such that it can return to 'business as usual', conjunctural crisis does not simply leave things as they were before the emergence of crisis. Everything is restored, yet everything is different. One can no doubt point to historical examples, such as the 'restoration' of the theatres in Britain in the 1660s, in which nothing was, in fact, 'restored', and, indeed, the 'new conditions' underpinning the return of legitimacy to the stage nonetheless contained the seeds of further crises of legitimation. (This became evident by the end of the 1690s, when theatre in Britain was compelled to embrace the new 'moralism' of the age as a precondition for justifying its position and credibility in the emergent bourgeois public sphere.) What crisis viewed in terms of opportunity also enables, however, is 'newness'. Here, we would suggest that the *Lebenswelt* dimension of crisis has a particular importance for, while the logics of the life-world limit the goals of institutions as social systems, crises of socialisation can themselves result in productive dynamics. This becomes clearer when one considers that socialisation processes are designed—in Habermas's terms—to 'shape the members of the system into subjects capable of speaking and acting' (1976 [1973], 9). When we said earlier that social systems under conditions of crisis require adaptability on the part of institutional 'steering mechanisms' (i.e., they must respond by learning from the crisis situation in order to resolve it), we also, of course, tacitly assumed that such systems rely on the cognitive competence of its members (i.e., their capacity to think critically). In other words, under more critical conditions, crises can create openings for different forms of socialisation, empowering members of the institution who (under 'normal' circumstances) are constrained by the hierarchical nature of steering processes. Habermas writes of the 'release' of the 'latent force embedded in the system of institutions' once the old belief system that sustains its legitimacy is challenged, and what is of interest here, specifically in terms of the prospects for analyzing institutional change, is the possibility that the latent force is released in 'the form of expansion of the scope for participation' (1976 [1973], 96). In other words, crisis conditions—as we see in the case of the Embros Theatre,

analysed by Gigi Agryopolou in this volume, for example—create the conditions for 'new' and 'democratic' forms of self-organisation.

Overview of chapters

Publics/public anxiety

It is a truism of theatre and performance studies that the public/audience is the foundation of theatre and that it completes the theatrical event. This applies to the exigencies of taste in the commercial theatre as well as to the heavy labour involved in deciphering much first-generation postdramatic theatre. If theatre is in a situation of structural crisis, then a key part of the diagnosis must apply to audiences and publics attending as much as to the artists and employees working in it. The concept of 'enculturative breakdown' enumerated earlier refers to the theatregoing public and its patterns of behaviour. When the 'habit' of theatre going is no longer transmitted, either through families or educational institutions, then disruption or even obsolescence leading to a loss of legitimacy may be the long-term result. While large-scale commercial theatre, especially in London's West End, seems to be remarkably resilient due to the tourist economy and the Hamburg-based musical industry in Germany remains robust, this does not necessarily pertain to the more challenging subsidised theatre cultures across the European continent. However, it remains to be seen how resilient the commercial sector is in the face of the economic repercussions of the Covid pandemic.

The public is at the centre of Peter M. Boenisch's analysis of the controversy surrounding Chris Dercon's appointment as artistic director of the Berlin Volksbühne. On the basis of an extensive discussion held at the conference with Dercon only days after his resignation and a broader discussion of the 'lifeworld' of the Berlin context, Boenisch focuses on the flagrant disjunctions between a stridently polarised public discourse and the discursive 'fault lines' pointing to a genuine structural crisis in the German public theatre. The latter is being increasingly forced to position itself 'within a substantially changed post-bourgeois and post-national cultural environment'. Boenisch draws on the recent research of German sociologist Andreas Rechwitz (2020) and his concept of conflictual 'singularities' as the defining characteristic of our neoliberal present. 'Singularised collectives' emerge around issues and beliefs which have little to do with class divisions and more to do with a polarisation between so-called transglobal 'cosmopolitan elites' and self-essentialising homogeneous 'communities'. This division corresponds roughly to David Goodhart's 'Anywheres' and 'Somewheres' and was notoriously reflected in Theresa May's speech castigating elites as 'citizens of nowhere' that influenced Brexit and British politics (2017). As a Belgian museum director resident in London, Dercon personified the neoliberal 'Anywhere'.

Shannon Jackson's contribution revolves around two key terms—*crisis dramaturgy* and *public assembly*. Her point of departure is the crisis that erupted around the fear of a 'Tate Modernised Volksbühne' under Chris Dercon: i.e., anxieties generated by the inclusion of 'performance' in the repertoire of the theatre. In German parlance, 'performance' is roughly equivalent to postdramatic theatre or

performance art. Jackson derives her understanding of crisis from Koselleck's *Crisis and Critique* (1988 [1959]), in which both words share the common Greek root *krínein*, 'that means both "subjective critique" or "objective crisis"'. Critique and crisis are closely intertwined in the Dercon/Volksbühne case as the theatre world's suspicion of the art world (which was also reciprocated) surfaced: the critique of Dercon's plans articulated by the theatre's staff was transformed into a full-blown institutional crisis as an enraged Berlin public staged demonstrations and occupations, which finally led to Dercon's enforced resignation. Such public expressions of contestation lead to Jackson's other key term, *public (re)assembly*, in which she argues for the conjoining of two quite distinct meanings of the term *assembly*: first, a gathering of persons for the purposes of deliberation and decision, and secondly, the assembly of 'public sector systems', which are deemed to be under threat—most prominently, public education itself. Drawing on Judith Butler's *Notes Toward a Performative Theory of Assembly* (2015), Jackson links the two meanings: 'The bodily assembly in public in fact provokes awareness of public sector systems, the need for access to such systems in order to sustain the lives of those bodies'. *Deliberation* is a key term of public sphere theory, particularly in the Enlightenment tradition represented most prominently by Habermas (1989) and Koselleck, which enshrined freedom of speech and assembly as basic preconditions for deliberation to take place. Public art projects have the potential to become sites of such deliberation, but more acutely, Jackson sees the deliberation principle threatened by alt-right demonstrations on university campuses, especially her own, UC Berkeley. How can one, she asks, counter alt-right public assemblies at US and UK universities that invoke claims to freedom of speech and assembly while at the same time disseminating hate speech and thus deconstructing the very principles of the public sphere. This produces a form of 'crisis dramaturgy', in which public assembly becomes little more than a façade or stage on which to enact often denigratory speech acts. Although Jackson notes the tendency to mobilise antitheatrical metaphors to describe the aporias of alt-right public assembly, she still argues for the constructive role of performance 'in advancing the critical function of crisis; such theaters and performances are the spaces in which crisis enacts itself and hence "places for viewing" and rethinking the conditions under which reality is produced'.

General Assembly is, in fact, the title of a re-enactment staged by Milo Rau, which, together with his *Storming of the Reichstag*, are examined by Ramona Mosse as moments of systemic crisis: in this case, affecting democracy itself. She argues that Rau 'emphasises the use of the theatre as a public forum of political engagement and the role of the audience as witnesses'. It is a new form of political dramaturgy focusing on the institutional rather than the interactional level. The genre of re-enactment provides a laboratory in which to formulate utopian ideas for new institutions for producing theatre as well as practising democracy. As Mosse shows, Milo Rau's Ghent Manifesto (2018) is a programmatic formulation of a such new, perhaps utopian model for a theatre that was published on 1 May 2018 in conjunction with his artistic directorship of NTGent, the city's municipal theatre.

Public assemblies of a slightly different kind are analysed in Gigi Argyropoulou's chapter. A member of the Mavili Collective, which occupied the Embros Theatre in Athens, a historical disused theatre building, Argyropoulou demonstrates how the group used the situation to develop a practice of 'non-continuous curation, moving simultaneously across forms and generations'. She draws on Gramscian terminology to describe the situation of crisis besetting Greece in the wake of austerity measures. According to Gramsci, crises arise when 'the old is dying and the new cannot be born; and in this interregnum a great variety of morbid symptoms appear' (1971, 276). She also shows how, during the first year of occupation, Embros destabilised dynamics in the cultural landscape of Athens 'as this unexpected space produced new relations between makers, forms and audiences'.

Funding and labour

The financial crisis of 2008–10 had severe repercussions for arts funding in many countries besides Greece. This was nowhere more apparent than in the Republic of Ireland, as Joshua Edelman demonstrates. Employing the concept of 'value regimes' developed by Luc Boltanski with Laurent Thévenot and Eve Chiapello (2005, 2006), Edelman argues that the period before and after the crisis saw a major shift in Arts Council funding. While the Council employed values before the crisis that still respected ideas of artistic autonomy in which the theatre field itself defined funding criteria, which led to a significant increase in support for professional theatre-makers, this shifted after the crisis as new value regimes came into play. Apart from a radical defunding of especially independent groups in favour of established 'flagship' institutions, a new emphasis on reception and a valorisation of the social function of the arts meant that funding could flow to amateur rather than professional groups as the former could often better demonstrate links to the 'community' and 'society'. This broader shift in values has also seen a concomitant marginalisation of the Arts Council itself as the main conduit of state funding to the arts. The example of Ireland shows that one type of crisis, a financial one, can precipitate far-reaching institutional changes that are no longer economically determined but reflect shifts in values and discourses. In terms of the structural mode of crisis discourse, the economic downturn presented institutions with unforeseen opportunities to be transformed, whereby the change was extrinsic, politically driven, and not intrinsic to the institutions themselves.

The 2008 financial crisis also precipitated reforms of arts funding in the Netherlands. However, as Quirijn Lennert van den Hoogen argues, the welfare state logic behind Dutch funding policies, which go back to the early 1990s, had already been questioned by populist and 'nativist' parties in the early 2000s. The established system was based on a four-year policy cycle administered and evaluated by the independent Council for Culture. Massive cuts were enacted in 2013, which hit the performing arts in particular. Also employing the value regimes of Boltanski and Thévenot, van den Hoogen shows how values associated with artistic autonomy in the old system were eroded in favour of new or

upgraded criteria, such as, heritage as part of a creative, tourist economy and how entrepreneurial criteria are assessed by management consulting firms. Alternatively, using the arts for mainly instrumental means, such as preventing social exclusion, is reflected in Boltanski's terminology 'civic reasoning behind cultural policies'.

The example of Italy also demonstrates that economic crises are used by government to enact far-reaching administrative reforms that transcend purely financial concerns. Livia Cavaglieri shows that the core of a reform passed in 2015 was not directed at artistic events but the administrative process of funding itself. While there was a consensus that reforms were needed, especially to address the imbalances of a system of state funding that directed an excessive amount of money towards opera, the actual result of the new law was probably more radical than expected. Funding in Italy is now allocated using an algorithm that correlates different criteria such as artistic quality (assessed by a commission), investment of labour, and output in performances, which means that 65% of the evaluation is purely mathematical. Cavaglieri's study demonstrates that the effects have been both negative and positive: on the one hand, 15% of the previously funded organisations lost their grants, while on the other hand, the number of first-time recipients has increased, which suggests that a hitherto closed system has been made more permeable. The power of commissions and evaluation boards with their intrinsic susceptibility to lobbying has certainly been reduced, as their votes now only account for 35% of the final decision, compared to 65% determined algorithmically. The economic crisis mutated into a structural reform in which mathematics determine the future.

Ever since Baumol and Bowen (1966) first formulated their famous theory of the 'cost disease' afflicting the performing arts, employment and labour costs have occupied a central place in crisis prognoses. The lag between wages in the performing arts and those earned in the more 'productive' manufacturing sector must, of necessity, drive ticket prices ever upwards, they argued, or else workers will leave the market. Their solution was to call for public support of the performing arts to close the gap. Fifty years later, the cost disease is apparent, even in the highly subsidised German system, yet the supply of willing labour shows few signs of decreasing. As Axel Haunschild shows in his chapter, conditions have never been particularly favourable for theatre workers and have even deteriorated since the late 1980s. He shows that there has been a noticeable trend to adopt 'forms of work organisation from the creative and cultural sector in order to foster creativity, innovation, agility, and flexibility'. The latter have become the hallmark of the independent theatre scene especially. Potential for conflict has arisen through the tendency to merge generally underpaid but 'innovative' independent artists with employees in public theatres. Whether such convergences between work practices in theatre and elsewhere are more an indicator and driver of crisis or the avenue for overcoming an existing crisis remains to be seen. He concludes that 'in the last three decades, work has become (even) more precarious, more intense, more market-driven, more competitive, and thus more self-exploitative', which can no doubt be extended to other countries as well.

Post-socialism

There can be little doubt that the theatre systems of the Eastern bloc countries, including the former Yugoslavia, have undergone the most radical transformations in the past decades within Europe. All countries had a state-managed-and-financed repertoire and ensemble system based around national and city theatres. The implementation of market forces, often in a radical neoliberal version, also affected the theatres: the size of the ensembles was reduced, contracts were 'flexibilised', and attendance dropped as the theatre as a site of resistance to the ruling regimes lost its importance. This scenario played out in the individual countries in different ways. Radka Kunderová argues that in the case of the Czech Republic, a more nuanced perspective is required for the so-called 'crisis narrative', which only focused historical research can provide. Czechoslovakia, as it was then, constitutes a special case because its Velvet Revolution literally took place in theatres, and its first president, Vaclav Havel, was a dramatist. Although, following the collapse of the old soviet state, theatre attendance dropped, the drop was not as severe as is often claimed. The state remained the most important sponsor of the performing arts, probably the most important of the many continuities between pre- and post-1989. Kunderová also highlights the declining importance of artistic autonomy, understood aesthetically rather than politically, with reference to the Prague Linguistic Circle where Jan Mukařovský's concept of the aesthetic function had been marginalised under Communist rule. After 1989, artistic autonomy was threatened not by politics but by competition with other media.

More recently, however, theatre artists in former socialist countries have had to contend once again with political interference as right-wing populist governments assert control of the performing arts. None more so than Bosnian director Oliver Frljić, as Weber-Kapusta shows in her analysis of two controversial productions in Croatia and Poland. She argues that the public debates there are less a reflection of the challenging subjects and the radical forms of their theatrical representation and much more a result of the relationship between the state and the theatre and the way in which the ruling cultural policy understands the purpose of theatre and defines its aims. Protests are driven by an alliance of right-wing populists and Catholics, which reflects, in turn, a deep crisis of the democratic system and the way the state defines art. Here, too, artistic autonomy is challenged in an almost conventional manner by the ruling political parties.

Hedi-Lis Toome and Anneli Saro analyse the 'double crisis' of 1989 and 2008 in Estonia and how it affected the new independent theatre movement in two waves. In Estonia, too, a sudden drop in theatre attendance was followed by a gradual resuscitation of interest. As in other former Eastern bloc countries, the state-financed repertory theatres survived the transition from socialism to capitalism, albeit with more 'streamlined' staffing numbers. A particularity of the Estonian example, which may be true for the other Baltic states as well, is the emergence of an independent theatre scene. In both cases, the crises actually produced an increase in the number of permanent independent groups. Even the recent financial crisis of 2008–10 resulted in the establishment of eight new theatre institutions and only one closure.

The crisis in Slovenian theatre analysed by Maja Šorli and Zala Dobovšek bears structural resemblances to the situation in Estonia. Here, too, we find a publicly subsidised 'institutional' system and an active independent scene that were affected by the financial crisis of 2008. The former has been forced to curtail all but their essential functions, which has meant a reduction in international touring, guests, and collaborations. For the latter, change has been more profound, even existential, as funding has been reduced and redirected. Following Roberta Levitow (2002), the authors argue that crises in performing arts are not specific or intrinsic to the art form but result from a cluster of problems, a crisis of values, and the political system. They read this configuration of factors through a production of Alfred Jarry's *Ubu the King*, performed during the 2015–16 season on the main stage of the Slovenian National Theatre (SNT) in Ljubljana, directed by Jernej Lorenci. The controversy it generated is read as a form of institutional critique because it adopted the principles of devised theatre and media genres on the stage of SNT Drama, where the dramatic theatre is prevalent. Within this open devised form, the production alluded to burning contemporary issues such as the refugee crisis, the condition of Slovenian theatre, and the newly erected razor fence on Slovenian borders. Thereby, it implicitly mocked those who finance it and, indirectly, the theatre audience attending the performances as well.

Independent theatre scene

The emergence of an independent theatre scene in Europe was certainly a feature of the 1990s and 2000s, although its roots go back to the 1980s. In his study of the theatre crisis in Frankfurt in the 1990s, Lorenz Aggermann shows how the traditional bureaucratic means of running public theatres in Germany, which are essentially part of the municipal administration like botanical gardens or rubbish collection, was changed by forming a holding known as the Frankfurt *Kulturgesellschaft*. This initiated wide-ranging cultural investments in the 1980s that led, in turn, to the current museum quarter on the banks of the river Main (the famous Museumsufer) and to the lesser-known Theater am Turm, which became one of two main German hubs for what Hans Thies Lehmann later dubbed 'postdramatic theatre'. In 1986, TAT became one of the first co-production houses with partners in Amsterdam (Felix Meritis), Vienna (Wiener Festwochen), and later Berlin (Hebbel-Theater) and Brussels (Kaai-Theater). This was a new model of funding independent theatre based on sharing costs and risks. Aggermann argues that the rise of postdramatic theatre was occasioned not just through aesthetic innovations, such as integrating media and blurring genres, but also by instituting new and hybrid organisational structures that fostered collaboration and interdisciplinary work that was almost impossible to realise within the compartmentalised traditional German theatre system.

The independent performing arts scene, organised as EU-funded networks, is the subject of Georg Döcker's contribution. He argues that that networks create a web of institutions and artists 'who are bound together by a complex relation of potential, need, and risk': the artists are constructed as subjects of creative

potential who provide the artistic core of the network (the EU's preferred organisational form) while their construction as bearers of need and risk legitimises the network as an organisational form, providing care and management but also control. As bearers of risk and exposed to a continual state of precarity, independent theatre artists are perhaps the most 'crisis-prone' element of the crisis configuration.

Reduction of precarity and better integration of independent theatre into the well-funded public system were among the ongoing issues driving debates in Germany when Matthias Lilienthal assumed the artistic directorship of the Munich Kammerspiele. His much-criticised efforts to combine the two systems culminated in his decision not to renew his contract. A combination of cancelled subscriptions, fierce attacks in the local press, and a campaign by a major political party led to this outcome. In her contribution, Bianca Michaels argues that the controversy points to institutional transformation processes whose impact extends beyond Matthias Lilienthal, the city of Munich, and its municipal theatre. Michaels employs the theory of institutional logics (Thornton, Ocasio, and Lounsbury 2012) to untangle the deeper structural issues surrounding the controversy. In this case, they concern the integration of the independent theatre, its aesthetics, and its working methods into a traditional ensemble and repertoire theatre as well as the growing number of events that do not constitute staged representations of a dramatic text such as lectures, symposia, and concerts. The crisis was 'resolved' by Lilienthal's decision not to renew his contract, but the issues his program of reform highlighted remain. The programming of 'other events', combined with the attempt to integrate independent theatre groups potentially question the legitimacy of the traditional city theatre and its repertoire system. In the terminology of institutional logics, it posed a significant challenge to, if not a destabilisation of, the 'structures of expectation' that underpin any institution.

Conclusion

Theatre throughout Europe is predicated on institutional norms that have emerged over the past century. These norms acknowledge the necessity of public funding and have led to the establishment of public theatres funded by the state, municipalities, or a combination of both. These may be in the form of national theatres (Croatia has five) or municipal theatres (the preferred model in Germany, of which there are approximately 140). Either way, this means that theatre has been absorbed into the logic of the welfare state. This was designed to shield it from the vagaries of the market and, at the same time, create a representative institution for the nation or city. While the amount of public funding varies enormously across the continent, its largely accepted existence represents a structure of expectation. Even if citizens do not attend, surveys generally register a solid support for the continued existence and public funding of theatre.

In most cases, the notion of crisis analysed in this volume does not, therefore, refer to a fundamental rejection of theatre or its public funding. The level is a discursive one, and it is here that our theoretical approach is located. We have

proposed a structural mode of crisis analysis. Institutional crises, seen in structural terms, arise from complex conjunctions of elements, in which institutions are confronted with either internal or external pressures. The latter can be financial when the state decides to reallocate resources and funding imperatives (Italy, the Netherlands, Ireland) or political when the state intervenes in programming and artistic decisions (particularly in East European countries). Internal pressures can take on a number of forms, including dissatisfaction with working conditions, but also a desire to integrate new artistic forms, especially those emanating from the independent theatre scene, into the established hierarchies of the public theatres. What we can observe everywhere, although to differing degrees, is a rapid expansion of expectations and goals that publicly funded theatre (whether state or independent) is expected to meet. These can refer to control or 'steering' mechanisms (governance and administrative structures, policy directives, literary management objectives, financial decisions, etc.), goal values and 'system imperatives' (demands for outreach and audience development, etc.), and a need to articulate strategic aims in practical form through new processes of production which demand different forms of cooperation, socialisation, and the embedding of individuals in shared values, goals, and norms. These are, in many cases, responses to changes in the life-world (the shared understandings, norms, and values on which a society is built) that derive from what we have termed 'enculturative breakdown', in which shifts in the public sphere render theatre only one option for engagement among many for a new generation. In summary: the analysis of the institutional crisis of European theatre, we argue, can only be achieved through studying the configurations of those elements that comprise its structure—it is seldom reducible to specific factors or events.

Notes

1 www.goethe.de/ins/gb/en/ver.cfm?fuseaction=events.detail&event_id=21131063.
2 "Hungary Turned Far Right. That's Meant Millions for Its Opera. State Opera Is Awash in Political Theater." *New York Times*, October 28, 2018, AR10. www.nytimes.com/2018/10/26/arts/music/hungary-viktor-orban-trump-opera.html?action=click&module=Editors%20Picks&pgtype=Homepage.
3 See Lyn Gardner, "As Emma Rice Departs, the Globe Has Egg on Its Face—and No Vision." *The Guardian*, October 25, 2016. www.theguardian.com/stage/theatreblog/2016/oct/25/shakespeares-globe-emma-rice-department-comment.

References

Baumol, William J., Bowen, William G. 1966. *Performing Arts: The Economic Dilemma: A Study of Problems Common to Theater, Opera, Music, and Dance*. Madison: Twentieth Century Fund.
Benjamin, Walter. 1999. "Theses on the Philosophy of History." In *Illuminations*, translated by Harry Zorn, 245–255. London: Pimlico.
Boltanski, Luc, and Eve Chiapello. 2005. *The New Spirit of Capitalism*. Translated by Gregory Elliott. London: Verso.

Boltanski, Luc, and Laurent Thévenot. 2006. *On Justification: Economies of Worth*. Translated by Catherine Porter. Princeton, NJ: Princeton University Press. Original publication. Paris: Editions Gallimard, 1991.
Butler, Judith. 2015. *Notes toward a Performative Theory of Assembly*. Cambridge, MA: Harvard University Press.
Delgado, Maria, and Caridad Svich, eds. 2002. *Theatre in Crisis? Performance Manifestos for a New Century*. Manchester: Manchester University Press.
Goodhart, David. 2017. *The Road to Somewhere: The New Tribes Shaping British Politics*. London: Penguin Books.
Gramsci, Antonio. 1971. *Selection from Prison Notebooks*. New York: International Publishers.
Habermas, Jürgen. 1976 [1973]. *Legitimation Crisis*. Translated by Thomas McCarthy. London: Heinemann Educational.
Habermas, Jurgen. 1989. *The Structural Transformation of the Public Sphere: An Inquiry Into a Category of Bourgeois Society*. Translated by Thomas Burger. Cambridge, MA: MIT Press.
Husserl, Edmund. 1970. *The Crisis of European Sciences and Transcendental Phenomenology*. Translated by David Carr. Evanston, IL: Northwestern University Press.
Kershaw, Baz. 1999. "Discouraging Democracy: British Theatres and Economics, 1979–1999." *Theatre Journal* 51, no. 3: 267–283.
Koselleck, Reinhart. 1988 [1959]. *Critique and Crisis: Enlightenment and the Pathogenesis of Modern Society*. Translated by Thomas McCarthy. Cambridge, MA: MIT Press.
Koselleck, Reinhart. 2002. *The Practice of Conceptual History: Timing History, Spacing Concepts*. Translated by Todd Samuel Presner. Stanford, CA: Stanford University Press.
Lehmann, Hans Thies. 2016. *Tragedy and Dramatic Theatre*. Translated by Erik Butler. London: Routledge.
Levitow, Roberta. 2002. "Some Words about the Theatre Today." In *Theatre in Crisis? Performance Manifestos for a New Century*, edited by Maria M. Delgado and Caridad Svich, 25–30. Manchester: Manchester University Press.
Müller, Heiner. 2003. "Theater ist Krise. Heiner Müller im Gespräch mit Ute Scharfenberg." In *Manifeste europäischen Theaters: Grotowski bis Schleef*, edited by Joachim Fiebach, 330–371. Berlin: Theater der Zeit.
Roitman, Janet. 2014. *Anti-Crisis*. Durham and London: Duke University Press.
Schmitt, Carl. [1922] 2005. *Political Theology: Four Chapters on the Concept of Sovereignty*. Translated by George Schwab. Chicago: University of Chicago Press.
Thornton, Patricia H., William Ocasio, and Michael Lounsbury. 2012. *The Institutional Logics Perspective: A New Approach to Culture, Structure and Process*. Oxford: Oxford University Press.
Tolstoy, Leo. 2010. *War and Peace*. Translated by Amy Mandelker. Oxford: Oxford University Press.

Part 1
Publics

1 Struggles of singularised communities in German theatre

The 'culture war' around the Berlin Volksbühne

Peter M. Boenisch

For 255 days, from September 2017 to April 2018, former director of PS1 New York, Haus der Kunst Munich, and Tate London Chris Dercon was *Intendant* of Berlin's Volksbühne. From the public announcement in spring 2015 of the Belgian art curator's appointment to succeed the theatre's notorious artistic director of 25 years, Frank Castorf, until Dercon's dismissal three years later, an unprecedented culture war raged in Berlin. During its course, the Volksbühne was occupied, Dercon had to be put under police protection, and personal friendships broke up as old friends accused each other of being either 'neoliberals' or 'neo-nationalists'. From early on, no more dialogue, let alone reconciliation, seemed possible. The hostile demarcations had been set by 2016, when Castorf's dramaturg, Carl Hegemann, and the theatre's house philosopher, Boris Groys, branded Dercon a marionette of 'neoliberal capitalism' while dubiously envisaging the Volksbühne, as Groys put it, as 'a theatre that celebrates the glorious history of the German spirit, not as tragedy, but as a history of victory and triumph', thereby helping to create 'a new "Volksgemeinschaft" or people's community that's not founded on the principles of the welfare state or socialism' (Groys and Hegemann 2016). Even critics and scholars joined the mudslinging. Once Dercon had arrived, local reviewers gave up objective discussion by bashing any premiere under his tenure while far beyond Berlin, even the reputable American Society for Theatre Research, in lieu of academic analysis, dedicated an issue of its journal *Theatre Survey* (59.2, 2018) solely to Dercon's outspoken opponents. Yet, underneath its highly dramatised surface, this inglorious recent episode of Berlin theatre history was never about individuals or aesthetics. Theatre scholar Bojana Kunst correctly interpreted what she termed 'the Volksbühne affair' first and foremost as a 'symbolic rebellion', in which 'both Chris Dercon and Frank Castorf represent the true embodiment of ideological and cultural differences in contemporary art production' (Kunst 2018, 17).

In this chapter, I will accordingly seek to explore some of the complex social, cultural, and aesthetic fault lines that came to a head in this controversy. I propose that the battle around the Volksbühne may offer important insights into an underlying crisis of the systemic structure of the German city theatre institution, once founded as a 'national' institution of and for the emerging bourgeoisie, structurally consolidated in the 19th century, and eventually paradigmatic for the liberal European culture of *Bildung* (education). What propels its present crisis is

that this cultural institution is now forced to position itself within a substantially changed post-bourgeois and post-national cultural environment. The following analysis takes as its point of departure a discussion I held with Chris Dercon, two weeks after his dismissal, at Goethe Institute London, as part of the symposium Systemic Crisis in European Theatre, from which this volume emerged.[1] In this conversation, Dercon suggested three key terms to debate 'the Volksbühne affair': crisis, disruption, and friction. I shall employ these headlines in order to first interrogate the context of the wider societal and cultural crisis that caused this 'affair' to explode publicly. I will then chart Dercon's interventions, which disrupted the institution's symbolic efficacy, before reflecting on systemic frictions induced by the artistic work he produced. I thereby intend to point out some of the key ideological and cultural antagonisms within the German public theatre system today, concerning its modes of production and aesthetic formats; its crucial symbolic function; and, not least, its relational but also exclusional mechanisms.

Crisis: coming to terms with transglobal hyperculture

On the one hand, the fierce battle around Dercon's appointment merely continued a long series of politically motivated controversies that regularly emerged within the German theatre and wider art scene: from the protracted dispute over Daniel Libeskind's Berlin Jewish Museum in the 1990s to a number of similar, expressly anti-globalist 'affairs' within a few weeks of Dercon's dismissal, such as Matthias Lilienthal's resignation as *Intendant* of Kammerspiele Munich and the late Okwui Enwezor's departure from Munich's Haus der Kunst, officially for health reasons, yet also amidst allegations of financial misconduct and the cancellation of exhibitions he had scheduled (see Van den Berg 2009; Williams 2019). On the other hand, in accordance with Bojana Kunst's proposition, the case is a particularly poignant study to observe the manifest cultural tensions engendered by the dynamics of neoliberal globalisation as they affect local cultural ecologies and institutions. Following German sociologist Andreas Reckwitz, the late-modern, post-bourgeois socio-cultural and economic formation of the present precipitated a shift from the bourgeois common consensus of Habermasian deliberation to a contemporaneity of conflicting singularities, thereby further radicalising the modern primacy of individualism into a neoliberal competition of all against all (see Reckwitz 2020). Against Samuel Huntington's idea of a clash of (Western and other) civilisations (Huntington 1997), Reckwitz identifies at the core of this wider societal crisis a clash *within* our culture(s), as the effects of globalisation have shifted the material and economic antagonism from class struggle (and its characteristic political factions of the 'left' and the conservative 'right') towards the site of a symbolic 'identity struggle' (Reckwitz 2019, 45). A central conflict is the opposition of what he terms, adopting a notion from philosopher Byung Chul Han, transglobal 'hyperculture' (see Han 2005) and the 'cultural essentialism' of what Reckwitz analyses as 'singularised collectives', which essentialise a homogenised shared identity (see Reckwitz 2019, 29–62).

This sociological perspective offers a compelling framework to explain the malignant force of the culture battle around the Volksbühne. In fact, in an interview back in 2015, following the first wave of heated debate after the announcement of his appointment, Chris Dercon himself described the issues behind the fierce controversy around (and against) his appointment along similar lines:

> The rage has less to do with my person than with the situation of theatre today, and its future. Of course, German theatre is very important, but the audience, the public has changed. Berlin today is a cosmopolitan city, and to come to terms with this fact, is not easy for German theatre.
> (in Häntzschel 2015)[2]

One might, in fact, consider the entire hugely problematic political manoeuvring by which Berlin's social-democratic city government had installed Dercon at the helm of the Volksbühne without any transparent process as a political attempt to 'come to terms' with these fundamental societal transformations.[3] As only an aesthetic epigone of Frank Castorf's trademark radicality would have been able to 'succeed' him without rupture, it seemed a good idea to opt for the most radical break by bringing in a new artistic director not just from beyond Castorf's circle, but entirely from outside the German theatre establishment. Putting forward Dercon—who had begun his career as producer for the theatre and dance festival Klapstuk in Leuven, one of the birthplaces of the interdisciplinary 'Flemish wave' of theatre and performance in the 1980s, and who had kept cooperating with theatre-makers, performers, and choreographers throughout his career—from this perspective was no outlandish proposition at all. One should not forget either that the same city government had been highly successful, only two years prior, in enforcing a similarly radical systemic change from above at its smaller Maxim Gorki Theater. In 2013, the appointment of a new artistic directorship there was used to introduce an experimental model of a new 'hypercultural' city theatre under the leadership of Shermin Langhoff and Jens Hillje.

In fact, back in 1992, the appointment of Castorf, the unruly East German theatre berserk, to run the Volksbühne, had also been the politically decided outcome of the governmental restructuring of Berlin's theatre scene after reunification, which at the time also led to the controversial closure of the Schillertheater and the fraught attempt at installing a shared artistic direction of the Berliner Ensemble under Heiner Müller, Matthias Langhoff, Peter Zadek, Peter Palitzsch, and Fritz Marquardt. Back then, the non-conformist Castorf personified the spirit of the Volksbühne's immediate neighbourhood, Berlin's Prenzlauer Berg district, where he was born and where his father would continue to run a well-known hardware store until 2012, well into his 90s (see Ballitzki 1995). In the years following the fall of the wall, a vibrant artistic subculture had blossomed in this tattered district that was full of cheap, semi-empty houses with coal-fired heating, ancient electrical wiring, and toilets in the courtyard. Over the years, more and more of these apartment blocks, sold off by the city, which could not afford their renovation, were modernised by international investors, with the new rents

no longer affordable by the old tenants. Equally, more and more tourists began to arrive on more and more low-cost flights, while more and more global creatives also flocked to Berlin, finding the higher rents still cheap compared to London, New York, Tokyo, or even Munich.

Not least, the buzz of the Volksbühne itself eventually turned the quarter into one of the prime spots of Berlin gentrification and one of the city's most desirable and most expensive districts.[4] Dercon today embodies the Prenzlauer Berg no less than Castorf once did as the theatre nowadays is surrounded by international boutiques, hip eateries, English-language kindergartens, and trendy workspace cafes for the mobile cognitariat. In fact, the district is also still an 'artists' quarter', yet of rather different artists than those Castorf's Volksbühne once gathered. Now, protagonists of transglobal hyperculture have one of their many bases here, from Olafur Eliasson to Ai Wei Wei and also from Albert Serra to Yael Bartana, Apichatpong Weerasethakul, and the artist-duo Calla Henkel and Max Pitegoff—those 'local'-international artists living in Berlin whom Dercon commissioned to work at his Volksbühne. Nicolas Stemann, who, as new artistic director of Schauspielhaus Zurich, brought in a similarly international interdisciplinary team of film directors, choreographers, and art-makers as residents at his theatre, was thus wrong in claiming that none of Dercon's artists lived in the city (in Behrendt and Wille 2019, 66). His erroneous assumption was symptomatic, though: the two scenes, that of the new Berlin hyperculture and that of the established local theatre-makers from Castorf to Pollesch and elsewhere Ostermeier, had cultivated little, if any, line of communication. This contributed to the enmity between fellow artists and, similarly, to the widening rift within the entire 'cultural left' that would surface during the Volksbühne conflict (see Diederichsen 2017). In a textbook example of the mechanism of totalitarian ideology, according to Slavoj Žižek's classical analysis, Dercon ended up personifying the neoliberal enemy, who seemed otherwise intangible (see Žižek 1989). At the same time, even respected sociological scholarship began likewise attributing the growing right-wing populism to the faults of a privileged, hypercultural 'left elite' rather than to the ever-greater inequalities created by neoliberal capitalism (see, for example, the widely discussed book by Koppetsch 2019).

The Berlin politicians, but also Dercon and his team, misjudged the explosive dynamics set free by this—to go back to Reckwitz's term—'identity struggle'. At the Maxim Gorki Theater, Shermin Langhoff and Jens Hillje successfully navigated these tensions, in fact turning them into a productive force in their performances and their programming, partly capitalising on local post-migrant culture, partly bringing in international artists such as Yael Ronen, Oliver Frljić, and the theatre's Exile Ensemble (see Cornish 2019). As both artistic co-directors had worked in the city for many years, at Ballhaus Naunynstrasse and the Schaubühne, respectively, they 'came to terms' more easily with the global cosmopolis that Berlin had become in the early 21st century and the new symbolic antagonism of competing singularities. Above all, having experienced the limits and potentials of the public German theatre institution, they were able to adapt systemic structures, avoiding the drastic disruption and friction that Dercon would cause within

the institutional apparatus. Coming from the (geographic and systemic) outside, he was eventually unable to repeat the Berlin politicians' attempt at 'globalising' another one of their city theatres.

Disruption: lessons about the institution's symbolic potency

Asked in our conversation about his motivation to accept the post, Dercon made a significant remark:

> I said immediately 'yes'; not because the Volksbühne is an important branding for Berlin, which it is, but because . . . I wanted to go to a place where I could work with audiences. My ambition was to find out what the word Volksbühne, the people's theatre, and what *Volk* and *Bevölkerung* really means today in the city of Berlin. . . . I really believed, and I still believe, that Berlin has been long enough dealing with the East-West axis, so it seemed important to me to finally open a new axis that could be explored as a form of 'city making' and creating a social work.
>
> (Dercon and Boenisch 2018)

The theatre's existing audience rejected such an attempt at 'city making' outright. They perceived not least Dercon's proposal of a 'new axis' to replace the East-West dichotomy as a threat of disenfranchisement. His fraught intervention into the theatre's symbolic position within the city's socio-cultural landscape and the perception of its audiences offers a particularly productive lesson to discern the often-neglected potent symbolic efficacy of the city theatre institution.

The notion of 'East' had been the singular defining signifier of the old Volksbühne's institutional dramaturgy. Castorf had demonstratively erected the letters 'OST' (East) on the theatre's roof. As a matter of fact, except for the *Intendant* himself, few of his theatre's popular protagonists were actually East German. Rene Pollesch hails from Hesse, Carl Hegemann is from Paderborn, actor Martin Wuttke is from Gelsenkirchen, and Sophie Rois is Austrian, to name only some. 'Ost' hence had little to do with nostalgia for the waned East Germany; rather, and far more potently than any 'branding', it stood in as an 'empty signifier' to address a range of—in Reckwitz's terms—'singularised' desires: 'Ost' signified difference as such.[5] Vastly heterogeneous groups, who would otherwise barely have had contact with each other, formed an 'imagined community' under the banner of the alternative signalled by the empty signifier 'Ost' (see Anderson 2006). Notwithstanding the problematic phrasing, the Volksbühne, under Castorf, had indeed brought together Groys's 'new "Volksgemeinschaft" or people's community that's not founded on the principles of the welfare state or socialism', which I cited at the beginning. The Volksbühne served as an important locus of identification and distinction on the basis of its expressly curated imaginary narrative, conveyed by the suggestive signifier 'Ost'. Its symbolic efficiency created that remarkable sense of ownership that connected so many different people to this theatre. The fact that Castorf's team had managed such a wide-ranging socio-cultural anchoring of the

old bourgeois institution of theatre was, in one way, their greatest achievement. Cultural theorist Diedrich Diederichsen describes an important effect:

> As the most long-lived, and at the same time dynamically developing accumulator and transformer, the Volksbühne was also a unique archive of the experiences made in Berlin and its cultural sphere since the 1990s. This fact is the deeper reason for the theatre's inexchangeability.
>
> (Diederichsen 2017, 160)

On such highly charged symbolic terrain, a clash was inevitable. Dercon's appointment (arguably, the appointment of *anyone* from outside the existing Volksbühne) could only have been perceived as an existential threat by all those drawing their cultural identity from this symbolic space. Where the invalidation of entire biographies and life experiences remained one of the deep-seated traumata of German reunification, Dercon's arrival was interpreted as a further attempt at symbolic annihilation.

The imaginary narrative associated with this signifier 'East' asserted a resistant 'counter-cultural' position: a self-fashioning characteristic of German middle-class '*Bildungs*'-culture from its roots in post-(1789)-Revolutionary German Idealism and newly rekindled in the bourgeois revolt of 1968 (see Boenisch 2014). Now, against the city's gradual globalisation, the signifier allowed for the projection of *any* alternative to the dominant system of 'West'. It does not even require a second glance to realise that the Volksbühne, as the second most highly subsidised Berlin theatre, far from being the 'counter-cultural' institution of its institutional imaginary, is a prime body underwriting the dominance of the particular German middle-class culture. Thus, at stake in the 'Volksbühne affair' were also such counter-cultural narratives. In recent years, in Germany, new contenders, emerging from queer, Afro-German, and other contexts, had articulated new intersectional critique that turned the hegemonic German culture from the dominant critical subject into the very object of critique. As a result, Dercon's disruptive project was linked with hopes for furthering the overdue symbolic 'de-essentialisation' of white German *Bildungskultur* that had begun at the Maxim Gorki Theater elsewhere in the city. Berlin artists such as Savvy Contemporary's curator Bonaventure Soh Bejeng Ndikung and media artist Hito Steyerl, as well as other protagonists of the German art sphere's postcolonialisation, such as the already-mentioned late Okwui Enwezor, Dercon's successor at Munich's Haus der Kunst, and African studies scholar Manthia Diawara spoke out in Dercon's support. The inapt, allegedly ironic flirtation of protagonists of Castorf's Volksbühne with fascist ideas—further kindled by stickers posted around the theatre with the slogan '*Tschüss* Chris' ('Bye Chris'), printed in old German Gothic typeface, iconographically reminiscent of Nazi placards with the infamous slogan '*Juden raus*'—hardened the irreconcilable fronts.

Dercon was perceptive of the peculiar dynamics of the 'old' Volksbühne audiences, commenting in our conversation:

How different they might be, they are still all believers—like a fan community. They go to see their heroes, their actors, and they want to be part of them, they want to belong to that community: so it's a community of believers.

(Dercon and Boenisch 2018)

Seeking to open up this quasi-religious circle of 'believers', Dercon revealed that the Volksbühne's efficient focalisation of heterogeneous audience groups factually relied on deeply exclusionist foundations.[6] This became obvious as Dercon approached the Volksbühne as an experiment in Bourriaudian 'relational aesthetics' (Bourriaud 2002). In our conversation, he stated:

The reason I left the museum to go to the theatre was that I . . . was absolutely triggered by that question—how can we engage audiences in a different way? The theatre is of course absolutely vital for such ideas of engagement and community building, and I do think that's why the theatre is so important today. The politics of the theatre are an effect of being in an audience and forming a community, that's where things take place, not because of what is said on the stage. . . . For me, [the Volksbühne] was a place where this community building, where this engaging of audiences really could take place.

(Dercon and Boenisch 2018)

Programmatically, Dercon opened his tenure in September 2017 with Boris Charmatz's *Fous de danse*, a weekend of public choreographies, staged on the Tempelhofer Feld, the former runways of the US-allied forces' old city airport, now a wide green space in the midst of Berlin. With free admission, around 150 dancers—from Anne Teresa De Keersmaeker to young ballet students, hip-hoppers, and Syrian dancer Mithkal Alzghair—performed for and partly with 15,000 spectators, celebrating their being together as a diverse, heterogeneous community. Meanwhile, in and around the emptied-out Volksbühne auditorium itself, Tino Sehgal framed a trilogy of Beckett plays with a new version of his Tate Modern piece *These Associations*; this opening was also staged as a quasi-ritualistic ceremony, a participatory offer to join in, experience, and take over the space.

The existing audiences rejected such gestures of opening beyond their own community and sneered at the families with their buggies having picnics, which the public event at Tempelhof drew in, and, later, during Dercon's short season, at local parents enthusiastically cheering their offspring as they were performing Charmatz's piece for children, *Enfant*. Such productions, alongside the Syrian refugees from the refugee camp next door at the former airport performing in Mohammad Al Attar's *Iphigenia*, demonstrated that there were not only different theatre audiences but also entirely different groups of people, hitherto all non-audiences, who could be attracted by a Volksbühne that would indeed seek to address the *Volk* of present-day Berlin, as Dercon envisaged. His relational politics thus exposed a major systemic problem of the German theatre institution: its structural exclusion of wide parts of the public. At the same time, the work he produced suggested that not only the Gorki's popular dramatic forms but also an

expressly aestheticist performing arts centre may, in fact, offer a greater openness towards those 'other' Berlin people.

Friction: undoing institutional paradigms

Meanwhile, a further related intervention of Dercon's revealed that the most crucial lever to effect such intended community building was actually embedded right within the systemic structure of German theatre: its ensemble of permanent actors. The single most controversial decision of Dercon's team was their attempt to rejig the ensemble structure. Again, they got trapped by the forceful symbolic dynamics within the systemic structure. It is significant that Castorf's Volksbühne was perceived as the epitome of ensemble theatre, despite the fact that of the 27 positions for permanent actors allowed for in the theatre's budget, he had only employed nine actors on permanent contracts. Most of the theatre's prominent 'ensemble members', such as Wuttke and Rois, were actually guest performers, thereby free to take on more lucrative film and TV work or to perform elsewhere too. Dercon thus perceived himself as merely continuing Castorf's practice:

> We thought we want to continue with this, we want to have a reduced group of ensemble members. Also, they don't necessarily have to be actors and actresses. We considered somebody who is a choreographer, or a director, as part of the ensemble, and so I created an ensemble position for Boris Charmatz, Mette Ingvartsen, and others. So we thought about creating a different kind of ensemble. . . . I like to work with a steady group of people; also in the museums, I never worked with freelance curators. I want to work with people who are here, and not going in and out. . . . I wanted to create a laboratory situation, and for that you need the same kind of people. . . . The idea of an ensemble in a new way was fixed in my head.
>
> (Dercon and Boenisch 2018)

Yet this 'new way' ignored the symbolic power of an entirely projected notion of 'ensemble' that functioned as a further canvas for the audience's desire to identify, thereby complementing the signifier 'Ost' as the basis of the ensuing 'imagined community'.[7] Interpreting the ensemble as a purely organisational factor instead, Dercon overlooked the fact that, regardless of their actual contractual status, all these actors were inseparably associated with the theatre's symbolic identity. He did not grasp the ensemble's own direct relational power, as the theatre's 'public face', to glue the fans to the venue and play a crucial role in forging the sense of identification and belonging. Noting the consequences of Dercon's experimentation, it will be hard to imagine that this system may effectively realise civic community building when deprived of this essential force: its own micro-community of ensemble performers, who, evening after evening, share the space and time with the spectators. Dercon, for the purpose of also reaching out to his audiences in kinetic and affective ways, eventually had only the choreographers to rely on while all the institutional communication with which he framed the stage

productions was, without a supporting anchor in recognisable ensemble faces and voices, overlooked as purely optional add-on.

Yet elsewhere, Dercon's deliberate decision to throw spanners into the otherwise self-perpetuating machinery of the German city theatre system offered productive systemic challenges (see also Knörer 2018). His envisioned 'laboratory' sought nothing less than to dissociate the German city theatre system from *Regietheater* (directors' theatre) as its virtually synonymous methodology, encompassing both an aesthetic approach (of staging a text of whatever provenance in performance) and an organisational model (of a production time of some weeks of rehearsal spent on a rehearsal stage, culminating in the premiere night):

> I definitely wanted to change the normal pattern of the German theatre repertory theatre, where a director has 4 to 6 weeks' time to work with actors. This is like a machine, constantly on and off. We didn't know yet how we were going to do this, but . . . we learned from our mistakes, and we made really many mistakes. But we did not have time, and in theatre you need two or three seasons to work out something that is new and different.
> (Dercon and Boenisch 2018)

Notwithstanding his flawed conception of the 'ensemble', Dercon did create a different mode of making and presenting theatre performances, in which, indeed, not just the performers on stage were considered the ensemble realising the show. Instead of the typical stage director, who leads a production to its premiere and then moves on, Dercon's directors were present during every performance as part of the ensemble, continuing to actively work on their productions from one evening to the next. For this reason, Dercon based his programme on a series of repertoire shows, presented alternatingly in short en-suite runs.

In what seemed his most daring (and, perhaps, ultimately fatal) move, Dercon gave the artists he worked with carte blanche for experimenting with the stage, the space, and the performers. More radical than the postdramatic dissolution of characters and plots, their work was given licence to play with entirely different posttheatral approaches. The one thing Dercon sought to avoid was producing theatre evenings that looked like theatre evenings as expected and foreseen. Ahead of opening the Volksbühne in 2017, he stated in an interview:

> The so-called directors' theatre is not the solution to revive the theatre. The image is in the way. I have no appreciation for directors, who revive a play solely through some form of updating and modernisation, and serve it as ready and finished. I believe what we are missing in director's theatre is the unfinished (*das Unfertige*), and this is what we need in theatre.
> (in Riechelmann 2017)[8]

He went on to envisage a 'third form' beyond visual arts and performing arts. The artistic work he presented indeed opened towards uncharted territory beyond the established dualities of dramatic and postdramatic theatre, and of theatre and 'free'

independent performance-making, again reminding us of the limitations of accepting as fixed given parameters, whether of audiences, forms, formats, or production structures. In addition to choreographers such as Charmatz, Ingvartsen, and De Keersmaeker, Dercon programmed artists who either challenged existing theatre forms and conventions as theatre-makers (Susanne Kennedy, Tim Etchells, Mohammad Al Attar, and Tino Sehgal, alongside Dercon's frequent references to Beckett's and Piscator's earlier radical experiments towards 'third forms', undertaken at Berlin) or came to theatre, often for the first time, from other media (Weerasethakul, Bartana, Serra). Their performances were embedded in an encompassing discursive context that allowed for dialogue, exchange, and debate, from pre- and post-performance talks to the symposium Ingvartsen curated around her retrospective of works, further complemented by the events in the theatre's Red and Green Saloons, which Dercon brought back into the domain of the artistic director after they were outsourced sub-venues under Castorf's tenure. The Green Saloon was given over to Berlin-based US artists Calla Henkel and Max Pitegoff, who formerly ran the 'New Theatre' in a Berlin Kreuzberg shop window. The Red Saloon, meanwhile, hosted discussion events such as the series of debates curated by philosopher Armen Avanessian and the globalisation 'board game' by British cultural critic Paul Mason.

This comprehensive programmatically curated vision of embedded, relational post-theatre art followed a relentless logic. Above all, it attempted to reverse the traditional time vector of bourgeois city theatre, which grounds the present in the canonised past and, therefore, is prone to reiterate the power structures of bourgeois hegemony. The artistic work at Dercon's Volksbühne, on and off the theatre stage, sought to strategically extend this vector into the future, suggesting a principally unfinished 'futurability' as major force in order to open cultural spaces of possibility, which might effectively counter the epidemic of nostalgic 'retrotopia' as the sole response to the ongoing processes of political disempowerment associated with globalisation (see Berardi 2019; Bauman 2017). Dercon probably went a step too far too quickly in his attempt to aesthetically reimagine the theatre system beyond the prescripts of the (post)dramatic and in venturing instead into an all-encompassing relational social and spatial 'post-theatre' experiment. As Ekkehard Knörer suggested, he eventually failed 'not for reasons of apathy but for oversized ambitions' (Knörer 2018, 35). Not least as a push towards an unfinished, post-theatral 'third form', Dercon's work aligns with numerous contemporary experiments to rethink the city theatre institution, from Lilienthal's equally cut-short tenure at the Munich Kammerspiele to the more outright success stories of Berlin's Maxim Gorki Theater in Germany, Milo Rau's NT Ghent, and Tiago Rodrigues's Teatro Nacional D. Maria II in Lisbon.

Beyond 'culture as usual'? A concluding vision with a pessimistic end

Politically doomed to fail even before its start, Chris Dercon's brief Volksbühne interlude of 2017–18 highlighted some decisive issues for this ongoing systemic (re)calibration. Largely *ex negativo*, it disclosed the sometimes underestimated

potential of the theatre institution itself to occupy a powerful symbolic space within society while also emphasising the crucial role of a recognisable ensemble as affective negotiator between the institution and the public. Furthermore, substantive openings were created within the system's given parameters, specifically by dissociating the institution from the dominant aesthetic practice of *Regietheater*, with its problematic singular authoritarian nature, its privilege of interpreting the present through a canonised perspective of forms and stories, and its perpetuation of a certain set of organisational modes of production and operation. Meanwhile, the escalation of the veritable culture war itself palpably demonstrated the societal transformations within the city theatre's main reference point, the city as *polis*. It is not the phenomenon of 'globalisation' that is new here (see Sassen 2001), but the collapse of the heterotopic urban, cosmopolitan space of ambivalent possibility into the anxious spaces of Reckwitz's combatting 'singularities': a society that has no more space for communal solidarity, but which is characterised by competing subsets, even within the same societal group. The crisis of the theatre system is both intensified and resolutely played out in this sociocultural space that is no longer characterised by a 'shared urban geography' or a 'singular urban space' that performance research on the city used to evoke (Hopkins, Orr, and Solga 2009, 2). Even behind the self-declared all-inclusive 'hyperculture' lurks an obsolete hinterland of exclusion, right within the cosmopolitan city itself, let alone the regions beyond its borders: wastelands of social abandonment and political disenfranchisement.

True 'city theatre' as medium of the *polis* ought to break through such rejective societal dislocation. To do so, it can no longer rely on old textual metaphors of 'reading the city' as context or on narratives provided by the canonical tradition as sole guidelines for critical exploration. The complex structures of singularised interests, demands, and sensitivities require different analytic approaches in order to navigate and situate the theatre institution, as much as possible in non-exclusionist ways, within a plurality of localities and communities. As a generator of community and a transmitter of shared experiences, theatre in its very form engenders a productive antidote to brute singularisation. Amidst its flaws, Dercon's Volksbühne project demonstrated that it is possible to reach beyond the bourgeois template of mainstream and counter cultures and to challenge aspects of ownership (not least of 'signification' and overdetermined symbols) and participation (in an opening beyond its own group of 'believers'). Seeking to undercut singularisation through relational practice, his manoeuvre insisted on its radical openness and incompleteness, no longer claiming the usual primacy of a unified, 'right' meaning occupied by a singularised community and affirmed by being broadcast from the stage to the audience. Against singular essentialism, it maintained a complex aesthetic over-differentiation on stage, refusing to deliver products as much as easy identification and appropriation. As a vision of an 'unfinished' city theatre, it re-invoked the more radical spirit of enlightenment culture in activating the aesthetic-political force of a persistent 'redistribution of the sensible', as Jacques Rancière would describe it (Rancière 2009).

The ensuing 'dissensus' confirms this post-theatral experiment, rather than invalidating it. It proposed one way out of the systemic crisis of the German city theatre institution that begins with the radical questioning of any given aesthetic, as well as the institutional and organisational tenets of the theatre institution itself, in order to open up future inclusive spaces where a plural community might come together, full of curiosity, to engage in new mutual debates that are open to their future outcomes. Sadly, though, the end of the affair left little reason for optimism. Many had hoped that, if not Dercon's tenure, then at least its abrupt ending might foster a different new beginning that would allow for the 'recognition of political practices that transcend the ways and means of culture-as-usual' (see Annuss 2018, 94). Eventually, though, the city politicians in charge of their city theatre installed the former managing director of the Gorki Theatre, who once had made way for Langhoff and Hillje, and then appointed Castorf's principal heir Rene Pollesch as the Volksbühne's new artistic director. Even Castorf's own biographer, critic Robin Detje, described this decision as 'proclamation of the dictatorship of the apparatus', and, in its lack of vision, as 'a nightmare' (Detje 2018). In Berlin, the affect-driven battle of a singularised community defending its *Kiez*, as the Berlin local districts are called, against a hallucinated threat from without instead of challenging the systemic deformations at the heart of all upheaval will continue: nothing new in the 'East'.

Notes

1 The live stream is archived on the Royal Central School of Speech and Drama's website. Accessed October 27, 2018. www.cssd.ac.uk/news/centrals-professor-european-theatre-discusses-theatre-crisis-chris-dercon.
2 All translations from German sources are my own.
3 The disturbing series of absurd promises, fantastic visions, and shocking political mischief, which led to the eventual collapse of the Volksbühne, became the subject of in-depth investigative reporting, yet without any consequences for the politicians concerned (see Goetz and Laudenbach 2018).
4 The ambivalent dynamics of cultural gentrification have been explored through a South London example by Jen Harvie in Chapter 3 of *Fair Play* (2013), "Exclusion and Engagement," 108–149.
5 Following Lacan, the thesis that the dominant 'Master Signifier' is necessarily empty and, for this reason, all the more powerful is a main argument of Slavoj Žižek's early work (Žižek 1989).
6 I take the term *focalisation* from Mieke Bal's method of cultural analysis (Bal 2002).
7 In fact, one might propose as characteristic of the German theatre system that audiences do not identify with dramatic characters but, instead, with 'their' ensemble actors.
8 It is noteworthy that the critical debate about Dercon's actual work (as opposed to agitation in the Volksbühne case) happened exclusively in film journals (*Cargo*), music magazines (*Spex*), and visual art publications (*Texte zur Kunst, Frieze*) instead of the German theatre media.

References

Anderson, Benedict. 2006 [1983]. *Imagined Communities: Reflections on the Origin and Spread of Nationalism*. London and New York: Verso.

Annuss, Evelyn. 2018. "On the Future of the Volksbühne: Failure is an Option." *Texte zur Kunst*, no. 110: 92–106.
Bal, Mieke. 2002. *Kulturanalyse*. Frankfurt: Suhrkamp.
Ballitzki, Jürgen. 1995. *Castorf, der Eisenhändler: Theater zwischen Kartoffelsalat und Stahlgewitter*. Berlin: Ch. Links.
Bauman, Zygmund. 2017. *Retrotopia*. Cambridge: Polity Press.
Behrendt, Eva, and Franz Wille. 2019. "Agenten für Diversität." *Theater Heute*, Yearbook, 62–72.
Berardi, Franco 'Bifo'. 2019. *Futurability: The Age of Impotence and the Horizon of Possibility*. London and New York: Verso.
Boenisch, Peter M. 2014. "What Happened to Our Nation of Culture? Staging the Theatre of the Other Germany." In *Theatre and National Identity: Re-Imagining Conceptions of Nation*, edited by Nadine Holdsworth, 145–160. Abingdon and New York: Routledge.
Bourriaud, Nicolas. 2002. *Relational Aesthetics*. Dijon: Presses de Réel.
Cornish, Matt. 2019. "Common and Uncommon Grounds at Berlin's Gorki Theater." In *Postdramatic Theatre and Form*, edited by Michael Shane Boyle, Matt Cornish, and Brandon Woolf, 179–195. London: Bloomsbury Methuen.
Dercon, Chris, and Peter M. Boenisch. 2018. "In Conversation." At Conference Systemic Crisis in European Theatre. Goethe Institute London, April 27, 2018. Transcript.
Detje, Robin. 2018. "Einsam wartet der Champagner: Eine Verbeugung vor dem weggeekelten Berliner Volksbühne-Intendanten." *Die Zeit*, April 16, 2018. Accessed May 29, 2020. www.zeit.de/kultur/2018-04/chris-dercon-volksbuehne-berlin-ruecktritt.
Diederichsen, Diedrich. 2017. "Weder Wohnung noch Währung." *Texte zur Kunst*, no. 105: 158–163.
Goetz, John, and Peter Laudenbach. 2018. "Die 255 Tage von Chris Dercon: Chronologie eines Desasters." *Süddeutsche Zeitung*, April 16, 2018.
Groys, Boris, and Carl Hegemann. 2016. "The Shock of Socialism Is Gone." *e flux*, June 25, 2016. Accessed May 29, 2020. https://conversations.e-flux.com/t/boris-groys-in-conversation-with-carl-hegemann-the-shock-of-socialism-is-gone/4098/2.
Han, Byung Chul. 2005. *Hyperkulturalität: Kultur und Globalisierung*. Berlin: Merve.
Häntzschel, Jörg. 2015. "Theatermacher: 'Ich werde produzieren': Chris Dercon über seine Ziele an der Volksbühne." *Süddeutsche Zeitung*, April 25–26, 2015.
Harvie, Jen. 2013. *Fair Play: Art, Performance and Neoliberalism*. Basingstoke: Palgrave Macmillan.
Hopkins, D.J., Shelley Orr, and Kim Solga, eds. 2009. *Performance and the City*. Basingstoke: Palgrave Macmillan.
Huntington, Samuel P. 1997. *The Clash of Civilizations and the Remaking of World Order*. London: Simon & Schuster.
Knörer, Ekkehard. 2018. "Sand ins Getriebe: Die Dercon-Volksbühne, das Theater und die anderen Künste." *Cargo*, no. 37: 32–40.
Koppetsch, Cornelia. 2019. *Die Gesellschaft des Zorns: Rechtspopulismus im globalen Zeitalter*. Bielefeld: Transcript.
Kunst, Bojana. 2018. "The Volksbühne Affair: Theatre and the Cultural Struggle." *Maska*, no. 193/194: 16–23.
Rancière, Jacques. 2009. *Aesthetics and Its Discontents*. Cambridge: Polity Press.
Reckwitz, Andreas. 2019. *Das Ende der Illusionen: Politik, Ökonomie und Kultur in der Spätmoderne*. Berlin: Suhrkamp.
Reckwitz, Andreas. 2020. *The Society of Singularities*. Cambridge: Polity Press. [orig. Berlin: Suhrkamp, 2017].

Riechelmann, Cord. 2017. "... nicht einfach Atmosphären aus schlechten Buletten." *Spex*, no. 376: 82–90.
Sassen, Saskia. [1991] 2001. *The Global City*. 2nd ed. Princeton, NJ: Princeton University Press.
Van den Berg, Klaus. 2009. "Staging a Vanished Community: Daniel Libeskind's Scenography in the Berlin Jewish Museum." In *Performance and the City*, edited by D.J. Hopkins, Shelley Orr, and Kim Solga, 222–239. Basingstoke: Palgrave Macmillan.
Williams, Sam. 2019. "A Struggle in the House of Art." *Tribune*, no. 9. Accessed May 29, 2020. https://tribunemag.co.uk/2019/09/a-struggle-in-the-house-of-art.
Žižek, Slavoj. 1989. *The Sublime Object of Ideology*. London and New York: Verso.

2 Public (re)assembly and crisis dramaturgy[1]

Shannon Jackson

In a collection on 'crisis', one might ask why this chapter seeks to integrate the language of 'assembly'. Aren't these two terms at odds, subjects for different publications? Fortified by a complex sense of the conditions that produce crisis—or, rather, the conditions that so-called 'crisis' reveals—my hunch is that what I have decided to call crisis dramaturgy has a great deal to do with past and current debates on 'assembly' and public (re)assembly. Thinking about assembly's relation to cultural sectors, to political sectors, and to labour sectors, this chapter considers what such a term has to contribute to an edited collection on systemic crisis and theatre in Europe. My contribution demonstrates a deep interest, if a foreigner's interest, in how performance cultures catalyse and symptomise larger systemic crises in European theatre—especially crises around economics, governance, social welfare, new technologies, and the relation amongst various art worlds. But my invitation from the editors also suggested that I share thoughts about 'the American context' and the parallel crises we endure there. Let us see if I can get reflections on and in both sides of the Atlantic to cohere and, moreover, to see if Reinhart Koselleck can help me do it (Koselleck 1988). I offer a chapter in three parts. First, I will share some thinking about performance and its relation to a recent debate and the resignation of Chris Dercon at one of the most revered 'mother ships' of European theatre, the Volksbühne in Berlin. I will then turn to the phrase 'public (re)assembly', which has guided my own research as well as an ongoing public platform at my home institution of the University of California, Berkeley. Then I'll conclude with some reflections on the aesthetics and politics of the educational sites in which we teach, including that home institution in which I teach. In discursive and embodied formats, each of these sections shows the dramaturgy of 'crisis' at work, undoing and redoing normalised habits of thinking, making, deliberating, and imagining.

Performance

> Fake, artifice,
> Medium specific
> To furnish forth, to carry out
> Theatre: a place for viewing

As a scholar of theatre and performance, I have an obsession for thinking about a form that combines bodies, language, spectacle, sound, time, and space in ever-new combinations (Jackson 2011; Jackson 2004; Jackson and Bryan-Wilson 2016; Jackson and Marincola 2019). That context has become newly energised and estranged by performance experiments sited not only in theatres but also in visual art galleries, biennials, museums, installations, and site-specific locations. In recent scholarship, I found tremendous variance in how such practices are produced and received as those contexts proliferate. Former sculptors, painters, and contemporary art curators have different assumptions of what it means to mobilise bodies, language, spectacle, sound, time, and space than do theatre practitioners or choreographers. Meanwhile, contemporary visual art curators began to 'discover' performing artists—actors, dancers, opera performers—in a way that is at once exciting, de-familiarising, and perplexing for those of us who have known of the existence of these discoveries for quite some time. In my published work, I have sought to frame these instances of productive misrecognition and to show the interdisciplinary variety. That effort was extended in a recent collaboration with Paula Marincola at the Pew Center for Art & Heritage to create a large site of keywords with commissions from curators, artists, and critics from across forms: In Terms of Performance Jackson and Marincola 2019). Our goal was to create an open glossary that exposed disciplinary variety and interdisciplinary contradiction, one with reflections that were not definitive but invitational, prompting more reflections about the connections and disconnections amongst art practices across painting, installation, theatre, dance, sculpture, video, and media art. Different artists have different ways of responding to classic terms such as *composition, duration, character*, and *narrative*. So, too, more contemporary terms such as *performativity* and *participation, re-enactment* and *experience economy* are differently loaded for differently positioned artists, performers, writers, curators, and audience members. The site had a pre-launch at the Tate Modern in London—to anticipate a later part of my argument, it has been 'Tate Modernised'. It has been part of courses and public programming at a range of institutions. In 2018, it received a new assembly at the Brooklyn Academy of Music (Brooklyn Academy of Music 2018), when BAM's curators and archivists created a gallery exhibition to promote both offline and online exchange around the terms. Placed adjacent to the opera lobby, this exhibition/educational-engagement platform was activated in extended participatory events by a variety of artists—Sharon Hayes, Malik Gaines, and more. Even here, we have a productive disjunction: Sharon Hayes, a site-specific performance artist exhibited at major museums and biennials—indeed, winner of the Golden Lion award at the Venice Biennial—noted that this would probably be the only time she would ever be presented at a theatrical venue like the Brooklyn Academy of Music.

For a brief period of time, however, it seemed that someone like Sharon Hayes was going to have the chance to be presented at another internationally renowned theatrical venue, the Volksbühne. Perhaps that is an over-statement, but I use it to foreground just how rich and interesting the Volksbühne debates were for a modest site like In Terms of Performance. At the conference that spawned this

collection, Chris Dercon offered a more detailed account of the political turmoil. But from afar, the appointment, the debate, and Dercon's resignation as head of the Volksbühne typified the struggles, the productive and unproductive misrecognition that seem to follow current experiments across the visual arts and performing arts worlds.[2] Such debates raise concerns about the re-skilling or de-skilling of performance, about the potentials and perils of an art world embrace of performance. Without chronicling a cacophony of debate between the so-called 'visual arts world' and the so-called 'performing arts world', it is worth noting how much the signature moves within such debates were repeated in the Volksbühne 'crisis'. Take the well-circulated 2016 open letter from the Volksbühne staff as an example. Its writers accused Dercon of re-presenting 'dance, musical theatre, media art—already core elements of the Volksbühne—as "novelty"': as forms erroneously discovered by the then-outgoing Tate Modern director (Volksbühne Staff 2016). In response to Dercon's desire to move across disciplines beyond what he called the 'spoken word' form of the theatre, practitioners were alarmed by his desire for an alternative 'polyglot stage language'. Of course, his infamous assertion that Hito Steyerel and Wolfgang Tillmans were the only good artists in Berlin stung (Furtado 2016). But in these and other exchanges, we saw a tussle around vocabulary (how strange to hear theatre called 'spoken word') artistic literacy, and a confrontation of inherited artistic genealogies. Experimental art practices in visual art and theatre art have often collided, and, more often, they run in parallel without deep knowledge of each other. The post-optical or post-studio practices of the expanded visual art world have not always had any clear relation to the post-dramatic practices of a theatrical world. With Dercon's appointment, I was actually interested to see if they might. Of course, it seems that this was not to be.

Now, as we start to understand why this was not to be, we might turn to the language of crisis as an analytic frame for understanding the fear of a Tate Modernised Volksbühne. In my own reading of Reinhardt Koselleck, I am struck first by his varied ways of describing 'crisis' historiographically and second by the link he sees between crisis and critique. On its historiographical positioning, we might decide whether this crisis has been incrementally rising, whether it forms a decisive break, or whether it marks a public realisation of circumstances that have been changing implicitly for quite some time. Wherever we locate this crisis as a temporal form, Koselleck would have us realise the epistemological opportunity of crisis; crisis produces the capacity for critique, the capacity to realise that the world could be otherwise—indeed, that it might already have changed. We can turn to etymology again to note that 'crisis' and 'critique' share a Greek root *krinein*, which means both 'subjective critique' and 'objective crisis'. For Koselleck, the bourgeois intellectual, the active citizen, and the arts have been vehicles for critique and, in particular, vehicles for foregrounding or even expediting a 'crisis' of moral subjectivity against the absolutist authority of the ruling power. So what does the Volksbühne crisis say to us? What kind of critique does it exemplify or propel? On the one hand, we could say that some of my and our formal and disciplinary inter-art preoccupations are here revealed to be highly political. Who would have thought that people would care so deeply about the disconnect

between post-visual and post-dramatic performance practices? However, I think it is terribly important not to narrow the political frame of the aesthetic debate; the crisis is not fundamentally about how the visual art world is taking over the theatrical world. Indeed, over the last several years, I have had to respond somewhat defensively to accusations that theatre was taking over the visual art world. Visual artists—along with art historians from Michael Fried to Hal Foster—have lamented the invasion of performers, choreographers, and time-based artists whose work de-skills and distracts attention from the contemplation of visual art (Fried 1967; Foster 2017). Having navigated the art world's ambivalence towards theatre for so long, we now find ourselves in a reversal; we are navigating the theatre world's ambivalence towards the art world. But each accuses the other in similar terms. Each accuses the other of ushering in a commercialised event culture. Each accuses the other of neoliberal takeover. Critics in both camps are concerned about the effects of globalisation, whether the empty internationalism of the biennial form or Dercon's internationalism, perceived by Volksbühne staff to be a 'a historical leveling and destruction of our identity, [ushering in] a global consensus culture with unified patterns of presentation and scale' (Volksbühne Staff 2016). It is surely inside this volley of projections that we find the real symptoms of historical crisis. And, of course, undergirding this volley about aesthetic differences is a primary concern about economics, about jobs. New polyglot stage languages might require a different kind of expertise from an artistic and technical staff trained in producing the 'spoken word' form of theatre. Or, as Brandon Woolf has shown in his study of theatrical cultural policy in Germany, an institutional commitment to the one-off contract with the international artist undermines the repertory model of local theatrical employment (Woolf 2018). The open letter put it bluntly: 'We fear that with these plans there will be no need for our expertise and capacities. We fear job cuts, even liquidation of entire subsections' (Volksbühne Staff 2016). In other words, these salaried theatre artists feared what Axel Haunschild might call the boundaryless career of the itinerant, 21st-century creative labourer (Haunschild 2003).

With this gloss on an exceedingly interesting case of crisis in European theatre, I find myself reflecting more about what 'crisis dramaturgy' might mean. On the one hand, we have at the Volksbühne (and in other examples invoked on the In Terms of Performance site) a crisis about dramaturgy—what makes good art, what is a polyglot performance, what parameters and propositions can be explored in performance? Our aesthetic preoccupations, our dramaturgical questions, were elevated to the status of global crisis and global critique in Berlin during this period. On the other hand, and more significantly, performance and theatre became vehicles by which larger societal crises were made visible—whether in the 'people's theatre' itself or in protest performances (some of them offensive) staged outside its doors and on Dercon's doorstep. As Jan Verwoert said in a piece called 'Shoot the Messenger' for *Frieze*, Dercon is figured as an antagonist in a much larger story (Verwoert 2016). As Dercon himself suggested in his summary of projected critiques against him, his brief tenure became the symptom, scapegoat, and staging ground for airing broader anxieties around neoliberal change in Europe: 'I come from London.

I come from the art market. I am responsible for Brexit, the climate change. I am neoliberal, I stand for the event culture' (Furtado 2016). For good and for ill, we could say that on these occasions, the etymologies of crisis and critique are joined to the etymology of performance and theatre. Such performances—such 'event cultures'—become arenas for recognising the fact that the world could always be otherwise or for recognising the changing conditions that are bringing another reality into being.

Public (re)assembly

With these meditations on performance, theatre, and crisis in the background, I would like now to turn to 'public (re)assembly', a phrase that has animated much of my current research and my recent life as a teacher and administrator at the University of California, Berkeley. At a time when Berkeley was threatened with public defunding, its activist legacies were facing new challenges to freedom of assembly and free speech around the same time that the Volksbühne's challenges unfolded; at Berkeley, alt-right speakers appropriated the legacies of free speech to take over our campus. In the summer of 2017, my colleagues and I had already planned a co-curated series that explored these freedoms and practices of assembly—indeed, of public re-assembly in our contemporary moment. As more alt-right speakers threatened to arrive on our campus in the fall of 2017—prompting racist posters and threatening speech acts in advance of their arrival—we found that the gatherings around this series became newly reframed and newly precious for all of us.

Let me share some basic parameters of the platform. First of all, we explored the keyword *assembly* for its range of associations.

1 A bringing or coming together.
2 A gathering of persons for the purposes of deliberation and decision.
3 A work of art consisting of miscellaneous objects fastened together.
4 In a line, a series of workers and machines in a factory by which a succession of identical items is progressively assembled.
5 In schools, a general gathering of staff and pupils.

These associations are wide and varied and perhaps already anticipate how the assemblies of performance can respond to systemic crisis. We might consider the first definition and differentiate, as perhaps Koselleck would, between a bringing together and a coming together, with the first suggesting an agent of centrifugal gathering and the second suggesting an historical arrival of unexpected people and entities who come unbidden. The third aesthetic association is also intriguing. It recalls the aesthetic use of assembly or assemblage: the practice of assembling miscellaneous parts in painting, in sculpture, in combines, and in events and happenings that bring that miscellany into three and four dimensions. Of course, this artistic association reflects and refracts back on my earlier disquisition on performance; the relationship between 'theatre' and the 'polyglot' languages and genealogies of

assemblage art is part of what was contested in the Volksbühne debates. Meanwhile, the assembly line is a central image from industrial labour history; it prompts an image of work that arguably has been changed by post-industrial shifts in the nature of labour. A post-Fordist labour sphere focused on immaterial production welcomes the insidious flexibility of creative labour now: one that underpinned what Ulrich Beck once called *The Risk Society* (Beck 1992) and that underpins Axel Haunschild's concept of the boundaryless career (Becker and Haunschild 2003). Furthermore, we can consider the school assembly, the gathering of pupils and teachers that is so formative for citizens in democratic life, even as we as educators work in worlds where 'school' itself is being re-assembled. But it is the second association—'a *gathering* of persons for the purposes of *deliberation* and *decision*'—on which I want to linger most, as it brings us to the social and political dimensions of assembly, theatre, and the processes by which we navigate systemic crisis.

Here, of course, is the definition most associated with the long tradition of democratic social theory. Such democratic assemblies might take shape as protest—a space of gathering, as the public sphere; a space of deliberation; or in governmental bodies, a place of decision. Koselleck might suggest that it is in such spaces that we reckon with social crisis and its implications for our relationship with governance and ruling powers. Indeed, when I first started this project on public (re)assembly, I wanted to explore the relation between protest and governance, a pursuit that I would now like to read through Koselleck as a question—maybe even a crisis—about the role of public critique next to the operational maintenance of state systems. My first overriding question was: what does it mean to assemble in public in our present moment? And the second question isn't obviously related: what does it mean to assemble public sector systems? Is there a relation between the public appearance of the former (protest) and the systematic operations of the latter? To take up the first question about the present meaning of 'assembling in public' is to invoke the long history of reflection about protest, about the public sphere, and especially about the physical appearance, arrangement, and performance of bodies in real time and co-present public space. Within social theory, to assemble in public is to recall both the embrace and the condemnation of this appearance, embraced as a key element of the so-called 'democratic process' and condemned as an unruly takeover by the 'masses'. In her *Notes Toward a Performative Theory of Assembly*, my colleague Judith Butler recalls the ambivalence amongst thinkers of all political persuasions about whether and how such assemblies index 'the people' and whether they index a 'populism' to be celebrated or a 'populism' to be castigated (Butler 2015). Butler cites Ernesto Laclau and Chantal Mouffe to reinforce her argument that any appeal to 'the people' as such depends on a 'constitutive exclusion' of who is not recognised within the assembly or who is rightly or wrongly represented by said assembly. For Butler, the performativity of assembly 'establishes a fundamental problem of democracy even as—or precisely when—it furnishes its key term, "the people"' (Butler 2015, 3). Like an Austinian speech act that does things with words, Butler highlights the world-making power of assembly to produce a 'people' that it simultaneously appears to describe and can never fully include.

But assemblies are performative in other ways, ways that invoke not only the rhetorical sense of the performative but also the embodied sense of performance. This means returning to the physicality of assembly, the appearance of bodies in real time and space, with roles assigned or assumed, sometimes with appropriate infrastructure for managing safety, crowd flow, sightlines, and durational unfolding. Notably, Butler brings this orientation to bear on her understanding of what it means to 'assemble in public', an orientation that takes seriously the physicality of 'a concerted bodily enactment' next to their rhetorical effects. Here it is worth sharing a longer quote:

> After all, there is an indexical force of the body that arrives with other bodies in a zone visible to media coverage: it is *this* body, and *these* bodies, that require employment, shelter, health care, and food, as well as a sense of a future that is not the future of unpayable debt; it is *this* body, or *these* bodies, or bodies *like* this body or these bodies, that live the condition of an imperiled livelihood, decimated infrastructure, accelerating precarity.
> (Butler 2015, 10; emphasis in original)

I have lingered on this passage from Butler because it is in a formulation like this that we can see a possible answer to my opening questions. Again: what does it mean to assemble in public in our present moment? And what does it mean to assemble public sector systems? Is there a relation between the public appearance of the former and the systematic operations of the latter? Here, Butler suggests that there is an acute and urgent relationship between the former and the latter. The bodily assembly in public, in fact, provokes awareness of public sector systems, the need for access to such systems in order to sustain the lives of those bodies. As someone who has devoted a substantial portion of her scholarly and administrative career to isolating such moments of provoked awareness, this perceived link is music to my ears. If only it were always true that bodily assembly provoked awareness in fellow citizens about everyone's need for access to health care, employment, shelter, food, and free education. Does it? Does it always? Does it in London or in France or in Germany? Indeed, for many in the US, is not the arrival of bodily assembly greeted with shock (and awe); disdain; even disgust; and, at the very least, annoyed feelings of inconvenience? Do they really have to block my way as I travel to my place of employment or to my grocery store for food?

Let's return one more time to other elements in the political definition of assembly. Having thought about the performativity of gathering, the middle term—deliberation—connects assembly to the goals of the liberal public sphere, as Habermas, Koselleck, and their critics have elaborated (Habermas 1989). It suggests that the assembled gathering is, indeed, a place to share perspectives, to share disagreements, and to reconcile the aspirations and demands of varied citizens and constituents. Decision, however, takes us elsewhere—certainly when set within the context of democratic governance. In such a context, decision might imply the institution of a new process, a new law, a new regulation, a new binding

agreement. And, once again, this is where we also find an interesting dialectic between the act of assembling in public and the act of assembling (and implementing) public sector systems. For Butler, there is a recursive and transitory relationship between the physical assembly and the decisions and power they have on something like 'government'. In speaking about the Occupy movement or Arab Spring, she says,

> such enactments are invariably transitory when they remain extra-parliamentary. And when they realise new parliamentary forms, they risk losing their character as the popular will . . . [further]. . . . As the popular will persists in the forms it institutes, it must fail to lose itself in those forms if it is to retain the right to withdraw its support from any political form that fails to maintain legitimacy.
> (Butler 2015, 7)

Consider, then, the dialectical relationship between the parliamentary and the extra-parliamentary implied here. Dissatisfaction with the law or governmental processes—whether the laxity of their regulation or the restrictions of their regulation—prompts the desire to assemble, which, in turn, might evolve a new law or governmental process, which, in turn, might create new dissatisfactions, which might, in turn, prompt new acts of public assembly. However abstract, the effort is to ensure that the popular will not 'lose itself' in its 'instituted' forms. What does that mean? When citizens worry about losing themselves in institutions, that concern is often read as a concern to avoid one's own bureaucratisation, to ensure that the spirited expression of the people's will remains alive and lively *against* governmental regulation. Understanding and largely appreciating that interpretation, I myself have been more interested in exploring how the people's will might remain alive and lively *in* regulation: that is, *in* the public forms they institute. When and how do people see themselves in their instituted public forms? And is it possible for them to see themselves there more? I will note here that this pursuit might differently engage another dimension of the 'crisis' dramaturgy outlined by Koselleck: i.e., the genealogy that tracks the liberal bourgeois intellectual's utopic self-conception as somehow outside political organisation, as somehow not a politically organised subject. As Koselleck says in the preface to the English edition, his book's

> hypothesis argues that the Enlightenment itself became Utopian and even hypocritical because it saw itself excluded from political power-sharing. The structure of Absolutism, which was rooted in the dichotomy of the sovereign and subject, between public policy and private morality, prevented the Enlightenment and the emancipation movement produced by it from seeing itself as a political phenomenon.
> (Koselleck 1988, 1)

You could say that I am wrestling with a similar blindness or a reluctant political self-reflexivity. As a member of a generation who inherited (from the 60s on)

a utopic self-conception and the myth of the extra-political political position, I am trying to navigate crisis and critique without automatically assuming my/our being outside the state processes, the parliamentary processes that past generations and current ones often try to critique.

For me, this is where performance as both an aesthetic and a social practice comes back in. Indeed, if I recast some of my past preoccupations with the concerns of this chapter, I have always been interested in art projects that enliven our relation to the institutions that keep us alive, in public art projects that have a chance of re-sensitising citizens to their public systems, to the 'will' behind and within their instituted forms. In a book called *Social Works* and, more recently, in a co-edited collection called *Public Servants*, I shared some of my favourite examples of such publicly re-assembled art and performance work (Jackson 2011; Burton, Jackson, and Willsdon 2016). Subsequent to the publication of *Social Works*, Occupy and Occupy-like movements offered alternative modes of assembling aesthetics and politics. In addition to exploring artists who enter systems of public service, we could also cite examples of public servants—or governing figures—who deploy aesthetic practices. Take the feted career of the former mayor of Bogotá, Antanas Mockus. This mathematician, philosopher, and son of an artist ran for mayor and won, then proceeded to engage the city as, he said, 'a 6.5 million person classroom' (Caballero 2004). The corruption, violence, and incivility of Bogotá was perceived by some to be on the verge of chaos, unfixable. Mockus responded by using aesthetic humor to try to activate a different citizen consciousness.

He put on a Superman costume and acted as a superhero: 'Supercitizen'. Another time, he asked citizens to put their power to use with 350,000 'thumbs-up' and 'thumbs-down' cards that his office distributed to the populace. The cards were meant to approve or disapprove of other citizens' behaviour; it was a device that many people actively and peacefully used in the streets. In another example, he addressed urban planning and urban crises through art and culture; faced with extreme traffic, gridlock, and accidents, for instance, Mockus responded by hiring 420 mimes to control traffic in dangerous streets. Drivers who ran red lights and jaywalking pedestrians would be tracked by mimes who mocked their every move. Mockus called it

> a pacifist counterweight. . . . With neither words nor weapons, the mimes were double unarmed. My goal was to show the importance of cultural regulations. . . . In a society where human life has lost value, there cannot be a greater priority than reestablishing respect for life as the main right and duty of citizens.
>
> (Caballero 2004)

Traffic fatalities dropped by more than half during this period.

Such mechanisms allowed individual citizens to leverage their relationship to law and government in exchanges with each other; that is, it allowed citizens to reconsider their living relation to 'instituted forms'. It dispersed that power to a

range of citizens, turning Bogotá's systemic crises into parodic critique. Crisis dramaturgy turned everyday events into mini-assemblies: i.e., mini-gatherings for tacit and explicit deliberation and for reconfirmation of or objection to societal decision-making over the norms by which individuals would interact with each other. Mockus's ideas of citizenship culture certainly displayed a normative function and was aligned with parliamentary decision-making. In these systemic performances, however, the attempt was to re-stitch something like the popular 'will' of the people—their emotions and desires—to public governance. Extra-parliamentary practices are not only a counter to parliamentarian process but also serve as a vehicle for re-performing and negotiating regulation. From the perspective of Koselleck's genealogy, we might note that criticality is not positioned completely outside the state or as a utopic emancipation movement that is somehow other than 'a political phenomenon'. Rather, citizenship performance was deployed by 'the people' as a vehicle for reckoning with the effectiveness of their systems, for joining 'public policy and private morality', for seeing themselves included in 'political power sharing', and for reckoning or not with the effectiveness of the 'forms they instituted' (Butler 2015).

I'll close now with another instance of crisis dramaturgy from my own location as a US professor, a return that reflects back on the 'school' as a site of assembly and what it means to teach at the publicly re-assembled site of the University of California at Berkeley. As already discussed, many of our campus's debates around assembly have taken place around the concept of free speech, where our historic place in the history of the Free Speech movement now makes us a target for alt-right interventions. The phrase 'freedom of speech' is used to protect very hateful speech, including racist, homophobic, and anti-trans discourses. For many on our campus and other campuses, the speech of Milo Yiannopoulos bordered on violent incitement; at one event at University of Wisconsin, for instance, he called out the name and displayed the Facebook profile of Adelaide Kramer, a trans student, and exhorted the crowd to jeer at her (Lang 2016). The protest cultures surrounding the appearance of such figures—whether Nazi sympathisers, Black Bloc anarchists, or many others in between—took on their own kind of dramaturgy and required new kinds of expensive digital and physical security systems for our campus. With every action, with every passing week, it seemed that our individual and collective understanding of this crisis changed.

Indeed, if we use the language of crisis to describe the situation—one implicating a number of campus and other public spheres—how would we describe that crisis? And how might it become an opportunity for new critique: that is, a deeper understanding of the changing parameters of our world, where our inherited principles for action and decision-making do not seem fully adequate? Well, first, we could turn to an argument like the one provided by Nicholas Dirks, our outgoing chancellor, whose career was (in part) derailed by this situation. In an essay called 'The Real Issue in the Campus Speech Debate: The University Is under Assault', he maintained that the interventions demonstrated a wider distrust of higher education and, in particular, the principles of liberal arts education—the principles of openness, diversity, critique, and deliberation.

For the most troubling issue we confront today has to do with the loss of faith—on the part of those holding different political positions—in values and institutions that must provide the foundation for the real political work ahead: to make our society genuinely more inclusive . . . to allow deep political differences to be debated with respect and serious efforts at mutual understanding.

(Dirks 2017)

The localised appearances were thus part of a systemic effort to exacerbate public distrust and, of course, in Berkeley's case, to rationalise the continued disinvestment by democratic governments in public higher education. As a result, it also rationalises disinvestment in the university as a space of critique.

Equally interesting for this edited collection, the scene also recalls other questions around the role of theatre and performance in responding to systemic crises. In Berkeley's crisis dramaturgy, performance metaphors abounded in our campus discourse—often carrying pejorative associations. Both our outgoing and incoming chancellors described the 'spectacle' created by the 'role-play' of these speakers; they used metaphors of excess and fakery to describe the protests around them. Our chancellors and others talked about alt-right sympathisers using Berkeley as a 'stage set or staging ground' for their movements (Oreskes and Panzar 2017). To me, there is a slight difference between the two. The stage set connotes the designed setup for an experience, and, when Chancellor Christ used the term, she likely meant that the entirety of our campus—or at least Sproul Plaza—was turned from a place of assembly to a place of artifice, a living, breathing thing had become a set, a setup, for someone else's brainwashing and deceiving spectacle. But let's think more about the metaphor of the staging ground. The gerund use—staging—signals a sequence of stages: staging this before and this after. In many contexts, the staging ground is a way of delineating a unique kind of temporal space, a proto-space of assembly in which tools, objects, and materials are laid out before a process of construction begins. Such associations not only emphasise Berkeley's status as a set and ground for someone else's spectacle; they also emphasise our place as a launch and quasi-construction site, a space of emergence where many miscellaneous parts are assembled together.

Amidst these largely pejorative theatrical metaphors, there are more rigorous metaphors and dramaturgical reflections on the performance of this crisis, especially as our campus leaders dig deeper into the legal issues around free speech, as well as its concomitant right, the freedom of assembly. There we find performance analysis coming in, not as a negative but as a vehicle for gaining a more complex policy around the time, place, and manner of such speech acts. The Berkeley campus has subsequently released a new 'events policy', new codes for crisis dramaturgy in managing the *time* and *place* of such events, though the *manner* in which they unfold is still debated.

The question of manner brings me to other dimensions of this crisis which return us to the core principles—and perhaps to a crisis in our shared understanding of what freedom looks like and the manner in which critique is performed.

Berkeley's constituents became strongly divided about the university's stance toward hateful speech. I realise that there might be a distinctly American character to this division, one that pits supporters of free speech (no matter how offensive) against those who feel injured by it and expect a nontraumatic learning environment on campus. For many, this division read not only as a crisis of political division, but also as a generational crisis. As a product of and now the steward of a university that recently celebrated the 50th anniversary of the Free Speech movement, it seemed absolutely obvious to Chancellor Christ that she should do everything possible to allow Milo's appearance to occur—including millions of dollars of security—no matter how odious she found his words. For others, including students and some faculty, it seemed absolutely obvious that such a practice violated our university's 'Principles of Community' and Title IX protocols around diversity, sexual harassment, and respect that guide our behaviour as educators. One could say that this crisis revealed a conflict between two value systems—free speech and the regulation of appropriate classroom conduct—that now found themselves at odds. The university was supporting a mode of hateful speech on campus that would not be sanctioned if performed by an educator in one of its classrooms. What was striking to many was that we appeared to be reversing the generational positions of the Free Speech movement narrative. In the 60s, students and faculty of the Free Speech movement announced that they were 'sick at heart' with the operations of the university's 'machine', accusing the administration of over-regulating free speech (Savio 1964). Now, in the early 21st century, students and faculty accused the administration of not regulating speech enough, asking for more operational oversight and more protection and care of their welfare.

The question of manner involves another dimension of speech and assembly in our 21st-century context: i.e., the technological changes in the manner and medium of expression. Milo caused injury to Adelaide Kramer—and to so many of my students who were subsequently doxed—by leveraging digital and social media as a weapon. As Judith Butler noted in a special meeting of our academic senate, 'the legal vocabulary we have for distinguishing expressive activity from actual threats or incitement . . . changes when new technologies produce new possibilities for harassment' (Butler 2017). This moment was telling, as it reflected back on Butler's published scholarship on the power of assembly when bodies are visible to media coverage. Here, the political power of that media visibility is turned towards other—some would say injurious—goals. In the end, Milo and company's physical appearance on campus fizzled; he came for only 15 minutes so that he could take a quick selfie holding a sign that declared 'feminism' to be a 'cancer' and 'liberalism' to be a 'mental disorder'. After being uploaded to social media, the digital experience of that appearance did not fizzle. In what was called a 'two-million-dollar selfie', Milo used the threat of offline arrival—performance in the flesh—to activate the power and distress of an online, networked performance.

This is just one of many examples one could broach about how technology and commerce have altered the character and context of free speech: i.e., the character and context in which crisis and critique emerge. It is one of many examples that prompt us to ask whether our inherited moral and legal principles are adequate to the

task of understanding the context in which we are living. In his article 'Is the First Amendment Obsolete?' legal scholar Tim Wu argues that the conditions that activated the First Amendment for free speech in the Constitution of the United States (one whose 18th-century legacies Koselleck elaborates) are not dominant now (Wu 2018). Wu notes that the freedom of speech amendment assumed that there would be, in fact, a very limited number of speakers in the public sphere, rather than the information overload we endure now. And the First Amendment assumed that speakers most urgently needed protection from government censorship and punishment. Such assumptions inform Koselleck's arguments—the elevated bourgeois intellectual critic was a special figure, one whose main target was the state or sovereign; that figure did not occupy a contemporary social media sphere, one where everyone can be a critic now. The fundamental conditions for free speech's moral and legal principles seem to be shifting under our feet, prompting crises in our classrooms, on the protest plaza, and in our overwhelmed Twitter and Facebook feeds.

Finally, whether in London, at the Volksbühne in Germany, on a university campus like Berkeley, or at many of the other sites explored in this collection, we find shared terms in which crises are expressed, even if different scapegoats are villainised (or messengers are killed) as these conditions become visible. Concerns around labour and employment, around the financing of social institutions, around the commercialisation of expressive activity, around the digital effects of expressive activity, around the local and global experience of difference—all these issues seem to cohere and collide in these performances. On the one hand, all of us are trying to figure out how we, as critics, come to terms with crisis. On the other hand, and perhaps somewhat unselfconsciously, I would suggest that we are reckoning with the limits of a utopian conception of the critic in the first place, finding ourselves unsettled as our supposedly extra-political, extra-parliamentarian conception of our critical position erodes. Finally, if we are to use crisis as an epistemological tool, we might also recognise how often performance becomes the site for plotting new ways of knowing. Crisis and critique expose the conditions of naturalised realities, making assumptions visible and, hence, available for reflection. At such moments, we face the disorienting realisation that things could be otherwise. It is telling that such revelations often coincide with performances that citizens celebrate and denigrate as theatrical. While 'crisis dramaturgy' sometimes takes shape as crisis management, it also bespeaks the necessary role of performance in advancing the critical function of crisis; such theatres and performances are the spaces in which crisis enacts itself and, hence, 'places for viewing' and rethinking the conditions under which reality is produced. At their most productive—if not their most comfortable—such performances can become arenas that make visible the changing conditions that furnish reality and that are re-assembling our world anew.

Notes

1 Some of the text in the chapter was published in another Routledge publication. Jackson, Shannon. 2019. "Performance, Public (Re)assembly, and Civic Re-enactment." In

Cultures of Participation: Arts, Digital Media and Cultural Institutions, edited by Birgit Eriksson, Carsten Stage, and Bjarki Valtysson London: Routledge, 13–29.

2 For more background on the debate and resignation, see articles such as Dercon (2017), Dercon (2011), Eddy (2018), Frieze.com (2018), Schließ (2017), and Slawson (2017).

References

Beck, Ulrick. 1992. *Risk Society: Towards a New Modernity*. Translated by Mark Ritter. London: Sage Publications.

Becker, Kai Helge, and Axel Haunschild. 2003. "The Impact of Boundaryless Careers on Organizational Decision Making: An Analysis from the Perspective of Luhmann's Theory of Social Systems." *The International Journal of Human Resource Management* 14, no. 5: 713–727.

Brooklyn Academy of Music. 2018. "In Terms of Performance." Accessed May 2018. www.bam.org/visual-art/2018/in-terms-of-performance.

Burton, Johanna, Shannon Jackson, and Dominic Willsdon. 2016. *Public Servants: Art and the Crisis of the Common Good*. Cambridge, MA: MIT Press.

Butler, Judith. 2015. *Notes toward a Performative Theory of Assembly*. Cambridge, MA: Harvard University Press.

Butler, Judith. 2017. "Limits on Free Speech?" *Academe Blog*, December 7, 2017. Accessed December 12, 2019. https://academeblog.org/2017/12/07/free-expression-or-harassment/.

Caballero, M.C. 2004. "Academic Turns City Into a Social Experiment." *The Harvard Gazette*, March 11, 2004. Accessed December 12, 2019. https://news.harvard.edu/gazette/story/2004/03/academic-turns-city-into-a-social-experiment-2/.

Dercon, Chris. 2011. "The New! Museum?" In *Circulo Arte Y Mecenazgo*. Barcelona: Fundación Arte y Mecenazgo.

Dercon, Chris. 2017. "Chris Dercon Responds to Open Letter from Hands Off Our Revolution & e-flux." *e-flux*, September 28, 2017. Accessed December 12, 2019. https://conversations.e-flux.com/t/chris-dercon-responds-to-open-letter-from-hands-off-our-revolution-e-flux/7115.

Dirks, Nicholas. 2017. "The Real Issue in the Campus Speech Debate: The University Is under Assault." *Washington Post*, August 9, 2017. Accessed December 12, 2019. www.washingtonpost.com/news/grade-point/wp/2017/08/09/the-real-issue-in-the-campus-speech-debate-the-university-is-under-assault/.

Eddy, Melissa. 2018. "Protest-Hit Director Quits Berlin Theatre." *New York Times*, April 13, 2018.

Foster, Hall. 2017. *Bad New Days: Art, Criticism, Emergency*. New York: Verso.

Fried, Michael. 1967. "Art and Objecthood." *ArtForum* (Summer): 12–23.

Frieze.com. 2018. "Chris Dercon Steps Down as Director of Berlin's Radical Volksbühne Theatre After Brief, Turbulent Tenure." *Frieze*, April 13, 2018. Accessed December 12, 2019. https://frieze.com/article/chris-dercon-steps-down-director-berlins-radical-volks-buhne-theatre-after-brief-turbulent-0.

Furtado, Will. 2016. "Chris Dercon: 'There Are Only Two Good Artists in Berlin'." *Sleek Magazine*, December 13, 2016. Accessed December 12, 2019. www.sleek-mag.com/article/chris-dercon-berlin/.

Habermas, Jurgen. 1989. *The Structural Transformation of the Public Sphere: An Inquiry Into a Category of Bourgeois Society*. Translated by Thomas Burger. Cambridge, MA: MIT Press.

Haunschild, Axel. 2003. "Managing Employment Relationships in Flexible Labour Markets: The Case of German Repertory Theatres." *Human Relations* 56, no. 8: 899–929. https://doi.org/10.1177/00187267030568001.

Jackson, Shannon. 2004. *Professing Performance: From Philology to Performativity*. Cambridge: Cambridge University Press.
Jackson, Shannon. 2011. *Social Works: Performing Art, Supporting Publics*. London: Routledge.
Jackson, Shannon, and Julia Bryan-Wilson. 2016. "Time Zones: Durational Art and Its Contents" [Special Issue]. *Representations* 136, no. 1.
Jackson, Shannon, and Paula Marincola. 2019. In Terms of Performance. http://intermsofperformance.site/.
Koselleck, Reinhart. 1988. *Critique and Crisis: Enlightenment and the Pathogenesis of Modern Society*. Translated by Thomas McCarthy. Cambridge, MA: MIT Press.
Lang, Nico. 2016. "Trolling in the Name of 'Free Speech': How Milo Yiannopoulos Built an Empire Off Violent Harassment." *Salon*. December 20, 2016. Accessed December 12, 2019. www.salon.com/2016/12/19/trolling-in-the-name-of-free-speech-how-milo-yiannopoulos-built-an-empire-off-violent-harassment/.
Oreskes, Benjamin, and Javier Panzar. 2017. "Milo Yiannopoulos Confronted by Dozens of Counter-Protesters during Brief Appearance on UC Berkeley Campus." *Los Angeles Times*, September 24, 2017. Accessed December 12, 2019. www.latimes.com/local/lanow/la-me-ln-berkeley-milo-20170924-story.html.
Savio, Mario. 1964. "'Bodies Upon the Gears' Speech at FSM Rally, Sproul Hall Steps." In *The Essential Mario Savio: Speeches and Writings that Changed America*, edited by Robert Cohen, 233–237. Berkeley, CA: UC Press, 2014.
Schließ, Gero. 2017. "Chris Dercon Says He's Not Staging Plays for the Fan Club." *Deutsche Welle*, May 17, 2017. Accessed December 12, 2019. www.dw.com/en/chris-dercon-says-hes-not-staging-plays-for-the-fan-club/a-38870135.
Slawson, Nicola. 2017. "'Not Acceptable': Head of Berlin Theatre Hits Out at Volksbühne Occupation." *The Guardian*, September 24, 2017.
Verwoert, Jan. 2016. "Shoot the Messenger." *Frieze*, August 23, 2016. https://frieze.com/article/shoot-messenger.
Volksbühne Staff. 2016. "Open Letter to the Parties in the Berlin House of Representatives." *e-flux*, June 20, 2016. Translated by Janto Schwitters. Accessed December 12, 2019. https://conversations.e-flux.com/t/volksbuhne-staff-on-chris-dercon-we-fear-job-cuts-and-liquidation/3911.
Woolf, Brandon. 2018. "Frank Castorf's Art of Institutional Dis/Avowal: A Volksbühne Elegy." *Theatre Survey* 59, no. 2 (May): 249–261.
Wu, Tim. 2018. "Is the First Amendment Obsolete?" *Michigan Law Review* 117, no. 4: 547–581.

3 Re-enacting the crisis of democracy in Milo Rau's *General Assembly*

Ramona Mosse

> We have to develop new, utopian institutions outside of existing institutions, which will be there when the current ones collapse. And they will in the course of the next generation.
>
> (Milo Rau 2018, *Gobaler Realismus* [*Global Realism*])

> It is not so much a question of whether this or that politician, or this or that party, is ineffective or corrupt (although that, too, is true) but whether the representational political system more generally is inadequate.
>
> (Hardt and Negri 2011, "The Fight for Real Democracy, at the Heart of Occupy Wall Street")

Crisis is constitutive of modern theatre, as Peter Szondi analysed in his *Theory of Modern Drama* (1987). Such a crisis has been defined more generally as a crisis of representation (Fischer-Lichte 2001)—that is, of dramatic form—and it fundamentally shaped the various expressions and developments of theatrical performance throughout the 20th century. If this volume turns once more to this much-used term to examine contemporary European theatre, it does so in a substantially different way. '*Krísis*' becomes a point of convergence at which theatre and democracy meet again. The connection between democracy and theatre is well established, most explicitly so in the making of citizenry in ancient Greek theatre. As Simon Goldhill puts it, 'to be in an audience was not just a thread in the city's social fabric, it was a fundamental political act' (1997, 54). Goldhill posits civic agency and theatregoing as necessarily conjoined in shaping the public sphere of ancient Athens. In the contemporary context, such a direct link between the making of citizens and the making of the theatrical event is more remote. It seems timely, then, to inquire how the connection between theatre and democracy is defined today. One might begin by saying that theatre and democracy share the contested (rather than constitutive) status of their institutions in a rapidly changing public sphere. As the opening quotation by Negri and Hardt frames it, representational democracy itself has been put into question. This skepticism about current democratic processes coincides with the rise of economic globalisation. Colin Crouch first defined this effect of globalisation as a progression in the post–Cold War period towards a post-democratic state. Crouch has tied this decline to the

increasing power of international corporations on a transnational level to shape global systems while national governments, in turn, lacked the tools to contain these powers (2016, 71). Crouch is part of a wider move by intellectual historians and political theorists to investigate the nature of modern democracy under capitalism with a focus on investigating democracy's own historicity (e.g., Richard Bourke and Sheldon Wolin), as well as engaging in a redefinition of its practices (e.g., Chantal Mouffe). As the limits of democratic structures are uncovered in the face of neoliberal economic expansion, the implicit suggestion at the end of the Cold War that 'democracy has been given the status of a transhistorical and universal value' (Wolin 2004, 585) is put into question (Bourke 2008, 10). The French political historian Pierre Rosanvallon pinpoints it: democracy '*is* rather than *has* a history' (cited in Hobson 2015, 207, emphasis in the original). Democracy is subjected to an ongoing process of redefinition, its crisis constitutive of its pairing with the economics of capitalism.

This chapter will investigate how theatre engages with the current precarity of democratic institutions and how it, in turn, continues to reframe the crisis of political as much as aesthetic representation. It does so by using Swiss director Milo Rau's *General Assembly* and *Storming of the Reichstag* as a case study to explore the overtly political performativity with which his re-enactments examine the making and undoing of democratic institutions—courts, parliaments, NGOs, public broadcasting, and not least the theatre itself. In this context, Rau's quotation at the opening of this chapter, which highlights the possibility of building 'new, utopian institutions', might be seen as formulating a response to Negri and Hardt's evaluation of systemic crisis. Theatre and democracy, then, come together in their joint need to address the changing manner in which the idea of publics is constituted in society today. No longer a *demos* that physically gathers in the agora, the contemporary global publics can be characterised by their fluidity, multiplicity, and disparateness and by the wealth of possible forms of self-expression, be it the news, social media, or protests. In each case, they are fundamentally interconnected beyond the city, region, or nation, thus also reshaping how democratic and theatrical exchange can be thought of. I will show how Milo Rau's re-enactments of specific political institutional crises in history ultimately mark crisis itself as an institution within critical thinking, which, in turn, demands an investigation into how such a dependence on crisis might itself prove a challenge to creating alternate models of political agency. Rau's combined event of the *General Assembly* and *Storming of the Reichstag* offers the chance to examine that gap because it combines the two: 'new, utopian institutions' and the advent of crisis as revolution.

Re-enactments as Rau's political dramaturgy of the public sphere

In the scholarly assessment of theatre developments in the 21st century, the return of a politically engaged theatre has been a crucial point of reference. Andy Lavender suggests that theatre 'has been exploded, and it has regathered' (2016, 9)

in order to display 'the nuanced and differential negotiations, participations, and interventions of an age of engagement' (2016, 21). The participatory and interventionist nature of contemporary theatre that Lavender highlights implies a new relationship to the notion of realism and the real in performance, ranging from reconceptualising documentary theatre to the activation of the audience as protagonists who explore expansive performative environments. Re-enactments, be they historical (e.g., of wars), political (e.g., of trials), or artistic (e.g., of iconic performances), play an important role in this 21st-century return of an engaged theatre practice (McCalman 2010; Backoefer 2009; Roselt and Otto 2012). Rebecca Schneider has perhaps most prominently theorised re-enactments as a way of reconceptualising temporality in performance while arguing for their affective impact as a form of social experience that is fluid and mobile (2011, 35–36). Schneider's emphasis on non-linear temporalities may serve as a point of entry to Milo Rau's complex exploration of historical re-enactments, which do not—as in the restaging of American Civil War battles that Schneider analyses—serve to celebrate the past that is being re-performed. Instead, Rau's theatre projects identify moments of history that are in one form or another incommensurable and remain at the limit of being socially and historically processed. In re-enacting moments of systemic crisis, these events themselves highlight the persistence of such crises. Examples include *The Last Days of the Ceaușescus* (2009), which re-enacted the trial and execution of the Romanian dictator and his wife, and *HATE Radio*'s (2011) exploration of the role of public media in the Rwandan genocide. In the interview with Vera Ryser '*Situationismus Rückwärts*' ('Situationism in Reverse'), Milo Rau emphasises his re-enactments as identifying the potential futurity of these events of the past:

> Firstly, that reenactments create situations, not dead pictures or reproductions . . . but scenic processes of decision-making, which have political potential and which—even if this may seem contradictory—can have a utopian dimension. Secondly, reenactments look backwards—much like Walter Benjamin's angel of history—at events which have remained potent in a strangely undead manner, 'which have not been processed', as one might say.
> (Ryser and Rau 2013, 45)

Rau's re-enactments loop time to distil situations of extreme violence that simultaneously appear as embedded into the social fabric. Repeating them in front of an audience does not serve to explain such violence but rather to reiterate how these situations show the limits of discursive control. Nor do Rau's projects relegate these situations to the realm of memory; instead, the re-enactment has the audience experience the past as present in a temporal loop of traumatic repetition. He identifies the utopian moment of his performances in confronting the audience with states of exception that evade control through signification but that, as Rau reminds us, are embedded in rather than set apart from the fabric of contemporary social life. Therein lies the Benjaminian messianic moment that Rau evokes in harnessing a utopian potential of his work: collective trauma as activating political agency.

Rau thus repurposes the aesthetic dimension of the theatre to forge the possibility of a new utopian horizon in the political imagination. In this context, it is striking how Rau's re-enactments pose a challenge to the existing theatrical vocabulary—down to the question of whether 'General Assembly' is the italicised title of a theatre performance or the non-italicised description of a political gathering. His performative practice exemplifies the privileging of '*monstrative* processes, that do not refer to or represent something, but which are themselves a reality that wants to be experienced' (Mersch and Marszalek 2016, 22; emphasis in original). One might add that, in Rau's case, the emphasis lies on the experience of a political reality. In foregrounding the reality of the theatre as a space of encounter with sites of violence, Rau emphasises the use of the theatre as a public forum of political engagement and the role of the audience as witnesses. In doing so, Rau is a prominent example of the re-politicisation of theatre, willing to exploit what Christopher Balme has identified as the public sphere's directedness towards making and shaping the future (2014, 18) while arguing for the current need 'to revisit the theatre's function as a forum of protest and intervention' (2014, 23). Rau's dramaturgy, then, is a part of the movement to counter the privatisation of theatrical experience, critiqued by Adam Alston in his assessment of contemporary immersive performances as an expression of the neoliberal experience economy (Alston 2016). The theatre becomes a space for reclaiming political agency.

The focus of these political dramaturgies no longer lies on the interactional but instead on the institutional level. Rau, in fact, engages with both levels: he employs the stage as a site for historical re-enactment and as a laboratory to simulate the 'new, utopian institutions' that form the other side of his theatrical practice. In his work, re-enactment meets simulation in order to demonstrate the destructive history of institutions while rehearsing their new utopian alternatives. More specifically, Rau deliberately counters the established theoretical narrative of a loss of political alternatives to neoliberal capitalism in a post-1989 world. Tanja Bogusz has been among those who have highlighted this loss of utopia as a crucial dilemma in contemporary cultural production, which remains caught up in offering gestures of critique, disruption, and alterity into what has effectively become a political vacuum with the disappearance of socialism (2007, 159–160). Rau's frequent embrace of the manifesto genre seeks to undo this vacuum, as in 'Unst' (2009), the 'Ghent Manifesto' (2018), and *Die Rückeroberung der Zukunft* (*Recapturing the Future*) (Rau 2019). The 'Ghent Manifesto' in particular adds a new dimension to Rau's engagement with institutional crisis since it marks his takeover of an existing institution, the NT Ghent, as Artistic Director in 2018. At the NT Ghent, Rau, incidentally, is departing from the ensemble structure of the European repertory system, arguing in the *Financial Times* for 'a synthesis' (August 31, 2018) between state-funded and independent theatre sectors—a move that, as the article points out, had led to the demise of Chris Dercon at the Berliner Volksbühne only months before. Strikingly, the criticism of embracing a neoliberal approach to the arts and its institutions levelled at Dercon in Berlin has yet to be voiced in Rau's case. The difference might lie in the fact that Rau's attack

on the repertory structure comes against the backdrop of his extensive theatrical practice, situating him as promoting change from within the institution of the theatre. It might also have to do with Rau's highly efficient publicity strategy, run through his independent production company, the International Institute of Political Murder, which has done much to connect the advent of a revolution from the left with the figure of Rau himself. Or, in the words of the manifesto: 'One: it is not just about portraying the world anymore. It's about changing it' (Ghent Manifesto 2018).

In addition to adopting a utopian lexicon in his theoretical texts and, most explicitly, embracing the manifesto as a genre, Rau also takes on more generally the ubiquity of critique as the only viable intellectual stance:

> Intelligence meant analyzing and deconstructing existing stories and existing conceptions of reality—and then, if one became an artist, to suffer through these or, depending on one's aesthetic approach, to stand apart from or to be already above them. The social imagination is the opposite: it is active, it craves for realization, it wants to embrace the whole world at once, but most of all it wants to change it.
>
> (Bossart and Rau 2013, 24)

Change here is not an abstraction; rather, Rau employs the potentiality of the theatrical stage to embody institutions that have yet to gain a political reality. This is the case in various formats of trials and tribunals that either re-enact real-life court cases, as in *The Last Days of the Ceausescus* (2009); anticipate missing prosecution, as in the *Congo Tribunal* (2016); or unveil the theatricalisation of the legal system in the show trials of the *Moscow Trials* and the *Zurich Trials* (2013). It is also the performative horizon against which *General Assembly* has to be read. This theatre of the real tackles the crisis of democracy by seeking to implement a global parliament that produces a charter for a globalised version of democracy.

Re-enacting democracy with *General Assembly*

1789, 1917, 2017! These are the dates that framed Rau's performance project at the Schaubühne in Berlin in late 2017. They are dates that mark the advent of revolution: the French Revolution as the moment that laid the groundwork for the emergence of modern democracy, the Russian Revolution as a radicalisation of the call for equality that 1789 had formulated and the attempt to institute socialism as a new form of governance. 2017 is tagged as #global democracy—Milo Rau's proposition for reframing democratic political agency in the face of economic globalisation. Rau's project, in this context, is massive in scale and dissolves the division between theatrical and political acts in his triple bill of performances: beginning with the hyper-naturalist play *Lenin* about his final days, followed by the staging of a *General Assembly* of political activists rehearsing a world parliament in action over the course of an entire weekend with over 20 hours of performance; finally, *Storming of the Reichstag* re-enacted the storming of the

Winter Palace on its centenary, 7 November 2017. Rau called the performances a 'triptych', which works on several levels: a triptych of historical moments; of performance formats (hyper-naturalist play, platform of political debate, participatory re-enactment); and, ultimately, of democracy and revolution.

Half a year earlier, in March 2017, the annual FIND Festival at the Schaubühne had run under the heading 'Tragedy and Democracy'. Hardly any of the guest productions present then would necessarily be considered to belong to the tragic genre in the classical sense of the word. During the festival, it became evident that these were reflections on present-day democracy at an impasse: democracy as tragedy. Rau's performance marathon took a different path. He instead reimagined the theatrical stage as a laboratory for democratic exchange. *General Assembly* was divided into seven three-hour sessions, with delegates offering four-minute speeches on topics ranging from diplomatic relations and war, migration, and border regimes to the idea of a natural global commons. The assembly also included an elected president and vice presidents, simultaneous translation, and screens for online streaming of the event. The auditorium was separated into three sections: a cordoned-off area for delegates at the front; a seating area for the press; and, further back, the audience. Sixty political activists from around the world—among them lawyers, economists, film-makers, workers, engineers, and unionists—made up the selection of those 'who are underrepresented, who are not heard, the Global Third Estate', which moved beyond the human frame as well to 'the oceans, the atmosphere, animals, and plants' (*General Assembly* 2017). The theatre's function, then, turns very literally into giving a voice to those without adequate political representation, be they delegates from the global South speaking on the economic dominance of the global North; the disabled, who often remain altogether excluded from the vote; or the vast sphere of the nonhuman, which are accounted for in legal terms as property without agency. The question of who may speak illustrates both the mechanisms of representative democracy and its limits, thus illuminating the core of the current crisis of democracy.

On an overarching level, the question of who may speak posited itself in the organisational logic of *General Assembly*: that is, in the selection of delegates for the various sessions; it required a prerequisite suspension of disbelief with regards to the issue of legitimation that underpinned *General Assembly*. At an assembly that was gathered by invitation of Rau and his team at his production company, the International Institute of Political Murder, the foundational question of who legitimised this global parliament became entrenched in questions of expediency that the artistic team had to tackle and, on the side of the audience, the theatrical conventions, such as ticket purchases, that provided the frame for the event. The Bangladeshi human rights activist Khushi Kabir, the assembly's president, introduced Milo Rau in the constitutive session as the 'author, director, and initiator of the *General Assembly*' (video archive 'Constitutive Session', *General Assembly* 2017, 0:35:14–0:35:37), which implied a far less collective approach to imagining forms of radical democracy than the idea of a global parliament might suggest. Similarly, the Austrian journalist Robert Misik, one of the assembly's designated 'stenographers', offering live feed commentary on the event, summed up Rau's

opening speech: 'The legitimation of the world parliament is constituted in the fact that there is no other, better legitimation. We'll just legitimize ourselves. Basta!' (author's personal notes on constitutive session, November 3, 2017). This gesture of self-legitimisation is one shared with both political and art manifestos, which engage in a rhetoric that performs an ultimately still-missing authority through theatricalisation, as Martin Puchner explored in *Poetry of the Revolution* (2006). *General Assembly* becomes a manifesto in the moment of its enactment. In the missing legitimation and lacking transparency of the selection processes and session organisation lies the license of the theatrical frame: *qua* art, the theatre gives Rau the freedom to institute a world parliament without having to address the administrative and bureaucratic complexities needed to create a legal and political infrastructure for legitimising the selection procedures of the delegates on a global scale. 'It is time for a revolution of the democratic institutions', says Rau in his opening statement at the assembly ("Constitutive Session", *General Assembly* 2017, 0:45:00–0:45:37). The implicit autocratic gesture of crafting this *General Assembly*, then, according to Rau, mirrors the many instances in which national democracies insufficiently attend to the global impacts of their decision-making processes and fail to represent those whose livelihoods are at stake. A similar tension is evident in Rau's treatment of the audience, which remains strangely passive and is largely ignored by the world parliament. When entering the general assembly, the audience passes several posters stating: 'The time for spectating is over. Remember: you are not the audience. You are the sovereign'. The posters toy with expectations: while the activated theatrical spectators have long since left their seats to curate their own theatrical experience in a variety of participatory formats, the sovereignty of the demos in a representational democracy is based on being an observer of and audience to the democratic process. The audience as democratic sovereign thus remains silent and somewhat passive in the events on the parliamentary floor, which is further complicated by the fact that they also do not engage in any act of transferring their power to the assembly in front of them. Somewhat ironically, and in a flaw in the structure of the event, the audience of Milo Rau's *General Assembly* sits in the dark without ever being given a chance to participate in the debate.

When it comes to the mechanisms of democratic exchange itself, the dramaturgy of *General Assembly* privileged a confrontational model: delegates from different social, political, and geographical contexts made their cases in a single session, but since contextual knowledge about any debated case study was often missing, the confrontation of world views moved into the foreground. Theatrically, this offered an increased level of engagement on the part of the audience; politically, this implied one of the weaknesses of the general assembly since it seemed to unveil a willingness to manufacture clashes among the delegates. Over the course of the weekend, the delegates' performances within the sessions also changed from an initial eagerness to play according to 'the rules of the game' set up by Rau as the director, evident in the swift passing of motions. Instead, there was a greater willingness to improvise the handling of the confrontations that inevitably arose. This was especially true for the moments in which its tightly regulated structure,

with rigidly implemented speaking and response times, threatened to unravel. The fourth session on the cultural commons, which dealt with cultural memory and expression, offered a particularly striking example of this tension between a dramaturgy of confrontation and the limits of freedom of speech in democracy. In this session, Mihran Dabag, an historian of Armenian descent speaking on the Armenian cultural heritage, was followed by Tugrul Selmanoglu, a supporter of Erdogan's Turkish AKP party, who closed his speech to the assembly by denying the Armenian genocide and was then asked to leave by Rau in a piece of executive decision-making. The incident created a rupture on two levels. First, it uncovered the inherent problem for democracy of how to deal with anti-democratic speech and how to draw the line between freedom of speech and the neutrality of any governing body to the content of speech (see Brettschneider 2012, 1–4). At the same time, it uncovered a fundamental tension implicit in the staging of democracy in the theatre. Rau's move, communicated via headphones to the moderator of the session, who then communicated it in an act of apparent ventriloquism, passed over the previously asserted sovereignty of the assembly and threatened to destabilise the doubling of theatrical and political frames as a mere show. 'For some of us, this is not theatre. This is something that impacts our lives, and we are not your actors' ("Cultural Global Commons", *General Assembly* 2017, 2:36:18–2:36:30), shouted the cyborg activist Aral Balkan in response as the assembly's delegates rebelled against Rau and successfully demanded the right to vote on the inclusion or exclusion of any given delegate. Balkan pointed to a fundamental charge and problem of the increasing indistinguishability of political and theatrical frames in *General Assembly*: the theatre, which enables the revolutionary establishment of the world parliament out of nothing, now becomes a threat to its political efficacy. In this moment, the repeated calls for Milo Rau by the session leaders and the suspicion that the conflict itself was staged by him in order to enhance the theatricality of the event put the enterprise of the general assembly into question.

Thus, the near collapse of the fourth session turned into the peculiar process of understanding if, when, and how democratic processes themselves silence speech. The confusion itself about how to respond to Selmanoglu's speech act, as it denied Armenian suffering and political responsibility, also pointed to what Chantal Mouffe (herself one of the political commentators and participants in *General Assembly*) called the democratic paradox: that is, the irreconcilability of the democratic and liberal dimensions of modern democracy. Respect for and freedom of the individual are not necessarily consensual but rather exist in a constant struggle with each other: 'In a liberal democracy, limits are always put on the exercise of the sovereignty of the people. Those limits are usually presented as providing the very framework for the respect of human rights and as being non-negotiable' (Mouffe 2000, 4). Mouffe's proposition stresses an agonistic model of democracy that emphasises the continuous need for political debate. The encounter between Rau and Selmanoglu, however, does not exemplify a form of agonistic exchange but rather the end of debate on either side in the face of dogma, thus showing the real struggle that exists in practising an agonistic debate without falling into the closed-off position of antagonising the other. The momentary breakdown

of the fourth session of the cultural commons thus showed the limits of the currently dominant form of liberal democracy, which here faced its own impasse in the competing demands of freedom and equality. Nevertheless, the assembly's subsequent reassertion of itself as a political body of live debate simultaneously marked a potential and a willingness to think beyond this framework. Such a willingness to move beyond the established value frame of the existing public sphere was analysed by Tony Fisher as a rise of forms of dissensual speech, which he defined as 'unlicensed speech, meaning its utterances derive from a place other than that of sanctioned discourse . . . capable of opposing itself to authorized speech' (2017, 200). The hubristic act of self-legitimisation that Rau generated with the general assembly to give a political voice to those who have none aspired to just such a 'place other than that of sanctioned discourse' that Fisher sketches here as a site of radical democratic alternatives. Ultimately, *General Assembly* remains a fundamentally ambiguous experiment since, for the majority of its performance, the participants revert to the established administrative processes and implicit hierarchies of the event; they are hovering between their desire to accomplish consensus in order to complete the Charta for the 21st century as the set output of the performance and the live demand of dissensus as a performative necessity to remain a credible body of radical democratic reconceptualisation.

Revolution or democracy?

By way of conclusion, I will offer a merely cursory consideration of the follow-up event to *General Assembly* two days after its final session: *Storming of the Reichstag* (Figure 1.1) allowed delegates and spectators to join together as participants on the centenary of the storming of the Winter Palace.

The storming was to allow the assembly to deliver the Charta for the 21st century and to emphasise the strong link between revolution and democracy, both in its origin in the French Revolution and in casting its future as essentially performative. Rau here plays with the fact that the 1917 storming of the Winter Palace gained its iconic place in historical memory through its theatrical re-enactments: the 1920 restaging by Nikolai Evreinov to mark the three-year anniversary of the storming, as well as its treatment by Sergei Eisenstein in his 1927 film *October: 10 Days that Shook the World*. In both, the somewhat anticlimactic and bloodless historical storming is transformed into a dramatic battle of the masses, the images of which have tended to overwrite historical facts in the cultural memory. Hence, it may be fitting that the 300 people gathered on the lawn in front of the Reichstag for Rau's re-enactment seemed a tiny crowd somewhat lost on the big lawn in front of the building since Rau did not seek to start a revolution but set out to restage the iconic imagery of storming, creating yet another visual record. So, do not make the revolution; fake the revolution. Faking it seemed doubly relevant, since the planned delivery of the Charta for the 21st century became impossible because no consensus had been found on all the different motions of the Charta, still in need of further revision. Meanwhile, the filming of the storming proved successful, at least as a publicity stunt, although the event lasted all of 40 seconds.[1]

Figure 1.1 Participants gathering for *Storming of the Reichstag* in front of the Reichstag Berlin, 7 November 2017

Source: Author photograph

Storming thus re-enacted the highly mediated nature of the October revolution rather than its political potential or ultimate failure. To borrow from Gil Scott Heron, the revolution will not be televised; one might add that its re-enactment(s) will be. Rau's deflationary combination of democracy and revolution unmasks the intensely positive rhetoric of revolution on the left that has mutated into the gesture of disruption for its own sake while neglecting the aspect of proposing an alternative political programme to go along with it. Ultimately, this is what the anticlimactic and farcical version of Rau's *Storming of the Reichstag* showed: that disruption has to be considered along with a proposition for something else. One has to dare to move beyond the ubiquitous sense of crisis, not least in reformulating the task of academic inquiry to accompany the gesture of critique with the proposition of alternatives.

When returning to the question of theatre and democracy in one of his late essays, British playwright and director John McGrath defines the theatrical engagement with democracy as a probing of its borders. McGrath here draws extensively on Cornelius Castoriadis and his concept of the 'social imaginary' at the heart of democracy, which transforms it into a perpetual process of renegotiating its core terms of justice, equality, and freedom (2002, 136–137). Rau's *General Assembly*, as well as its conclusion in *Storming of the Reichstag*, offers one such probing of borders that McGrath calls for here. It enlists the theatre as a place of embodiment, in which we cannot just critique the existing political structures but need to actively commit to rehearsing their alternatives. At the same time, the playfulness of theatrical framing also destabilises the asserted performativity of *General Assembly*. In looking back on this performance marathon of the general assembly, its most evocative lesson lies not necessarily in the potential of utopian alternatives but rather in watching and actively attending to the intense labour that goes into political parliamentary work. It is a labour that is far from the apparently more glamorous and radical task of sweeping up minds and hearts in revolutionary symbols and discourses. Instead, it very slowly and meticulously has to consider all the various facets of a given issue in order to propose and implement meaningful legislation. The unfinished Charta speaks to that fact. Watching *General Assembly*, then, is no doubt often 'an immensely boring parade' (Höbel 2017). Yet for all its ambiguity, which has the event oscillating between the hubris of thinking oneself able to actually represent those without power and a superficial zapping through all the world's ailments, there are momentary glimpses of delegates engaged in the boring yet essential and difficult political labour of taking a stab at framing how a global democracy might be constituted. That leaves the audience filled not so much with a sense of their role as the political sovereign but—rather ironically and in a crisis to Rau's revolutionary impetus—with a new appreciation for political labour.

Crisis, then, gains a multifaceted treatment in Rau's performance of global democracy. Rau's call for 'new, utopian institutions' marks his keen awareness that the crisis of democratic institutions is, importantly, a crisis of the left to formulate a political future beyond neoliberal capitalism. His manifestos and performances are an attempt to open up such a future. At the same time, the pervasiveness and

somewhat sensational appeal of thinking with, through, and around crisis also pervades Rau's own dramaturgy in *General Assembly* and *Storming of the Reichstag*. George Edmondson and Klaus Mladek, in their study on a politics of crisis, termed this 'our ubiquitous crisis consciousness' (2017, 1). Such ubiquity is, ironically, also evident in the structuring of the assembly's sessions, which appeared implicitly to seek moments of conflict, and the collapse of political debate in both its specific pairings of speakers and its rapid treatment of a multiplicity of equally complex and contentious political topics. The example of the near collapse of the cultural commons session discussed earlier is exemplary in this context, as is the gesture of combining the completion of the Charta with the reenactment of the storming. It is a reminder that thinking about the interdependencies between theatre and democracy goes hand in hand with thinking about a necessary gap between the two. And still, if Rau's and my own point is that the task at hand is to think theatre and political practice beyond critique, it is his willingness to see theatre as a laboratory of the future of politics that needs to stand at the close of this chapter.

Note

1 The video of *Storming of the Reichstag* is available on the *General Assembly* website, which also provides video documentation of all the sessions of *General Assembly* and an archive of the texts produced in its preparation, as well as the draft version of the Charta for the 21st century. www.general-assembly.net/en/storming-the-reichstag/.

References

Alston, Adam. 2016. *Beyond Immersive Theatre: Aesthetics, Politics, and Productive Participation*. London: Palgrave.
Backoefer, Andreas, ed. 2009. *Reenactment*. München: Epodium.
Balme, Christopher. 2014. *The Theatrical Public Sphere*. Cambridge: Cambridge University Press.
Bogusz, Tanja. 2007. *Institution und Utopie*. Bielefeld: Transcript.
Bossart, Ralf, and Milo Rau (2013). "Das ist der Grund, warum es die Kunst gibt." In *Die Enthüllung des Realen: Milo Rau und das International Institute for Murder*, edited by Ralf Bossart. Berlin: Theater der Zeit.
Bourke, Richard. 2008. "Enlightenment, Revolution, and Democracy." *Constellations: An International Journal of Critical and Democratic Theory* 15, no. 1: 10–32.
Brettschneider, Corey. 2012. *When the State Speaks, What Should It Say? How Democracies Can Protect Expression and Promote Equality*. Princeton, NJ: Princeton University Press.
Crouch, Colin. 2016. "The March towards Post-Democracy, Ten Years On." *The Political Quarterly* 87, no. 1 (January–March): 71–75. Wiley Online Library.
Edmondson, George, and Klaus Mladek. 2017. *Sovereignty in Ruins: A Politics of Crisis*. Durham, NC: Durham University Press.
Fischer-Lichte, Erika, ed. 2001. *Theatralität und die Krisen der Repräsentation*. Stuttgart: Metzler.
Fisher, Tony, and Eve Katsouraki, eds. 2017. *Performing Antagonism: Theatre, Performance and Radical Democracy*. London: Palgrave Macmillan. https://link.springer.com/book/10.1057%2F978-1-349-95100-0.

General Assembly. 2017. "Homepage: Opening Statement Milo Rau/IIPM: International Institute of Political Murder." Accessed July 1, 2019. www.general-assembly.net/en/.

Goldhill, Simon. 1997. "The Audience of Athenian Tragedy." In *The Cambridge Companion to Greek Tragedy*, edited by P.E. Easterling, 54–68. Cambridge: Cambridge University Press.

Hardt, Michael, and Antonio Negri. 2011. "The Fight for 'Real Democracy' at the Heart of Occupy Wall Street." *Foreign Affairs*, October 11, 2011. Accessed June 20, 2019. www.foreignaffairs.com/articles/north-america/2011-10-11/fight-real-democracy-heart-occupy-wall-street.

Höbel, Wolfgang. 2017. "Weltrevolution der Laberköpfe." *Der Spiegel*, November 4, 2017. Accessed June 22, 2019. www.spiegel.de/kultur/gesellschaft/milo-rau-an-der-berliner-schaubuehne-mit-general-assembly-a-1176506.html.

Hobson, Christopher. 2015. *The Rise of Democracy: Revolution, War, and Transformations in International Politics since 1776*. Edinburgh: Edinburgh University Press.

Lavender, Andy. 2016. *Performance in the 21st Century: Theatres of Engagement*. London and New York: Routledge.

McCalman, Iain. 2010. *Historical Reenactment: From Realism to Affective Turn*. Basingstoke: Palgrave Macmillan.

McGrath, John. 2002. "Theatre and Democracy." *New Theatre Quarterly* 18, no. 2 (May): 133–139.

Mersch, Dieter, and Magdalena Marszalek, eds. 2016. *Seien wir realistisch: neue Realismen und Dokumentarismen in Philosophie und Kunst*. Zürich and Berlin: Diaphanes.

Mouffe, Chantal. 2000. *The Democratic Paradox*. London and New York: Verso.

Puchner, Martin. 2006. *Poetry of the Revolution: Marx, Manifestos, and the Avantgardes*. Princeton and Oxford: Princeton University Press.

Rau, Milo. 2009. "Was ist Unst?" *Neue Zürcher Zeitung*, February 20, 2009.

Rau, Milo. 2018. *Globaler Realismus/Global Realism. Goldenes Buch I*. Berlin: Verbrecher Verlag.

Rau, Milo. 2019. *Die Rückeroberung der Zukunft*. Zürich: Kein & Aber.

Rau, Milo, Stefan Bläske, Steven Heene, Nathalie De Boelpaep, and the Team of NT Gent. 2018. "Ghent Manifesto." Accessed October 22, 2019. www.ntgent.be/en/manifest.

Roselt, Jens, and Ulf Otto, eds. 2012. *Theater als Zeitmaschine. Zur performativen Praxis des Reenactments*. Bielefeld: Transcript.

Ryser, Vera, and Milo Rau. 2013. "Situationismus rückwärts." In *Die Enthüllung des Realen: Milo Rau und das International Institute for Murder*, edited by Ralf Bossart. Berlin: Theater der Zeit.

Schneider, Rebecca. 2011. *Performing Remains: Art and War in Times of Theatrical Reenactment*. London and New York: Routledge.

Szondi, Peter. 1987. *Theory of Modern Drama*. Cambridge: Polity Press.

Wolin, Sheldon. [1960] 2004. *Politics and Vision: Continuity and Innovation in Western Political Thought*. Princeton, NJ: Princeton University Press.

4 Fugitive transformations of performance practice in landscapes of crisis

Gigi Argyropoulou

Since the 1990s, multiple 'crises' have dominated political, social, and cultural imaginaries and vocabularies. Whether these 'crises' were a result of radical economical and hegemonic reforms or geographical and political challenges, they often destabilised neoliberal imaginaries and existing social modus operandi. Antonio Gramsci noted in the early 20th century that the hegemonic ideology in any given period reflects the dictates of the mode of production: it maintains and legitimises that mode of production. He argued that conformity and domination are achieved by the forceful assurance of common sense, understood as a way of seeing things. For Gramsci, the conjuring trick that 'common sense' achieves is that it convinces people that the interests the state works towards are not actually the interests of the ruling class but rather the interests of everyone (Gramsci 1971). In other words, the ruling hegemony as 'common sense' projects itself as the embodiment of the common good. In this chapter, I will focus on how such processes are reflected in the cultural/theatre field and argue that times of crisis, although related to hegemonic processes, carry the potential to challenge dominant societal and cultural imaginaries, or, in other words, what is perceived as common sense.

During the last decade, southern Europe and Greece in particular underwent a radical economic and social crisis that resulted in a wider contestation of social frameworks while multiple political events questioned what is perceived as 'common sense' and what constitutes the 'common good'. Diverse cultural and political experiments manifested themselves amidst constraints and needs challenging familiar forms of political and cultural/theatrical praxis. Theatre occupations, activist interventions, and forms of institutional critique emerged, bringing to the fore both the challenges and the potentialities of the political and the cultural while exemplifying the tension inherent in the fugitive relationship between the two. As the cultural workers that occupied Teatro Valle in Rome in 2011 stated:

> The Teatro Valle is not only a valuable space to be saved but a symbol of the state of Art in Italy. We are here to become protagonists in the political decisions that affect our industry, our work, our lives. We are here to imagine and build together the theatre that we would like. Lacking any form of dialogue and having witnessed every principle of representation ignored, we want to

reclaim the places that belong to us. We want to participate in the political processes that decide the fate of our lives and the culture of our country.

(Teatro Valle Occupato 2011)

This chapter is situated in a specific cultural landscape—that of Athens during the years of the economic and social crisis—and discusses diverse forms of practice that cultural workers instituted in response to the changing socio-political conditions of Greece. Ranging from constituent practices that attempted to propose viable alternative institutions and communities to destituent acts that sought to reveal the anomy of power and challenge dominant hierarchies, these actions were simultaneously cultural and theatrical manifestations that produced questions about the validity of political practice and the wider conditions of cultural/theatre production as such. By focusing on a series of performative manifestations initiated by evolving collective formations, this chapter explores how performance practices are redefined in places undergoing political, social, and economic transformations. These performative manifestations do not operate in familiar forms of political theatre but seek to bring questions about the politics of theatre, the theatricalisation of the political, and the potential of performance practice in landscapes of crisis. I will discuss in what follows how emergent practices that challenge what is considered 'appropriate' political or performance practice might repeatedly produce new, unexpected forms as ongoing responses to hegemonic domination.

Instituting: a theatre politicised

At the beginning of the economic crisis in 2011, a then-emerging group of performance-makers, the Mavili Collective, occupied Embros Theatre in Athens, deserted for seven years, at a moment when Greece was without a government and repeated strikes and occupations in schools, universities, and public squares were taking place. The occupation sought to explore what culture could do in times of political and economic crisis and took the form of an intense 12-day programme as a response to the evolving Greek cultural landscape of the previous decade and the emerging new landscape under new crisis conditions. The 291 participants who presented work ranged from established practitioners, students, and collectives to immigrant groups and university professors. The Embros occupancy sidestepped hierarchical forms of categorisation of the art market, moving simultaneously across forms and generations hosting multiple experimental performative and discursive events. As the Mavili Collective stated in the manifesto that was sent to the press and the public on the first day of the occupation:

> Today we occupied the historical disused theatre building of Embros in Athens, deserted and left empty for years by the Greek Ministry of Culture. We act in response to the general stagnation of thinking and action in our society through collective meeting, thinking and direct action by reactivating a disused historical building in the centre of Athens. For the next 11 days Mavilli

will reconstitute Embros as a public space for exchange, research, debate, meeting and re-thinking. In the sight of the current situation we refuse to wait for 'better days', we refuse to accept the current crisis as terminal and we refuse to sit back. We actively propose new structures, which we hope, can become sites of negotiation, debate, re-formulation.

(Mavili Collective 2011)

The programme drew large and diverse audiences that attended various diverse performative forms of artistic production—including short performances, talks, participatory events, residencies, and political debates, amongst others—that explored practically how theatre might respond to times of crisis. Through these events, the audience began to actively take part in the ongoing production of a theatre that operated as a public cultural space. After the initial 12-day programme, the collective continued to operate the space and experiment with its role as a cultural force in the city. In the following year, Embros not only hosted multiple forms of performance and artistic practice but also operated as a site of critical discourse and public debate with short residencies, festivals, performances, meetings, research clusters, conferences, collaborations, community events and assemblies, political discussions, solidarity actions, and a community garden.

In its initial period, Embros succeeded in producing new relations between makers, artistic forms, and audiences by creating conditions for unexpected exchanges, hybrid events, multiple artistic experiments, and public encounters. Critical artistic practices, according to Chantal Mouffe, can play an important role in the creation of multiple sites where the dominant hegemony can be contested. For Mouffe (2013), hegemony is the exclusion of alternative ways of understanding—ways which run contrary to a fantasised, totalised social truth. Critical artistic practices, Mouffe continues, 'should be seen as counter-hegemonic interventions which by contributing to the construction of new practices and new subjectivities aim at subverting the dominant hegemony' (2013, 213). Embros, during this first year, challenged the ways artistic practice intervened in the political reality within the Greek milieu, producing a bottom-up modus operandi of a counter-theatre: a theatre that sought to cultivate experimentation and collaboration between makers, forms, and audiences. Encouraging short and incomplete sharings, hybrid performative experiments, and cross-disciplinary collaborations, it offered an alternative paradigm of a cultural/political space. Critical debates regarding the validity of artistic work and its relation to political reality were literally spatialised on the stage of Embros by participants from different generations, artists, activists, and audiences, giving rise to a wide range of practices experimenting with both theatrical and political potentialities.

In 2012, a year after Embros' occupation, the debt crisis in Greece deepened. The Greek government implemented new austerity measures and promoted both the privatisation of public/common goods and a return to nationalistic values. As Gramsci (1971) had argued, the state, in a repressive capacity, restricts discourse, permitting only that discourse that reflects the hegemonic common sense. The Greek state, at this critical moment while urban impoverishment deepened,

attempted to close all self-organised spaces of solidarity, defining them as centres of illegality. Within this policy, the state demanded the evacuation of Embros. Embros had hosted over 500 cultural activities in that year, free of charge, and consistently drew large audiences, but despite repeated attempts to establish a dialogue with state representatives, Minister of Culture Mr. Tsavaras stated: 'We are informed, we will apply legality' (personal communication, October 24, 2012). The collective refused to hand over the keys to the theatre, despite repeated threats by the state, and called upon political collectives, groups, and parties to support the space and oppose the police. This collective opposition succeeded in keeping the space open and also led to a change in its mode of organisation. As the situation at Embros changed, the methods Mavili instituted initially had to alter, and the space began to operate with a weekly open assembly—that is, open to anyone. Thus, Mavili as a collective withdrew from the organisation of the space while some members continued taking part in the assemblies. Assemblies initially drew large and diverse audiences across cultural and political groups, which slowly reduced to a smaller number of participants. Embros transformed gradually from a collective artist-led experimental space that sought to question existing cultural and political modus operandi to a space that resembled the structure and modus operandi of anarchist squats in the Athenian landscape: an open space of participation but less interested in experimentation with cultural and political structures, forms, and audiences.

Deinstituting: theatricalising publics

As this moment of collective instituting in the cultural landscape of Athens seemed to diminish, cultural workers returned to navigating the landscape of crisis with limited support and funding possibilities. Funding for performing arts ceased in the years of crisis as the Ministry of Culture withdrew from offering any form of support for or interest in contemporary artistic production while, at the same time, a few new wealthy private institutions appeared, dominating the cultural landscape and the media and often seeking to intervene in the city life itself. On the other hand, the new artistic director of the National Theatre, Mr. Xantzakis, appointed in 2013 directly by the new centre-right coalition government (2012), was programming work that promoted nationalism, religion, and Greek exceptionalism. It is in relation to this transformed landscape that we should understand the transformation of Embros, particularly a series of activist actions that took the form of direct intervention (instituting a different approach than the original Embros occupation). Rather than creating critical artistic spaces and instances that might produce new practices and new subjectivities, these actions sought to de-institute, to question the role of existing structures, and to reveal how culture might be utilised for political ends in times of crisis. Agamben has theorised the notion of 'destituent power' as a possible strategy in today's security societies by suggesting we should refuse the constituent power of a new institutional order that creates a new law. This destituent power, according to Agamben, cannot be captured 'in the spiral of security' and bears the potential to reveal 'the (real) anomy

of power' (Agamben 2013). Perhaps destituent tactics can produce instances of questioning notions of legality and how it is utilised by power.

In February 2014, the Mavili Collective initiated an intervention during an EU presidency conference under the title 'Financing Creativity'. The conference took place at a private institution in Athens and sought to discuss models of cultural policy for the EU in the coming decades. At the conference, not a single artist was invited as a speaker nor was the conference promoted publicly. The Greek minister of culture, Mr. Panagiotopoulos, delivered the opening speech of the conference and stated that sectors of the economy that were non-competitive were now non-sustainable since Europe had to follow the economies of China and the Middle East. The Mavili Collective called for artists and theorists from different fields of practice to attend the conference and intervene spontaneously as audience members using the 'weapons' of audience laughter and applause. In the face of this intervention, the minister of culture, who had refused all representations for dialogue over recent years, resorted to calling on the audience to accept a structured form of dialogue while attacking audience members as syndicalists. As the minister intoned that 'Europe needs to initiate processes that cultivate competition'(Mavili Collective 2014), the audience responded derisorily with laughter. Awkwardly attempting to ignore the disturbance, the minister continued his prepared speech, but when he noted 'culture is not only our national pride and heritage', a further round of laughter and applause burst out from the audience. At that point, the minister lost his temper and, abandoning his speech, began an aggressive and incoherent rant at the audience so that his speech was transformed by the intervention into a strange theatrical monologue, produced on an empty stage: 'Come onstage, have the bravery of public speech, not with uproar. Don't hide behind the crowd, you who annihilate and eliminate everything. You have no right to expose the country and its public image; you serve the uncontrolled noise'. At that point, someone from the audience shouted back, 'It is a political act'. The minister responded: 'I am the one doing a political act; you do the uproar'. The audience continued to cheer. Someone from the audience responded, 'We are not syndicalists; we are artists', and the minister responded: 'You are not artists. I know who you are. I can see you; you are the ones who serve the uncontrolled noise; you serve the uproar', and 'Come here, you ought to come here; let's engage in a dialogue about our country'. But as a woman stood up in response and began to mount the stage, he turned to her with an admonishment: 'Sit down, miss; you have no right'. Then someone from the audience asked: 'Can I say something?' The minister replied: 'You have no right to say anything', which provoked further derisory cheering, laughter, and applause from the audience. The minister left the stage, stating that such acts would 'not stop us from doing our job'.

The next day, the Mavili Collective released a video file of the event on YouTube, with English subtitles. Within only a couple of days, the YouTube video had received over 150,000 views. This was followed a several days later by another EU conference, organised by the minister of culture. This time, the event was held in private, although it took place inside a public museum. For 'security' reasons,

74 *Gigi Argyropoulou*

the museum and the conference room were closed to the public on the day of the event, with access to the building denied not only to visitors but also to employees of the museum.

A month later, on World Theatre Day, 28 March 2014, over 5,000 posters appeared in the centre of Athens, promoting a new performance by the National Theatre (Figure 4.1 and 4.2). The poster juxtaposed elements of ancient culture, Byzantine typography, and TV aesthetics with direct references to symbols of the years of military junta (1967 to 1974). The posters were art works that satirically commented on the nationalistic approach of the National Theatre, and the performances they promoted were fictional, seeking to criticise and make visible the nationalist politics of the National Theatre. The National Theatre rushed to remove the posters from the city centre and announced their intention to institute legal measures in order to prosecute the 'unknown' and irresponsible persons responsible for them. Those responsible were undeterred; a week later, another poster ghosted the city of Athens (Figure 4.3). Following the same satirical logic, this new poster appeared to promote another performance of National Theatre—this time, literally making visible the faces of the leading people in the National Theatre administration.

Several months later, in the summer of 2014, following similar tactics, a series of stickers appeared in the streets and cultural spaces of Athens (Figure 4.4). The stickers took the form of satirical critiques vis-à-vis various dominant Greek institutions. Each sticker copied the graphic design and logo of one institution and included a short text commenting ironically on the policies and politics of the

Figure 4.1 The first poster that appeared in the streets of Athens
Source: K. Tzimoulis

Figure 4.2 The first poster that appeared in the streets of Athens
Source: K. Tzimoulis

target institution. 'The revolution will start from Stegi/Onassis Cultural Centre', one sticker commented on the 'interest' of the Athens Onassis Centre in politicised forms of theatre. 'From outside Bella Bella [all pretty] from inside *katsivella* [mess]' referred to the National Opera. 'What did you used to do in the National Theatre of Northern Greece, Sotiri?', another commented, referring to the artistic director and his previous position in Northern Greece regional theatre and linking him to certain scandals. These stickers kept appearing on posters for upcoming shows, during events, and in other unexpected locations—e.g., in the streets of the city centre and the toilets of cultural spaces—performing an intervention ephemerally before being removed by security guards and staff (Figure 4.5).

These activist tactics could be considered examples of a micro-scale destituent practice that, as Agamben notes, has the potential to reveal the anomy of power while questioning both its legal and its social legitimacy. As a result, these actions in a critical period of the economic crisis sought to make visible the prevailing hegemonic common sense and question its social legitimacy. Destituent acts can be useful tactics that contest the distinction between legality and illegality, exposing the gap between actual and possible law. The examples I cited here can be thought of in terms of micro-tactics that bring about changes in the way in which political reality is configured, specifically through the configuring of city space. These are acts of resistance that open up space for what could otherwise be.

Figure 4.3 The stickers of cultural critique in unexpected locations in Athens
Source: K. Tzimoulis

Re-instituting: transformational infrastructures

Lauren Berlant argues that, in times of crisis, glitches have appeared in the reproduction of life—the revelation of infrastructural failures. She discusses transformational infrastructures to describe generating 'a form from within brokenness beyond the exigencies of the current crisis, and alternatively to it too' (2016a, 393). She writes further 'how to be in the space of broken form and nonetheless understand that as you proceed transformation can proceed' (2016b).

Figure 4.4 The second poster.

Figure 4.5 The stickers of cultural critique in unexpected locations in Athens
Source: K. Tzimoulis

After years of 'brokenness' and instituent and destituent acts in the cultural field of Athens, in June 2015, an 'unidentified' collective, consisting of members of Mavili, artists, theorists, participants in Embros, and people who took part in the series of direct actions of cultural critique that followed, initiated a cultural occupancy in a disused building in Pedion tou Areos—one of the two central parks of Athens. This action took place six months after the election of a left-wing government that came out of the collective struggles of recent years but also after the experience of Embros and in the face of a different (or so it seemed) political landscape. The Green Park occupancy sought to rethink how an intervention should operate in the changing here and now of Athens. Stefano Harney and Fred Moten argue that 'fugitive publics do not need to be restored. They need to be conserved, which is to say moved, hidden, restarted with the same joke, the same story, always elsewhere' (Harney and Moten 2013, 63). In a similar way, this evolving collective experiment sought to engage again with questions of instituting, of remaking, of repairing, of coexistence. As stated in the Green Park manifesto that was released by the collective on the day of the occupation:

> Almost 4 years after the occupation of the Embros theatre in 2011 we are activating with our own means a space deserted and left empty for years by the Greek state and propose a 10 day program of cultural and political intervention in the here and now of Athens.... [I]n a struggle against cultural and artistic monopolies, 'creative cities' and their production lines of co-optation, through this ephemeral collective experiment we aim to co-imagine with fellow city dwellers, the here and now of Green Park and our city.
>
> (2015)

The space experimented with different forms of participation, testing how a cultural space might operate in these times of crisis and impoverishment. During the following years, the space experimented with modes of production and organising, hosting and initiating numerous conferences, talks, residencies, neighbourhood meetings, concerts, solidarity events, and a DIY performance biennial.

The events re-informed each other constantly, affected by the urgent needs of the project's urban surroundings. Located in the heart of the city in the midst of crisis, away from the gentrified parts of Athens, artistic and political activities took place in which diverse audiences mixed, producing an unexpected and, at times, even uncomfortable public space, practically questioning methods of cultural/theoretical/political production. Green Park offered a mode of operating a cultural space in years of crisis and received recognition and support from the local and international communities. However, internal tensions that developed and ongoing external attacks by the state and other actors made its continuity challenging. The electricity and water supply were often cut off, and there was ongoing pressure to evacuate. In the summer of 2017, some members of Green Park organised the exhibition and public programme Where Are We Now? Struggling Autonomies in Closing Times, which generated a public debate on both methods

of cultural autonomous initiatives and potential infrastructures appropriate for current conditions. The space stopped its activity shortly after this last event.

Berlant (2017) suggests that, in times of crisis, one task for theory and art is to provide infrastructures for transformation. Infrastructures, however, are not that same as institutions. Infrastructures are defined by use. These infrastructures of transformation, operating from within brokenness, manifested across the social strata in Greece during the years of crisis. As social frameworks and societal imaginaries were contested, alternative ways of creating appeared. These alternative ways of creating and being did not appear from a place of experimentation but rather were inseparable from the forms of life they expressed. They emerged out of a necessity to find ways to be present and create alternative life infrastructures. These infrastructures came into being through continuous forms of response to the cultural and social crises that afflicted Greece. Embracing the impossibility of being reproduced and yet inducing repetition of such forms, as Berlant argues, 'makes an infrastructure possible' (2017).

Performance as a form

These instances of improvised instituting/de-instituting, viewed as emergent forms of cultural critique, acted as a response to a specific 'here and now': they were simultaneously performance manifestations and a means of producing critical questions about the specific manifestation of cultural politics: i.e., the forms of political practice underpinning cultural/theatre conditions. Such critical practices in the landscape of crisis challenged dominant societal imaginaries and modus operandi by exploring what performance can do within such impotent contexts. Testing the limits of the political, the theatrical, and established categories and forms of action and operating from within brokenness, these instances contributed to a shift in the form of common sense—a paradigm shift, perhaps—which as Ranciere notes 'is polemical to a new landscape of the visible the sayable and the doable' (2010, 149). By politicising theatres and theatricalising politics, cultural workers questioned not only the content of the work, but also the form, producing modes of organisation and practice that had the potential to intervene in how contemporary reality is configured in landscapes of crisis. Utilising constituent practices that attempt to strategically create critical alternative sites to destituent tactics that reveal the anomy of power, these actions challenged dominant hegemonies in the public realm. Repeatedly taking space functioned ephemerally as transformational infrastructures that were able to produce new publics, giving rise to new forms of public response. The fugitive relation of the political and the performative remained unresolved and in tension, however; thus, such experiments also reveal trajectories of practice from within the strictures of a specific here and now—culturally and politically.

Nonetheless, it cannot be denied that by their very nature, such practices are also impotent, ephemeral, precarious, insufficient, and vulnerable in the face of dominant powers. Perhaps such practices call for new a understanding of continuity as an evolving, precarious, ephemeral, ongoing practice of producing performance

forms in response to an ever-changing here and now. Ephemeral evolving infrastructures give rise to new performative forms of responding, improvising, organising, and insisting with others through the specific stakes and limitations of a 'here and now'. Like performance itself, as a person onstage replays movements and words in a different context trying to find the here and now, to discover the reason to be there with a specific audience at a moment in time. Creating a world and taking it apart. Again and again.

References

Agamben, Georgio. 2013. "For a Theory of Destituent Power." Accessed September 2, 2019. www.chronosmag.eu/index.php/g-agamben-for-a-theory-of-destituent-power.html.

Berlant, Lauren. 2016a. "The Commons: Infrastructures for Troubling Times." *Environment and Planning D: Society and Space* 34, no. 3: 393–419.

Berlant, Lauren. 2016b. "Interview, IPAK Centre." Accessed August 19, 2017. www.youtube.com/watch?v=Ih4rkMSjmjs.

Berlant, Lauren. 2017. "Q & A about Transformational Infrastructures." Presented at public programme In Spite of Everything: Stubborn Returns and Urban Afterlives. Athens, May 25.

Gramsci, Antonio. 1971. *Selection from Prison Notebooks*. New York: International Publishers.

Green Park Athens. 2015. "Manifesto." Accessed September 2, 2019. https://greenparkathens.wordpress.com/manifesto/.

Harney, Stefano, and Fred Moten. 2013. *The Undercommons: Fugitive Planning & Black Study*. New York: Minor Compositions.

Mavili Collective. 2011. "Re-Activate Manifesto." Accessed September 2, 2019. http://mavilicollective.wordpress.com.

Mavili Collective. 2014. "A fiasco @Megaro." Accessed May 30, 2020. www.youtube.com/watch?v=TYva1Q-u4bk.

Mouffe, Chantal. 2013. *Hegemony, Radical Democracy and the Political*. New York: Routledge.

Ranciere, Jacques. 2010. *Dissensus: On Politics and Aesthetics*. London: Continuum.

Teatro Valle Occupato. 2011. "The Occupation of Teatro Valle, Rome." Accessed September 2, 2019. www.teatrovalleoccupato.it/the-occupation-of-teatro-valle-rome.

Part 2
Funding and labour

5 Justifying theatre and its funding after 2008

Joshua Edelman

The crisis that beset much of the Western world in 2008 may have begun in the global financial markets, but it did not end there. That turmoil upset economic certainties that many had relied on, from mortgage holders who found that they owed more on their homes than they were worth to small business which saw their access to supplies and capital suddenly dry up. The crisis affected the certainties that governments relied on as well; not only did their tax revenue drop precipitously, but there was also sudden pressure to re-examine the ways in which their spending was justified to a variety of different audiences, each with their own needs: their own citizenry, their investors, and the global financial institutions that they depended on for their solvency.

These pressures were particularly strong in those smaller countries whose economies were dependent on ready access to international capital. In many ways, the Republic of Ireland makes for a paradigmatic case study for the 2009 economic crisis. Long a poor relative to its European neighbours, the country grew considerably richer quite quickly in the so-called 'Celtic Tiger' period of the 1990s by attracting direct international investment and embracing a neoliberal model of public governance that was attractive to the European Union. In the decade up to 2004, the Irish GNP (per capita and inflation adjusted) soared over 57%, and the unemployment rate plummeted from 12% to under 4% (Central Statistics Office 2005, 17, 35). But when the Irish banking and real estate sectors collapsed in late 2008, the effects were similarly staggering. In the first quarter of 2009, the GNP was down 12% from the previous year, and unemployment rose to over 11%; it would peak at 16% in January of 2012 (Central Statistics Office online). This collapse necessarily engendered a public need to explain the political logic behind the economic system that had caused so much damage. A country with a more stable economic or political record might have been better able to resist this pressure for justification; newly prosperous and internationally vulnerable Ireland could not do so.

While this crisis was not about the arts in any direct sense, the arts were not free from its effects. Theatre, after all, is not just an art form; it is a social field as well, a public practice that cannot be separated from the larger economic and political forces that influence all other public practices. And of all art forms,

theatre is particularly demanding of resources: funding, space, training, and public attention from potential audiences and the press. This makes theatre especially responsive to the values of the society in which it operates. While theatre-makers often seek to question and critique those values, they often lack the social stature to do so without (potentially adverse) consequences to their social standing and livelihoods. It was not for nothing that Pierre Bourdieu placed drama (his term) at the least autonomous end of the field of cultural production (see Bourdieu 1993, especially 46–52). The dynamics of claims to theatrical autonomy—that is, of theatre's claims to conduct its work on the basis of values that are set by and responsive to the dynamics and assumptions of the theatrical field itself, rather than operating on the basis of values imposed on the field by forces outside it, such as economics or politics—are complex and can be deployed for a variety of reasons (see Edelman, Hansen, and van den Hoogen 2017), but, broadly speaking, they allow theatre artists to refract, violate, or reframe values external to the field, rather than to ignore them completely. The Irish economic crisis, then, inevitably led to an intellectual crisis about what sorts of values ought to prevail in other aspects of Irish society. Irish theatre, like every other part of Irish public life, had to justify its work in ways the public could accept. In the context of sharply limited resources, all publicly funded activities were forced to re-articulate the justifications for their continued existence and support.

A useful way of thinking about this notion of justification comes from the so-called 'value sociology' of Luc Boltanski, as he developed it with Laurent Thévenot in *On Justification: Economies of Worth* (Boltanski and Thévenot 2006) and Eve Chiapello in *The New Spirit of Capitalism* (Boltanski and Chiapello 2005). Boltanski and his colleagues talk about the 'value regimes' (or 'economies of worth'—the French term translated as 'regimes' or 'economies' is *cité*, suggesting the structural organisation of a polity) on which claims to justification can be made for any sort of decision. These forms of legitimation are general theories of what that is present in the culture is valuable, and any of them can be called on when a justification is required. These regimes derive from practical patterns of thought present in the culture at large, rather than from social analysis or philosophy as such. Boltanski and Thévenot's initial delineation of them comes from their reading of popular business books (what they call 'behavioural handbooks designed for business') rather than social theory (Boltanski and Thévenot 2006, 17). This sort of mass-market advice is useful for their purposes because they aim to 'guide action' rather than to participate in the abstract 'debate over justice' and thus do not aim for intellectual consistency but rather look 'to accommodate various forms of generality by pointing toward possible ways of getting beyond their contradictions, thereby heading off disputes and avoiding the risk of escalating criticism' (*ibid.*). These books, like the value regimes that they embody, use general social acceptability as a criterion for justification, rather than criteria of moral or intellectual rigour.

While all the value regimes Boltanski identifies are, in theory, available in any situation, different fields have tended to make use of some more than others. For instance, the 'civic regime', which focuses on the general public interest

and derives legitimacy from membership and consent of a majority (as expressed in an election, for example), is more likely to be the source of justification used in government and democratic advocacy than is the 'inspired regime', in which creativity, novelty, and (personal, pseudo-religious) inspiration are the key values. The other value regimes discussed—the industrial, the market, the domestic, the fame-based, and the so-called 'project regime' (this last only added in *The New Spirit of Capitalism*)—have their own values and means of deriving legitimacy. The justifications made for any particular decision (such as public support for the arts) may rest on a single value regime but are more likely to be a negotiated compromise between a number of them. These compromises, however, are always subject to renegotiation as social power dynamics shift or crises make the previously assumed justifications no longer convincing.

I have studied the value regimes at play in the Irish theatre field—including both theatre-making and the policy work that justifies the state funding of it— during the 'Celtic Tiger' years, roughly 1990–2008 (see Edelman 2009). These values, and the ways in which they are negotiated, derive both from the anti- (or simply pre-) neoliberal values of Irish arts-making and from the neoliberal governmentality that began to dominate the field in this period.

The main Irish agency for state arts support is called the Arts Council or, in Irish, *An Chohaile Ealaíon*. It is a body established by law with a broad statutory mandate to promote and develop the Irish arts with at least superficial similarities to other arts councils in Britain and elsewhere. Irish arts funding has always been more meagre than its continental cousins, and so, both artists and their supporters in and out of government have long made considerable effort to make a strong case for raising that support. This required the explicit use of justificatory language in ways that could be understood by politicians and bureaucrats with little sympathy for explicitly aesthetic arguments.

In previous research, which involved both large-scale archival work and interviews with a large number of Irish theatre-makers and arts policy workers, I argued that the field made two forms of diametrically opposed justification for arts funding (Edelman 2009). This first set of justifications, present in formal policy documents, was aimed towards government and potential funders, based on the same neoliberal, capitalist logic that had been so important to the Irish government in encouraging the EU to support its general economic development in the 1990s. In Boltanski's terms, these were based on the logic of the industrial and civic polities: maximising the efficiency of the theatre system so that it could serve the public good. The other, passed on in informal conversations and many a quiet word, was directed to artists, who were implicitly told that these first justifications were not, in fact, the basis on which the funders would be making decisions, that decisions would be made on the basis of artistic quality, and that artists simply should tolerate this kind of language because it would lead a rising tide lifting all boats. While one could see this second justification as part of Boltanski's domestic polity (a family-like structure with clear hierarchies in which all members rose or fell together), it was hard to find it so clearly articulated in those terms. Because this was a justification passed informally between friends and

colleagues, it was often offered in hazy terms of verbal reassurance and was rarely written down. In fact, most artists I interviewed said that they would very much have liked to know what evaluation criteria were, in fact, used in making funding decisions rather than relying on the overly vague term 'excellence'. Arts Council advisors and staff told me that, of course, there was no strict definition, and this was not an accident. The Arts Council's advisor for theatre wrote, in a master's thesis composed while she was in post, that

> there were no formal criteria for evaluation. The sector knew this, and it has warily asked for transparent evaluation since the appearance of the first plan (1994). . . . The sector understandably wanted input into the creation of criteria but has also expressed fears that the Council might simply impose the criteria for evaluation.
>
> (Reid Whyte 2001, 26)

The opacity of artistic criteria is common in artistic evaluation and, in fact, serves a useful purpose. In Bourdieu's terms, the autonomy of an artistic field depends on its ability to set its own values, and since the development of what Bourdieu calls the 'institutionalisation of anomie' (Bourdieu 1996, 132), this means a firm insistence that no forces from outside the artistic field can set the definition of artistic value. Bourdieu discusses this in terms of the independence that visual artists such as Edouard Manet achieved from the Académie Française in the late 19th century, but the principle applies here too: if the Irish theatre field is to be autonomous, it must define the terms of evaluation and not the Arts Council.

But while such opacity might have been useful, it was extremely frustrating for those artists I spoke with, who found the council's decision-making process simply inscrutable. This led to a lack of trust between the artists and the Arts Council, a mistrust that persists to this day. In Boltanski's terms, artists were suspicious that the council operated under different value regimes than they did. This infuriated council members and staff, who were industry veterans themselves and did not see themselves as separated from the field in a way that others did and saw decisions as essentially correct and ones the field should support, even if they could not articulate their reasons for them. From the council's perspective, its actions in making funding decisions demonstrated that it operated on the basis of the same values as the artists it supported, but it was forced by its political position to copy a prevailing neoliberal language in articulating justifications for its work in ways that the government could hear. And this attempt to balance formal and informal justifications was, in fact, quite effective. In looking back over the council's first arts plan in 1998, four years after its launch, the council's chair noted that it had 'implicit aim in addition to those explicitly stated': 'One implicit aim [of the plan] was to move the arts and their funding on to the political agenda in such a way as to achieve a cross-party consensus on the need to support the arts in Ireland adequately' (Chomhairle Ealaíon 1998, 3).

In other words, the plans were not designed to actually guide the development of the arts in Ireland. (In fact, they never did so.) Rather, they were used

to present a formal justification of arts funding to the political field, one which, as I argued, emphasised the neoliberal values of EU economic polity: efficiency, order, professionalism, and market value. Artists were not asked to accept this justification—that was the function of the second, informal version—so much as agree to pay lip service to it in exchange for the promise of greater funding.

This arrangement worked for a while, if frustratingly, so long as that promise was plausible. The Arts Council managed to raise its funding year on year for most of the 1990s and 2000s, and the field went along with this distance between what they were saying and what they were doing. This détente may have protected the autonomy of the Irish theatre, but in doing so, an unexpected and perhaps psychologically unhealthy dynamic developed, in which the council served not just as a distributor of funding, but as a grantor of legitimacy for the field. The council was not seen as rewarding excellence so much as creating it through its grant-making. This power dynamic meant that artists began to look to the council not just for subsidy but for affirmation and reassurance in ways that seemed to many psychologically unhealthy. The council began to use its grant authority to legitimate theatre-makers' work as genuinely artistic and communicate messages about it. Many of my interviewees described a parent-child dynamic with the council, in which clients were expected to be grateful for funding but were often quite anxious about pleasing a father figure they could not, ultimately, understand. The Boltanskian model here is the domestic polity, in which the patriarchal family provides the template for other social relationships. This meant that metaphors of inclusion and rescue (especially the term 'funding ladder') were often used by theatre-makers in describing their relationship with the Arts Council.

One story that I was told both in a formal interview and in a social setting captures this dynamic nicely:

> I remember one great moment when they finally gave us some money—I think about ten grand or something—and we met Phelim [Donlon, then the Arts Council's drama officer] at some function, and he shook our hands and said, 'well done boys, it's good to have you on the raft'. To which my friend . . . said, 'Thanks Phelim. Any chance of getting on the ship?'
> (Edelman 2010, 180)

But grant-making can be used both to invite groups in and to threaten them with exclusion. One theatre, for instance, was given a cut of exactly €1 in its annual funding as a 'pretty blunt message' that it needed to change its ways, as the council chair at the time told me in an interview (Edelman 2010, 140). This message was not communicated verbally because of the difficulty of the council, as an institution, articulating a justification for a particular decision as any written text could be published and debated in the press. The council was thus left to use money as a means by which to communicate its satisfaction with various companies. Though this was a regular part of the council's grant-making practice, it had nothing to do with the justifications for the council's work that it offered to the central government.

But how long is it possible to sustain such a gap between the values that, in fact, undergird a practice and the overt arguments used to justify it? Whatever the answer, it is shorter than a business cycle.

As soon as the council could no longer sustain its implicit promise to the field of continually increasing funding, this duplicity was no longer feasible. The large-scale cuts that followed the 2008 crash forced the council, like all other Irish public entities, to cut its funding; as a consequence, it could no longer maintain this strategic ambiguity. The capricious but powerful provider-father figure had been revealed to be impotent, and the system fell apart. This crisis provoked what Boltanski and Thévenot call a 'test'—in which the necessity of a decision meant that different value regimes were forced to justify themselves, and either one would win out over the others or a new compromise would emerge.

The result of the test was clear. Funding was preserved for the larger companies at the expense of the smaller. A great many of the smaller theatre companies, which had been sustaining themselves year to year on project grants, simply folded. Larger, prestige institutions suffered cuts as well, but not ones that were any sort of existential threat. And, in many artists' minds, this showed where the council's priorities were: not innovation and the pursuit of artistic excellence, as artists had been assured, but the maintenance of established, mainstream institutions to preserve Ireland's sense of national identity, international reputation, and tourism industry. The market and domestic value regimes were shown to be dominant over the civic, the inspired, and even the industrial ones. (Cutting smaller, more efficient companies is not, of course, healthy for the theatrical ecosystem.) Policy documents might still talk about the celebration of excellence as they did before, but this language was more of a comforting veneer than anything meaningful; the field could no longer see it as determining for the council's decisions.

But in more recent years, as the economic crisis continues, there has been an effort to raise funding again. Each political party has put out arts policies within their electoral manifestos that call for raised arts funding, and these receive some (limited) press coverage and public attention. The current prime minister, Leo Varadkar, has made a point of promising a doubling in arts funding over his premiership. But neither he nor anyone else is proposing a return to the relationship between the arts and the state that was in place before the crash. While the documents may use similar language, a new and quite different pattern is emerging. I would like to point out three aspects of it.

First, there is an increased emphasis on reception and not just production. Encouraging public interest in the arts has, in statutory terms, been a priority of the Arts Council from the beginning, but this is a shift in values from work deemed excellent by peers to work that the audience, demonstrably, wants to see and wants to see made. Historically, the council's role in promoting public engagement with the arts had something of a paternalistic character—it purchased visual art for exhibition, organised tours of proper theatre and ballet, and used other techniques to make art identified as 'great' work available to the public. Dissemination may have been distributed across the country, but taste was still centralised with the experts in Dublin. Now, taste, too, is being distributed. More

populist forms such as circus, traditional music, and cinema are now a significant draw on state funds. The Arts Council's 2015 planning document *Making Great Art Work* argues that, while the council does have an obligation to support artists, it also has an obligation to encourage public engagement with the arts, and these two mandates carry equal importance (Chomhairle Ealaíon 2015). The document's language focuses on the social relationship between artists and the public and presents art works themselves as facilitators of that engagement. For instance, it states its two central intertwined policy goals primarily in terms of people, not artwork: 'Artists are supported to make excellent work which is enjoyed and valued' and 'More people will enjoy high-quality arts experiences'. The language of quality is still here, but it is placed in a subordinate position to the social function of the arts, and it opens up the possibility that excellence ought to be defined by audiences, not experts. This development can be phrased in the traditional language of the tensions between expert and popular judgements and between so-called 'intrinsic' and 'extrinsic' functions, but I would argue that this is not the most critically useful. A focus on these tensions tends to ossify into philosophical dichotomies that do not respond to political and social change. It is more sociologically useful, I believe, to describe this development in terms of a shift from the values of the inspired and domestic regimes towards a narrowly defined version of the civic and industrial regimes.

Secondly, there is concern that this shift may also herald a de-professionalisation of Irish arts-making. The idea of the arts as a proper profession in Ireland is still relatively new and perhaps never has been fully accepted. While some training in theatre arts has been available at Irish universities for decades, it was not seen as a requirement—many Irish actors and other artists developed their craft through apprenticeships, youth theatre, or training abroad. And many performers and artists, even those with considerable success, rely on television work, voiceovers, or day jobs to support themselves and never really expected theatre work to be financially remunerative. In fact, it was the Arts Council's own policies in the 1990s that did a great deal to encourage the development of professional practices in the field, at least in terms of the formal financial and bureaucratic management of theatre companies. The explicit desire here was to formulate the Irish arts on the 'professional', corporate model that EU authorities understood and were willing to fund. With the demise of that interest in favour of a much broader sociological view of culture, Irish artists fear that they will lose the professional status they have worked so hard to earn. Amateur theatre, after all, has a great deal of social relevance for a great many people, and it is hard to say that it cannot provide genuinely meaningful experiences (see, for instance, Nicholson, Holdsworth, and Milling 2018). This trend is evident across Europe; as contemporary notions of cultural democracy focus on the engagement and creative life of citizens, they begin to blur borders between artists and audiences and thus between professionals and their publics (see Wilson, Gross, and Bull 2017). The theatre veteran and Arts Council advisor John O'Brien (2018) told me recently that his concern is that because the discussion has shifted from the arts as such to broader notions of community and creativity, there might seem to be little reason to keep paying artists.

Finally, part of the reason this pattern is emerging is that the Arts Council is losing its dominance over Irish arts funding, a dominance it has effectively held for 60 years. Until the 1990s, essentially all other sources of arts funding were trivial compared to that offered by the council. Now, that is not the case. Over the last decade and a half, the council has worked to develop arts offices within each local authority. These offices now distribute money according to their own criteria (which often differ from those of the Council), and in conjunction with all the less formal, in-kind support that the local authorities provide, they are supporting the arts about twice as much as is the Arts Council itself. Also important is the rise of Culture Ireland, a state body that aims to encourage the export of Irish arts and to develop Ireland's international cultural prestige. Culture Ireland's funding is currently much smaller than that of the Arts Council, but it is growing rapidly. When Varadkar talks about doubling arts funding, many assume that he is not talking about the Arts Council but all the other ways the government funds the arts: capital projects; direct provision to large national institutions; support for the (commercial) film and music industries; and, of course, Culture Ireland. And unlike the Arts Council, Culture Ireland has no specific statute setting out its mandate and operating procedures; it is a division of the state's Department of Culture and thus can operate in direct service of the agenda of the government of the day with no arm's-length distance.

I would argue that these changes add up to a very different image of the arts than that of an autonomous field, free to pursue its own values through its protection from the vicissitudes of the market by the courtly benevolence or wisdom of the state. Instead, the arts are taking the role of any other civic amenity: the state provides them for the sake of popular enjoyment, education, national identity, tourism, economic development, the flourishing of its citizens, and so on. They are part of democratic civic life, like parks, public debate, sport, or education, and are justified by the same blend of economic, social, or nationalist reasons. For a small Anglophone nation like Ireland, the rewards for selling the national brand in the global economic and tourist markets are particularly lucrative, and governments have found in the arts a rather useful way to do this. (The goal is to make Ireland the Qatar of culture, as it is sometimes mockingly put.) The logic here is that of the civic, domestic, and industrial regimes (and, to a much lesser extent, the fame regime). The arts, and the theatrical arts in particular, are starting to be seen as a means to an end; this broad civic-and-industrial regime has lost the language to recognise artistic inspiration as a value as such.

Although the idea of a less-professional, less-autonomous, less-well-defended Irish theatre field that is forced, by necessity, to draw closer to broader understandings of public creativity and cultural life is a genuine pattern emerging as a consequence of the 2009 economic crisis, it is not unprecedented. In the early 2000s, Richard Florida's idea that cities should cultivate their 'creative class' for the sake of economic development found many adherents, though his theories are now generally discredited (see Florida 2005 and, in contrast, Krätke 2010). There are also older precendents, however. The move against the autonomy of the arts can be seen as a move towards their democratic relevance. Colm Ó Briain, a

prominent Labour Party politician who helped push for the rise of the Arts Council's prominence in the late 1980s, made the case that if the arts are, in fact, an important part of human life, then, in a democratic society, it would be abdication of responsibility to remove them from the political sphere entirely. In a 2008 interview, he told me: 'A political class have been given permission to shrug [the arts] off saying, it's an aesthetic question. We're not competent to discuss aesthetic questions. I think it's a civil rights question' (Ó Briain 2008). There is a difference between the social democratic logic of Ó Briain and the more right-wing populist logic of Varadkar, of course, but structurally, they are quite similar. If we agree that theatre is a social practice, then I would argue we must accept that debates over the justification for the support of that practice will necessarily happen in the public sphere under the influence of the same value regimes as operate for any other form of social justification. This is not to say, however, that the arts must operate like any other social practice. In order to function properly, the arts—including the expensive, collective art form of theatre—require a certain degree of autonomy, as do certain other specialised fields, such as the law and the academy. Artistic autonomy may be more difficult to conceptualise than judicial autonomy, but it has a parallel necessity. The tension between the political necessity for a public justification for the support of the arts and the artistic field's need to set and pursue its own values is a challenge that each generation of artists and policy-makers will need to face for itself. Crises like that caused by the collapse of the Celtic Tiger will inevitably force a reappraisal of those challenges, but these reappraisals are also opportunities. When a crisis forces the public to reassess the fundamental values that undergird the arts' role in society, it offers an opportunity to re-establish that role in a new way. With a fuller understanding of the ways in which these crises have played themselves out in other times and places, we will be able to give the arts a larger and richer place within society, one which is more effective and more humane.

References

Boltanski, Luc, and Eve Chiapello. 2005. *The New Spirit of Capitalism*. Translated by Gregory Elliott. London: Verso, 2005.
Boltanski, Luc, and Laurent Thévenot. [1991] 2006. *On Justification: Economies of Worth*. Translated by Catherine Porter. Princeton, NJ: Princeton University Press.
Bourdieu, Pierre. 1993. *The Field of Cultural Production: Essays on Art and Literature*. Translated by Randal Jonson. Cambridge: Polity Press.
Bourdieu, Pierre. 1996. *The Rules of Art*. Translated by Susan Emanuel. Cambridge: Polity Press.
Central Statistics Office. 2005. *EU Survey on Income and Living Conditions (EU-SILC)*. Dublin: Stationery Office.
Central Statistics Office. "Statbank Online Dataset." Accessed August 6, 2019. www.cso.ie.
An Chomhairle Ealaíon/The Arts Council. 1998. *The Arts Plan 1999–2001: A Plan for Government, a Strategic Framework for the Arts*. Dublin: The Arts Council.
An Chomhairle Ealaíon/The Arts Council. 2015. *Making Great Art Work: Leading the Development of the Arts in Ireland: Arts Council Strategy 2016–2025*. Dublin: The Arts Council.

Edelman, Joshua. 2009. "Theatre Planning in Ireland: A Cautionary Tale." In *Global Changes/Local Stages: How Theatre Functions in Smaller European Countries*, edited by H. van Maanen, A. Kotte, and A. Saro, 229–264. Amsterdam: Rodopi.

Edelman, Joshua. 2010. "Misrecognition, Planning and Cultural Capitalism: Independent Theatremaking in Ireland, 1990–2007." PhD thesis, Trinity College, The University of Dublin.

Edelman, Joshua, Louise Ejgod Hansen, and Quirijn Leinert van den Hoogen. 2017. *The Problem of Theatrical Autonomy*. Amsterdam: Amsterdam University Press.

Florida, Richard. 2005. *Cities and the Creative Class*. New York: Routledge.

Krätke, Stefan. 2010. "'Creative Cities' and the Rise of the Dealer Class: A Critique of Richard Florida's Approach to Urban Theory." *International Journal of Urban and Regional Research* 34, no. 2: 835–853.

Nicholson, Helen, Nadine Holdsworth, and Jane Milling. 2018. *The Ecologies of Amateur Theatre*. Basingstoke: Palgrave.

Ó Briain, Colm. 2008. Interview with the author. April 30, 2008.

O'Brien, John. 2018. Interview with the author. March 5, 2018.

Reid Whyte, Enid. 2001. "From Promise to Sustainability: An Chomhairle Ealaíon/the Arts Council and Irish Theatre: Planning for the 21st Century." MPhil. diss., Trinity College, The University of Dublin.

Wilson, Nick, Jonathan Gross, and Anna Bull. 2017. "Towards Cultural Democracy: Promoting Cultural Capabilities for Everyone." Report. Cultural Institute, King's College, London.

6 Dutch theatre politics in crisis?

Quirijn Lennert van den Hoogen

This chapter investigates the values behind Dutch theatre policies. If we consider crises as 'significant shifts in the way theatre is understood, organised, delivered, and received' (Balme and Fisher in the introduction), it is interesting to research shifts in the values behind theatre politics as an important condition for the functioning of theatre in society. What values does the government impart to the theatre sector, and do changes in such values represent a crisis that provides 'productive ways to think about the future' (*ibid.*)? The analysis presented here focuses on spoken theatre, a part of the Dutch theatre sector that, to a very large extent, is dependent on subsidies, much like (modern) dance and opera, but in sharp contrast to musical and cabaret, genres that are almost exclusively privately produced. However, the analysis may have a wider relevance than just spoken theatre.

The first of January 2013 may be considered a crisis moment in Dutch theatre politics. As of that date, substantial cuts in the national budgets available for theatre, and the arts at large, were implemented, amounting to a decrease of about 25% in public funding for theatre. The budget cuts should be considered a seismic shift in Dutch cultural policies as, until then, the cultural budget was always relatively spared in times of austerity measures. Now, the cuts on culture were twice as high as the general austerity measures, which amounted to about 10% of the national budget (Van Meerkerk and Van den Hoogen 2018). This chapter first presents some background information on the Dutch theatre policy, its legal underpinnings, and its arm's-length principle arrangements. Then the research method, which is based in the value sociology of Boltanski and Thévenot (2006), is presented, followed by a description of the outcomes of the empirical research and a discussion as to how they present a crisis.

Dutch theatre policy

Just as in many continental European countries, Dutch cultural policies on a national level developed as of 1945 as part of the expansion of welfare state arrangements. The Dutch cultural sector gradually became more and more dependent on support from the national government, necessitating 'rules of conduct' for the government regarding the sector. These rules were provided with the

institution of the Cultural Policy Act (CPA) (*Wet op het Specifiek Cultuurbeleid*) in 1992. The act made Dutch cultural policies systematic, directing the government to adopt a four-year policy cycle. The CPA is generally regarded as the outcome of a rather pragmatic legislative process that only provides the legal basis for the involvement of the Dutch government in the cultural sector but shuns directives regarding the content of cultural policies, other than that they be guided by principles of 'quality and diversity' (article 2 of the CPA; see Van Meerkerk and Van den Hoogen 2018 for a comprehensive analysis of the act). At the time, the act was in no way controversial: it represented the relative agreement amongst the major political movements in Dutch politics (Christian-democrats, socialists, and liberals), which, though they may disagree about particular decisions in cultural politics, do not dispute the right of the government to have such policies in the first place (Hoefnagel 1992; Winsemius 1999). This situation has radically changed since the early 2000s, when particularly right-wing political parties (such as the Freedom Party, PVV, and later the Forum for Democracy) questioned this self-evident position of cultural policy. In their view, the government does not have the right to interfere in personal matters such as culture. And if it does, the government should take the national interest into account rather than the—until then uncontested—focus on the 'free' development of the cultural sector that leads to a focus on experimentation and renewal, welcoming international exchange. A more 'nativist' perspective to politics has taken root, arguing for more attention to the values that are constitutive of Dutch identity. Schrijvers (2018) points to a new social-cultural divide in Dutch society: the difference between a cosmopolitan elite and a more 'inward-looking' part of the population. In politics, the nativist perspective is no longer only represented by populist parties. Also, political parties with a traditionally more cosmopolitan outlook, such as CDA (Christian-democrats) and VVD (liberals), have taken on a nativist agenda. In cultural policies, this is exemplified by the suggestion of the CDA to focus secondary education on the national anthem and the obligation of all children to visit Rembrandt's *Night Watch* in the Rijksmuseum, suggestions that were taken over in the coalition agreement of the current Rutte III administration.

The budget cuts were envisioned by the short-lived Rutte I administration, a minority cabinet of VVD and CDA, supported by the right-wing populist Freedom Party (PVV) that was in power from October 2010 to April 2012. The budget cuts, however, were implemented by Minister Jet Bussemaker (social-democratic party, PvdA), minister for education, culture, and science in the Rutte II administration (2012–17). Although this cabinet changed the tone of cultural policies considerably, it did not alleviate the budget cuts as it saw no possibilities for more spending in the aftermath of the economic crisis of 2008. Nor was the budget for the following policy period (2017–21) raised. In formal policy discourse, the budget cuts were legitimised, pointing to the overreliance of the arts sector on public funding and their underdeveloped orientation towards the market while the great artists of the Dutch Golden Age were tradesmen just as much as artists. In public debate, the judgement was harsher. The right-wing populist parties in particular openly criticised the cultural sector (and public broadcasting) as solely catering

to a city-based elite of cosmopolitans and multiculturalists, a prosecco-sipping bunch of lefties, benefitting from their (also publicly funded) university education while leaving the burdens of the global economy to those less fortunate.

As indicated earlier, the act dictates a policy cycle in which the government discusses policy goals and subsidy allocations with parliament every four years (i.e., once per term of an administration). Moreover, the act stipulates subsidy allocations to individual institutions (in the case of theatre, production companies) are subject to advice by the independent Council for Culture. The allocations, however, are ministerial decisions, which implies that the Architect State model as identified by Hillman-Chartrand and McCaughey (1989) with a central role for the ministry is used, but with the addition of an arm's-length arrangement allowing for autonomy of the theatre sector (Edelman, Hansen, and Van den Hoogen. 2017). Furthermore, the act stipulates that deviations from the council's advice must be substantiated with arguments. In policy practice, this means that deviations hardly occur: Dutch politics always follows the council's advice when individual allocations are concerned—negative advice by the council implying a refusal of the subsidy application. The council uses committees of experts to evaluate the individual policy plans of theatre institutions (production companies). Committee members are recruited from the theatre sector itself. Members hold various positions, such as theatre critics, programmers, or directors of companies or of theatre venues. Age and gender diversity of the committee is a priority when appointing members (see Van den Hoogen 2016). Hence, the advice may be considered to reflect the perspectives of the professional theatre field, although the Council for Culture must follow the criteria as formulated by the ministry. It should be noted that the Dutch theatre system is a touring system in which the national government funds theatre production companies that tour locally funded theatres. Subsidies comprise about 70% to 80% of the budgets of theatre companies. In other words, negative advice means a company must find other sources of income, usually local subsidies or project-based funding, or it must follow a more commercial strategy. This implies their plans are seriously compromised if structural funding is denied.

This chapter investigates the seven policy cycles between 1992 and 2017. The value regimes of Luc Boltanski and Laurent Thévenot will serve as a methodological framework (as suggested by Edelman, Hansen, and Van den Hoogen 2017). By analysing the values present in the consecutive cultural policy documents published by the ministry[1] and in advisory documents provided by the Council for Culture,[2] the chapter provides a timeline of changes in the values behind policy and subsidy allocations.

Value regimes and theatre policy

Boltanski and Thévenot (2006) argue that people evaluate social situations based on relatively durable sets of values. Such a set of values is referred to as a 'value regime'. These regimes are potentially present in all social situations. However, usually only a few of the regimes are relevant in any particular situation. Conflicts

can arise when agents in the same social situation refer to different value regimes. According to Boltanski and Thévenot, such value conflicts are the drivers of social change. I briefly introduce the regimes next and relate them to the theatre sector.

- Values that can be associated with artistic autonomy, such as quality (both the quality of the art work and of the nature of the experience it affords) belong to the 'inspired regime'. Boltanski and Thévenot, in fact, use the art world to explain this regime that focuses on ambiguity—that which cannot be expressed in words—and on emotions and revelation.
- The 'domestic regime' relates to history and ancestry. In theatre, the use of ancient performance techniques may represent domestic values.
- The 'industrial value regime' is a professional regime in which experts are important protagonists. The regime values knowledge highly and foregrounds efficiency and effectiveness.
- The 'civic regime' is bound not to individuals but to the collective: its central principle is the general interest.
- The 'market regime' revolves around competition. It values those who try to make the best deal. Money, profit, and the possession of luxury goods can be used to measure success.
- The 'fame regime' is about public recognition. It revolves around press attention, public meetings (press conferences, product demonstrations), and public relations.
- A seventh regime, the 'project city', was introduced by Boltanski and Chiapello (2005) in their critique of capitalist economies. This regime combines features of the inspirational (creativity), the market (competition), and industrial (efficiency) regimes. It is a project-based regime, focusing on the ability of agents to move from one project to the next.

The inspired and domestic regimes present obvious examples of autonomous values in theatre, as does the notion of artistic expertise, which belongs to the industrial regime. Cultural policies in and of themselves should be regarded as a compromise between civic and inspired values, reflecting the ideal of *Bildung*, in which the arts are seen as an opportunity for members of society to grow personally and as members of that society, providing a line of Enlightenment reasoning which forms the core of the legitimisation of most cultural policies in Western societies (Belfiore and Bennett 2008; Edelman, Hansen, and Van den Hoogen 2017). However, cultural policies also can be, and frequently are, legitimised by an appeal to more heteronomous values. The use of heritage and the arts to attract visitors to cities or countries, the success of the creative economy, and cultural diplomacy can be seen as manifestations of the market, industrial, and fame value regimes. Using the arts as a means to prevent social exclusion reflects the civic reasoning behind cultural policies. Finally, as New Public Management introduces ever-growing demands for objectification and quantification of the outcomes of cultural policies (Gray 2007; Van den Hoogen 2010), it can be regarded as a trend promoting industrial values. Based on the developments

in Dutch cultural policies sketched in the previous section, market values can be expected to become more dominant, reflecting the discourse of 'overreliance' on subsidies, alongside an increased emphasis on domestic values, as promoted by the nativist perspective.

Empirical method

Through discourse analysis of policy documents, value changes can be demonstrated empirically. Boltanski and Thévenot indicate that discourse analysis can be done quantitatively, by classifying certain words used in a text under one (or two or more, in the case of compromise words) of the regimes and thus counting the number of references to each regime in that text. According to Boltanski and Thévenot, nouns and verbs should be classified as they represent the objects and acts which are deemed important. They provide lists of nouns and verbs that can be assigned to each regime. These lists were used as the basis for the empirical analysis, although—as Boltanski and Thévenot indicate—amendments have to be made to cater to the specific social context under investigation: in this case, theatre politics. First, it was decided to include adjectives in the analysis, as these are used to express evaluations. Secondly, a specific meaning was attached to the project city regime. As this regime consists of a compromise between three other value regimes, it can be difficult to assign words specifically to this regime. Therefore, the regime is usually neglected in quantitative analyses (see, e.g., Van Winkel, Gielen, and Zwaan 2012). In the present research, the regime was used when the connection of cultural institutions to their environment was indicated. Thus, words such as *connecting* and *cooperation* were counted as belonging to this regime.

The research was carried out using a custom-designed computer program. The word lists for each regime were fed into the programme, which scanned all policy and advisory documents, counting the occurrence of each word and, subsequently, of the value regimes in each document. When confronted with a word not on the list, the program would prompt the researcher to assign the word to an appropriate value regime. Proper assignment in some cases needed to be inferred from the context.[3]

The regimes were also used as a basis for interviews with current and former members of the theatre committee from the Council for Culture. Interviews were held during summer 2016, the period when the Council for Culture was drawing up its advice for the policy cycle of 2017–20. While the interviews had a more extensive setup, here they are only used to contextualise the changes in the values behind theatre policies and subsidy allocations as found in the quantitative document analysis.

Values in policy documents and policy advice by the Council for Culture

Figures 6.1 and 6.2 present the outcome of the quantitative discourse analysis.

98 *Quirijn Lennert van den Hoogen*

Figure 6.1 Distribution of values in cultural policy documents (in percentage of total words counted per document)

Although there are differences between the relative importance of the value regimes over the course of 25 years, the overall distribution does not seem to change greatly. The industrial regime ranks highest for all periods and for both the policy documents and the policy advice. The civic and inspired regimes are ranked second and third, again in both the policy documents and the advice.[4] Apart from the industrial values, policy decisions and subsidy allocations appear to be motivated by civic and inspirational values. This reflects the hypothesis that cultural policy in itself is a compromise between these two regimes. All other regimes are of secondary importance and are never found in the top three, although market values come close—as expected—in the period 2013–16. The position of the industrial regime needs to be discussed first. Then the changes regarding the market and domestic regimes and the general patterns will be discussed.

The high scores for the industrial regime can be easily explained. First, policy in itself is an industrial phenomenon; it concerns the measures being taken to achieve certain ends. Public policy also requires procedures, which are explained in the documents, particularly in the introductions to the advice documents. Secondly, the theatre sector uses vocabulary which is industrial in nature: for

Figure 6.2 Distribution of values in advice by council for culture (in percentage of total words counted per document)

example, 'production', 'institution', and 'producing'. Thirdly, the exact nature of the industrial regime is easy to put into words, most notably when compared to the ephemeral nature of the inspired regime. This applies particularly to the advice documents. A sentence such as 'The expertise of the artistic management is solid' leads to a score of 1 for inspirational policy ('artistic') and 3 for the industrial regime ('expertise', 'management', and 'solid'), while, in fact, the message is about artistic quality. Moreover, industrial adjectives are frequently used in negative evaluations, with words and phrases such as 'not realistic', 'too ambitious', or 'insufficient'.[5] As a result, the high score does not indicate a particular industrial perspective of Dutch theatre policy.

The figures do reflect one of the assumptions as formulated at the end of the second section: a rise of market values for the period 2013–16. However, it should be noted that the rise is only temporary (for the period 2017–20, market values return to a lower position), and it is only relative; it does not lead to a fundamental change in the dominance of values behind politics or subsidy allocations. A rise in domestic values is not evident, so the expectation that a more nativist perspective on cultural policy is present in cultural policy and/or subsidy allocations is not confirmed. It is questionable whether these trends are indicative of a crisis.

However, the general patterns tell a different story. First, particularly for the cultural policy documents after 2002, the pattern of values becomes more erratic. So, if we interpret the result as a crisis, the crisis is on the side of politics but does not appear to have a particular direction. Also, it should be noted that the crisis occurred earlier than 2013, the year when the nativist perspective was able to impact the cultural budget significantly. The policy crisis rather seems to occur in the early 2000s, when Geert Wilders's Freedom Party entered the Dutch political scene. However, on the side of the council, the pattern is far more stable: it seems the theatre field is able to continue to function as it did before as the council seems to be able to mitigate political pressure on the theatre field.

However, there are limits to the extent the council is able to do so. The peak of market values in the 2013–16 advice indicates that the council, indeed, has taken market values into account more prominently. Evidently, it could not fully ignore this pressure from politics. Moreover, though they recede in relative importance for the period 2017–20, market values do not return to the low position they held before. The interviews with the committee members confirm this: over time, management-related criteria, amongst them marketing, have become more important at the expense of artistic criteria, although it is questionable whether this is a trend solely instigated by politics and whether this only concerns market values. Van den Hoogen and Jonker (2018) provide a more elaborate description of how committee members describe the practice of subsidy allocations. Here, it suffices to summarise the evaluations as follows.

The core of the evaluation is based on the artistic profile a company chooses. This profile is evaluated based on a combination of inspirational and civic values, reflecting the legitimisation of cultural policies. After this profile is evaluated, the assessment consists of two elements: the company's strategies for forging connections with the environment and the audience it seeks to serve and its internal organisation. The first entails the capacity to effectively market performances and the company as a whole to theatre venues and audiences (i.e., market values). It also entails the capacity to develop effective cultural education programmes (i.e., domestic values). Furthermore, this concerns questions as to how performances connect to the identity of the region where the company is based (i.e., project city values as the regime was applied in this research). The assessment of the 'internal' organisation of the company regards two issues: the continuity of the company and its efficiency. Continuity relates to the question of whether a company has a rigorous financial plan and the ability to deal with financial risks. However, it also concerns artistic risks; for example, what will happen if an artistic leader leaves the company or when the artistic leadership comes under internal or external scrutiny? In Dutch cultural politics, these issues are denoted as 'cultural governance', a topic that has gained prominence over the last decade. Furthermore, the Council for Culture wants public funds to be allocated efficiently. These issues all relate to the industrial value regime.

Interviewees describe the following development over time: while earlier, evaluations mainly regarded the expertise of artistic personnel, currently, committee members also want to know who will develop the educational programmes

or who will be responsible for marketing and what their qualifications are. So more is going on than simply replacing artistic values with market considerations. The evaluations by the council, indeed, have taken on a wider scope, no longer focusing on artistic quality—a trend that the interviewees, by the way, do not see as politically motivated. Politics here is rather following trends in the sector itself that favour a wider interpretation of the role of artistic leaders of companies. They argue that younger generations of theatre-makers see concerns for the marketing of their performances as part of the process of running a company, rather than as inhibitions to their artistic autonomy. The same goes for financial issues: making sure a company is financially viable is no longer considered the exclusive responsibility of financial managers but a shared responsibility of the company's management team. So, though attention to industrial and market values certainly has risen over time—in line with the predictions based on the introduction of New Public Management—this need not be a bad thing. It points towards a more 'embedded' vision of artistic autonomy, enmeshing the theatre sector more firmly in society and towards professionalisation of the theatre sector. This changed value perspective does not seem to be reflected in the quantitative outcomes of the discourse analysis that point towards continuity rather than seismic changes.

But this does not reflect all developments. First, it should be noted that the 2013 budget cuts were accompanied by yet another decision: until 2013, artistic criteria were always paramount, and criteria such as entrepreneurship were secondary, only assessed when artistic quality was deemed sufficient. As of 2013, criteria of artistic entrepreneurship and artistic criteria have become equally important. From 2013, these entrepreneurial criteria are assessed by management consulting firms and operate as 'knock-out' criteria: not meeting the management criteria means the theatre company is denied subsidy. Secondly, the quantitative analysis does not indicate the budget cut itself. Although the evidence presented here indicates subsidies were allocated based on a consistent pattern of values, the total budget did decline considerably, impacting the sector. Of 101 performing arts institutions (including all genres, not only spoken theatre) that received structural funding on state level, in 2013, only 52 were still receiving national funding, a further 26 relying on local structural funding. Only 14 companies were still active without structural funding (i.e., receiving project funding or operating commercially), and 9 companies had stopped their activities (Ministerie OCW 2013), a number that, in later counts, rose to 17 (Algemene Rekenkamer 2015). However, this does not tell anything about what these companies were doing.

Dutch theatre policy and crisis

At first glance, the analysis presented in this chapter seems to suggest the Dutch theatre policy system is not in crisis. The stable pattern of values behind subsidy allocations, predominantly based on the inspirational and civic value regimes, which together provide legitimisation for cultural policies across Europe, indicates that the system can pursue its course as it always has without much political

interference. But that only applies to the internal logics of theatre policies. On the level of the system as a whole, political influence is substantial: by determining the total budget available, politics indeed has impact. But there is an older trend in the theatre sector itself: the changing conception of the role of cultural leaders, taking on more responsibilities than just artistic. The wider conceptualisation of the notion of 'expertise' in the evaluations of the Council for Culture, including marketing and educational expertise, is indicative of this new conceptualisation of the theatrical profession, a trend that seems to be an expression of the professionalisation of the Dutch theatre sector rather than the result of policy intervention or austerity measures. And indeed, as expected, the wider values included in evaluations come at the expense of artistic criteria. This trend can be (and, in practice, is) viewed in a positive light: it may allow Dutch theatre to take up a more socially embedded position, making theatre more explicitly relevant to wider audience groups.

However, this analysis does not include information on the reception of theatre in Dutch society. If current political trends are indicative of how the Dutch recognise theatre, the picture may not be so positive. The loss of the self-evident political support for cultural policies points towards a different perception of the role of the government in the arts, and theatre in particular. Indeed, we could see this as a legitimation crisis. The data presented do not point to one particular moment of crisis but rather to a general trend. If we are to pinpoint a crisis moment, this moment precedes the austerity measures of 2013. It is in the early 2000s, when nativism entered the Dutch political scene. How Dutch theatre (or the arts in general) will address the concerns of the nativist perspective may be crucial for the continued existence of Dutch publicly funded theatre and the role the Dutch afford to theatre in society.

Notes

1 These are the so-called *uitgangspuntennotities*: i.e., discussion papers on cultural policy. For the first period (1993–97), no discussion paper was drafted. For this period, the policy document containing the subsidy allocation decisions was used.
2 For each policy cycle, the Council for Culture produces a document with advice on individual subsidy allocations to all cultural institutions that applied for a four-year national subsidy. For this research, only the allocations to theatre institutions are considered. Between 1992 and 2009, the advice documents are extensive as they comprise advice for a large number of decisions (between 111 and 219 individual decisions per cycle). For these cycles, samples of the individual subsidy allocations were taken. As of 2009, the role of the Council for Culture was restricted to allocating resources to the largest theatre institutions and assessing the policy of the National Performing Arts Fund that henceforth subsidises smaller theatre companies and festivals. The council's evaluations of all theatre institutions and of the fund were included in the analysis; a sample was no longer necessary.
3 Some words cannot be assigned to a value regime as they are too generic: e.g., the verb 'to be'. In these cases, the word was assigned to the category 'other' in the computer program. This category was disregarded in the analysis.

 Furthermore, it needs to be mentioned that qualitative descriptions of each document were made as well. Moreover, the words used most frequently in each value regime in each period were identified through the analysis. For lack of space, this information is not provided here, but it was used for the interpretation of the trends found.

4 We should note that the word *raad* (council) was counted as a civic word, making up a relatively large proportion of the civic words in the advice documents (7% to 17%). We deemed this correct, as *council* represents the government in the cultural field, rather than representing the cultural field in public administration. Contrary to what artists wanted, the council has never served as an artists' parliament. If the word is omitted from the calculations, the inspired regime becomes more important than the civic in the advice documents.
5 In fact, participatory observation revealed that, while in meetings, the committee may speak in inspirational terms, the text of the advice is amended by lawyers to use more precise terms, as the advice is open to appeal in court by theatre institutions. Again, this favours the industrial over the inspirational regime.

References

Algemene Rekenkamer. 2015. *Bezuinigingen op cultuur. Realisatie en effect*. Den Haag: Algemene Rekenkamer.
Belfiore, Eleonore, and Oliver Bennett. 2008. *The Social Impact of the Arts: An Intellectual History*. London: Palgrave Macmillan.
Boltanski, Luc, and Eve Chiapello. [1999] 2005. *The New Spirit of Capitalism*. Translated by Gregory Elliot. London and New York: Verso.
Boltanski, Luc, and Laurent Thévenot. [1991] 2006. *On Justification, Economies of Worth*. Translated by Catherine Porter. Princeton, NJ: Princeton University Press.
Edelman, Josh, Louise Ejgod Hansen, and Quirijn Lennert van den Hoogen. 2017. *The Problem of Theatrical Autonomy: Analysing Theatre as a Social Practice*. Amsterdam: Amsterdam University Press.
Gray, Clive. 2007. "Commodification and Instrumentality in Cultural Policy." *International Journal of Cultural Policy* 13, no. 2: 203–215.
Hillman-Chartrand, H., and C. McCaughey. 1989. "The Arm's Length Principle: An International Perspective." In *Who Is to Pay for the Arts: The International Search for Models of Arts Support*, edited by M.C. Cummings, Jr. and J. Mark Davidson Shuster, 43–79. New York: American Council for the Arts.
Hoefnagel, Frans J.P.M. 1992. *Cultuurpolitiek: het mogen en het moeten* [Cultural Politics: Between What One Might and Should Do]. The Hague: WRR [Scientific Council for Government Policy].
Ministerie van OCW. 2013. "Kamerbrief 684554 gevolgen cultuurbezuinigingen." December 1, 2013.
Schrijvers, Erik. 2018. "Cultural Policy at a Crossroads? How the Matthew Effect, New Sociocultural Oppositions and Digitalisation Challenge Dutch Cultural Policy." In *Cultural Policy in the Polder: 25 Years Dutch Cultural Policy Act*, edited by Edwin van Meerkerk and Quirijn Lennert van den Hoogen, 243–264. Amsterdam: Amsterdam University Press.
Van den Hoogen, Quirijn Lennert. 2010. "Performing Arts and the City: Municipal Cultural Policy in the Brave New World of Evidence-Based Policies." PhD diss., University of Groningen.
Van den Hoogen, Quirijn Lennert. 2016. *Tussen tellen en wegen: over de ontwikkeling van de instellingsbeoordeling door de commissies Theater, Jeugdtheater, Dans en Productiehuizen van de Raad voor Cultuur*. Groningen: University of Groningen, Research Centre Arts in Society.
Van den Hoogen, Quirijn Lennert, and Florine Jonker. 2018. "Values in Cultural Policy Making: Political Values and Policy Advice." In *Cultural Policy in the Polder: 25 Years*

Dutch Cultural Policy Act, edited by Edwin Van Meerkerk and Quirijn Lennert van den Hoogen, 107–130. Amsterdam: Amsterdam University Press.

Van Meerkerk, Edwin, and Quirijn Lennert van den Hoogen, eds. 2018. *Cultural Policy in the Polder: 25 Years Dutch Cultural Policy Act*. Amsterdam: Amsterdam University Press.

Winkel, Camiel van, Pascal Gielen, and Koos Zwaan. 2012. *De hybride kunstenaar: de organisatie van de artistieke praktijk in het postindustriële tijdperk* [The Hybrid Artist: the Organisation of Artistic Practice in the Postindustrial Era]. Den Bosch/Breda: AKV/ St Joost (Avans Hogeschool).

Winsemius, Aletta. 1999. *De overheid in spagaat: theorie en praktijk van het Nederlandse kunstbeleid* [Government Doing the Splits: Theory and Practice of Dutch Art Policy]. Amsterdam: Thela Thesis.

7 Crisis in funding policies
The paradox of National Theatres and the dilemma of evaluating theatre in Italy

Livia Cavaglieri

Today, in the second decade of the 21st century, Italy is undergoing a wide-ranging reform of its entire performing arts institutional framework. The rules to allocate public funding to organisations operating in this environment have been drastically reformed, and National Theatres have been established for the first time ever. A general law that will reconfigure the relationship between theatre and the state is also expected. The new funding system expresses a culture of evaluation based on quantitative measurements and algorithms. Using the Italian example, this chapter explores, from a historical perspective, how such a funding tool raises questions about the prevalence of the economic value of theatre. This analysis is also situated within a wider discussion of crisis as a transformational force in the institutional frameworks of 20th-century Italian theatre.

Preliminary notes

This chapter deals with professional, well-established theatre organisations that receive public subsidies granted by the *Ministero per i beni e le attività culturali* (Ministry of Culture), through the *Fondo Unico per lo Spettacolo* (FUS) (Single Entertainment Fund). It does not consider public spending on theatre by regions and municipalities, whose global allocation is difficult to determine because of a lack of up-to-date aggregate data on second- and third-level subsidies.

Subsidised organisations do not strictly coincide with art theatres and not-for-profit companies in Italy. Private theatres and companies are supported as well, given that they can also serve a public function, following the principle of horizontal subsidiarity (i.e., private citizens may directly provide—as individuals, as well as associations—for the collective needs and activities of general interest, thus leaving a subsidiary function to the authorities). Commercial theatre is subsidised, too, albeit minimally. Nevertheless, the significant number of organisations funded by the FUS do not exhaust the picture of contemporary Italian theatre organisations since it does not support many smaller or independent professional theatres and companies.

Facts: a transformation of the performing arts institutional framework?

The reform of the Italian theatre system began in 2013 with a broader legislative act by the then-minister of culture and tourism, Massimo Bray, regarding cultural heritage as a whole and its structural repositioning. The emergency decree prescribes 'urgent dispositions for the preservation, valorisation and relaunch of cultural heritage and tourism'[1] (Decreto-Legge 2013). Its underlying logic is inferable from the eloquent abbreviation *Decreto valore cultura* (cultural value decree). It signifies a radical conceptual shift. We can condense it into a few words: from funding conceived as aid, the aim of which is to support the existence of the cultural offering (this was the traditional stance of Italy and many European states during the 20th century) to funding conceived as a means of development, the aim of which is to support the economic and social value produced by culture (cf. Throsby 2001). On this premise is based the argument that a rationalised exploitation of cultural heritage—considered an essential and stand-alone pillar of sustainable development—might help developed countries emerge from the financial crisis (cf. Pascual 2016).

As far as the performing arts are concerned, *Decreto valore cultura* set in motion two relevant structural actions. In 2014, the subsequent minister, Dario Franceschini, reformatted the regulations used to allocate public funding to the performing arts, with the decree *Nuovi criteri per l'erogazione e modalità per la liquidazione e l'anticipazione di contributi allo spettacolo dal vivo* (New Criteria for Allocation, Settlement, and Advance of Subsidies to the Performing Arts) (cf. Decreto MIBACT 2014). Formally, the decree is a technical act rewriting the rules for financing since it constitutes denominations and categories, providing the institutional framework within which subsidised organisations operate and with which they should comply. Practically, it is much more, as Fabio Donato pointed out while promoting a critical debate among scholars and professionals on the impact of the crisis on the European cultural sector: 'in reform processes, the financial leverage is generally much more efficient than the normative one' (Donato 2014, 10). It is interesting to note that the decree *Nuovi criteri* was not written behind closed doors in the ministry offices: numerous meetings with theatrical unions and associations and representatives of municipalities and regions took place during the entire process. This strategy identifies the act as the product of a multi-stakeholder perspective, even if it did not hinder the furious public debate that followed its announcement.

Moreover, since autumn 2017, two different governments have been working on a general law at the political level: an overall text establishing the juridical principles at the root of public intervention for the performing arts.[2] The final promulgation of the so-called *Codice dello spettacolo* (Code of the Performing Arts) (cf. Legge 2017; Disegno di Legge 2019) is expected within the term of the present parliament (XVIII *Legislatura*, from 23 March 2018) while the government has already published the first Italian law on cinema and is amending the existing *Codice dei beni culturali e del paesaggio* (Code of the Cultural Heritage

and Landscape). That this process is still open and that the *Codice dello spettacolo* is not yet finished does not detract from the overall importance of such a change in national cultural policies. From the foundation of the national state in 1861, the performing arts have never been regulated by a general law, nor has their function in the country as a whole ever been defined. They have been regulated in subordinate matters, however—such as public order, security, and taxation—and, since a first feeble hint in 1921, they have also been financed by a series of acts, pragmatically concentrated on funding mechanisms and comparatively lacking in general principles (cf. Di Lascio and Ortolani 2010). If the bill's provisional text passes, the Italian Republic will declare, for the first time, a commitment to promoting the performing arts 'as an element of development, not only cultural, but also economic' and will recognise their 'educational, as well as socially useful value' (Disegno di Legge 2019).

Crisis: a driver of transformation and a 'super concept' for the theatre of the 20th century and beyond

The recent reform was prompted by the perception of a crisis in the institutional environment of the Italian performing arts. But what kind of crisis are we talking about? Official documents do not dwell on matters of the arts but underline the necessity of overcoming two perceived breaking points: the economic-financial imbalance of the *Fondazioni lirico-sinfoniche* (i.e., class A opera houses) and the unclear juridical situation. The latter pertains, on the one hand, to a confused stratification of fragmented, outdated legislative acts and, on the other hand, to the controversial state-region jurisdiction of performing arts matters, subsequent to the reform of the Italian Constitution in 2001. The first problem concerns only a specific segment of the whole environment, one that represents by far the main interests of the state, according to a policy deeply rooted in the country's identity for centuries. These are the 14 *Fondazioni lirico-sinfoniche*,[3] most of which are beset with structural deficits, with profound consequences for repertoire and working conditions. Traditionally, the *Fondazioni lirico-sinfoniche* receive the bulk of FUS funding, in absolute as well as in relative terms. In 2018, amongst 960 performing arts organisations subsidised in the whole country, the 14 opera houses received 53% of the FUS while 307 theatre organisations received 21% (cf. Osservatorio dello spettacolo 2019, 49). The difference is gigantic and, probably, peculiar to Italy. Critically, while opera is the flagship of the Italian theatrical system, it also hinders the rest of the performing arts system. Not only is robust reform of the governance and management of these institutions needed, but also serious reflection on the competition among the theatre genres.

If we assume a wider historical perspective, accept Reinhart Koselleck's argument that crisis is a 'structural signature of modernity' (Koselleck 2006, 392), and transfer it to the theatrical sphere, we can first observe that *crisis* became a recurring term in the narrative of 20th-century theatre—probably in most European countries, and certainly in Italy. It can even be argued that crisis is a core

concept in 20th-century theatre, with particular regard to its problematic relationship with the public and society. After the boom in theatre consumption during the 19th century—nowadays known as 'the theatrical age' or 'the performing century' (Marx 2017, 1; Charle 2008)—theatre underwent a structural transformation, entering a wider industrialisation process and losing its predominant position in the social and cultural life of Europeans, variably attracted by a gradual but inexorable pluralisation of the entertainment and cultural offerings that we still experience today. There is a long, persisting historical process of redefining the sense and role of theatre in society.

If we apply Koselleck's method of *Begriffgeschichte* (history of concepts), we may also note that the economic theory of the 'cost disease' (Baumol and Bowen 1966) is based on the significant metaphor of illness, in which the acceleration of the income gap between the industrial sector and the performing arts can, in theory, propel theatre to extinction. The semantic field of *crisis* and related words, therefore, seems embedded in the discourse of and about theatre in the 1900s. Indeed, the crisis of theatre could be elevated to the level of a 'historical "super concept" (*Oberbegriff*), with which to analyse the challenges of the century' (Koselleck 2006, 392).

A glimpse into the crisis of funding resources

Theatre crisis and funding are two strictly intertwined concepts. As far as Italy is concerned, the launch of public funding policies in favour of theatre in the 1920s was only partly due to the recognition of its value as an art. For the state, it was much more a reaction to an economic crisis in which labour was a fundamental issue: a dramatic increase of the discrepancy between supply and demand required aid to prevent the theatre as an industry from dying in the midst of an acceleration in the income gap, due to technological innovation and new aesthetic formats (cinema, in the first place). The crisis of theatre was much more complex. According to Silvio D'Amico, the crisis of theatre was that 'it has no more, *in the practice of the stage*, any relation with the spiritual life of the country' (D'Amico 1945, 14; emphasis in original). *Il teatro non deve morire* (*Theatre Must Not Die*) is the title of his book, which expresses the pre-modern conception of crisis, rooted in the fundamental meaning connoted by the Greek term κρίσις ('The concept imposed between stark alternatives—right or wrong, salvation or damnation, life or death'; Koselleck 2006, 358).

Theatre has not died; funding ideologies and policies have continued to evolve over the decades. The amount of financing from the structural actions implemented during Fascism—the *Direzione generale del teatro* (General Directorate of Theatre) was established in 1935—increased. The ideology of theatre as a 'public service', pursued with determination by Paolo Grassi (Grassi 1946), cofounder of the *Piccolo Teatro di Milano*, strengthened the legitimation of public spending for theatre in post-war Italy until the 1980s. While the literature and the debates on reasons for financing theatre have grown dramatically since then, a gradual definancing of the performing arts in general began during the 1990s, due to neoliberal policies, and came to a critical point in 2006 (Figure 7.1).

Figure 7.1 FUS trends from 1985 to 2018: € million in current (unbroken line) and adjusted for inflation (broken line) prices

Source: Osservatorio dello spettacolo 2019, 41

The result of the spending review for the performing arts is that the FUS-to-GDP ratio in the period from 1985 (the year the FUS was established) to 2018 fell from 0.085% to 0.019%. This outcome was produced by factors endogenous to the performing arts environment too. We cannot ignore that, in the 1990s, the critique of established theatre institutions, emerging since the end of the 1960s, came to a breaking point. A major crisis of the 'supra-individual functionality' (Balme 2014, 43–44) of the *Teatri stabili pubblici*[4] broke out, as the post-war generation of theatre directors without heirs apparent vanished from the scene. At the same time, the avant-garde scene was flourishing, but it was thoroughly marginalised by the FUS and could count only on regional and local funding.

Regarding the very recent past, public expenditure in this field has been legitimated, at least for now. Since 2014, despite this enduring negative trend for the performing arts, the allocation to theatre has been increased and safeguarded (Figure 7.2).

Analysis: the new funding system for theatre

Instead of discussing this definancing trend in a country whose Ministry of Culture has one of the lowest budgets in the European Union, I will instead focus on the core of the *Nuovi criteri* decree: i.e., on funding policy and its mechanisms. The act came into force in 2015, but because of specific criticism expressed by organisations, and even several appeals against it, some paragraphs were amended in 2016 and 2017. From this point on, I will refer to the 2017 version (cf. Decreto MIBACT 2017).

Rooted in the concept of economic development, the decree brings to the fore not only traditional parameters such as the cultural relevance and activity dimension of the organisations, but also audience response, efficiency, self-financing ability, and managerial regularity (cf. Hinna, Minuti, and Tibaldi 2015, 32). The decree governs the allocation of subsidies for a triennium and is therefore conceived as a three-year renewable act. This is already a significant and positive novelty in terms of planning activities since subsidies were previously allocated annually.

An analysis of the decree, even if brief, needs some detail, apparently tedious but, in reality, meaningful. Subsidies are granted according to a three-step mechanism. First, the decree identifies the categories under which applicants must submit their requests, depending on the prevailing activity and a combination of characteristics. Every application is checked by the Office of the General Directorate of Performing Arts, and its assignment to the category applied for is confirmed or, if considered incorrect, reassigned. After the assignment of categories, the funds are allocated using a computational method based on the principle of peer evaluation. Organisations are split into homogenous clusters by means of an algorithm; a maximum of three clusters is fixed for every category. The goal of the cluster system, as one of its developers notes, is 'to assure the most reciprocity between the quantity of planned activity, the quality of the projects, and the received grant'

Figure 7.2 Funding allocation in favour of theatre from 2006 to 2018: € million in current prices (unbroken line) and adjusted for inflation (broken line)

Source: Osservatorio dello spettacolo 2019, 71

within an environment where organisational heterogeneity is very high (Hinna, Minuti, and Tibaldi 2015, 38). Finally, organisations are evaluated inside the cluster, following three parameters—quality, quantity, and indexed quality—assessed through a highly segmented set of indicators. Quality is based mainly on artistic issues and described in the triennial activity project submitted, in connection with the strategic objectives expressed in the decree. It is necessary to reach a minimum score in quality; otherwise, the application is rejected. Quantity is intended as the amount of labour employed and the number of performances given/hosted in relation to the number of attendees (admission-free performances—so common in modern urban performance—are not considered). Indexed quality considers qualitative elements that can be expressed in numbers: development of territory activities, employment of venues, development of the audience, fundraising, employment of young artists, and internationalisation. If quality, assessed by a subject ranking by a commission of five members (*Commissione consultiva per il teatro*),[5] has an incidence of 35%, quantity (incidence: 25%) and indexed quality (incidence: 40%) are both automatically calculated by an algorithm. In conclusion, 65% of the evaluation is based on mere numbers: the quantities declared by the organisations are automatically processed by algorithms.

The mechanism works for all the performing arts, whose funding allocation and evaluation process is divided into five independent fields: theatre, music (with exception of the Class A opera houses, which are an autonomous field), dance, circus, and multidisciplinary projects. As far as our topic—theatre—is concerned, the decree establishes seven categories (Table 7.1), depending on the prevailing activity (i.e., producing or hosting visiting productions) and on a combination of characteristics (of which mission and business dimension are the most important).

Under a simplified mechanism, the decree also subsidises promotion, touring abroad, and residencies. It is notable that three organisations—the *Piccolo Teatro di Milano*, the *Biennale di Venezia*, and the *Istituto Nazionale per il Drama Antico*—are not involved in this rating system. They receive a guaranteed subsidy as a minimum percentage of the FUS without evaluation: 6.5% of the FUS for the *Piccolo Teatro* and 1% each for the other two. The national schools for theatre and dance may also receive a grant-in-aid.

Table 7.1 Prevailing activities of theatres

Category	Prevailing activity
Teatri nazionali (National theatres)	Resident production
Teatri di rilevante interesse culturale—TRIC (Theatres of significant cultural importance)	
Centri di produzione teatrale (Centres of theatrical production)	
Imprese di produzione teatrale (Touring companies)	Touring production
Circuiti regionali (Regional circuits)	
Organismi di programmazione (Host venues)	Hosting
Festivals	

Impact: general effects of the decree on the theatre system and theatre institutions

The general opinion is that, after the first triennium of enforcement in 2015-17, the decree's concrete impact on the theatrical system has been less than expected, giving grounds for suspicion that the new elaborate procedure had been artificially parameterised on the past. But I argue that, at least on the systemic level, it goes beyond the traditional government strategy, more inclined to incremental innovations than to organic structural reform—i.e., to acknowledge and follow transformations already occurring in the country (Gallina 1990, 48), balancing a top-down approach on the formal institutional level with a bottom-up approach on the concrete organisational level. If, on the one hand, the decree reforms the system by introducing a new field (multidisciplinary projects) and a new category (residencies)—both already experimented with by the professionals committed to new aesthetic techniques and production processes—it becomes, on the other hand, a policy instrument whereby the whole category of *Teatri stabili pubblici* (municipal or regional resident theatres) is eroded and compelled to adapt to the substantial innovation of National and 'Regional' Theatres,[6] as we shall see later.

On the economic level, the decree has governed the effects of the global financial crisis on the theatre system by tightening the selection process: the borders of the map of subsidised theatre have been redrawn and the area narrowed. In the triennium 2015–17, an average of 301 organisations were subsidised while in 2014 (the final year of the previous system), this number stood at 357. Thus, 15% of the previously subsidised organisations lost their grants. Such a result discouraged some organisations from applying for the second triennium (2018-20), and the pressure on central funding relaxed. The government's aim to overcome the crisis by carrying out a more competitive selection to reduce indiscriminate aid and concentrate resources seems to have been attained. The reduction of the grant area was achieved by increasing the degree of activity required to receive aid from the FUS. By 'activity' is meant performances, and the number of performances means labour costs. Such a strategy during a general labour crisis had its effects. The government also expected to stimulate the concentration of theatres and companies, a phenomenon that did not occur, confirming the traditional preference for working on a small scale.

In the past, theatre unions asked for a redistribution of resources according to more internal equity (Hinna, Minuti, and Tibaldi 2015, 33). This goal was probably achieved. If we take a closer look at the subsidised area, we observe that in 2015, 76% of applicants increased their funding in comparison with the previous system (cf. Gallina and Ponte di Pino 2016, 33). More money was available for fewer applicants, given that the FUS amount for theatre did not change from 2014 to 2015 and was increased in both 2016 and 2017. This increase in the single funding amounts is also related to a boost in the requested activity: organisations are pressed to produce and host more theatre, according to efficiency principles.

The decree also operated successfully in the area of so-called external equity (Hinna, Minuti, and Tibaldi 2015, 33), that is the relationship between funded and

not-funded organisations. It rejuvenated the grant area by introducing facilities for first applications and applicants under 35. The result in 2015 was that 11% of the subsidised organisations were first-time recipients or had at least 50% of their employees aged under 35 years (cf. Gallina and Ponte di Pino 2016, 37); previously, there were virtually no such cases, and the system was considered to be locked in.

The paradox of National Theatres

Despite the productive effects, some not-incidental aspects of the decree nonetheless point to symptoms of a still-unresolved crisis (cf. Donato 2014). I will concentrate first on National Theatres. Italy has no tradition of such institutions, unlike the majority of European countries, where 'national theatres are facing enormous challenges as they seek to adapt to changing social, cultural, and economic conditions' (Wilmer 2008, 1). Attempts, projects, and discussions appeared immediately after reaching nationhood, but the absence of a homogenous national identity did not help (cf. Cavaglieri 2018). The *Nuovi criteri* decree creates National Theatres *ex nihilo*. This a critical point as I want to demonstrate that the original aim of relaunching the theatre system is endangered by a poor, inconsistent legislative measure.

The category of National Theatres is established by a ministerial decree, while it is self-evident that it should have been a law of the republic, both because of the adjective they bear and because they are be expected 'to represent the apex in production standards and artistic creativity within the country, as well as reflecting the legacy of national theatre traditions' (Wilmer 2008, 1). Secondly, the decree does not designate the institutions considered national but leaves to the *Commissione consultiva per il teatro* the heavy responsibility of appointing them from amongst the applicants as an ordinary step of the funding mechanism previously described. In 2017, only the *Piccolo Teatro* requested and obtained the status of National Theatre by right.[7] The label of National Theatre is a temporary one that expires every three years. National Theatres may lose their title, as happened when the Teatro Stabile del Veneto and the Teatro della Toscana both lost their status in the 2018–20 funding period (Table 7.2).

Table 7.2 National Theatres

	2015–17	*2018–20*
Piccolo Teatro di Milano	•	•
Teatro Stabile di Torino	•	•
Teatro Nazionale di Genova		•
Emilia Romagna Teatro	•	•
Teatro di Roma	•	•
Teatro Stabile del Veneto	•	
Teatro della Toscana	•	
Teatro Stabile di Napoli		•

Can there be any 'implicit, and symbolic, responsibility tied to the adjective "national"' (Argano 2019, 222) for short-term 'national' institutions? National Theatres are elliptically described as 'organisations that carry out theatrical activity at a prestigious national and international level, with consideration of their tradition and historicity' (Decreto MIBACT 2017). They must primarily meet operating numbers and are 'exposed to an onerous range of objective performance-indicators, particularly burdensome because of their nature as public institutions' (Argano 2019, 222) while their cultural mission and the different functions they should carry out remain unwritten. Evolved from a concept of municipal and regional theatre houses, underfinanced, devoid of a permanent actor ensemble, and lacking a large and unquestionable national dramatic repertoire, the newborn Italian National Theatres have to face a start which resembles a half legitimation of their existence, one which may or may not be resolved by the expected Code for the Performing Arts. Interestingly, the establishment of National Theatres coincides with the impotency of politics to invent a systemic and credible vision of theatre.

Crisis in evaluating theatre institutions

As we have seen, the funding system's new evaluation methodology clearly expresses a culture of rating based on the prevalence of quantitative measurements and on algorithms. This trend is particular neither to Italy nor to theatre; it is linked to a general transnational economic approach to cultural institutions and to a rising recourse to methods of accountability in public expenditure, accelerated by technological innovations, the possibilities fostered by the Big Data revolution, and the related general mathematical turn to algorithms. But mathematical models are cultural models, and evaluation models can easily become governing models (cf. Van Haken 2017).

By taking into account a survey of the reform process published by insiders, we can obtain a deeper understanding of the matter. The survey stresses how 'the *relevance* and the *urgency* of the process of the FUS reform can be better appreciated if contextualized inside the broader project of reform of the Italian Public Administration' (Hinna, Minuti, and Tibaldi 2015, 24; emphasis in original). In other words, it shifts the focus from the performing arts to the public administration. The issue of ensuring transparency, accountability, and objectivity in an impartial evaluation, at the core of the new method, is targeted first to reverse the former mechanism, which was based on a much simpler system in which quality was a multiplier—from 0 to 3—of quantity. While today, the commission's subjective assessments influence the final result at 35%, until 2014, the commission could affect it up to 300%. The aim of reducing the excessive power of human ranking in the preceding commissions is clear and understandable. However, it is also clear that this goal has dramatically shaped the decree, so it can be argued whether the core of the reform is still the performing arts.

The rhetoric of the impartiality of numbers points to artistic quality in the *Nuovi criteri* decree being an incidental question. Quality involves what David Throsby

called the cultural value (Throsby 2001) in a book that suggests how essential it is, for cultural goods, to take into consideration both the economic and the cultural value. The difficulties in analysing and evaluating cultural value don't reduce the importance of the latter. It is revealing, then, that the survey doesn't consider the lively global debate on the adequate use of systematic measurements in the arts. Assessing the quality (and sometimes even the quantity, as indicators based only on the number of visitors to museums have shown; cf. Santagata 2014, 106) of cultural goods is an open challenge in today's Europe, where a frontier is the accurate measurement and evaluation of intangible goods such as the performing arts. As it is undeniable that funding legitimation will pass more and more through formal evaluation systems conceived far from the theatre environment, something of an impasse has been reached when it comes to fostering a reform without seriously engaging with the specificity of the performing arts sector and the features of producing and consuming immaterial cultural goods.

The *Associazione Generale Italiana dello Spettacolo* (General Italian Association for the Performing Arts and Cinema) (AGIS)[8] is stuck in a similar deadlock, as became clear during ministerial meetings promoted to modify some critical paragraphs in the first version of the decree. Because of widespread discontent regarding the low percentage of the qualitative criterion, the ministry offered to raise the parameter value (originally 30%) to 40%. In the end, the proposal was rejected by AGIS and the value increased only to 35%. Such an unforeseen outcome has to be put in context. Quantifiable indicators mainly express the economic value of theatre and generally reward big, historical, expensive institutions. These represent the powerful wing but are not immune to the commercialisation of the theatrical offerings, with minimal impact on new aesthetics and a failure to capture the attention of younger generations. Perhaps a solution to the crisis of theatre in Italy, as elsewhere, lies in the implementation of policies courageous enough to tip the scale in favour of smaller, younger organisations, committed to creating new formats and uses of theatre beyond the modernist black-box scene rather than preserving a historical and numerical supremacy.

Notes

1 Translations into English from Italian sources are my own.
2 The Italian Republic considers performing arts (*spettacolo dal vivo*) as theatre (spoken theatre, puppet theatre, street arts, performance), music (opera and classical music), popular music, ballet and dance, circus, multidisciplinary events, historical carnivals, and commemorations—the latter being a much-debated new entry since 2017.
3 The 14 opera houses are Teatro Petruzzelli (Bari), Teatro Comunale (Bologna), Teatro Lirico (Cagliari), Teatro Maggio Musicale Fiorentino (Firenze), Teatro Carlo Felice (Genova), Teatro alla Scala (Milano), Teatro San Carlo (Napoli), Teatro Massimo (Palermo), Teatro dell'Opera (Roma), Accademia Nazionale di Santa Cecilia (Roma), Teatro Regio (Torino), Teatro Lirico Giuseppe Verdi (Trieste), Teatro La Fenice (Venezia), and Arena (Verona).
4 The emergence of the *Teatri stabili pubblici*, resident municipal theatres founded after the exemplum of the *Piccolo Teatro di Milano* in 1947, was a radical innovation in the history of Italian theatre. A new concept of permanent public theatre was established

after commercial touring companies had prevailed for four centuries. Not only was it an institutional and political achievement; a new model of theatricality was developed as well. Theatre was transformed into an art form. Following the modern direction in Europe, the creative figure of the director was introduced and imposed against a tradition based on actor-managers and actor-creators. Differently from other European countries, no repertory system and no fixed companies were achieved by *Teatri stabili*. Radically changed in their aesthetics, touring companies are still a fundamental production pillar in Italy today.

5 Chaired by Lucio Argano, the commission itself has been critical of the decree and drew up a useful commentary at the end of the first year of mandate (cf. Commissione Consultiva Teatro 2015). The members of the commission receive no emolument.
6 The 17 *Teatri stabili pubblici* have been redefined as *Teatri Nazionali* or *Teatri di Rilevante Interesse Culturale* (TRIC), the main differences being the dimension and the (national or regional) territory they are expected to operate with respect to.
7 Yet the complete appellation *Piccolo Teatro di Milano—Teatro d'Europa* states that its identity is much more rooted in its municipal origins and in the later struggle for a European theatrical culture, as demonstrated by the founding of the *Union des Théâtres de l'Europe*.
8 AGIS is the confederation of the show entrepreneurs, joined by over 30 national professional associations.

References

Argano, Lucio. 2019. "I Teatri Nazionali in Italia: quale ruolo, quali prospettive." *Economia della Cultura*, no. 2 (June): 221–231.
Balme, Christopher B. 2014. *The Theatrical Public Sphere*. Cambridge: Cambridge University Press.
Baumol, William J., and William G. Bowen. 1966. *Performing Arts: The Economic Dilemma: A Study of Problems Common to Theater, Opera, Music and Dance*. New York: The Twentieth Century Fund.
Cavaglieri, Livia. 2018. "Memoria e Stabilità: i racconti della costruzione del teatro pubblico italiano." In *Fonti orali e teatro. Memoria, storia e performance*, edited by Donatella Orecchia and Livia Cavaglieri, 137–146. Bologna: Dipartimento delle Arti e ALMADL- Area Biblioteche e Servizi allo Studio. Accessed June 1, 2020. http://amsacta.unibo.it/5812/.
Charle, Christophe. 2008. *Théâtres en capitales. Naissance de la société du spectacle à Paris, Berlin, Londres et Vienne*. Paris: Albin Michel.
Commissione Consultiva Teatro. 2015. *Relazione. Il decreto del 1° luglio 2014: il lavoro della Commissione Teatro nel primo anno di applicazione, con alcune raccomandazioni e proposte di modifica del provvedimento*. Accessed June 1, 2020. www.ateatro.it/webzine/wp-content/uploads/2015/12/Relazione-finale-Com_Teatro_anno-2015_def.pdf.
D'Amico, Silvio. 1945. *Il teatro non deve morire*. Rome: Edizioni dell'Era nuova.
Decreto-Legge. 2013. *Disposizioni urgenti per la tutela, la valorizzazione e il rilancio dei beni e delle attività culturali e del turismo*. no. 91, August 8.
Decreto MIBACT. 2014. *Nuovi criteri per l'erogazione e modalità per la liquidazione e l'anticipazione di contributi allo spettacolo dal vivo, a valere sul Fondo unico per lo spettacolo, di cui alla legge 30 aprile 1985, n. 163*. July 1.
Decreto MIBACT. 2017. *Criteri e modalità per l'erogazione, l'anticipazione e la liquidazione dei contributi allo spettacolo dal vivo, a valere sul Fondo unico per lo spettacolo, di cui alla legge 30 aprile 1985, n. 163*. July 27.

Di Lascio, Antonio, and Silvia Ortolani. 2010. *Istituzioni di diritto e legislazione dello spettacolo. Dal 1860 al 2010, i 150 anni dell'Unità d'Italia nello spettacolo*. Milan: Franco Angeli.
Disegno di Legge2019. *Deleghe al Governo per il riordino della disciplina in materia di spettacolo e per la modifica del codice dei beni culturali e del paesaggio*. no. 1312, May 29.
Donato, Fabio. 2014. "A che cosa serve il FUS?" *Economia della Cultura*, no. 3–4 (August–December): 407–420.
Gallina, Mimma. 1990. *Teatro d'impresa, teatro di Stato?* Turin: Rosenberg & Sellier.
Gallina, Mimma, and Oliviero Ponte di Pino. 2016. *Oltre il decreto. Buone pratiche tra teatro e politica*. Milan: Franco Angeli.
Grassi, Paolo. 1946. "Teatro, pubblico servizio." *Avanti!* April 25, 1946, 2. Republished in *Il coraggio della responsabilità. Scritti per l'"Avanti!" 1945–1980*, edited by Carlo Fontana and Valentina Garavaglia, 2009, 192–195. Milan: Skira.
Hinna, Alessandro, Marcello Minuti, and Angela Tibaldi. 2015. "Organizzazione, principi e strumenti del nuovo sistema di finanziamento statale ai progetti per lo spettacolo dal vivo." In *Il nuovo decreto per le performing arts: una prima guida per gli operatori*, edited by Alfonso Malaguti and Camilla Gentilucci, 24–52. Milan: Franco Angeli.
Koselleck, Reinhart. [1982] 2006. "Crisis." Translated by Michaela W. Richter. *Journal of the History of Ideas* 67, no. 2 (April): 357–400.
Legge. 2017. *Disposizioni in materia di spettacolo e deleghe al Governo per il riordino della materia*. no. 175, November 22.
Marx, Peter W. 2017. "Cartographing the long nineteenth century." In *A Cultural History of Theatre V*, edited by Peter W. Marx, 1–32. London: Bloomsbury.
Osservatorio dello spettacolo/MIBACT, ed. 2019. *Relazione sull'utilizzazione del Fondo Unico per lo Spettacolo e sull'andamento complessivo dello spettacolo (anno 2018)*. Rome: Gangemi.
Pascual, Jordi. 2016. "Culture as a pillar in sustainability: the best is yet to come." *Economia della Cultura*, no. 4 (December): 557–572.
Santagata, Walter. 2014. *Il governo della cultura. Promuovere sviluppo e qualità sociale*. Bologna: Il Mulino.
Throsby, David. 2001. *Economics and Culture*. Cambridge: Cambridge University Press.
Van Haken, Mauro. 2017. "Una cosmologia di procedure. Per un'etnografia delle culture della valutazione e della loro seduzione autoritaria." In *Università critica. Liberi di pensare, liberi di ricercare*, edited by General Intellect, 91–105. Effimera-Il: Lavoro Culturale.
Wilmer, Stephen E., ed. 2008. *National Theatres in a Changing Europe*. Basingstoke: Palgrave Macmillan.

8 The theatrical employment system in crisis?
How working conditions are changing in theatre and elsewhere

Axel Haunschild

Introduction

This chapter draws on recent research in the field of work and employment studies and asks how shifts in other spheres of employment map onto current practices in the performing arts. It shows that developments such as immaterial labour, the predominance of project-based work, and concepts such as boundaryless careers (Arthur and Rousseau 1996) and the creativity and authenticity imperatives (Reckwitz 2018; Fleming 2009) are already fixtures of theatrical labour markets. In the last two decades, work and organisation studies have therefore increasingly referred to the so-called 'creative industries' in order to study the effects contingent and project-based work, as well as flexible and highly competitive labour markets, have on individuals and organisations. In this chapter, I seek to relate these debates to the institutional crisis in European theatre, with a focus on the German repertory and independent theatre. The theatrical institutional crisis as analysed in this edited volume comprises enculturation breakdown, a pluralisation of the public sphere, increasing heterogeneity in models of labour, and the emergence of new aesthetic techniques and production processes. The chapter addresses the labour dimension of this crisis, which has its roots in theatrical working conditions—conditions that have never been particularly favourable for workers but that have become even worse, starting in the late 1980s. More recently, an increasing awareness of and public debate about theatrical working conditions has been prevalent. At the same time, business organisations as employers seek to adopt forms of work organisation from the creative and cultural sector in order to foster creativity, innovation, agility, and flexibility. This noticeable convergence of work practices in theatre and the labour market as a whole raises the question of whether this development is more likely to foster or to mitigate theatrical institutional crises.

The chapter is structured as follows. First, an overview is given on how work and working conditions have been changing in the world of work in general, highlighting marketisation and its ambiguous demands of workers. In the creative industries, such developments started much earlier, and research on artistic labour markets has come up with some general characterisations of artistic working conditions. In a next step, the German theatrical employment system is introduced

from an institutionalist perspective. Based on qualitative empirical studies conducted by the author, the role of a shared lifestyle of theatre workers, oriented towards bohemian ideals, is illustrated. Recent changes in working conditions and employment relations in theatre are then analysed by taking a closer look at labour market entry, artistic traditions, economic pressure since German reunification, and developments towards work intensification and self-optimisation. By bringing these developmental paths together, I finally discuss the prevalent convergence of work practices in theatre and the labour market as a whole against the background of debates on theatre institutions in crisis.

Changing world(s) of work

Work has not changed for everybody, and, where it has changed, developments are heterogeneous, multifaceted, and sometimes contradictory. Nevertheless, some broad trends can be identified, and some diagnoses from the social sciences help to explain directions and paths of a changing world of work. More recently, digitalisation has sparked broad debates about the future of work (and society as a whole).

As early as in the 1980s, the Fordist model of mass production, linear organisational careers, bureaucratic work norms, standard employment relationships, and steep hierarchies came under pressure. More flexible forms of production (Piore and Sabel 1984) and workforce management (Atkinson 1984; Pollert 1988) emerged and were debated. These forms were not historically new, though, as flexible and project-based forms of production in the pre-Fordist phase of industrialisation show, but they challenged the existing Fordist model of work organisation. At the same time, a broader movement towards the humanisation of work life developed, seeking to overcome the negative sides of alienating and deskilling Taylorist work organisation. Since then, and accelerating since the 1990s, a broader trend has been to promote a market logic in labour policy (also driven by EU policy) as well as within and between organisations. Market-based forms of coordination have a significant impact on labour market regulation (deregulation, rise of contingent work arrangements, workfare systems that supersede traditional welfare systems), interfirm collaboration (strategic networks, supply chains, outsourcing), and intra-organisational management (pay for performance, profit centres, indirect control through performance indicators). Working in a self-organised manner on projects with a defined outcome, financial and time budgets, and a temporary team has also become central to most of today's workers. Demands of workers have changed significantly, from being servile and internally career-oriented occupational and organisational members towards being 'entreployees' (Pongratz and Voß 2003), working self-organised, self-marketing, and optimising one's skill set to maintain employability (Garsten and Jacobsson 2004). Rather than adapting oneself to explicit external control, such workers tend to internalise the market logic and regard themselves as the objects of self-optimisation (Storey, Salaman, and Platman 2005).

Boltanski and Chiapello (2005) offer a much-debated explanation of these developments. They argue that capitalism is not just able to react to a social

critique of exploitation by developing social welfare systems but has also been able to integrate an 'artistic critique' of managerial and bureaucratic organisational structures that inhibit self-actualisation, creativity, and autonomy. The 'new spirit of capitalism' values exactly this: flexible individuals who work on projects and in networks; avoid stability and routines; and are active, entrepreneurial, adaptable, marketable, and polyvalent (Garsten and Haunschild 2014). Work in such a post-industrial (or post-Fordist) regime is more characterised by informational and immaterial labour than by physical labour (Hardt and Negri 2000), and it is organised by activity in networks within and across organisational boundaries (Castells 1996)—boundaries that have become blurred and subject to continuous negotiation and re-definition (Marchington *et al.* 2005). Against this background, current management strategies aimed at a more agile, less hierarchic organisation and a 'new mindset' of self-organised creativity, such as design thinking, scrum, or lean start-up, come as no surprise. Cross-functional temporary teams, innovation labs, co-working, and start-up challenges interestingly resemble, in part, a way of working that is typical for the performing arts (Caves 2000).

Whereas creativity, flexibility, and agility have, at least for contemporary managers and politicians, a positive connotation, precariousness has not. The standard employment relationship, full time and open ended, is still around but has lost its dominance due to an increase in atypical employment (Stone 2012) and contingent work, respectively. Atypical employment (temporary agency work, fixed-term contracts, part-time employment) is not precarious as such but regularly is accompanied by low wages (e.g., in the service sector and low-skill industrial work). A new dynamic of labour market segregation has been prompted by digitalised labour: e.g., platform work, in which platform organisers deny employer status and tasks—physical or digital—are allocated to self-employed workers as (physical or virtual) 'workplace vagabonds' (Garsten 2008) by algorithms (Kirchner and Schüßler 2018). Precarious work, which entails a high degree of insecurity regarding pay and working hours as well as uncertain status achievement and retention (Greer 2015), is widespread in artistic labour markets (as further outlined in the next section).

For workers, recent changes in the world of work are ambiguous and can be evaluated either historically, in contrast with Fordism or times before, or from a normative standpoint that is based on a common understanding of what good or bad work is and what it is not. In comparison with a Fordist work regime, work today (when neo-Taylorist and casual labour are disregarded) is characterised by more freedom, creativity, self-organisation, teamwork, networking, continuous learning, flexibility, challenges, self-actualisation, and perhaps even fun. The other side of the coin is work intensification, flexibility and creativity as imperative, market pressure, indirect control, permanent organisational change and optimisation, contingent work arrangements, and a lack of solidarity due to individualised market transactions. The combination of these attributes of today's work seems to contribute to high psychological strain and stress, resulting in an increasing number of diagnosed psychological illnesses (roughly doubled in Germany since 2000; Meyer, Maisuradze, and Schenkel 2019; www.wido.de/).

Artistic labour markets

The conditions of working as an artist (in the visual or performance arts, music, or literature) change as societies and work in general are changing. The arts and cultural industries are also heterogeneous, consisting of more individual (writing, painting, composing) and collective (bands and orchestras, performance ensembles) forms of production, embedded in art worlds as social spheres (or fields) characterised by certain institutions, practices, and actors (galleries, critics, awards, schools, media, etc.) (Becker 1982; Bourdieu 1993; Caves 2000; Jones 2002). Despite this diversity of art worlds and artistic production processes, there is a broad literature on artistic labour markets, which seeks to identify common features of the arts as an area of work and employment, demand and supply, production, sales, and consumption. Such a perspective is, again and again, criticised by artists and humanities scholars for neglecting what art is all about at its core. However, as this edited volume shows, there is also a growing openness in the humanities, and theatre studies in particular, to a social science perspective on the arts.

Artistic labour markets are, foremost, typified as markets in which labour supply exceeds labour demand significantly. It is beyond the scope of this chapter to analyse the roots of this mismatch, but these certainly include the social construction of talent, a bourgeois appreciation of self-actualisation, and the societal division of paid und unpaid labour. This oversupply results in a 'pool of talent' (Throsby 2001), which is much larger than the number of paid jobs, and artists' income is lower than that of occupational groups with similar levels of education ('starving artist syndrome'; Filer 1986). Multiple-job holding is therefore prevalent in the arts (Menger 1999; Throsby and Zednik 2011) and also in the media industry (Dex et al. 2000). The tense labour market, together with continuous evaluations of talent, artistic skills, and creativity, imply immense barriers at labour-market entry. Whereas some benefit from 'early career effects' (a quick entry directly from often-elite schools, followed by a steep career), many others never achieve full entry into the labour market, which leads to highly competitive 'entry tournaments' (Marsden 2011). In some arts markets, including the film industry but less in theatre, only small variations in talent combine with superstars obtaining extreme remuneration, fame, and popularity ('winner-takes-all markets'; Rosen 1981).

The labour process in the arts is less a topic for labour market economists than for critical social science scholars who study creative labour or industries (e.g., McKinlay and Smith 2009; Hesmondhalgh 2007). What I have highlighted here as elements of a post-Fordist work regime and the new spirit of capitalism have long been typical for artistic and creative work: project-based work, trans-organisational careers, permanent performance evaluation (reputation) within social networks, contingent work arrangements, and idiosyncratic and informal human resource management practices, as well as a high degree of self-marketisation and self-economisation. 'You're only as good as your last job' (Blair 2001), and 'Doing the work is fun. Finding the work is the job' (Randle and Culkin 2009, 101), quotes

from the film industry, illustrate how a project- and network-based employment system requires continuous effort to maintain employability and keep working.

German theatrical employment system

The German theatre has a long-established institutional structure and can itself be regarded as an institution. It originated from royal theatre companies at court and independent citizens' theatres and evolved into a theatre landscape that comprises around 140 publicly funded theatres (for more details, see Eikhof, Haunschild, and Schößler 2012; Haunschild 2003). Nearly all German theatres of artistic relevance are public theatres owned by cities or local states, and the respective local governments subsidise up to 90% of the annual budget (Schmidt 2017). There are also private theatres, but they are of less significant artistic relevance and artistic reputation overall. In addition, there exist some subsidised production houses (e.g., in Berlin, Hamburg, Munich, and Frankfurt) as well as an independent theatre scene, funded partly on an institutional basis but mainly on a project basis. The overall financial volume is much below that of public theatres though.

Germany's public theatres employ a standing group of actors—the ensemble— consisting of approximately 10 to sometimes 40 actors. Theatre artists' employment contracts are fixed-term in nature—usually 12 months—based on a collective agreement between the employer association and the union ('*Normalvertrag Bühne*'). Collaboration is therefore stable due to the ensemble structure but, at the same time, temporary due to project-related teams, external guests joining a production, external directors, and the fluctuation of ensemble members, in particular when theatre managers move from one theatre to another (for details and consequences, see Haunschild 2003). Artistic demands, mobility between theatres, and competition for roles require permanent self-marketisation and networking in order to self-ensure future employment.

In three phases of data collection and qualitative analysis, conducted between 2000 and 2009, Doris R. Eikhof, Franziska Schößler, and I focused on the theatrical employment system with its rules and institutions; the work strains and strategies of theatre artists; and the artists' lifestyle, gender-related working conditions, and career patterns (Haunschild and Eikhof 2009; Schößler and Haunschild 2011). A shared lifestyle that resembled bohemian ideals and values was salient in our second study (Eikhof and Haunschild 2006):

> Theatre artists are flexible, mobile, restless, excessively work-dominated, inconsiderate regarding personal relationships and overtly concerned about employability and their artistic reputation. They rate artistic impact over hierarchical position and artistic reputation over high wages, (net-)work in public spaces (e.g. the theatre canteen or at premiere celebrations) and affirm themselves regularly of their unique- and otherness compared to 'the world out there'.
>
> (Haunschild and Eikhof 2009, 118)

In summarising our findings, we identified five central characteristics of theatre artists' bohemian lifestyle: distinction from bourgeois and middle-class values, devotion to 'art for art's sake', communication in public spaces, artistic perception of work (neglect of economic logics), and subordination of private life to work (Eikhof and Haunschild 2006). These collectively shared perceptual, cognitive, and behavioural patterns enable artists to conflate an artistic logic with a market logic and to match lifestyle with existing contingent work arrangements and even precariousness (for the precarious financial situation of German artists, see Haak 2008).

The market pressures described here are not new to artists. However, beginning in the 1990s, after German reunification, economic strain increased due to budget cuts—in particular in Eastern Germany and in provincial areas—and a further flexibilisation of work (e.g., by substituting ensemble members with freelance artists) could be observed. Furthermore, an increase in performances and the reduction of periods for relaxation between rehearsals and performances has intensified theatrical work. This is also prevalent among technical staff, for whom more and more fixed-term contracts are used and whose workers are required to work more flexibly and beyond traditional occupational boundaries. The theatre artists we interviewed in 2009 emphasised a growing awareness of body fitness and exercising (rather than socialising with colleagues in the theatre canteen) in order to keep up with the physical demands of their intensified artistic work (Schößler and Haunschild 2011). Female actors in particular suffer under a combination of factors that make it difficult for them to get and keep work. Owing to a still-relevant classical repertoire with fewer female roles and more women than men applying to drama schools, entering and staying in the labour market are more competitive for them. A major drawback for female actors still is the implicit, and sometimes even explicit, expectation by theatre managers, directors, and colleagues that acting is a lifestyle choice that includes the absolute subordination of all other dimensions of life to being an artist and producing art. This requirement puts extreme pressure on actresses with children in particular. Once they withdraw from bringing in their whole personality and body fitness for art's sake, they are regarded as less employable because of an alleged lack of unconditional devotion and effort. Consequently, many women drop out of the theatre-based labour market in their mid-30s or early 40s, which is also when attractive roles become scarce.

In sum, perpetuated aesthetic body and gender norms, as well as labour market characteristics and economic pressures, shape and reproduce working conditions and career prospects that are disadvantageous for women performers in particular (see also Dean 2005; for new media work, Gill 2002). Since these working conditions and career prospects are still based on an artistically legitimised labour demand, they resist change. Theatre artists, it seems, still cannot expect their employers to consider individual social needs in their artistic hiring and casting decisions.

In independent theatre, with its often less traditional aesthetics and more collaborative forms of production, gender and role stereotypes are less prevalent. However, economic strain is even higher than in the state-funded theatres, which

mostly receive annual subsidies rather than project-based funding based on competitive application procedures. Some regard independent theatre as the more creative, 'free', and experimental context for performance arts in comparison to public repertory theatres with more or less stable ensembles (see also Eikhof 2009). There is a certain political pressure on public theatres to collaborate more with independent theatres and to overcome milieu closure by integrating larger parts of society into their production processes. Independent theatre groups seek such collaborations, too, and specific funding can support the involved collaboration partners. Whereas some regard this as the combination of the strengths of two worlds, others criticise an ongoing erosion of working standards from bringing the precariousness of independent theatre into public theatres.

Conclusion: convergence and crisis

Is the German theatrical employment system in crisis? In the previous sections of this chapter, I sought to identify major general trends in the world of work as well as characteristics of and changes to theatrical work and employment. The project-based nature and the temporariness of labour contracts are not new to theatre artists. However, in the last three decades, work has become (even) more precarious, more intense, more market driven, more competitive, and thus more self-exploitative. These developments affect not just artists in a narrower sense but also coordinating and administrative roles and technical staff.

A crisis from an employer perspective could be that skilled labour is structurally in short supply. This is obviously not the case in theatre, despite comparably low pay, high work intensity, and precarious working conditions. The intrinsic motivation, the meaning of work, and the lifestyle-related status of being a theatre artist still seem to outweigh existing working conditions. This analysis falls short, however. Some years ago, Franziska Schößler and I concluded that discrimination against female artists is deeply rooted in institutional theatrical structures and legitimised by artistic freedom and (traditional and claimed) artistic inevitabilities (Schößler and Haunschild 2011). We presumed that such structures are very difficult to change, in particular from within the employment system itself. This is aggravated by the fact that solidarity and collective political action has been uncommon among theatre artists due to an individualised labour market with tight competition, strong hierarchical structures within theatres, fixed-term contracts, dependency on theatre managers' (often informal) hiring and casting decisions, and an artistic habitus that denies the role of the dependent worker in need of protection. Overall, there has been a lack of voice and participation in the theatrical workplace, maintaining a structural antagonism and power asymmetry that is in sharp contrast with working together in an ensemble. These structures of power and domination were major reasons that the independent theatre scene emerged as early as in the 1960s.

The last five or so years have brought about significant changes though. In 2013, the 'art but fair' initiative went online with a forum in which performing artists and musicians could upload their precarious, unfair, or even humiliating

experiences with employment contracts or contracts for work. The initiative has since developed into a network and a collective voice for the respective artists. In 2014, the annual conference of the Dramaturgs' Association (DG), which unites theatre practitioners from all German-speaking regions, was held under the general theme of Life, Art and Production: How Do We Want to Work? In 2015, the Ensemble-Netzwerk was founded, which serves as a collective voice for theatre artists and has gained significant member support and public visibility. In 2017, the #MeToo debate sparked public discussions of working conditions in the arts. Recently, in 2018, *Deutscher Bühnenverein*, the employers' association of German theatres, developed and published a 'Value-Based Codex Against Sexual Harassment and Power Abuse' (Deutscher Bühnenverein 2018). Anecdotal evidence from conferences and public discussions also shows that more theatre managers reflect on new leadership styles that integrate models of participation; more formality and transparency of human resource management practices; and social issues such as work-life-balance, equality, and fairness.

What is remarkable about these recent developments is that the established nexus of artistic traditions, hierarchical power structure, and unquestioned self-exploitation for art's sake seems to have been challenged and become open to debate. The #MeToo debate and a growing movement towards collective articulation of theatre artists' precarious work have brought a new dynamic into a highly institutionalised employment system that tends to prioritise artistic norms and traditions over decent working conditions. Are theatres turning into normal employers? This is not just a rhetorical question. When being an arts institution no longer justifies a system in which artists as workers are expected to devote their whole lives to the arts and to accept insecurity combined with high work intensity and relatively low pay, the current system of work and production is under crisis. This is not meant to be a critique of the 'old' or a prospective 'new' system, but an indication that the substantial improvement of working conditions as they are now is likely to entail a fundamental transformation of the theatrical employment system.

The convergence of work practices in the business and cultural sector implies another challenge, or even threat, for theatres. When agility and creation, as well as self-management, wholeness ('bring all of who we are to work'), and organisational purpose (Laloux 2014), become guiding principles of organisations, theatres as traditional manufactories with their hierarchical structures appear to be outdated and less creative and open than they wish to be perceived. For artists, there is also a diminishing distinction when knowledge workers in other industries adopt elements of an artistic (often bourgeois bohemian) lifestyle. One reaction of public theatres to the threat of losing their ascribed role as strongholds of artistic creativity and novelty is to increase collaboration with independent theatres, either by providing their infrastructure for independent productions or by realising joint projects with independent theatre groups. This, however, conflicts with improving theatre artists' working conditions. Whether converging work practices in theatre and elsewhere are more an indicator and driver of crisis or the avenue for overcoming an existing crisis remains to be seen.

References

Arthur, Michael B., and Denise M. Rousseau, eds. 1996. *The Boundaryless Career.* Oxford: Oxford University Press.
Atkinson, John. 1984. "Manpower Strategies for Flexible Organizations." *Personnel Management* (August): 28–31.
Becker, Howard S. 1982. *Art Worlds.* Berkeley and Los Angeles: University of California Press.
Blair, Helen. 2001. "'You're Only as Good as Your Last Job': The Labour Process and Labour Market in the British Film Industry." *Work, Employment and Society* 15, no. 1: 149–169.
Boltanski, Luc, and Eve Chiapello. 2005. *The New Spirit of Capitalism.* London: Verso.
Bourdieu, Pierre. 1993. *The Field of Cultural Production: Essays on Art and Literature.* New York: Columbia University Press.
Castells, Manuel. 1996. *The Rise of the Network Society.* Cambridge, MA: Blackwell.
Caves, Richard E. 2000. *Creative Industries: Contracts between Arts and Business.* Cambridge, MA: Harvard University Press.
Dean, Deborah. 2005. "Recruiting a Self: Women Performers and Aesthetic Labour." *Work, Employment and Society* 19, no. 4: 761–774.
Deutscher Bühnenverein. 2018. "Wertebasierter Verhaltenskodex zur Prävention von sexuellen Übergriffen und Machtmissbrauch." Accessed May 29, 2020. www.buehnenverein.de/de/publikationen-und-statistiken/kulturpolitische-statements/statements.html?det=505.
Dex, Shirley, Janet Willis, Richard Paterson, and Elaine Sheppard. 2000. "Freelance Workers and Contract Uncertainty: The Effects of Contractual Changes in the Television Industry." *Work, Employment and Society* 14, no. 2: 283–305.
Eikhof, Doris R. 2009. "Does Hamlet Have to Be Naked? Creativity between Tradition and Innovation in German Theatres." In *Creativity and Innovation in the Cultural Economy*, edited by Paul Jeffcutt and Andy Pratt, 241–262. London: Routledge.
Eikhof, Doris R., and Axel Haunschild. 2006. "Lifestyle Meets Market: Bohemian Entrepreneurs in Creative Industries." *Creativity and Innovation Management* 15, no. 3: 234–241.
Eikhof, Doris R., Axel Haunschild, and Franziska Schößler. 2012. "Behind the Scenes of Boundarylessness: Careers in German Theatre." In *Careers in the Creative Industries*, edited by Chris Mathieu, 69–87. London: Routledge.
Filer, Randall K. 1986. "The 'Starving Artist': Myth or Reality? Earnings of Artists in the United States." *Journal of Political Economy* 94, no. 1: 56–75.
Fleming, Peter. 2009. *Authenticity and the Cultural Politics of Work.* Oxford: Oxford University Press.
Garsten, Christina. 2008. *Workplace Vagabonds: Career and Community in Changing Worlds of Work.* Basingstoke: Palgrave Macmillan.
Garsten, Christina, and Axel Haunschild. 2014. "Transient and Flexible Work Lives: Liminal Organizations and the Reflexive Habitus." In *Management and Organization of Temporary Agency Work*, edited by in Bas Koene, Nathalie Galais, and Christina Garsten, 35–49. London: Routledge.
Garsten, Christina, and Kerstin Jacobsson, eds. 2004. *Learning to Be Employable: New Agendas on Work, Employability and Learning in a Globalizing World.* Basingstoke: Palgrave Macmillan.
Gill, Rosalind. 2002. "Cool, Creative and Egalitarian? Exploring Gender in Project-Based New Media Work in Europe." *Information, Communication and Society* 5, no. 1: 70–89.

Greer, Ian. 2015. "Welfare Reform, Precarity and the Re-Commodification of Labour." *Work, Employment and Society* 30, no. 1: 162–173.

Haak, Carroll. 2008. *Wirtschaftliche und soziale Risiken auf den Arbeitsmärkten von Künstlern*. Wiesbaden: VS Verlag.

Hardt, Antonio, and Michael Negri. 2000. *Empire*. Cambridge, MA: Harvard University Press.

Haunschild, Axel. 2003. "Managing Employment Relationships in Flexible Labour Markets: The Case of German Repertory Theatres." *Human Relations* 56, no. 8: 899–929.

Haunschild, Axel, and Doris R. Eikhof. 2009. "Bringing Creativity to Market: Theatre Actors as Self-Employed Employees." In *Creative Labour: Working in the Creative Industries*, edited by Alan McKinlay and Chris Smith, 156–173. Basingstoke: Palgrave Macmillan.

Hesmondhalgh, David. 2007. *The Cultural Industries*. 2nd ed. London: Sage.

Jones, Candace. 2002. "Signaling Expertise: How Signals Shape Careers in Creative Industries." In *Career Creativity*, edited by Maury Peiperl, Michael Arthur, and N. Anand, 209–228. Oxford: Oxford University Press.

Kirchner, Stefan, and Elke Schüßler. 2018. "The Organization of Digital Marketplaces: Unmasking the Role of Internet Platforms in the Sharing Economy." In *Organization Outside Organizations: The Abundance of Partial Organization in Social Life*, edited by Göran Ahrne and Nils Brunsson, 131–154. Cambridge: Cambridge University Press.

Laloux, Frederic. 2014. *Reinventing Organizations: A Guide to Creating Organizations Inspired by the Next Stage in Human Consciousness*. Brussels: Nelson Parker.

Marchington, Mick P., Damian Grimshaw, Jil Rubery, and Hugh Willmott, eds. 2005. *Fragmenting Work: Blurring Organisational Boundaries and Disordering Hierarchies*. Oxford: Oxford University Press.

Marsden, David. 2011. "The Growth of Extended 'Entry Tournaments' and the Decline of Institutionalized Occupational Labour Markets in Britain." In *Regulating for Decent Work: New Directions in Labour Market Regulation*, edited by Sangheon Lee and Deidre McCann, 91–120. London: Palgrave Macmillan.

McKinlay, Alan, and Chris Smith, eds. 2009. *Creative Labour: Working in the Creative Industries*. Basingstoke: Palgrave Macmillan.

Menger, Pierre-Michel. 1999. "Artistic Labor Markets and Careers." *Annual Review of Sociology* 25: 541–574.

Meyer, Markus, Maia Maisuradze, and Antje Schenkel. 2019. "Krankheitsbedingte Fehlzeiten in der deutschen Wirtschaft im Jahr 2018—Überblick." In *Fehlzeiten-Report 2019*, edited by Bernhard Badura, Antje Ducki, Helmut Schröder, Joachim Klose, and Markus Meyer, 413–477. Berlin and Heidelberg: Springer.

Piore, Michael J., and Charles F. Sabel. 1984. *The Second Industrial Divide: Possibilities for Prosperity*. New York: Basic Books.

Pollert, Anna. 1988. "The Flexible Firm: Fixation or Fact?" *Work, Employment and Society* 2, no. 3: 281–316.

Pongratz, Hans J., and G. Günter Voß. 2003. "From Employee to 'Entreployee': Towards a 'Self-Entrepreneurial' Work Force?" *Concepts and Transformation* 8, no. 3: 239–254.

Randle, Keith, and Nigel Culkin. 2009. "Getting in and Getting On in Hollywood: Freelance Careers in an Uncertain Industry." In *Creative Labour*, edited by Alan McKinlay and Chris Smith, 93–115. Basingstoke: Palgrave Macmillan.

Reckwitz, Andreas. 2018. "The Creativity Dispositif and the Social Regimes of the New." In *Innovation Society Today*, edited by Werner Rammert, Arnold Windeler, Hubert Knoblauch, and Michael Hutter, 127–145. Wiesbaden: Springer VS.

Rosen, Sherwin. 1981. "The Economics of Superstars." *The American Economic Review* 71, no. 5: 845–858.

Schmidt, Thomas. 2017. *Theater, Krise und Reform. Eine Kritik des deutschen Theatersystems*. Wiesbaden: Springer.

Schößler, Franziska, and Axel Haunschild. 2011. "Genderspezifische Arbeitsbedingungen am deutschen Repertoiretheater—eine empirische Studie." In *Geschlechter Spiel Räume: Dramatik, Theater, Performance und Gender*, edited by Gaby Pailer and Franziska Schößler, 255–269. Amsterdam and New York: Rodopi.

Stone, Katherine V.W. 2012. "The Decline in the Standard Employment Contract: Evidence from Ten Advanced Industrial Countries." *Law-Econ Research Paper*, No. 12–19, UCLA School of Law, Los Angeles.

Storey, John, Graeme Salaman, and Kerry Platman. 2005. "Living with Enterprise in an Enterprise Economy: Freelance and Contract Workers in the Media." *Human Relations* 58, no. 8: 1033–1054.

Throsby, David. 2001. *Economics and Culture*. Cambridge: Cambridge University Press.

Throsby, David, and Anita Zednik. 2011. "Multiple Job-Holding and Artistic Careers: Some Empirical Evidence." *Cultural Trends* 20, no. 1: 9–24.

Part 3
Post-socialism

9 Crisis?
Czech theatre after 1989[1]

Radka Kunderová

To what extent has the 'Velvet Revolution' of 1989 represented a watershed in the course of the developments of Czech society? This issue of (dis)continuity in the pre- and post-1989 situation has been a contentious one in the Czech public debate and intensely discussed—particularly in the early 2010s. Some social historians challenged the prevailing historical narrative of the communist past, a narrative they found 'totalitarian' due to its being based on the binary opposition of the 'evil omnipotent regime' and the 'innocent oppressed society' (esp. Pullmann 2008; Rákosník 2010, 13–15; Pullmann 2011, 15–16). Most controversially, the historian Michal Pullmann proposed a hypothesis that the actual impact exerted by the post-1989 systemic and ideological changes on the value orientation of Czech society—the so-called 'social consensus'—might have been less significant than had generally been held. He suggested the possibility that there might, in fact, have been a much more significant continuity between the communist past and the post-1989 period than had formerly been assumed (Pullmann 2011, 225–227). The dominating Czech political discourse has perceived such opinions as highly controversial since the post-1989 paradigm has construed the events of November 1989 as a radical turning point and conceptualised the post-1989 developments as a correspondingly radical, comprehensive social transformation.[2]

In the field of theatre, the question of (dis-)continuity has not been raised yet, though its answering might fundamentally shape future interpretations of the three post-1989 decades in Czech theatre.[3] In general terms, Czech theatre historiography has devoted only minor attention to the issue of how the 1989 political events influenced theatre and its social relevance. A pioneering,[4] and so far solitary, attempt to provide a coherent interpretation of the post-1989 decade consists of a modest-sized section in the introduction to an extensive chapter on Czech plays of the 1990s written by Libor Vodička, a theatre historian of the 'middle generation' (Vodička 2008). It is symptomatic of the current situation in Czech theatre studies, which have been largely oriented towards older historical periods, that this outline of post-1989 Czech theatre was published in a volume on Czech post-1989 literature produced by an institute of literary studies.[5]

In his text, Vodička conceptualises the situation of Czech theatre after 1989 as a 'crisis of theatre'. His evaluation of the early 1990s strikes one as especially negative coming after a laudatory description of the preceding phase. According to

Vodička, the theatre stage became 'the main scene of the political life in the country' in November 1989, and 'it seemed that the connection of theatre with the society was reaching its apex and that perhaps never before had theatre enjoyed such a highly valued position in the collective consciousness of the Czechs and Slovaks' (Vodička 2008, 555). Herein, the historian embraces the prevailing narrative in Czech theatre historiography, which regards the role of theatre as an essential factor in the 1989 political events. In doing so, Vodička refers to well-known facts, such as the theatre-makers' strike in support of the student protest strike against the Communist Party's policy and the foundation of the country's leading pro-democratic movement, *Občanské fórum* (Civic Forum), under the unofficial leadership of the playwright and activist Václav Havel, at the Činoherní klub (Drama Club) theatre in Prague and its subsequent residence in the Laterna Magica theatre (*ibid.*). Vodička also highlights theatre's political and mobilising functioning within the 'revolution' in a broader historical context—'What was taking place at theatre venues in these "revolutionary" weeks seemed to be a historical consummation of the Czech national programme, in which the theatre culture had been enjoying a sovereign position since the beginning of the nineteenth century' (*ibid.*) Along these lines, he promotes the perspective of viewing the events of 1989 as an apogee of the social role of theatre in the history of the Czech nation, continuing a long tradition in which Czech theatre played a significant role in the building of national identity and the processes of Czech political emancipation.

In contrast, the following years brought, in Vodička's view, a steep decline in theatre's social relevance due to an interplay of several factors, and his interpretation thus implies a significant discontinuity between the developments in theatre prior to and in the aftermath of 1989.

Vodička argues that early-1990s society found itself in 'the first phase of post-totalitarian entropy' and that the theatre did not manage to maintain its pre-1989 'unifying role', losing its 'ability to formulate authentic stances and use them as a means to evolve one of its traditional functions' (Vodička 2008, 557). Moreover, according to Vodička, the 1990s saw the start of a 'crisis of attendance' when 'gradually, the auditoriums emptied out' (*ibid.*). In this respect, he states that in the early 1990s, theatres lost nearly one-third of their spectatorship within just one season (Vodička 2008, 558), although he acknowledges the fact that the decline in spectatorship was a part of a trend in Czechoslovakia and other European countries, which had been felt even prior to 1989, and that the 'revolutionary boom' of theatre in Czechoslovakia was more of a short-term deviation from this prevailing tendency.

A closer study of the statistics Vodička cites when speaking of the audience crisis may, however, offer a more nuanced image of the situation. In fact, the decline in box office numbers was not as severe as he claims. While professional theatres recorded 6,291,000 spectators in 1989, in 1990, the figure was 5,834,000 and, in 1991, 4,584,000, which indicates that the decrease in attendance between 1990 and 1991 amounted to less than one-quarter. Prague theatres—historically considered to have been of the greatest importance—were the least affected by this process (Pištora 1992, 3). Thus, the loss in audience turnout, while surely significant,

was not as radical, swift, and ubiquitous as has been asserted. Moreover, the ebb of audiences did not affect all theatres: even in 1991, ten Czech theatres, both Prague based and regional, recorded 80% to 96% attendance of their performances (*ibid.*). In this light, the claim that 'gradually, the auditoriums emptied out' (Vodička 2008, 557) seems to be rather overexaggerated.

Vodička sees another factor contributing to the 'crisis of theatre' in the 'chaos and inconsistency' and decrease of subsidies coming from state institutions that, purportedly, significantly interfered with theatres' operation (Vodička 2008, 558). Such interventions, as listed by Vodička, included mass denationalisation of theatre companies and putting municipalities and regional authorities in charge of theatre administration, as well as restitutions and privatisation of some of the theatre venues (*ibid.*). He argues that 'Economic reforms early in the decade faced theatres with considerable material insecurity' (*ibid.*) since the post-1989 governments imposed their austerity measures primarily on the field of culture, aiming first to revitalise the economic sector and only then to tend to the needs of culture. Thus, the pressure on theatres to adapt to the adverse economic conditions 'mounted enormously', Vodička argues, and 'In the period of 1991–1996, stringent economic interests gained complete control over all developments in theatre culture' (*ibid.*). In support of his thesis, he mentions discussions taking place in the early 1990s concerning abolition of some of the stable theatre ensembles in order to economise on salaries and the theatres' operation. This scenario, however, never came into effect, and the dense theatre network in Bohemia and Moravia, established already in the post-1945 period, was not just preserved but even grew in the 1990s. There were only a few exceptional instances of theatres actually closing down without being subsequently transformed into a different organisational form or being taken up by another authority or owner (Nekolný 2006, 13). The state, in some cases, even expanded the theatre system, re-establishing several theatres, such as České umělecké studio (Czech Art Studio), the Opera Mozart Theatre, and Černé divadlo Jiřího Srnce (Black Light Theatre of Jiří Srnec) (Nekolný 2006, 12, 15). Simultaneously, the 1990s saw the foundation of a number of commercial theatres, often focusing on musical productions (the 1994 staging of *Jesus Christ Superstar* being the first massive box office hit of this kind). Likewise, new theatres specialising in drama and physical or dance theatre came into being, and, in total, the number of theatre ensembles rose by 10% between 1990 and 1991 (Pištora 1992, 3).

Neither is the argument about the somewhat hostile attitude of the state towards the theatre entirely accurate. The relationship between the state and theatre did, indeed, undergo a significant structural transformation yet, at least in the very early 1990s, the government's motivation was not to release the state from its responsibility for the cultural sphere but to support culture and the arts by providing them with autonomy. This notion was understood as freedom from any ideological obligations towards the state: i.e., liberation from their earlier official role as a propaganda tool in the hands of the Communist Party. Thus, the emphasis on the emancipation of culture from utilitarian social and political roles appears to have been a logical result of the historical development. The supportive attitude

towards culture, and theatre in particular, might also be illustrated by the fact that the first culture ministers—Milan Lukeš and Milan Uhde—were distinguished and committed theatre professionals.

The first post-1989 government, chaired by Petr Pithart, articulated its liberalising mission in its program in 1990:

> We understand education, science, art—the whole of culture—as indispensable attributes of a modern nation, as features of its sovereignty and uniqueness. Natural cultural development is given a free rein by the democratic state, which provides it with encouragement, assistance and guarantee.
>
> The old and misleading question of what kind of culture we need has to be reversed in the sense of full respect for the autonomy of cultural values. Henceforth, we shall ask what our culture wants us to be like, that is, how we can best serve its natural growth.
>
> (*Programové prohlášení vlády* (Government Policy Statement) 1990)

Within the upcoming transformation, the government intended to reduce state subsidies to the segments of cultural life that were considered economically self-sufficient and to subsidise preferentially the areas that would otherwise be incapable of survival. The government was aware of the vulnerable position of culture in the newly forming market economy. This was an additional reason it was willing to seek alternative ways of financing culture, such as foundations whose establishment it intended to support via tax relief (*ibid.*). Indeed, the state took some supportive steps, such as the first grant system established by the Ministry of Culture in 1992 (Nekolný 2006, 15).

Nonetheless, there is validity to Vodička's claim about inconsistencies in state policies vis-à-vis theatres—the early 1990s governments did not provide any tangible strategy for the theatre sphere's transformation (Nekolný 2006, 12), and the framework for establishing a functioning culture within the new market-based economy was not clearly set. Thus, the fundamental share of responsibility was placed on municipalities and regional authorities that could decide what portion of their budgets would be allotted to theatres. Theatre-makers were sceptical about the willingness of these bodies to prioritise theatre over investments in decaying infrastructure (Nekolný 2006, 19). The theatres' financial difficulties were further exacerbated by the austerity measures implemented by the right-wing coalition government chaired by Václav Klaus, elected in 1992 (Nekolný 2006, 13, 31).

Besides the decline in attendance numbers and the state's policy towards theatres, Vodička finds another argument for conceptualising the post-1989 situation in theatre as a 'crisis' in reflections articulated by the people involved in theatre at the time in question. He does so by referring to articles published in the early 1990s in the theatre-oriented press and particularly to the debate on the then-current situation in theatre sparked in 1994 by President Václav Havel at the Villa Amálie and made public on the pages of the magazine *Svět a divadlo* (*World and Theatre*) ("*Od českého divadla*" 1994). The fact that the president of the country

initiated such a debate seems, in itself, to support the claim that the social position of theatre had still managed to maintain a degree of significance. When summarising the opinions gathered from these sources, Vodička speaks of an atmosphere of 'widely experienced crisis of theatre' (Vodička 2008, 560); in his view, theatre was 'wholly focused on itself, the issues of self-preservation and holding on to whatever social position it could' (Vodička 2008, 559).

On re-reading the texts cited by Vodička, however, one comes to realise that the perception of the situation then was, in fact, more varied. Perhaps the majority of theatre professionals shared the view that theatre underwent a substantial change once the 'velvet euphoria' had evaporated, yet only some of them would construe it as a 'crisis'. Those who tended to adopt such a perspective fairly commonly based their opinion on the advancing commercialisation of theatre and its propensity for sensationalist repertoire—and it was these opinions that co-form the basis of Vodička's argumentation. Even some of these critical voices, however, were well aware that this kind of pandering dramaturgy was by no means a brand new trend in Czech theatre and made comparisons to the eclectic, entertaining repertoires of the mid-1960s and even of the late 'normalisation' period in the 1980s (Hořínek 1992, 4). Some related Czech theatre's situation to the overall collapse of the concept of theatre which hoped to provide a critical image of the society and its arrangement (Pistorius in "*Od českého divadla*" 1994, 34) and thus actually undermined the relevance of the post-1989 political and social changes to the position of Czech theatre. Others admitted the existence of certain processes of change in some aspects of the field—in the organisation of theatres, their social position, and their economic situation—but did not observe any substantial change either in theatre's elementary focus and efforts or in its aesthetics (Kraus in "*Od českého divadla*" 1994, 26). Some voices even questioned the existence of any significant change whatsoever. Especially some representatives of the generation of studio theatres, which were aesthetically innovative and politically dissenting in the 1970s and 1980s, emphasised the current resonance of theatre and the ongoing intense interest of the audiences they were experiencing in the city of Brno (Kovalčuk in "*Od českého divadla*" 1994, 27).

Still, the narrative of change seems to have been prevalent within the theatre debate at the time. Could this finding be considered an argument in favour of conceptualising the relationship between the pre- and post-1989 periods in Czech theatre as discontinuous? In my opinion, the views of the contemporaries on the situation surely need to be taken into account, but care should be taken so as not to overestimate their relevance since the contemporaries, being themselves embroiled in the situation, were ill equipped to reflect on the situation from a more impartial, detached vantage point. Moreover, a close reading of their thoughts on theatre's position in the early 1990s and its future prospects reveals significant traces of continuity with the pre-1989 and even pre-1945 decades.

One of the most telling examples is represented by the theatre scholar, critic, and dramaturg Václav Königsmark (1946–96), whose perception of the situation belonged to the most sophisticated and complex contributions: he distinguished processes at institutional, organisational, and aesthetic levels. Königsmark was one

of the most influential and respected critical voices, publishing texts on theatre both in the samizdat and in official media since the late 1970s,[6] and was associated with the studio theatre generation. In August 1990, while summarising his view on the season of 1989–90, he conceptualised the change in theatre's position through the metaphor of the Trojan horse. He argued that whereas the pre-1989 theatre included a 'line of inner resistance, which actually played a role of a Trojan Horse within the diseased society' (Königsmark 1991, 40), after the political shift, theatre's former mission was consummated: 'What to do with a Trojan Horse after a victorious battle? It seems that its past represents a hindrance today: not only has the old mimicry been divulged, but at the same time, it is losing its function' (Königsmark 1991, 46). Thus, he saw the most important change theatre faced at the beginning of the new decade in the loss of the pre-1990 concept of social relevance.

Königsmark identified one of the reasons underlying the 'audience shock' (Königsmark 1991, 44), as he described the decline in spectatorship, with theatre's continuing tendency to appropriate the role of the mass media, even after the 'Velvet Revolution'. The audiences, however, turned their attention towards the news coverage provided by the no-longer-censored media, and, in his opinion, theatres could hardly compete with them. Königsmark, however, did not describe the situation as a 'theatre crisis'—in some contexts, he even understood it as a return to normality. In his view, theatre could finally return to 'communication through a work of art' (Königsmark 1991, 40), which he understood as the natural state of affairs. To keep or regain some degree of social relevance, theatre had better, in Königsmark's opinion, come back to its 'artistic specificity' (Königsmark 1991, 44):

> It is time to realise anew theatre's inherent specificity and apparently also the change in its social function. For its own benefit, theatre should no longer identify with a medium whose function is predominantly communicative: it is, after all, a space of encounters with different qualities, for instance a 'ritual' of sorts, producing cathartic effects.
> (Königsmark 1991, 40)

At the same time, Königsmark considered this 'artistic specificity' to be threatened by the economically unstable post-1989 situation in theatre, which

> is in a quandary: it is seeking its new autonomy amidst an economic struggle for its very existence. Articulated thus simultaneously, these fundamental requirements can put theatre in grave danger; hence it is necessary to create conditions for consistent preference of theatre's artistic concerns.
> (Königsmark 1991, 46)

Thus, Königsmark's vision of theatre's desired position within society clearly revealed his belief in the autonomy of theatre and its artistic specificity. These qualities, in his opinion, excluded any instrumental understanding of theatre— he was therefore opposed to the kind of theatre in which propagandist, communicative, or commercial functions predominated. Consequently, his thinking on

theatre resembles the Prague Linguistic Circle's structuralist theories, which promoted the notion of autonomy of the arts and defined them within a functional paradigm—indeed, Königsmark himself frequently used the term 'function' in 1990 (as may be obvious from the excerpts quoted earlier).

Taking into account the fact that the structuralist thought of the Prague School was suppressed by the communist regime, initially after the 1948 coup and then again in the aftermath of the 'Prague Spring' of 1968, this tendency in Königsmark's writing on theatre in the early 1990s might come across as somewhat surprising. The influence of structuralism, however, can be identified and traced throughout his whole career, which shows that the continuity of the Prague School tradition had been—to some extent—preserved in Czech arts studies, the adverse political pressures notwithstanding. Königsmark, who studied Czech and history at Charles University in Prague between 1964 and 1969, was educated by some of the leading figures of the 1960s wave of Czech structuralism—the literary scholars Felix Vodička and Miroslav Červenka (Kunderová 2015). During his tenure at the Institute of Czech and International Literature of the Czechoslovak Academy of Sciences in Prague in the 1970s and 1980s, Königsmark published a number of studies on Czech theatre history and theatre criticism that employed the structuralist approach in a natural and none-too-explicit manner. His writings on contemporary theatre in particular consistently signal the functional perspective, with an emphasis on the dominance of the aesthetic function within the artistic sphere, an analytical approach, and a continuous interest in the issue of values within the arts and society and their mutual inter-relations.

In the post-1989 situation, the autonomy of theatre and the dominance of the aesthetic function over a theatrical 'work of art' represented for Königsmark a vital condition for its future positive development. In this respect, his concept of theatre's autonomy and social function could be understood in terms of one of the key theories developed within the Prague School—Jan Mukařovský's concept of the aesthetic function (Mukařovský 1936). Mukařovský himself considered autonomy of the arts as a permanent initiator of the contact between a work of art and the natural and social realities (Mukařovský 1936, 70). When considering Königsmark's thoughts from such perspective, his understanding of theatre's social function might be construed as a successful realisation of the aesthetic function. Viewed from the Mukařovskian perspective, theatre would realise a number of diverse functions that the arts generally fulfil in society, such as recreational, representative, and communicative functions. These would, however, be dominated by the 'transparent', energy-like, and protean aesthetic function. And it is precisely for this reason that theatre would be part of the autonomous artistic sphere, within which the aesthetic function subordinates all other functions (Mukařovský 1936, 13), as opposed to other parts of social life, such as fashion, in which the aesthetic function may be present but not dominant. In doing so, theatre would fulfil a very specific social function, which cannot be realised by other means, while at the same time responding to many different needs of society.

Václav Königsmark's thinking is representative of the generations that typically employed the category of theatre's social function in their reflections on the

post-1989 situation. Within the Villa Amálie debate, the voices of these generations dominated the discussion, and it is the opinions of these figures that Libor Vodička, too, mostly refers to in his text. In accordance with Königsmark (who was one of the participants in the debate), the representatives of these older generations mostly noted that the original, pre-1989 function of the theatre had run its course and that theatre needed to reframe its social role so as to find a new 'sense of purpose'. Their thoughts regarding such redefinition were principally rooted in the variety of aesthetic backgrounds that had formed during the earlier decades of the 20th century: in addition to the structuralism of the Prague School in Königsmark's case, their reflections included references to Brecht (Hořínek 1992, 4) as well as to 'modernism', implicitly conceptualised in opposition to 'postmodernism' (Kraus in "*Od českého divadla*" 1994, 26).

It is worth noting, however, that the participants in the Villa Amálie debate did not represent the entirety of the contemporary generational and aesthetic range of the Czech theatre. Most conspicuously absent were the representatives of the generation born in the 1950s and 1960s, whose artistic style had been commonly labelled 'postmodern' ever since their first achievements in the amateur theatre circuit in the mid-1980s. The leading directors of this generation, such as Petr Lébl and Jan Antonín Pitínský, successfully established their positions in the professional theatre during the early 1990s and came to the fore as the most celebrated theatre-makers of the mid-1990s. Therefore, the conspicuous absence of their 'winners' perspective' in the debate—as well as in Vodička's text—merits due attention, particularly with respect to the fact that the 'postmodern' generation's approach to theatre seemed to differ considerably from the older generations' understanding of theatre's functioning in terms of its social role. This division even emerged in the Villa Amálie debate, owing to a contribution made by the theatre critic Karel Král, himself a member of the preceding 'studio-theatre' generation. He shared the sceptical view of the sweeping 'theatre crisis' rhetoric and only acknowledged a problematic situation with respect to the branch of theatre that was striving for 'universality', identified with a single overarching function of theatre and a single identical, universal effect on the audience members. 'Postmodern' productions, however, aimed—in his view—at a different kind of a relationship with their spectators:

> If a crisis of theatre is the issue under discussion, then I think it is particularly a crisis in the attitude of theatres to their audiences. It is indeed a crisis of the kind of theatre that systematically strives for universality. The audience, however, can perceive theatre in other ways than by universally espousing some idea, faith or perhaps even positive energy. They may perceive theatre as a succession of images, situations, and stories that each spectator understands according to their own personal experience and their own imagination. And yet precisely such kind of theatre may be attractive to that kind of audience. I think this is the quality found, for instance, in [Petr] Lébl's productions.
>
> (Král in "*Od českého divadla*" 1994, 34)

Král indicates that the 'postmodern' Czech theatre, exemplified by the work of Petr Lébl, promoted not only a distinct manner of aesthetic and communication, but perhaps also a different concept of theatre's function. The critic proposes the idea that theatre's functioning in the society may no longer be identified with the idea of one universal 'purpose' but rather with the concept of what might be called an 'individualised purpose'.

It therefore appears that while the older generations displayed a tendency to keep employing the category of theatre's social function (its 'purpose') even after 1989, the 'postmodern generation' introduced a different concept of theatre that no longer operated within the bounds of such a category. The presence of this more recent attitude can, however, be discerned in the field before the 'Velvet Revolution', and the innovative deconstructive principles of the emerging 'postmodern' aesthetic were discussed within the field as early as in the mid-1980s. Hence, the gist of the post-1989 debate on theatre might be briefly summarised as a debate which involved two tendencies. One part of the spectrum was asserting its belief in the category of the theatre's social function and, finding its pre-1989 fulfilment outdated, sought ways to redefine this function. The other part did not conceptualise theatre's role by means of this category and, therefore, felt no need to redefine theatre or their theatre aesthetic—rather, they continued developing the creative principles they had adopted in the 1980s. This distinction is only tentative and admittedly involves a great deal of simplification, yet preliminary findings such as these seem to indicate that the affiliation of the pre-1989 debate on theatre with the post-1989 one was of importance.

To conclude, a reconsideration of the hitherto predominant 'crisis' conceptualisation of the 1990s in the Czech theatre reveals some inaccuracies and contradictions on the one hand and a number of symptoms of continuity on the other—both on the level of the theatre system and in thinking on theatre articulated by the people involved in the theatre life of the period. These phenomena seem to temper or, in some cases, even oppose the crisis-framed interpretation. To what extent did the political shift in 1989 mean a disruption in the history of Czech theatre? This question still stands and merits a more comprehensive and deeper investigation.

Notes

1 This study is a part of a project which has received funding from the European Union's Horizon 2020 Research and Innovation Programme under Marie Skłodowska-Curie grant agreement no. 837768.
2 The lively debate unfolded in the pages of the Czech media in 2011. The academic debate on the suggested re-interpretation of the communist past was summarised, e.g., in Sedlák (2013).
3 This study focuses exclusively on Czech theatre since the situation in Slovak theatre was specific—it had already represented an autonomous system before 1989.
4 The few other available studies tend to share this 'crisis' perspective without articulating it so explicitly, focusing exclusively on partial aspects of the post-1989 situation in theatre (Machalická 2000; Jungmannová and Vodička 2016).
5 The volume was produced by the Institute of Czech Literature of the Czech Academy of Sciences.

6 The term 'samizdat' refers to manually produced underground publications which secretly circulated from reader to reader to evade censorship in the Eastern Bloc.

References

Havel, Václav et al. 1994."Od českého divadla k islámskému fundamentalismu (a zpět): ze setkání divadelníků pozvaných Václavem Havlem do vily Amálie u Lán (13. 5. 1994)." 1994. *Svět a divadlo* 5, no. 5: 26–48.
Hořínek, Zdeněk. 1992. "Divná sezóna aneb Život je jinde." *Divadelní noviny* 1, no. 1: 4.
Jungmannová, Lenka, and Libor Vodička. 2016. *České drama v letech 1989–2010*. Praha: Středisko společných činností AV ČR.
Königsmark, Václav. 1991. "Co s 'trojským koněm' po vítězné bitvě?" *Revue otevřené kultury* 2, no. 1: 40–46.
Kunderová, Radka. 2015. "Václav Königsmark." In *Česká divadelní encyklopedie: Česká činohra 1945–1989* [online]. Praha: Institut umění—Divadelní ústav. Accessed June 20, 2019. http://encyklopedie.idu.cz/index.php/Königsmark,_Václav.
Machalická, Jana. 2000, "Czech Theater from 1989 to 1996: Discovering Terra Incognita." In *Eastern European Theatre after the Iron Curtain*, edited by Kalina Stefanova, 43–59. Abingdon and New York: Routledge.
Mukařovský, Jan. 1936. *Estetická funkce, norma a hodnota jako sociální fakty*. Praha: Fr. Borový.
Nekolný, Bohumil. 2006. *Divadelní systémy a kulturní politika*. Praha: Divadelní ústav.
Pištora, Ladislav. 1992. "Divadlo v číslech." *Divadelní noviny* 1, no. 7: 3.
"Programové prohlášení vlády." 1990. Accessed June 20, 2019. www.vlada.cz/assets/clenove-vlady/historie-minulych-vlad/prehled-vlad-cr/1990-1992-cr/petr-pithart/ppv-1990-1992-pithart.pdf.
Pullmann, Michal. 2008. "Sociální dějiny a totalitněhistorické vyprávění." *Soudobé dějiny* 15, no. 3–4: 703–717.
Pullmann, Michal. 2011. *Konec experimentu: Přestavba a pád komunismu v Československu*. Dolní Břežany: Scriptorium.
Rákosník, Jakub. 2010. *Sovětizace sociálního státu: lidově demokratický režim a sociální práva občanů v Československu 1945–1960*. Praha: Filozofická fakulta Univerzity Karlovy.
Sedlák, Petr. 2013. "Druhý extrém?: Silné a slabé stránky revize výkladu komunistické diktatury." *Dějiny a současnost* 35, no. 2: 32–35.
Vodička, Libor. 2008. "Drama." In *V souřadnicích volnosti: česká literatura devadesátých let dvacátého století v interpretacích*, edited by Petr Hruška, 555–586. Praha: Academia.

10 Artistic freedom—state control—democracy

Oliver Frljić's theatre work in Croatia and Poland as an indicator of repressive cultural policy

Danijela Weber-Kapusta

The theatre director Oliver Frljić is one of the most internationally renowned theatre directors from the former Yugoslavia. He is known for controversial theatre that focuses on the burning social conflicts and taboos prevalent in different European societies. Since 2016, he has been working mostly in the German-speaking area. In the states of the former Yugoslavia, his performances cause scandals, and it has become more and more difficult—even impossible—for him to work there. In Croatia and Poland, for example, Frljić's theatre work has divided the public: while the ruling right-wing politicians and the Catholic Church try to prohibit his performances and stimulate mass demonstrations against him, the performances sell out, and there is huge demand to see them. This chapter analyses the impact that the populist and nationalist governments in Croatia and Poland have on the understanding and funding of institutional theatre. In this chapter, the term *institutional theatre* refers to publicly subsidised theatre, with the state and the city as the most important funding bodies. The chapter focuses on two different productions by Oliver Frljić—one staged at the Croatian National Theatre in Rijeka and Split and one at the Powszechny Theatre in Warsaw. The focal point of the chapter is the relationship between the performance, the public, and the state.

Oliver Frljić's theatre productions deliberately undermine the aims and aesthetic practices of institutional theatre, which are—in contemporary Croatia and Poland—subject to strict political regulation. Frljić is not interested in the theatre as a space for cultural enjoyment, art, or entertainment. For Frljić, the theatre is not a black box that isolates us from our everyday lives or confirms existing power relations. On the contrary, his theatre aims to activate the audience and to question its understanding of social reality. Frljić's theatre deals with general and not individual interests; it questions the strategies and structures of the ruling political power, exposes patterns of social injustice, catapults the spectators out of their positions as passive voyeurs, and strives to make them aware of their social and democratic responsibilities. While working in Croatian theatre, Frljić has continuously questioned the concept of national memory, official constructions of collective identities, rising nationalism and right-wing populism, the status of social minorities, and constructions of national mythologies about the so-called 'Homeland War' against Serbia in the 1990s. His last production in Poland

questioned the limits of artistic freedom, the state democratic system, and the power of the Catholic Church in defining the lifestyles of both Catholics and all other population groups. In both countries, the media, politicians, and the Catholic Church divide society into two camps: those in favour of and those against the theatre of Oliver Frljić. His productions trigger weeks of mass demonstrations, provoke murder threats against the director, and initiate legal proceedings against him. Why is it that in Germany and Austria, just a small percentage of the audience and theatre experts are interested in Frljić's performances while in Croatia and Poland, they became a national issue—a subject on which everyone wants to express their opinion? The answer to this question is complex. Neither the audience's understanding of theatre nor the provocative aesthetics of the performances is the reason. On the contrary, both Poland and Croatia have rich traditions of innovative theatre forms and aesthetics that have been developed and confirmed during the time of the repressive communist cultural policy. It suffices just to mention the theatre of Jerzy Grotowski and Tadeusz Kantor in Poland or the renowned international theatre festival of new forms, *Eurokaz*, in Croatia. At the same time, it is important to emphasise that a large part of the public that has seen the performances of Oliver Frljić talks very positively about them. The numerous national and international awards that the director has won for his productions testify that they find recognition both amongst the wider audience and in professional circles. In other words, the public debate on Frljić's theatre in Croatia and Poland is not the result of challenging subjects and the radical forms of their theatrical representation. It is much more the result of the relationship between the state and the theatre and the way in which the ruling cultural policy understands the purpose of theatre and defines its aims.

From the perspective of the state cultural policy in contemporary Croatia and Poland, a theatre is a place for entertainment and high culture. The performances that take place in institutional theatre must have a representative character. These are characterised by high aesthetic standards and the requirement to represent the nation in its best sense—in other words, to confirm the narratives of official historiography. This kind of understanding of theatre can be traced back to a theatre model that emerged during the period of growing nationalism in the 19th century. At that time, the function of theatre in a society was to foster the building of collective identities and the formation of the modern nation. The state's theatre policy in Poland and Croatia is, through today, determined by this theatre model, which strengthens the identification with collective identities propagated by the ruling political power. The case of Oliver Frljić illustrates what happens when an opposite model of theatre becomes a part of the institutional—that is, publicly subsidised—theatre.

In 2014, when the leftist Social Democratic Party was in power, Oliver Frljić became the artistic director of the Croatian National Theatre in Rijeka. He held this post until 2016, when the right-wing Croatian Democratic Party won the parliamentary elections. In Croatia, there are five national theatres. These were built in the largest Croatian cities and receive financial support from the city and the state. All of them serve as symbols of the cultural identity of the Croatian

nation. They appropriated this representative function with the founding of the first national theatre in 1860 in Zagreb. At that time, Croatia had no state sovereignty and was governed by two powers—Austria and Hungary. Against this historical background, it was the national theatre that played a key role in the formation and homogenisation of the Croatian nation. This representative role and homogenising function of the national theatre have not been lost, even today. Consequently, if a performance includes a critique of the system, then it should be within the permitted limits. The national theatre is expected to represent, homogenise, and entertain, not criticise and divide. The observance of this unwritten rule secures successful careers for the directors but hinders the conceptual, thematic, and experimental development of institutional theatre.

Frljić was the first to oppose the cultural policy of national theatre without any compromise. The forbidden, the taboo, and the marginalised became the focus of his work. In the Brechtian tradition, he searched for a thinking rather than a feeling or laughing spectator. With his provocative, often shocking, aesthetic, full of ambiguity and estrangement effects, he confronted the audience with the image of a deeply divided Croatian society, one that was being systematically manipulated and instrumentalised by the ruling right-wing populist party. The first result was a reduction in subsidy for the national theatre in Rijeka, and, soon after that, Frljić had to resign. At the same time, he lost the opportunity to work as a director in institutional theatre. There was, and there is, hardly any theatre in Croatia that is willing to work with him today. The climate of fear cultivated by the authorities—loss of funding and layoffs—blocks any potential cooperation. The politicians, the media, the social networks, the Catholic Church, and the public—all of them intensively discuss the function of state-subsidised theatre. While one side of the debate produces an audience who go to Frljić's performances to demonstrate their support of artistic freedom and freedom of speech—or perhaps simply wish to see the scandalous performances—the other side gathers in front of the theatre to protest against the abuse of art and taxpayers' money.

The debate dealing with the question of political activism in publicly funded theatre culminated in spring 2017 during the festival of Croatian drama *Days of Marko Marulić* in Split. The festival programme included a performance of *Our Violence and Your Violence*, directed by Oliver Frljić. The performance was commissioned by the Berlin theatre Hebbel am Ufer and developed in cooperation with the Croatian National Theatre in Rijeka and the Slovenian Mladinsko Theatre in Ljubljana. The world premiere of the performance took place during the *Wiener Festwochen* in May 2016. The performance became part of the theatre repertoire in Ljubljana and Rijeka and toured extensively through the German-speaking and Eastern European regions—from Berlin, Hamburg, Weimar, and Zurich to Sarajevo, Bydgoszcz, and Cluj. The first public protests against the performance took place in Sarajevo, where the performance was part of the International Theatre Festival MESS. Owing to numerous anonymous threats, the festival management decided to show the performance only to the members of the theatre jury in order to ensure the safety of the audience. Under great pressure from theatregoers and a divided media, *Our Violence and Your Violence* finally opened to the public

and took place without any disturbances. At the same time, the Sarajevo diocese demanded that the Bosnian government prohibit the performance. The protests in Sarajevo were the prelude to further demonstrations that culminated at the Split theatre festival in spring 2017.

Both in Sarajevo and in Split, Frljić's multi-layered performance dealing with the complex relationships between colonialism, capitalism, terrorism, the refugee crisis, and European policies was reduced to the problem of blasphemy with one central aim: to trigger mass demonstrations against this kind of theatre experiment and achieve official prohibition of the performance. The selection of the festival programme became a subject of intense debate in the highest political offices. The Croatian Ministry of Culture distanced itself from the selection, and the chairman of the federal state of Split and Dalmatia announced the reduction of festival funds (Moskaljov 2017). The state and the town authorities responsible for the funding of the festival stated clearly that institutional theatre has a representative function: it is a temple of art and a symbol of national identity. This definition of theatre has been uncritically adopted and defended by broad segments of the general public, such as the right-wing press, soldiers from the Homeland war, Catholic priests and believers, and representatives of the extreme right. The right-wing press used a simple strategy to create a kind of populist attack against the director and his productions. The typical argument was that the performance was a disgrace to Croatia and Croats and that the performance insulted national and religious feelings. This was underpinned by sensational photographs of the performance and a selection of international press reviews, which, however, included only the worst reviews. In response, hundreds of protesters gathered for days in front of the Croatian National Theatre in Split and demanded the official banning of the performance. On the day of the performance, the theatre was surrounded by demonstrators and security forces. The beginning of the performance was delayed because of a bomb threat. At the same time, the auditorium literally turned into a theatre within the theatre. Some of the demonstrators bought tickets and tried to obstruct the beginning of the performance. They occupied the last rows of the parquet and sang war songs. The audience reacted to the provocations, stood up, and responded with a cosmopolitan peace song. Finally, the theatre's security forced the demonstrators to leave the theatre because of the disruption of public order. The performance took place without any further disturbances.

Interestingly, the goals and mission of institutional theatre—which were the main question of public, political, and media debate—were, at the same time, among the central issues in the controversial performance. Oliver Frljić deals with this subject by referring to ideas from Peter Weiss's novel *The Aesthetics of Resistance*. What is the task of art? Why are you going to the theatre? These are the questions that are addressed to the audience right at the beginning of the performance. Should art just confirm and replicate the existing social and political order? Or is the task of the art to actively oppose prevailing power structures and make them the object of constant critical questioning? The Croatian National Theatre in Split and the Ministry of Culture answered this question. While the theatre supported the performance, the city of Split and the Ministry of Culture distanced

themselves from the performance, and they announced measures—cuts in the festival budget and the dismissal of the artistic director. Although the performance was not officially banned, the number of repeats at the Croatian National Theatre in Rijeka fell rapidly after the Split festival. In the 2017–18 season, *Our Violence and Your Violence* was performed two last times at the Rijeka theatre. At the same time, Oliver Frljić got no further opportunity to work in Croatia. The last offer from the institutional theatre came from Nataša Rajković, artistic director of the Zagreb Theatre &TD. From its founding in 1966, the Theatre &TD took on a special function within the network of publicly funded Croatian theatres. Its mission was to foster a critical, socially engaged theatre; new aesthetic; and forms of theatre organisation like collective theatre and theatre without a fixed ensemble. During the long-time artistic direction of Nataša Rajković, the Theatre &TD became for many young directors a place to work, shape their experiences, and develop their vision of theatre. The experimental, risky, socially engaged, and provocative projects made the Theatre &TD important. They differed from the usual practice of institutional theatre. This extra freedom in the field of critical and aesthetic practice was tolerated by official policy because the Theatre &TD was a small chamber theatre attended primarily by students. Nevertheless, the productions taking place there became too politically subversive, so the artistic director of the theatre, Nataša Rajković, was dismissed in the summer of 2018.

Poland is another EU state where institutional theatre is strongly affected by a restrictive cultural policy and ideological regulation. Anna Burzyńska—editor of the theatrical journal *Didaskalia* and lecturer at the department of drama and theatre at Krakow's Jagiellon University—writes about the devastating impact that ruling right-wing populist policy has had on the Polish theatre scene since 2015:

> A favourite slogan of the PiS people [Law and Justice party] is 'the good change'. Theatre is one of the institutions that 'does not fit into the new concept of Polish culture' and needs 'the good change'. What is their new concept of Polish culture? It's nationalistic, xenophobic, patriarchal, homophobic, obsessed with history and inextricably linked to the Catholic religion. . . .
>
> Minister Gliński has chosen Wanda Zwinogrodzka—critic and journalist writing for a far-right newspaper—to be a deputy minister for theatres. She defined her mission clearly: 'We have to silence the leftists' screams'. . . .
>
> Gliński's next step was an order to evaluate the activity of Polish theatres. They have been asked to send DVDs of all their shows to the Ministry for supervision [and] one of the new 'experts'. . . . His opinion is going to influence future financial support of these theatres.
>
> (Burzyńska 2016)

The examples of state interference in the work of the institutional theatre in Poland are numerous. To name a few: the attempt of Piotr Gliński to ban the production of *Death and Virgo* by Elfriede Jelinek at the Teatr Polski in Wrocław and the subsequent change of the artistic director, the withdrawal of funding for Michał Zadara's production of Adam Mickiewicz's masterpiece *The Forefathers's Eve*, and the

replacement of the artistic director of Stary Teater in Krakow, Jan Clata (Burzyńska 2016). Despite the repressive cultural policy in the institutional theatre and strong financial censorship, there have still been remarkable attempts to maintain ideological and aesthetic freedom. One of the best examples is Theatre Powszechny in Warsaw. On the website of the theatre, one finds the following statement:

> 'I'm an advocate of theatre that gets in the way', wrote Zygmunt Hübner, the patron of Powszechny Theatre, and specified: 'Theatre that sticks its nose into politics, social life and the most intimate human affairs. Theatre that has its own opinion in these matters, expresses it openly and tries to defend it—on stage, of course'.
>
> We want those words to be more than a slogan or theatrical curiosity. We want them to become a living idea, defining the space of artistic and educational activities planned in Powszechny Theatre.
>
> (Łysak and Sztarbowski 2019)

True to this credo, the artistic director of Powszechny Theatre, Pawel Łysak, invited Oliver Frljić to stage a performance dealing with the status of artistic freedom, democracy, and the power of the Catholic Church in contemporary Poland. Frljić's performance of *The Curse*, inspired by the eponymous drama of Stanisław Wyspiański, premiered in February 2017 and triggered mass demonstrations. The sensitive issues affecting the Catholic Church and their treatment in the performance provoked vehement criticism. The greatest excitement was caused by the presentation of the Polish Pope John Paul II. He was shown as a defender of paedophiles and also as having oral sex with a woman. Thousands of right-wing populists and Catholics demonstrated for days in front of the theatre, demanding the official prohibition of the production. The demonstrators cursed the theatregoers and tried to bar them from entering. They threw firecrackers at spectators and, at the same time, prayed for the souls of the theatre director and the actors engaged in the production. The performance and its interpretations made headlines in all media. Priests preached against the production throughout the country. The Polish prosecutor's office brought proceedings against Frljić on the basis of blasphemy laws. According to these laws, anyone who offends the religious feelings of other people can be subject to a fine, restriction of liberty, or imprisonment for up to two years. The investigation is currently underway, and the production is still playing to sold-out theatres. Visiting the performance on the one hand and the public demonstration against it on the other has become a clear political statement. The conflict between the opponents of the performance and its supporters revealed the whole depth of the social crisis and crisis of democracy in contemporary Poland. The left-oriented press expressed the point as follows:

> The reactions of local authorities in the capital, entirely respecting the Powszechny Theatre's autonomy, the intervention of the minister of culture in his calls for censorship, reactions of the Polish Episcopate and individual priests, a siege of the theatre by nationalist cadres, manifestations of solidarity with the artists,

the setting in motion of prosecution proceedings—all these events comprised a social performance initiated by the production, which then offered a constantly updated message about the state of our democracy and of our public sphere.

(Adamiecka-Sitek and Keil 2017)

Olivier Frljić's performance 'The Curse' (in Polish, 'Klątwa'), based on the drama by Stanisław Wyspiański, has caused a hitherto unseen media and political storm throughout Poland. The artistic director of the theatre, Oliver Frljić, and the actors involved, were verbally abused by the demonstrators, but the audience responded enthusiastically and applauded the courage of the artists. What happens here shows clearly how strong the division of Polish society is and what role the government plays in this.

(Staszczak-Prüfer 2017; the translation is my own)

There is no other production . . .—certainly not in the post-transformation era, probably even in the post-war history of Polish theatre—that has divided Poles with equal force and at the same time created a particular kind of 'community clash'.

(Adamiecka-Sitek 2017)

The structure of the demonstrations triggered by Frljić's work in Warsaw and Split is remarkably similar. In both countries, the protesters are mainly proponents of right-wing populist ideology and Catholics. They wear national and religious symbols, especially national flags, the cross, and images of the Virgin Mary. They sing national and religious songs and carry banners with sometimes identical content, such as 'Satan, leave our city!', 'This performance insults my feelings!', 'This is not a theatre; it is a brothel!', and 'Lower taxes instead of funding contemporary art'. In both countries, the director and the actors receive death threats, theatres receive bomb threats, and people on social media spread fake reports and hate speech. The argument against the director is the same in both countries: Frljić's theatre offends religious and national feelings. Institutional, publicly funded theatre should not allow this kind of artistic freedom. What is alarming is that those who protest against this kind of theatre have not seen the performance at all. In other words, the government, cultural authorities, and the Catholic Church instrumentalise them for their own ruling interests. The crisis situation is, therefore, an expression of state violence, which gains its visible form in thousands of manipulated demonstrators. If the state and the church did not interfere in the work of the institutional theatre—making theatre a public matter—then the discussions about the controversial performances would barely cross the boundary of the theatre sphere. In other words, right-wing governments initiate protests in order to achieve their own political goals and confirm their understanding of theatre. The demonstrations against Frljić's productions are therefore much more than a cultural controversy. They are an expression of a deep cultural crisis and a crisis of democratic values, both consciously generated by the government.

The question that arises is why the government is interested in creating a cultural crisis. Frljić's performances in Croatia and Poland and their public

perception make it clear that both countries have a heterogeneous audience interested in different theatre forms and aesthetics and that there is an audience interested in Frljić's productions. The problem is that his open, plural understanding of theatre, its aims, and its functions contradicts the way official cultural policy defines the theatre and its purpose. The fact that the authorities generate the crisis shows that theatre remains an important and influential social medium, which therefore requires special control. The result is the restriction of autonomy and artistic freedom in institutional theatre. It is important to stress that the crisis of artistic freedom affects only institutional theatre and not the independent theatre scene. The reason for this is that the independent scene has a small audience, and the productions experience few reprises due to lack of funds. In other words, the scandals that accompany theatre directors who question the ideology of the ruling political party are not generated by the actual theatre audience. They are, rather, the result of a cultural policy that protects the rulers and their interests. By defining theatre as high art, entertainment, and preservation of national identity, the state cultural policy fosters the path of dependence for institutional theatre with one crucial aim: to confirm the prevailing power relations and homogenise the audience. The cultural diversity and otherness, the questioning of official historiography, the images of collective identity, and the critique of ruling ideology remain subject to strict observation and control. These and similar tendencies can find their place on the independent scene or within the framework of a theatre festival, but not as a part of institutional repertory theatre. In other words, today's democratic states show striking similarities to the former repressive communist systems. There is, therefore, a question as to the extent to which we can speak of a successful liberalisation of the former communist countries.

By triggering the scandals, the cultural authorities and the church—both supported by the right-wing media—generate a multi-level crisis. First, it is a crisis of artistic freedom in institutional theatre. Preventive self-censorship is a keyword. In this way, every subversive practice that implies a criticism of the political system remains within the permitted limits. In order to avoid official censorship, the state appoints suitable officials from among artistic managers and theatre directors. Secondly, it is a social crisis that reveals the deep ideological division of society. Thirdly, it is a crisis of democratic values, such as the autonomy of the arts and freedom of expression—two constitutional rights—that have been repeatedly violated in both countries. Interestingly, the last two points are the focal points of Frljić's theatre work. The divided society or divided nation is an omnipresent theme. By cultivating the aesthetic of provocation, Frljić consciously challenges the principles of democracy and encourages the question: is it legitimate to restrict artistic freedom in a democratic society? In these ways, Frljić's productions actually anticipate the crisis generated by authorities as a response to his theatre work. The problem is that the authorities react by constructing a duality between 'real' art and Oliver Frljić's theatre. In the mass media, they present this kind of theatre as degenerate, talentless, and exhibitionist. By doing so, they force a normative understanding of theatre among both the theatre-makers and the uncritical readership of the mass media.

Against the backdrop of mass theatre demonstrations in contemporary Croatia and Poland, the question of the 'theatrical public sphere', which was treated in detail in the study of the theatre scholar Christopher Balme (2014), poses itself. Following Jürgen Habermas (Habermas 1989), Balme defines the public sphere as a right and possibility for all citizens to engage in debate on public issues on equal terms without regard to sex, race, creed, or caste (2014, ix): 'The public sphere hinges in turn on wide-ranging rights to freedom of speech and by extension artistic expression' (*ibid.*). In terms of democracy, there is a question whether the mass theatre demonstrations in Poland and Croatia can symbolise a public sphere in its ideal democratic form, as defined in Habermas's study. Considering the argumentation in this chapter, the answer would be quite the contrary. Rather than exercising democracy, the demonstrations in Croatia and Poland symbolise the degeneration of the public sphere 'under the influence of mass media . . . and the political manipulation of public opinion' (Balme 2014, 5; Habermas 1989). As Balme points out:

> [A] public sphere [is being] manufactured for show. The commercialization and commodification of media as well as changes in political organization, especially the emergence of pressure groups and lobbyists, have largely taken over the processes of opinion making from private citizens and relocated and professionalized them.
>
> (Balme 2014, 5)

That is what the mass theatre demonstrations in Croatia and Poland are about: they provide an example of the political staging of public opinion. The demonstrators do not act as political subjects but as political objects, unable to realise the difference between their opinion and their political function. The focal point of Habermas's idea of the public sphere is the freedom of opinion-making and its expression. The public that is demonstrating against Frljić's productions in Croatia and Poland, however, does not form an individual opinion about the performance. The majority of this population does not go to the theatre. Since they do not have a pronounced attitude towards theatre, they are particularly susceptible to medial and political influence. In other words, the right-wing media and authorities appeal to theatrically ill-educated sections of the population to create a temporary public sphere that contributes to the fulfilment of their own cultural and political goals. The demonstrators, convinced that they are exercising their democratic right, are, in reality, an executive instrument of political power and a very representative example of the political and media creation, manipulation, and mobilisation of a public sphere.

The political debate on publicly subsidised theatre in Croatia and Poland indicates that the standardisation and control of art—typical of communist and all repressive regimes—remain present even today. In conclusion, we can talk about a cultural crisis caused by the right-wing governments since there is a great need for new theatre forms and undogmatic theatre understanding among both the public and theatre professionals, but the authorities are hindering developments and

are interested in maintaining the status quo. The intensity of the debate indicates that theatre—as a public institution—plays an important social role in spite of the emergence of new media. The measure of its control indicates a measure of its social influence. Even though the freedom of art in Croatia and Poland is a constitutional right, the true extent of freedom depends on the political structure of the state and town authority that governs the organisational and financial affairs of the particular institutional theatre.

References

Adamiecka-Sitek, Agata. 2017. "How to Lift the Curse? Director Oliver Frljić and the Poles." *Polish Theatre Journal*, no. 1–2. Accessed April 29, 2019. www.polishtheatre journal.com/index.php/ptj/article/view/111/593.

Adamiecka-Sitek, Agata, and Marta Keil. 2017. "Theatre and Democracy. Institutional Practices in Polish Theatre." *Polish Theatre Journal*, no. 1–2. Accessed April 29, 2019. www.polishtheatrejournal.com/index.php/ptj/article/view/131/505.

Balme, Christopher. 2014. *The Theatrical Public Sphere*. Cambridge: Cambridge University Press.

Burzyńska, Anna R. 2016. "The Good Change: Theaterbrief aus Polen (13): How Polish Theatre Is Affected by the PiS-Government's Rightwing Populism." *nachtkritik.de*, February 2016. Accessed April 29, 2019. https://nachtkritik.de/index.php?option=com_content&view=article&id=12175.

Habermas, Jürgen. 1989. *The Structural Transformation of the Public Sphere: An Inquiry Into a Category of Bourgeois Society*. Cambridge, MA: MIT Press.

Łysak, Paweł, and Paweł Sztarbowski. 2019. "Idea Forum for the Future of Culture." Accessed April 29, 2019. www.powszechny.com/misja.html?lang=en.

Moskaljov, Vanja. 2017. "Župan Ževerja najavio kaznu za 'Marulićeve dane' zbog Frljićeve predstave." *tportal.hr*, April 25, 2017. Accessed April 29, 2019. www.tportal.hr/kultura/clanak/zupan-zevrnja-najavio-kaznu-za-maruliceve-dane-zbog-frljiceve-predstave-20170425.

Staszczak-Prüfer, Natalia. (2017). "Rosenkranz ins Gesicht. Theaterbrief aus Polen (15)— 'Klątwa' ('Fluch') von Oliver Frljić in Warschau—Analyse eines hochpolitischen Theaterskandals." *nachtkritik.de*, May 2017. Accessed April 29, 2019. www.nachtkritik.de/index.php?option=com_content&view=article&id=13772.

11 Creating new theatres during the economic crisis
The case of Estonia

Hedi-Liis Toome and Anneli Saro

Introduction

The aim of this chapter is to analyse how two major worldwide crises—first, the collapse of the Soviet Union at the turn of the 1980s and 1990s and secondly, the global financial crisis of 2008—influenced the theatre field of Estonia. The focus is on the emergence of small independent theatres[1] during these crucial changes. The chapter examines what kind of transformations emerged in the Estonian theatre system as a result of these two crises and attempts to detect possible similarities and differences between these two waves of new theatres.[2] After establishing a theoretical framework against which the developments are studied, the causes of establishing new theatres during these two waves are discussed, and, finally, the ideologies of the two waves of independent theatres are compared.

Theoretical background

The crises observed are understood as cases of 'transition' (Elliott and Dowlah 1993) in this chapter. Elliott and Dowlah use the notion of 'transition crises' to describe the economic situation during the collapse of the Soviet Union. Transition crises can be divided into intra- or inter-systemic crises. The intra-systemic crisis requires changes inside the system; the inter-systemic one 'by contrast, presupposes a crisis of the system itself, rather than a crisis within it' (Elliott and Dowlah 1993, 528). This distinction assumes that the inter-systemic crises led to a new type of economy, demanding a new type of order. At the same time, intra-systemic crises provoke changes inside the system but do not abandon the old rules completely. The collapse of the Soviet Union can be classified as an inter-systemic crisis since it involved changes in the social, economic, and, last but not least, political spheres. In 1991, Estonia regained national independence, setting as its aims 'to establish basic freedoms and democratic government, to reach prosperity by using the market-based economy as the likeliest road, and to "return to Europe"' (Rupnik 2010, 107). This meant that, in 1991, Estonia left a closed and centrally controlled economic and social system and opened up to the capitalist economy. Compared to other members of the former Eastern bloc, Estonia went through the most radical reforms and was named as a successful example of economic reforms by the World Bank (1999, 7). At the same time,

these drastic reforms also meant the 'end of the accustomed lifestyle for citizens' (Narusk 1996, 13 cited in Lauristin and Vihalemm 2017, 69), causing a division of Estonian society into 'winners' and 'losers'.

The global financial crisis of 2008, however, could be seen as intra-systemic. Designated 'the most significant economic crisis of our lifetime' by OECD (Ramskogler 2014, 47), it nevertheless did not 'destroy' the capitalist economic system. According to an analysis conducted by the *Wall Street Journal* ten years after the crisis, the recovery has been uneven and global inequality has grown, yet the financial sector is the 'same as it ever was' (Podkul 2018). Naturally, these large-scale changes, which could be felt in all aspects of society, also influenced the functioning of the Estonian theatre system.

According to the Dutch theatre researcher Hans van Maanen, a theatre system consists of four different domains—production, distribution, reception, and context—and should be analysed on the levels of organisational structures, processes, and outcomes (Van Maanen 2009, 11). Van Maanen presents these domains and levels as interrelated, and, to understand the functioning of the theatre system, the relationships between the domains should be examined on different levels. In the production domain, the types and numbers of performing institutions and the ways of making performances, as well as the final outcomes (types and numbers of performances), should be analysed. In the distribution domain, the venues, the programming, and the actual aesthetic events should be studied while in the reception domain, the structure of the audiences and the types and experiences of actual audiences should be examined. This chapter will focus on the first three domains and pays somewhat less attention to the context domain that analyses the position of theatre among other systems. Since the chapter focuses more on how the changes in the society affected the theatre field and not vice versa, the context domain will be left as a topic for later research.

The emergence of the first wave of independent theatres

The emergence of the first wave of new theatres can be located between 1987 and 1994. During the Soviet regime, it was extremely difficult to establish new theatres for all cultural institutions were state owned and subsidised, and the state had limited capacity to finance new organisations. Privately owned organisations were prohibited. This meant that the first independent theatres could only start emerging in the context of perestroika and the liberation of economic laws. The transition period has been divided into three sub-periods: heightened priority for investment and the military (1985–86); experiments with economic and political devolution (1987–89); and an endgame (1989–91), in which the old central controls 'unravelled and the rules of the economic and political game became obscure' (Hanson 2003, 177–178). In 1987, small-scale private enterprises were legalised in the Soviet Union, and so-called 'theatre experiments' provided more economic freedom to directors of some state theatres (Viller 2004, 65–70). Two major changes occurred for the theatre field. During the period of the Singing Revolution,[3] theatre lost its role as a social forum, a role it had taken on especially

during the Soviet era. Secondly, during the period of 1987 to 1992, the number of theatre visits dropped 50% (Saro 2010, 21), creating new challenges for the existing theatres. Thus, crises in theatre had started already before the general economic crises that peaked in 1991–92.[4] However, despite these challenges, new theatres started to emerge.

The first independent theatres were established in 1987 as a sign of the commencement of a more liberal era and followed the example of some newly established Russian studio theatres. During the first wave, all in all, 13 new theatres emerged, of which 8 are still active today.[5] (See Table 11.1.)

Estonian theatre researchers (Saro 2004; Karulin 2013) have pointed out that the state theatre system, created in the Republic of Estonia during the 1920–30s, was more or less preserved in Soviet-era Estonia and was also maintained by the new Estonian government. In comparison with neighbouring countries, it was quite exceptional that none of the ten state theatres was closed during the major crises at the turn of the 1980–90s, but new project-based theatres started to flourish in addition to these. Many of these theatres were established by people, even friends, with similar educational backgrounds that were different from the education of the actors and directors working in state theatres, who wanted to do something different, organisation-wise as well as aesthetically. In the beginning, none of these groups received any support from the state (neither the Soviet Union nor the Republic of Estonia), but, according to the statistics available, since 1995, between 4% and 5% of the annual subsidies for theatre have been allocated to more established independent theatres (Saro 2010, 27). Currently, five of the surviving theatres are partly financed by the Ministry of Culture; others apply for project-based funding from the Estonian Cultural Endowment.[6] Almost all of them have venues of their own (often, these are part of larger complexes), and many of them have a small but permanent troupe (Epner forthcoming).

The expansion of the number of theatres in the eastern part of the country (cities like Narva and Jõhvi, where there are large Russian minority groups and had been no permanent state theatres) can be explained by the economic rule of 'demand stimulating the supply'. The border between the Republic of Estonia and the Russian Federation was restored, and people needed visas to travel across the border. The Russians of the region were suddenly cut off from their closest cultural capital, St. Petersburg, only 150 kilometres from the border city of Narva, the third largest city in Estonia. Not all the theatres that emerged became professional, especially the Russian-speaking troupes, which have always operated on a semi-professional basis.

It is quite striking that the first wave developed several theatres for young audiences, both Estonian and Russian speaking. However, new Estonian-speaking children's theatres in particular do not exist anymore: ticket prices are usually lower for children's performances, and without state financing, these groups did not manage to survive.

As no existing theatres were closed during the crises, the new private theatres did not replace the current institutions but were added to the system already in place. As a result, there were twice as many theatre organisations in 1996 than in

Table 11.1 The theatres of the first waves

Theatre	Year	Target group	City	Type of theatre (in 2019)	Main financing body (in 2019)	Venue (in 2019)
VAT Theatre (VAT Teater)	1987	Children, Youth, Adults	Tallinn	Project theatre with permanent troupe	State + project based	Yes
Theatre Varius (Teater Varius)	1987	Adults	Tallinn	Project theatre with permanent troupe	Project based	No
The Pirgu Society of Singing and Performing (Pirgu Laulu- ja Näitemängu seltskond) Ruto Killakund	1987–1991	Adults	Rapla			
	1989–1992	Adults	Tallinn			
Studio Theatre Ilmarine (Stuudioteater Ilmarine)	1989	Children, Russian speaking	Narva	Project theatre with permanent troupe	State + project based	Yes
Tartu Childrens' Theatre (Tartu Lasteteater)	1989–2000	Children	Tartu	Repertoire theatre with permanent troupe		
Von Krahl Theatre (Von Krahli Teater)	1992	Adults	Tallinn	Project theatre (had a permanent troupe for years, but not currently)	State + project based	Yes
Nordic Star Dance Theatre (Nordic Star)	1991–1994	Adults	Tallinn			
Fine 5 Dance Theatre (Fine 5)	1992	Adults	Tallinn	Project theatre	Project based	No
Theatre Windmill (Teater Tuuleveski)	1993	Children, Russian speaking	Jõhvi	Project theatre with permanent troupe	State + project based	Yes
Theatrum	1994	Adults	Tallinn	Project theatre with permanent troupe	State + project based	Yes
Salong Theatre	1994–2006	First children, then adults	Tallinn			

1987; their number rose from 10 to 23. In contrast to state theatres, which had to maintain a certain income to keep their venues working and people on the payroll, the new theatres were free from such obligations and, in the beginning, maybe even opposed this kind of institutionalisation. The drive of the first-wave theatres was first and foremost to be different from the Soviet theatre system, which generally favoured only one type of organisational model (repertoire theatre with a permanent troupe) and limited types of aesthetics that had to be approved by the censors. At first, the new theatres did not receive any recognition from theatre critics and, therefore did not gain enough symbolic capital to be accepted by other agents (e.g., the big state theatres in the field). Bourdieu (1993, 55–61) has claimed that one has to possess the habitus which predisposes one to enter the field; therefore, over time, the independent theatres also invested in their own venues and permanent troupes,[7] which enabled them to function in the field, thus following partly the habitus of the pre-established theatre field of the Soviet era and continually supported by the theatre politics of the independent Estonian Republic.

Yet the new venues were different from those in earlier times. For example, the Von Krahl Theatre started managing a bar and a concert venue separately from the theatre space, creating a new type of setting that united different types of contemporary and alternative art forms. Although already common among smaller theatres all over Europe, it was—at the time—seen as something innovative. Other new project theatres started staging productions in found spaces and in very small spaces meant for limited audiences (as did the VAT Theatre and the Theatrum, both located in small venues in the old town of Tallinn). The Von Krahl Theatre especially started attracting the alternative youth interested in new forms and theatre aesthetics. In contrast, Theatrum, which produced mainly classical dramaturgy, was visited by intellectuals who were not interested in the box office comedies that started to dominate the repertoire of state theatres at the beginning of the 1990s.

The new theatres also introduced new aesthetics—postmodern theatre, technological theatre, multimedia theatre, 'poor theatre', contemporary and modern dance,[8] and physical theatre, which, according to Anneli Saro (2010, 22), were labelled 'experimental theatre' at the time—and small-scale productions for children. In addition, documentary theatre and performances based on heritage enabled new types of subject matter to be placed on the stage (Epner forthcoming). These new styles also extended the repertoire of the state theatres, which started producing more experimental productions in their black boxes, at site-specific venues, or as summer productions.

Artistic changes were possible and may also have been influenced by the unusual cultural capital the pioneers had, particularly regarding their education, which was slightly different from the prevalent training common to most of the creative staff of the state theatres. The VAT Theatre, the first independent theatre, was created by people who had studied together at the Tallinn Pedagogical University and not at the Tallinn State Conservatory, which produced 90% of the actors and directors active in the field. The VAT Theatre was a pioneer in physical

and poor theatre, first putting an emphasis on productions for young audiences, which still remain an essential part of their repertoire. Peeter Jalakas, one of the founding members of the VAT Theatre, studied at the Odin Theatre and Theater an der Ruhr from 1988 to 1990[9] before parting from his former friends and colleagues to create an independent group called *Ruto Killakund* and, later, Estonia's first private theatre, the Von Krahl Theatre. He was among the first to stage multimedia and intercultural performances, performing old myths with the help of modern technology and mixing different types of theatre.

The Theatrum was created by teachers and students of the Estonian Institute of Humanities. The theatre, which could be also seen as a family theatre (several actors are the children of its creative leader or their spouses and friends), has been following an aesthetic language based on subtle psychological acting and classical dramaturgy. Their slogan states that theatre should be a devotion, not a duty (Theatrum), and because of that, the members of the troupe used to have side jobs to avoid the pressure of having to earn their living by performing.

The number of theatres rose, but the audience numbers dropped from 1.7 million in 1987 to 700,000 in 1992. To overcome the loss of audiences, state theatres started producing more often commercially successful Anglo-American comedies in the belief that facile entertainment might bring people back to the theatre. The aesthetically more challenging performances were frequently accused of being escapist—meaning they were not tackling the new social challenges such as reforming the economy, the restitution of properties, the implementation of the Estonian crown instead of the Soviet ruble, or establishing new democratic institutions like Parliament and so forth. During these inter-systemic crises, theatre retreated to an ivory tower (Epner 2016, 28). The new capitalist economic system left several social groups with reduced incomes, with the consequence that many people could not afford to go to the theatre anymore. In addition, under the conditions of a privatised economy, new modes of entertainment emerged, and theatres had to start competing for audiences with other types of leisure activities. Thirdly, the value surveys of the 1990s conducted by sociologists at the Tallinn Polytechnical Institution also demonstrated that participation in cultural activities (reading; going to the theatre, cinema, etc.) was no less appreciated by the public than in the Soviet times (Eesti Inimarengu Aruanne 1999).

The drop in audiences did stop new theatres from emerging since they were more interested in finding their own spectators—people of a similar mindset—than being accessible and understandable for everyone. They hoped to compose new theatre communities, focusing mostly on young audiences, by creating new types of experiences (Manifesto of the Tartu New Theatre).

The emergence of the third wave of independent theatres

The independent theatres that emerged between 2008 and 2010 can be grouped together as a third wave (Table 11.2) (Manifesto of the Polygon Theatre). The process ran parallel to the global financial crisis and the Estonian economic transformation and integration with the European Union. (Estonia joined in 2010.) In 2008, the

Table 11.2 The theatres of the third wave

Theatre	Year	Target group	City	Type of theatre (in 2019)	Main financing body (in 2019)	Venue (in 2019)
Tartu New Theatre (Tartu Uus Teater)	2018	Adults, Children	Tartu	Project theatre	State, municipality, + project based	Yes
Polygon Theatre (Polygon Teater)	2008	Adults	Tallinn	Project theatre	Project based	Yes
Improtheatre (Improteater)	2009	Adults, Youth	Tallinn	Project theatre	Project based	No
Võru City Theatre (Võru Linnateater)	2009–2013	Adults	Võru			
Cabaret Rhizome	2009	Adults	Tallinn, Tartu	Project theatre with permanent troupe	Project based	Yes
Own Stage (Oma Lava)	2009	Adults	Tallinn	Project theatre	Project based	No
Tallinn Dance Theater (Tallinna Tantsuteater)	2010	Adults	Tallinn	Project theatre	Project based	No
Free Stage (Vaba Lava)	2010	Adults	Tallinn	Production house	State + project based	Yes

GDP of Estonia shrank by 14.3% (the biggest drop in the European Union), and the government reacted to this by making severe budget cuts that led to a 7% growth in the economy by the end of 2010 (Lauristin and Vihalemm 2017, 82). Estonian economists have suggested that the ability to overcome the crisis quickly proved the flexibility of small states such as Estonia, where the right-wing government was not afraid to make budget cuts and where society did not react with public protests in the street or similar reactions. In addition, integration into the EU only enabled certain kinds of strategies to overcome the crises (Friedrich and Reiljan 2015). The value studies conducted by the sociologists of the University of Tartu prove that by 2011, Estonians felt positive about their lives and had begun to believe in an economically better future (Lauristin and Vihalemm 2017, 82).

During this period, eight new theatre institutions were established, of which only one has closed down. In contrast to the first wave of theatres, which started receiving funding from the state typically only after six to ten years of existence, two representatives of the third wave—Võru City Theatre and Free Stage—received state subsidies from the beginning.[10] Compared to the theatres of the first wave, of which almost all have managed to gain support from the state, among the third-wave theatres, only the Tartu New Theatre and the Free Stage have obtained stable state funding. Half the third-wave theatres have their own venues. In fact, the Free Stage was established by nine project-based theatres as a production house, with the aim of creating a venue for independent theatres. Four of the founding members are among the third-wave theatres. After all, Free Stage is not actually used by these theatres.[11] Also, the theatres of the third wave have not hired permanent companies, and only the Tartu New Theatre—thanks to state funding—has managed to have technical and administrative staff on the payroll for the last few years. Keeping PR people, rather than actors, on the payroll can be seen as a sign of the times during a period of media dominance, when it is more important to have an active PR stream operating to compete not only with other theatres but also with other types of leisure activities than to keep actors attached to one organisation only. The number of freelance actors has also grown since the early 1990s, which makes it possible to run a theatre organisation based on projects.

The third wave also introduced some new genres into the theatre field—for example, improvisational theatre (the Improtheatre), combinations of physical and technological theatre (Tartu New Theatre), and combinations of participatory and technological theatre (the Cabaret Rhizome). Still, these theatres did not change the aesthetical habitus of the theatre field, unlike those established after 1990. Postdramatic theatre, as well as devised theatre and other collective staging techniques, had started to emerge in the Estonian theatre field at the beginning of the 2000s. The third wave theatres would either follow these aesthetic styles or leave them behind.

Some of the theatres manifestly opposed institutionalisation and were critical of the economic boom preceding the economic collapse. In the 1990s, theatres literally did not have anything, so starting from scratch was mandatory. However, at the end of the 2000s, even in the conditions of the financial crisis, doing theatre

with few resources was a matter of choice. The manifesto of the Tartu New Theatre says 'the theatre is not a building, but an idea; it is based on the opportunity to make theatre, it can only exist based on volunteering (i.e., having an inner urge to create theatre—authors), and not based on tradition, obligation or occupation' (The Manifesto of the Tartu New Theatre 2019). The Polygon Theatre in Tallinn writes 'we have nothing new, we will not do anything differently, because we do not have anything; our theatre is poor, re-cycling and re-using; you will not see wonders of technology, you will see the actor' (The Manifesto of the Polygon Theatre 2019). The notion of 'poor theatre' is often used by critics when they analyse performances at the Tartu New Theatre or the Polygon Theatre, sometimes referring to the Grotowskian concept of 'poor theatre', but sometimes just stating the fact that the theatre is literally poor.

The audience numbers started rising after 1993, peaking in 2007 (Eesti teatristatistika 2013), which saw over a million theatre visits in Estonia for the first time since it regained independence. The number went down for a short period just after the economic recession, stopping at 870,000 visits in 2010.[12] The statistics show that during the economic recession, the drop in the audience numbers was greatest among independent theatres (Oja 2010), yet the newcomers of 2008–10 established themselves in the field very quickly. While in 2006, 89% of the visits to independent theatres were made to seven larger private institutions and 11% to one-time projects, by 2010, 95% of the visits were made to ten different permanently existing private theatres, so the tendency of polarisation of the audiences among all the theatres in the field was rising (Oja 2010).

In the production domain, the new organisations did not introduce new ways of administering theatres, yet they widened the field of independent and project-based theatres even more. The processes and outcomes of the production field grew, but more in numbers than in aesthetic styles. The distribution domain changed mainly because more new groups were active in the field, and the variety of venues and marketing strategies was increasing.

The theatres have not introduced radically novel aesthetics, but the new types of organisations without permanent troupes made it possible to combine interesting short-term creative communities that definitely enriched the theatre field. The reception domain was affected by the emergence of new theatres as well. Similar to the first wave, the third-wave theatres also aimed for specific audience groups, not general audiences, creating even more different opportunities for theatrical experiences.

Similarities and differences between the two waves of independent theatres

The similarities and differences between the two waves of new theatres can be compared by considering three subsystems—institutional principles, financing, and aesthetics—all of which are involved with the production, distribution, and reception domains.

The collapse of the Soviet Union reshaped not just politics and the economy but also everyday life. In this radical period of transition, theatre lost its social role. Despite the fact that the state decided to continue to support the existing state theatres (none of them were closed by the new Estonian government), the subsidies started shrinking, also due to rising inflation at the beginning of the 1990s. The private theatres that emerged were at first marginalised and not considered as competition (either for state money or audiences) by the state theatres. However, as soon as the independent theatres proved themselves aesthetically, they were considered serious partners by the Ministry of Culture and started to receive state financing. The success of the new theatres showed that so called 'alternative artforms' were accepted by audiences and critics, encouraging the state theatres to follow some of their practices (summer productions, use of freelancers, different marketing strategies). At the same time, the independent theatres themselves became institutionalised as theatre organisations with their own venues and small but permanent troupes. The first-wave theatres slowly but surely changed the habitus of the field, making it much easier for the third-wave theatres to enter the field because juridical and economic platforms were established.

The theatres of the third wave could not change the theatre field as radically because the field itself was already much more diversified. The third-wave theatres were established during a period of intra-systemic economic crises, but not in the midst of the cultural crisis that characterised the first period. The theatres of third wave emerged in the capitalist economy despite the economic crises, not because of it. The founders of these theatres had not been denied positions at the state theatres but were either not interested in working or not welcome in big institutions. The driving force was the urge to do theatre rather than to make money. The third-wave theatres were more reluctant to become institutionalised. In contrast to the first-wave theatres, which tended to be managed more centrally by their creative leaders, the third-wave theatres are more informal and open to newcomers.

Many of the newcomers of both waves come from backgrounds that differ from those of most of the actors and directors active in the traditional state theatres that originated under the old Soviet regime. The theatre field shows that crises open up new modes of participating in theatre production, thereby changing the field conditions. Both waves brought new modes of theatre-making and styles into being. Aesthetically, the first-wave theatres had greater opportunity to produce something new while the third-wave theatres were aesthetically closer to the theatres that already existed in the theatre field, not least because, at the end of the 2000s, the theatre field itself was much more varied as in styles than in the turn of the 1980–90s.

Both the first and the third waves of theatres were often established through the enthusiasm of theatre-makers, despite not being funded by the state (at least in the beginning). The new theatre groups initially tended to be positioned at the margins of the theatre field, but their ambitions grew during the course of their activities and, with them, the inclination to become institutionalised and receive steady state subsidies. Officially, this was made possible for the first time in 1997 when the Performing Arts Institutions Act stated that independent theatres were eligible for financing, if deemed 'important in the context of natural culture'. The

act also stated that, whether state or private, a theatre can apply for state subsidy based on the same rules. However, the last years have seen a constant discussion (for example, Reidolv 2016) about whether the 4% of the state subsidies that go to private and project theatres is sufficient (96% of the money is distributed among eight state-owned theatre foundations).

Only 2 of the third-wave theatres receive an annual state subsidy, but the number of private theatres getting a state subsidy had risen to 15 (and the total number of independent theatres to approximately 30) by 2017 (Teatrielu kroonika 2017). Thus, there are more theatres competing for limited state subsidies, which make it possible to have a venue and a troupe, while, at the same time, the number of freelance actors who are eager to work on temporary rather than permanent contracts has grown as well. Understanding the limited amount of money the state distributes to the growing number of applicants, the theatres have also found alternative ways to finance their activities (recruiting sponsors, room rentals, organising parties, theatre courses, etc.).

During both waves, the reception domain was affected by a drop in the audience numbers. In both cases, the decrease was due to economic crises that created obstacles to citizens attending the theatre. However, in both cases, the new emerging theatres attracted new audience groups who were looking for different kinds of aesthetic experiences than those that had been previously available to them. Different from the large older theatres, which have to cater for the widest range of tastes, ranging from children to seniors, the new theatres could look for their own target groups with more specific interests and tastes in terms of their aesthetic preferences.

Most of the theatres created still exist today, which indicates that they have secured their audiences and found ways of financing their activity. Economic crises are usually accompanied by social crises that affect society as a whole, making both theatre-makers and potential audiences in the transition society more sensitive and open to exploration. Estonian contemporary theatre history shows that, during periods of economic crises, the theatre might unexpectedly undergo a quantitative boost, often acquiring new institutional and aesthetic dimensions.

Notes

This work was supported by the European Regional Development Fund (Centre of Excellence in Estonian Studies, TK145) and the University of Tartu (grant PHVKU20933).

1 The terms *theatre* and *group* are used synonymously in the chapter as it is often difficult to distinguish between them and because free groups in Estonia tend to institutionalise into theatres.
2 The second wave took place at the beginning of the 2000s as this was a time of economic growth in Estonia, but it will be left out of this chapter. In addition, after 2010, several new private and project theatres were established, but there is not sufficient temporal distance to see any patterns.
3 The period between 1987 and 1991 combines the different social and political movements and changes that took place in the three Baltic countries. The literal reference is to the mass events in 1988 that brought together around 300,000 persons to sing patriotic songs as a form of protest against political, economic, and cultural sovietisation.

4 The GDP of the Soviet Union decreased 2.4% in 1990 and 15.1% in 1991 (Hanson 2003, 236). Estonia declared itself independent in August 1991. In 1992, the GDP of the new state decreased approximately 15%, but it turned into growth (3%) by the next year. Nevertheless, the inflation rate in Estonia was 1053% in 1992 and 35.6% in 1993 (Annual Report 1993).
5 There were actually more theatres established during this period, but they were either short-term projects or amateur groups and therefore not included here.
6 The Estonian Cultural Endowment supports theatre projects and independent groups. It was established in 1925, shut down during Soviet era, and re-established in 1994. It has remained the main financial source of new performative initiatives.
7 Since all graduates of theatre schools had placements in state theatres, there were very few freelancers in the field until the turn of the century. Found spaces inscribe aesthetic limitations when used for a longer period.
8 Contemporary and modern dance was forbidden in the Soviet Union, but elements of both can be found in ballet, cabaret, and circus performances.
9 Estonian theatre training has been based on the Stanislavski system since the 1950s.
10 The Võru City Theatre was operating as a municipal theatre and was partly funded by the local municipality.
11 Most of the program is international, and, because of the limited state funding, the venue is rented out for other cultural activities like concerts, seminars, etc. This is done at the expense of rehearsal time.
12 For a long period, the number of visits (at least 800,000 annually in a population of 1.3 million) has been one of the goals of theatre politics in Estonia.

References

Annual Report. 1993. "Estonian Economy in 1993." *Eesti Pank*. Accessed August 3, 2019. www.eestipank.ee/en/annual-report-1993-estonian-economy-1993.
Bourdieu, Pierre. 1993. *The Field of Cultural Production, Or: The Economic World Reversed*. Edited and Introduced by Randan Johnson. New York: Columbia University Press, 29–73.
Eesti inimarengu aruanne. 1999. Accessed August 3, 2019. http://lin2.tlu.ee/~teap/nhdr/1999/EIA99est.pdf.
Eesti teatristatistika. 2013. "Estonian Theatre Agency." Accessed August 3, 2019. http://statistika.teater.ee/stat/main/show/29.
Elliott, John E., and Abu F. Dowlah. 1993. "Transition Crises in the Post-Soviet Era." *Journal of Economic Issues* 27, no. 2: 527–536.
Epner, Luule. 2016. "Pildi kokkupanek. Nüüdisteatri kaks aastakümmet." In *Vaateid Eesti nüüdisteatrile*, edited by L. Epner, M. Pesti, and R. Oruaas, 24–52. Tartu: Tartu Ülikooli Kirjastus.
Epner, Luule. Forthcoming. *Teatriprotsess*. Eesti nüüdisteater 1986–2006 (manuscript). Edited by A. Saro and L. Epner. Eesti Teatriliit, Tartu Ülikool.
Friedrich, Peter, and Janno Reiljan. 2015. "Estonian Economic Policy during Global Financial Crises." *CESifo Forum* 4: 37–44.
Hanson, Philip. 2003. *The Rise and Fall of the Soviet Economy: An Economic History of the USSR 1945–1991*. London: Routledge.
Karulin, Ott. 2013. "Rakvere Teater 'täismängude' otsinguil aastail 1985–2009." PhD diss., University of Tartu.
Lauristin, Marju, and Peeter Vihalemm. 2017. "1.3 Eesti tee stagnaajast tänapäeva: sotsiaalteaduslik vaade kolme aasta arengutele." In *Eesti ühiskond kiirenevas ajas. Uuringu*

"Mina. Maailm. Meedia" 2002–2014 tulemused, edited by P. Vihalemm, M. Lauristin, V. Kalmus and T. Vihalemm, 60–95. Tartu: Tartu Ülikooli Kirjastus.

"Manifesto of Polygon Theatre." Accessed August 3, 2019. www.polygon.ee/teater/nagemus/.

"Manifesto of Tartu New Theatre." Accessed August 3, 2019. www.uusteater.ee/teater/manifest.

Narusk, Anu. 1996. "Gendered Outcomes of Transition in Estonia." *The Finnish Review of East European Studies* 3–4: 12–39.

Oja, Kaarel. 2010. "Erateatrite etendustegevuste mahud 2004–2010." *Eesti teatristatistika 2010*. Eesti Teatri Agentuur, 95–98.

Podkul, Cezary. 2018. "10 Years after the Crises." *Wall Street Journal*, March 28, 2018. Accessed August 3, 2019. http://graphics.wsj.com/how-the-world-has-changed-since-2008-financial-crisis/.

Ramskogler, Paul. 2014. "Tracing the Origins of the Financial Crises." *OECD Journal: Financial Market Trends*. Published online, 47–61. http://dx.doi.org/10.1787/fmt-2014-5js3dqmsl4br.

Reidolv, Kristiina. 2016. "Otsides teatrivälja tasakaalupunkti." In *Teatrielu 2015*, edited by O. Karulin and L. Nigu, 277–281. Tallinn: Eesti Teatriliit.

Rupnik, Jacques. 2010. "Twenty Years of Postcommunism: In Search of A New Model." *Journal of Democracy* 21, no. 1: 105–112.

Saro, Anneli. 2004. "Formation of Events: Estonian theatre and Society under Loupe." In *Theatrical Events: Borders, Dynamics, Frames*, edited by V. A Cremona, P. Eversmann, H. van Maanen, W. Sauter, and J. Tulloch, 343–356. Amsterdam and New York: Rodopi.

Saro, Anneli. 2010. "Eesti teatrisüsteemi dünaamika." In *Interaktsioonid. Eesti teater ja ühiskond aastail 1985–2010*, edited by A. Saro and L. Epner, 8–36. Tartu: Tartu Ülikooli kultuuriteaduste ja kunstide instituut.

Teatrielu kroonika. 2017. "Estonian Theatre Agengy Webpage." Accessed August 3, 2019. http://statistika.teater.ee/images/upload/statistika_aastaraamat_12.pdf.

Theatrum. "Webpage of Theatrum." Accessed August 3, 2019. www.theatrum.ee/tutvustus/.

Van Maanen, Hans. 2009. *How to Study Artworlds: On the Societal Functioning of the Arts*. Amsterdam: Amsterdam University Press.

Viller, Jaak. 2004. "Teatriorganisatsiooni areng Eestis XX sajandi II poolel." MA thesis, University of Tartu.

World Bank. 1999. "Estonia: Implementing the EU Accession Agenda." *A World Bank Country Study*. Washington, DC: World Bank.

12 Cultural struggles in Slovenian institutional and independent theatre[1]

Maja Šorli and Zala Dobovšek

In her article 'The Volksbühne Affair: Theatre and the Cultural Struggle', Bojana Kunst lucidly analyses the struggle to lead the Volksbühne Theatre in Berlin that took place from 2013 to 2017, in which Chris Dercon and Frank Castorf personified ideological and cultural differences in the production of contemporary art. The famous director Castorf, who had led the Berlin theatre since 1992, was succeeded in the autumn of 2017 by Dercon, previously the director of the Tate Modern in London and one of the best-known modern art curators. Kunst describes the controversy as 'a cultural struggle symptomatic of its time, particularly when thought of in relation to the social role of contemporary art institutions and their economic and political transformation' (Kunst 2018, 17; see also Boenisch on his interview with Dercon in this book). Among other things, she describes the paradoxical yet indivisible links of aesthetic, institutional, and political dimensions; the confrontation between dance and theatre; and the confrontation between their conventional institutional models: a permanent house with a theatre ensemble versus a project-based, flexible, and precarious model of production—two models that, as Kunst points out, are 'connected with aesthetic expression': that is, the word and language versus the dancing body. She concludes her analysis with: 'It is, in fact, a conflict on the production of art, which is in no way fluid, simultaneous and non-hierarchical, but involves extreme inequalities, power relations, exploitations and destructions of the contemporaneity and presence of the other' (Kunst 2018, 23).

In Slovenia, a comparable cultural struggle in the production of art has been present since its independence in 1991 and even before. In the 1990s, the change of the law enabled individuals (especially artists and other creatives) to establish their own private institutes, which have a special non-profit, non-governmental status allowing them to work in the field of culture and apply for public funding tenders for their partial support, although they 'should primarily carry out a commercial function' (Pogačar 2016, 17). Along with the newly forming and rapidly growing independent scene, the emergence of new performing practices (physical theatre, contemporary dance, intermedia arts, performance, etc.) expanded the aesthetic field and subsequently became the antagonists to the repertoires of public institutions, which were dominated by dramatic theatre. Private institutes are also mostly state funded but to a much lesser extent than the institutional

repertoire theatres. After the global financial collapse of 2008, inequality, exploitation, and hierarchy deepened in the two opposing domains of the theatre system. This chapter will present how the Slovenian institutional and non-institutional theatres responded to the global financial crisis. Its consequences reflect the amalgam of aesthetic, media, and political problems in Slovenian theatre production and will be analysed in selected cases. At the institutional pole, we recognise this in the performance *Ubu the King*, which delved into the entrenched aesthetic and repertoire politics of the Slovenian National Theatre Drama Ljubljana. In the independent scene, however, due to its diversity, we highlight several typical examples.

We first present the Slovenian theatre system, then the aspects of crisis in Slovenian national theatres as reflected in *Ubu the King*, and we complete the picture of the cultural struggle with a sketch of the independent theatre scene.

Professional theatre productions and events in the field of performing arts in Slovenia are carried out by public institutions, private institutes known as the independent theatre scene, and individual artists. The 13 public performing arts institutions which receive most of their funding from the state budget constitute an informal network of Slovenian institutional theatres. This includes three Slovenian national theatres, nine municipal public theatres (of which two are puppet theatres and two can be classified as post-dramatic), and the Slovene Permanent Theatre in Trieste in Italy. The employees in the public institutions are part of the system of state and municipal employees; this allows the artists permanent full-time employment as well. Although it is a rigid and inflexible system, the actors, dramaturgs, directors, and language consultants employed in public theatres are in a markedly privileged position with respect to the independent theatre scene and the self-employed cultural workers. Public employees are entitled to paid contributions for social and pension security, 12 months of salary, and a holiday bonus every year. They are financed via a direct annual government allocation: each year, they are required to present their programme and financial plan to the Ministry of Culture. All the listed public institutions get funded, but the level of financing depends on the sum allocated to them in the budget of any particular year. On the other side of the system are about 40 different private institutes, which receive funding from the state budget but, all together, receive less than 10% of the money allotted to the performing arts. Private institutes are financed via public tenders, and the distribution of funds is determined by an expert committee (similar to the German system; cf. Wenner 2015, 132). The committee is nominated by the minister for culture for a period of three or five years, and the criteria by which the commission evaluates the programmes are roughly set out in the tenders. Since the budget is limited, many independent organisations do not get funded. The tender in 2018 also included a stipulation (which was abolished in 2019) that an organisation must have had at least two reviews in the last three years in relevant media to be considered for evaluation. Because of the decreasing space for professional reviews, even some more established companies do not receive two reviews. Another significant problem of the independent theatre scene is the lack of rehearsal and performance spaces: most of these spaces are

owned by the city of Ljubljana and managed by selected organisations; the non-governmental companies can apply to use some of them via tenders.

The notion of crisis in institutions and in the independent sector

In this chapter, we refer to *crisis* in the etymological sense—coming from a crucial stage or turning point in the course of something, especially in a sequence of events or a disease—a meaning which was later generalised into an unstable situation of extreme danger or difficulty.

As has been indicated so far, the difficult situation in Slovenian theatre followed the global financial meltdown of 2008. This was influenced by various factors: economic (less money was allocated to the state budget for the theatre arts, media related (less money and less space were available for reflecting theatre, as well as a general decline in interest in theatre due to different leisure-time activities), systemic (deepening the differences between text-based theatre and classical forms, such as ballet and opera, and new theatre forms), political (the rise of the market dictatorship in smaller countries such as Slovenia threatens the development of theatre), and so forth.

The reduced funding of theatre always cuts into the (artistic) production, but individual production systems, due to different methods of subsidies and state support, responded to the financial crisis quite differently. Between 2010 and 2018, theatres operating as public institutions initially saw salary cuts, halting promotions and freezing fees for external collaborators, but to this day, financial impediments can mostly be seen as reduced funds for material needs: for example, reduced budgets for stage and costume designs and modern AV effects, which then appear as 'reduced artistic realisation' in the end results and the aesthetics of the production. Likewise, public institutional theatres tour less frequently than in the period prior to 2008, which prevents the wider promotion of Slovenian theatre in the international field, and they also lack funding to invite foreign theatres and productions to Slovenia. International and intercultural permeability is inconsistent, and the tours that do happen often turn out to be compromises, as only productions with small casts and simple technical requirements are able to secure invitations.

The financial cuts and the austerity measures that accompanied them also meant that the public institutions simply could not allow for external independent collaborators, because that would have greatly increased the cost of many productions. This tendency shrinks the creative space and the 'creative cross-pollination' between permanent ensembles and guest actors from the independent scene. On the other side, recently, a trend of collaboration between public theatre institutions has become prominent. The lack of success of these co-productions has triggered the questioning and problematising of such collaborations. This opens the question of whether such moves are aimed at truly expanding the creative space or simply economising the repertoire and sharing costs.

On the other hand, the ongoing crisis of funding is far more apparent in the independent production sphere, and its critical consequences are deeper and more

far-reaching; they influence practically all segments of theatre production, from production, creative processes, and promotion to post-production. The crisis in the non-government sector is all encompassing: financial limitations impose poor conditions when it comes to fees, material, space needs, and post-production. The poor and unstable financing of private institutes leads to underpaid organisational and creative teams, who, over the last decade, have been involved in a constant struggle for normal working conditions across all fields of the sector: creation, research, marketing, reflection, education, and audience development. The already-mentioned decreasing space for professional reviews adds to this as the media are unable to provide a coherent reflection on independent arts groups and even public theatres located outside of the capital city.

So far, we have described the consequences of an economic crisis, which are distinctly reflected in the aesthetic level. In her essay 'Some Words about the Theatre Today', Roberta Levitow ascribes complexity to the notion of crisis in the performing arts as the crisis in art always implicitly comes from or is created because of a cluster of the global crisis of society, the crisis of values, and the crisis of political systems (2002). Although the author uses her own environment in the US to formulate her theses, we can recognise in them strong structural and content-based similarities to the European environment. One of the weaknesses visible within performing arts practices is reflected in the poor permeability between theatre and everyday life—that is, between societal problems and conflicts and performance arts—whereas other media, such as film, television, and the internet, are able to react to the social reality faster and reflect it more deliberately, thus gaining more attention (Levitow 2002, 26).

This spectrum of the crisis in performing arts was addressed in the Slovenian production *Ubu the King*, whose content dealt directly and daringly with the Slovenian political and cultural situation, which is rarely seen in public theatre institutions.

Ubu the King: a representation of 'off theatre' in the institutional theatre

Ubu the King was conceived by Jernej Lorenci, the director of the performance and the recipient of the 2017 Europe Theatre Prize (for New) Theatrical Realities. This was the first devised piece on the prominent stage of the Slovenian National Theatre Drama Ljubljana (SNT Drama Theatre); it premiered on 30 January 2016. In the 2015–16 theatre season (September 2015 to June 2016), Lorenci directed three performances on repertory stages that abandoned the dramatic text, but only one sparked public debate. By using the principles of devised theatre and thoroughly rejecting the brand-new translation of Alfred Jarry's text, *Ubu* triggered heated media responses in a way that paralleled the 'Volksbühne Affair'.

Ubu the King appropriated some significant points of the repertory politics in the central national theatre. First, there was the staging of a devised piece about *merdre* on the eminent main stage for the annual ticket subscribers, thus reaching the widest generational spectrum of the audience. The performance was staging

contemporary ways of 'being Ubu', especially the abuse of power. It irritated the (Slovenian) authorities, especially when it commented on the European migrant crisis and the building of a razor-wire fence along Slovenia's borders to control the flow of migrants two months before the premiere. In parallel with the substantive provocations about this broader social crisis, *Ubu the King* exposes similar patterns of territorial defenses in the Slovenian theatre system: the prevalence of text-based theatre over any other form or genre in Slovenian public theatres (we later refer to devised theatre, improvisation, *kleinkunst*, the Cool Fun genre, etc.), the choice of actors and acting methods, and the expectations of the professional and general spectators.

Let us study these points one by one. Devised theatre is a common theatre practice all over the world, including Slovenia, where it is prevalent in the independent scene. Similar to, for example, the United Kingdom, the beginnings of such theatre in Slovenia could be observed at the end of the 1960s (or perhaps a decade earlier; see Heddon and Milling 2006) in some practices which could easily be called avant-garde, experimental, non-institutional, or alternative. *Devised theatre* is a broad umbrella term, which does not define a particular genre or performing style (Govan, Nicholson, and Normington 2007, 4). It is characteristically a performance that results from a team of collaborators who invent, adapt, and create new work—devising it cooperatively. Emphasis is placed on the eclectic process that requires innovation, imagination, risk, and above all, group commitment to the emerging work (Oddey 2007, 1–3). In other words, 'devising implies that the dramaturgy of the work is not defined before the work commences' (Turner and Behrndt 2008, 272). Devised theatre is, in essence, an alternative to the mainstream drama tradition, which often dominated by hierarchical and patriarchal relationships, with the director and the playwright at the top. But very soon, and particularly in the 1990s, even in devised theatre, the roles started to shape themselves more hierarchically as a response to the changing economic and artistic climate. In the 1990s, devised theatre had less radical political implications and imposed a division of labour based on abilities, the specialisation of roles, and more responsibilities for directors or group leaders and their producers (Oddey 2007, 5–9). In Slovenia, several performances of this type were created as early as the 1980s (for example, *Missa in a-minor* by Ljubiša Ristić and *I am not I (Part I)* by Vito Taufer, both at the Mladinsko Theatre, and *Baptism Under Triglav* by Dragan Živadinov in *Cankarjev dom*), and they flourished in the 1990s, particularly in independent theatre. *Ubu the King* is thus the heir to the authorial practices of the 1990s but also more contemporary ones: for example, the independent group *Via Negativa*, led by director Bojan Jablanovec, and works by director Oliver Frljić, who always creates in public theatres in Slovenia.

The motifs for the performance derived from Alfred Jarry's text from 1896, but the performance did not stage the original text. The starting point was the idea of staging *merdre*, simultaneous eating and shitting in all the metaphorical meanings that both of Jarry's texts about Ubu are imbued with and that the creators of the performance believed characterised contemporary society. The performance of *Ubu the King* consisted of around 20 scenes in two parts. It was approximately

two hours and 45 minutes long; the second part was only an hour long and more concise in content. The performance had one interval, which functioned as a music gig. During this interval, the audience was invited to join the banquet onstage and could follow the second part of the performance from the seats on the stage.

The cast of the performance included seven actors and two actresses, four of whom were known to the wider Slovenian audience as television show hosts. The character of Papa Ubu was played by one of Slovenia's best-known actors Jernej Šugman, who frequently appeared in Slovenian TV series and films. (Šugman died following a heart attack in December 2017.) Throughout the performance, at least three other well-known TV actors appeared, in roles that required them to recycle their entertainment TV appearances. For example, one of them, Klemen Slakonja, a 34-year-old comedian, impressionist, and television host, explained to the audience the story of his professional career: that he started to work in television as a student at the Academy (of Theatre, Radio, Film, and Television) in Ljubljana, eventually gaining recognition that brought him offers for employment from all the Slovenian theatres. He chose the most prestigious repertory theatre, but, he complained, no matter what he did on the stage, no matter what character he played, he would always be seen by audiences as performing the image of himself as presented on television shows. Even the theatre programme listed him under his own name, while other actors were listed according to their roles. In any case, the cast of television personalities and, thus, the intrusion of popular culture into the so-called 'elite' culture caused an influx of 'entertainment', which was 'improper' in the national theatre. With this, the performance triggered self-criticism from the performers of *Ubu the King* towards the SNT Drama Theatre as an institution and its audience, which valued actors for their show business work much more highly than for their artistic labour. In the first place, the performance of *Ubu the King* dealt with exactly this: the function, evaluation, and effects of entertainment within a space and context in which we did not expect them. When the performing principles of two (potentially competitive or antagonistic) media—theatre and television—merged, a parallel and autonomous insight into the actual performing capacities of individual actors appeared. For many performers, their fundamental motives for attracting the attention of theatre audiences lay not in exploring performing practice, but in building in their TV personas.

If we stay with the acting method a little longer, the performance included a large number of improvised scenes in which the actor's presence overwhelmed the representation of a character (Fischer-Lichte 2008, 147–150). Considering the relationship to the drama-based tradition and the institution, using performative practices was certainly a risk in most Slovenian repertory theatres. An actor working in these public institutions had, as a rule, been educated at the Academy of Theatre, Radio, Film, and Television of the University of Ljubljana in a variation of a Stanislavskian, psychological approach to acting. The ensemble based in repertory theatres is thus trained in interpreting characters, dramatic situations, and circumstances, using their own interpretation of a text somebody else has written. Years of performing in professional ensembles were dedicated to nurturing the skill, based primarily on the successful psychological recreation of the

vision dictated by the text, the director, and others. On the other hand, the devised principle in *Ubu the King*, which came from a loosely sketched idea of staging contemporary *merdre*, stripped the repertory actors of the method they knew best and had used more or less successfully through most of their careers.

This type of acting brought so-called 'imperfection' into the performance, which was not supposed to belong on national stages. But as Jens Roselt writes, when we talk about the theatralisation and mediatisation of the everyday, the non-perfect in theatre promotes an aesthetic practice whose objective is producing not a perfect illusion but a confrontation with existing everyday life—with intervention and selection. So it is not merely about creation but about confrontation (Roselt 2014, 390). This is what *Ubu the King* staged.

Ubu the King in the national theatre, in fact, succeeded in doing the same thing Jarry managed to do during the play's original staging: split opinions and cause indignation, disdain, shock, enthusiasm and most importantly, weeks of public polemics and discussions in newspapers and the (now-online) media. The performance attracted large audiences. The positive media responses recognised the courage, risk, and provocativeness of the piece, while negative press coverage claimed the performance did not offer 'the possibility of rising from the "merdre" of everyday banalities and bizarreness' and that it 'co-produce[d] this general perversion'. Above all, the performance was criticised for being a kind of kitsch that 'remained on the level of tasteless stand-up comedy', that the director 'degraded' the avant-garde performance of the theatre of the absurd into 'third-rate cabaret numbers of a provincial entertainment venue' and 'in the style of vulgar television reality shows flattened it into cheap entertainment', and that everything turned into a 'loud parade of the director's narcissist egotism and profane histrionics' (Šorli and Dobovšek 2016, 22).

To those who rejected it, *Ubu the King* was too reminiscent of *kleinkunst*: a theatre style that includes cabaret, stand-up comedy, improvisational theatre, and similar genres (Toome and Saro 2015, 261). *Kleinkunst* is thus recognisably different from drama or spoken theatre, but it also has some important similarities to it. In a survey of theatre audiences performed over several years in four European countries called the STEP City Study, the researchers (including the present authors) found that the audience experienced spoken theatre and *kleinkunst* as the most socially relevant types of theatre and *kleinkunst* as the most personally relevant (Wilders *et al.* 2015, 321–322). *Ubu the King* was not a *kleinkunst* piece; rather, it used its methods to create a bridge between art and societal conflicts. Had the listed objections failed to notice the subversive affirmation and thus overlooked the overlap in which *Ubu the King* was the most engaged?

Ubu the King, at the same time, exemplified the principles of the 'Cool Fun' genre, as defined by Hans-Thies Lehmann (2006, 118–122). This branch of the theatre goes back to the 1980s and 1990s. The spectator follows the course of events composed of allusions, quotations, and counter-quotations; insider jokes based on TV, film, and pop music motifs; funny episodes that both keep an ironic distance and are sarcastic and cynical, without illusions and 'cool' in tone. This genre of theatre is designed to reflexively mimic the omnipresent media with their

suggestion of immediacy but, at the same time, look for a different form of public and detect the melancholy, loneliness, and despair behind the surface playfulness.

The meta-language in *Ubu the King* did not come from the performers, but rather from the methodological approach of the director, who placed the actors within the system in which the performers remained 'themselves' (television figures). It was only the structure of the event that elevated them to the performative model, which still uses the elements of entertainment but with the purpose of looking at it from another perspective, evaluating it, or even criticising it.

Since the production was created on the principles of devised theatre and improvisation, it offered freedom to the performers to ad-lib themes. While reflecting on political problems, the production wanted to establish a community as an antipode to the contemporary crises—not only onstage but also in the auditorium. The performance thus wanted to revolt against the atomised dynamics of contemporary society and the crisis of individualism and conceive the (national) theatre as a space that breaks through the stage convention of 'us and others' while also flirting with criticism of the discourse of the public itself and its ideological, racial, and gender segregations on an everyday level.

The battles of *Ubu the King* were temporary; the struggle in the independent scene is permanent

In the media, *Ubu the King* called into question the mission, identity, and aesthetic and value hierarchy of public cultural institutions as it embraced methods and content that were largely staged in the independent scene. In addition to employing the principle of devised theatre and the straightforward addressing of social problems, the creative team hired Gregor Zorc, one of the most established and profiled freelance actors. His performance in *Ubu the King* had a significant impact on the previously described spectrum of realistic-psychological and TV-entertainment approaches to acting and, consequently, on the performance as a whole as his strategies enabled perceptual multi-stability (Fischer-Lichte 2008, 148). His presence could also be understood on a symbolic level as an indication of the association of the independent theatre with the institutional one. However, an equal coalition between public institutions and the independent scene has proved impossible since no significant changes have taken place in the theatre system in the last decade, and an event that would distinguish the Slovenian theatre space as *Ubu the King* did has not been repeated. Public repertoire institutions insist on dramatic theatre, but at the same time, with neoliberal principles, they seek to please the audience rather than problematise their own production conditions of creation.

Unlike in the public theatre institutions, where consistent public funding enables stability, the economic conditions in the non-government sector are far more severe. The financial crisis and the simultaneously growing influence of neoliberal capitalism have contributed to a sense of insecurity that has infiltrated the production mechanisms and contents of the independent scene. The discerning stance of the independent performing scene draws attention to the wide range of

social and cultural anomalies. Frequently, performances created in the independent scene contain personal, documentary contributions devised as self-referential commentaries on the performance as well as the theatre system. Consequently, in recent years, there have been several productions fully dedicated to the questions and problems of the non-government sector or the conditions of artists without full-time employment.

One of these productions was *All Together Now!* (2013), directed by Mare Bulc, which tackled existential questions about emigration. The topic originated from the actual discussion of the impossible working conditions in the cultural sector at home and anxious dilemmas about whether to leave for abroad or to persist and 'win' integrity at home. Although the performance originally provoked its audience with the idea of necessary emigration (searching for better opportunities abroad), it retrospectively solidified the principle that power rests with the decision to stay. The performance thus supported the thesis that social and political resistance is not to be found only in pushing away and contradicting, but also in persisting in a certain (crisis) situation.

The renowned film and intermedia artist Ema Kugler has publicly warned about the incessant structural and legal irregularities in the independent sector. Despite her status and international acclaim, she often does not receive enough funding for her work, even if only symbolic at times, and sometimes she receives none at all. With her performance *Silence* (2016), she warned, through the negation of an artistic event, about the insufferable conditions in independent cultural production. Instead of staging a spectacle, she performed herself in her working space. Kugler's project *Silence* was, in fact, a scream: a minutes-long statement by the artist, sincere and vulnerable, but also furious and belligerent. This stance that the artist takes, and that at the same time sums up the positions of most non-government organisations, may well be a rebellious one, but it is moreover a gesture of despair, pessimism within an anxious dilemma of 'stay or go'. It is no longer simply about (technical) cutting or withholding subsidies; it is about the gradual destruction of artists' identities (Dobovšek 2016).

The insecure, precarious working conditions become even more problematic when intersected with gender, motherhood, age, and the self-employed status of female artists. There have been several productions in the independent scene dealing with this theme that questioned and tried to redefine the self-referencing position of the artist as she has to constantly struggle for creative agility and financial sustainability. The examination of female positions in contemporary performing practices falls under those 'marginalised' topics that often find their way onstage and are problematised only on the condition that the author (in her personal life) is directly a part of the situation. Performances by Simona Semenič; Maja Delak's *What If* (2013); Teja Reba's *Made with Love* (2015); and *Ideal* (2017) by Pia Brezavšček, Barbara Kranjc Avdić, and Saška Rakef as well as many others can be understood as liberation, but also as distress.

All the previously studied aesthetic and artistic questions, as well as topics of gender, migration, precariousness, and class, have been reflected since 2013 in the ongoing techno-burlesque project *Image Snatchers*, which merges different

kleinkunst genres and themes and uses them to react, through a queer optic, to actual cultural and political events. *Image Snatchers* is performed by some of the most visible artists of the Slovenian independent scene around five times a year, which allows them both to repeat existing content and to introduce new material. The shows are performed in a small alternative and underground club at the Autonomous Cultural Centre Metelkova Mesto. In short scenes and songs, they present content that appears in both institutional and non-institutional theatres, but it is the comparison to *Ubu the King* that shows the latter's avoidance of certain content, such as LGBTQI practices, feminism, and precarity in certain performing practices. Despite reaching beyond certain frames of institutional theatre, *Ubu* remains conservative and non-critical of such inequalities when it comes to dealing with gender roles and related content.

Ubu the King on the main stage of the central Slovenian theatre institution created a serious seismic shift or a test of the actual situation and the performing methods in SNT Drama Ljubljana, although within the Slovenian theatre landscape, these were not new procedures. As we have already explained, these procedures have been an established practice of the independent scene and also of, for example, the Mladinsko Theatre in Ljubljana, which stands out among the institutions for its ensemble playing as well as for its research into different performing formats and politically engaged content. It is therefore not surprising that it was on the premises of the Mladinsko that the project *Nova pošta* (*New Post Office*) came to life in 2017 and was conceived as a long-term collaboration between a theatre institution and the private institute Maska. Their merging can, at first glance, be read in the positive light of a 'solidarity' measure in which a theatre with a guaranteed budget welcomes under its roof a financially insecure independent organisation, but it is really the introduction of solvency on a collegial level instead of it happening on a state level. *New Post Office* is an experimental project not only on the level of creativity but also as a production model. As they mention on their home page, the guiding principle of their team is the idea that

> they should take artistic risks and try to move beyond the standardisation that increasingly restricts the ways of working in art and forces the final artistic objects into the predictable frames, which means that their social echo is barely perceptible or non-existent.
>
> (Nova pošta n.d.)

Such an ethically engaged gesture thus merges the two different production models of the Slovenian theatre system.

Conclusion

In this chapter, the example of *Ubu the King* reveals the effects of the global financial meltdown after 2008 on the Slovenian theatre system as a whole. Crisis, which is understood in the generic sense as a difficult situation, is caused by many factors, but we were most interested in how theatre reflects social problems and

growing inequalities, power relations, and exploitations that are also present in the production of art.

Ubu the King cut deeply into the established understanding of the function of the central national theatre but did not cause any major changes in it. However, the consequences began to manifest themselves at other levels throughout the field: at the main national theatre festival (Maribor Theatre festival) in 2017, many awards were given to independent productions, and the trend of devised theatre as an escape from hierarchical functioning is gradually being transmitted to institutions, mainly through the younger generation.

The cultural struggle within the theatre field in Slovenia, which resembles the 'Volksbühne affair' mentioned at the beginning of this chapter, still remains between institutional theatres and the independent scene. The former are provided with both infrastructure and regular financing while the independent scene is deprived and uncertain in both areas. Cultural struggle also takes place in understanding the role of contemporary art, which, unlike institutional theatre, sees the necessity of sharp criticism of existing social relations as well as self-criticism. Bojana Kunst concludes her analysis of the 'Volksbühne affair' with faith: 'If inequality in production and power relations gives new insight into the ways in which theatre is produced and opens up different spirits of theatre language, there is still hope left' (2018, 23). In recent years, the polemics about inequality between the institutions and the independent scene have been increasingly present with the main funding body, the Ministry of Culture, and perhaps it is the convergence of these two models that can provide an escape from a future crisis in the Slovenian theatre.

Note

1 Parts of this chapter have already been published in Slovenian by Šorli and Dobovšek (2016) with the title '*Ubu the King*—the Shock of Devised Theatre in a National Institution'. This research has been supported by the Slovenian Research Agency (project no. P6–0376, Theatre and Interart Research programme).

References

Dobovšek, Zala. "Tišina, ki vse pove." *Dnevnik*, December 29, 2016. Accessed May 3, 2019. www.dnevnik.si/1042758019.
Fischer-Lichte, Erika. 2008. *The Transformative Power of Performance: A New Aesthetics*. London and New York: Routledge.
Govan, Emma, Helen Nicholson, and Katie Normington. 2007. *Making a Performance: Devising Histories and Contemporary Practices*. London and New York: Routledge.
Heddon, Deirdre, and Jane Milling. 2006. *Devising Performance: A Critical History*. Basingstoke and New York: Palgrave Macmillan.
Kunst, Bojana. 2018. "The Volksbühne Affair: Theatre and the Cultural Struggle." *Maska* 33, no. 193–194: 16–23.
Lehmann, Hans-Thies. 2006. *Postdramatic Theatre*. London and New York: Routledge.

Levitow, Roberta. 2002. "Some Words about the Theatre Today." In *Theatre in Crisis? Performance Manifestos for a New Century*, edited by Maria M. Delgado and Caridad Svich, 25–30. Manchester: Manchester University Press.
Nova pošta. n.d. Accessed August 1, 2019. www.maska.si/index.php?id=154&tx_ttnews [tt_news]=1288&cHash=bb7ac3d0446a9b549e55fa023be0f98a.
Oddey, Alison. 2007 [1994]. *Devising Theatre: A Practical and Theoretical Handbook*. London and New York: Routledge.
Pogačar, Tadej. 2016. "The Second Explosion: The Nineties: New Radical Practices." In *The Second Explosion: The 1990's*, edited by Tadej Pogačar, 10–29. Ljubljana: Zavod P.A.R.A.S.I.T.E.
Roselt, Jens. 2014. *Fenomenologija gledališča*. Ljubljana: Mestno gledališče ljubljansko.
Šorli Maja, and Zala Dobovšek. 2016. "Kralj Ubu—šok snovalnega gledališča v nacionalni instituciji" (Ubu the King: The Shock of Devised Theatre in a National Institution). *Amfiteater* 4, no. 2: 14–35. Accessed May 3, 2019. https://slogi.si/wp-content/uploads/2017/11/Amfiteater-4-2_Raz_1_Sorli_Dobovsek_SI.pdf.
Toome, Hedi-Liis, and Anneli Saro. 2015. "Theatre Production and Distribution in Different European Cities." *Amfiteater* 3, no. 1–2: 256–279. Accessed May 3, 2019. https://slogi.si/wp-content/uploads/2015/11/Amfiteater-Toome-and-Saro-1.pdf.
Turner, Cathy, and Synne K. Behrndt. 2008. *Dramaturgy and Performance*. Basingstoke: Palgrave Macmillan.
Wenner, Stefanie. 2015. "Subvention." In *Glossary 'On Institutions'*, edited by Pirkko Husemann, *Performance Research* 20, no. 4: 127–133. Accessed May 3, 2019. https://doi.org/10.1080/13528165.2015.1071058.
Wilders, Marline Lisette, Hedi-Liis Toome, Maja Šorli, Attila Szabó, and Antine Zijlstra. 2015. "'I Was Utterly Mesmerised': Audience Experiences of Different Theatre Types and Genres in Four European Cities." *Amfiteater* 3, no. 1–2: 304–343. Accessed May 3, 2019. https://slogi.si/wp-content/uploads/2015/11/Amfiteater-Wilders-Toome-%C5%A0orli-Szab%C3%B3-and-Zijlstra.pdf.

Part 4
Independent theatre scene

13 Promises and side effects
The Frankfurt theatre crisis of the 1990s—a case study

Lorenz Aggermann

In 1994, a few days before Christmas, a flyer promoting a quite unconventional event in Frankfurt announced that there would be a 'try-out' of the new TAT production *Repetition* with pianist Marie Goyette, guitarist John King, and actor Johan Leysen, composed and directed by Heiner Goebbels. It was not yet time for the premiere. There would be no elaborate staging, fixed composition, or polished performance. The work was not yet finished, although tickets had already been sold. The event would just be a rehearsal or, to be more precise, a 'repetition', according to the flyer. But the flyer did not merely refer to what was, back then, an unconventional form of theatrical performance, framed by two musical performances by the Ensemble Modern (of Heiner Goebbels's *Samplersuite* and *La Jalousie*). The organising institution that was responsible for both the flyer and the event deserves a closer look. The city's experimental theatre TAT—an acronym for Theater am Turm—was also being tested to a certain extent at the time. The TAT was a division of the municipal holding Frankfurter Kulturgesellschaft, which was on the brink of closure. At the end of 1994, the TAT would lose its premises, which were to be sold to the Cinestar cinema chain, as the city of Frankfurt, the financier and owner of the Kulturgesellschaft, was being forced to consolidate its municipal budget. Well-informed newspapers estimated that the city was more than DM400 million in debt. Instead of analysing this unconventional event and its innovative and influential aesthetics (see Meyer 2001 or, in general, Lehmann 1999), it is this flyer that has prompted me to map the organisational structures and economic principles of TAT, which have had a profound impact on its aesthetics but have been mostly overlooked in the shadow of illustrious art works and performances. This perspective will enable me to trace how the disbanding of the Kulturgesellschaft and, in particular, the dissolution of the TAT reinforced the view of it as an ideal theatre in times of financial and political crisis. Without a building or workshop, relieved of its financial burdens, the TAT became a model for the reformation of the municipal theatre in Frankfurt in the 1990s. In this respect, the flyer provides a precise snapshot of the socio-political and economic conditions of Frankfurt's cultural fabric at the time and the role of its intended theatre.

New aesthetics in town

From the late 1970s onwards, Frankfurt's cultural policy was governed by the paradigm of '*Kultur für alle*' ('culture for all'), invented and promulgated by

Hilmar Hoffmann, then the councillor for culture and the arts. In light of the rise of the leisure society (the idea that there was not enough work for all inhabitants and that a typical working day would last a maximum of four or five hours), the council of Frankfurt spent approximately DM80 million per year building new institutions in the heart of the city, such as the Schirn Kunsthalle and the Museum für moderne Kunst, and renovating old ones like the Alte Oper (Frankfurt's 19th-century opera house) and other venues and exhibition sites on Museumsufer, the museum quarter on the banks of the river Main. These investments were made in addition to a cultural budget of up to DM460 million per year. The annual budget for the Städtische Bühnen (Frankfurt's municipal theatres) was about DM120 million, and the budget of the Kulturgesellschaft, a new, hybrid institution that was founded in 1985, ran to approximately DM12 million. The Kulturgesellschaft combined a newly built exhibition space, the Schirn Kunsthalle; a conventional theatre, the former Landesbühne Rhein-Main, called Theater am Turm (TAT); and a summer festival that later became an off-space referred to as the off-off TAT, now known as the Mousonturm. Due to its managing director, Christoph Vitali, the Kulturgesellschaft was quite a success—first and foremost, the Schirn Kunsthalle, with up to 400,000 visitors per year. The TAT was planned within this framework as a theatre dedicated mainly to new forms of drama, but since the existing municipal theatre, the Schauspiel (drama theatre), already had a similar focus, this plan was altered. Vitali and his dramaturg, Tom Stromberg, decided to take an alternative approach and changed the programme. Instead of staging new plays, they invited different artists and companies to perform and experiment there: Heiner Goebbels, Michael Simon, Jan Lauwers, Jan Fabre, the Woostergroup, Rosas, LaLaLa Human steps, Jana Sterbak, Asta Gröting, Saburo Teshigawara, and others. In 1986, the TAT became one of the first examples of a co-production house, with partners in Amsterdam (Felix Meritis), Vienna (Wiener Festwochen), Berlin (Hebbel-Theater), and Brussels (Kaai-Theater) (see Elfert 2009, 36–37). Co-production meant not so much producing shows together as selling them to one another and thereby minimising the economic risk. Although there was some harsh critique of this model in the beginning—mainly arguing that the TAT was funding theatres in Vienna, Amsterdam, and elsewhere and was not working with German artists (see Ruger and Siegmund 1992, p. 39)—the TAT offered Frankfurt the opportunity to present itself as a cosmopolitan city where contemporary art had its place. The TAT soon became well known for its new dramaturgy and its adaptable, open rehearsal opportunities, which—unlike at the Schauspiel—were restricted neither by union mandates nor by any other organisational regulations or technical limitations. It was a beacon of postdramatic, avant-garde performance, with a reputation that stretched well beyond Frankfurt in the late 1980s and 1990s. And it was a countermodel to the conventional municipal theatre in Germany and its production mode: in German municipal and state theatre, a performance or production is usually developed within the confines of a strict, predetermined corset. Renowned and trained specialists (singers, musicians, performers, and also technicians and tradespeople) make their specific skills and labour available to the aesthetic vision of a director (or production team,

as the case may be). The theatre's management ensures, above all, that nobody oversteps the prescribed hierarchies and defined competences during the production process, not least because everybody involved (as well as the other nonhuman elements) has a different (im)material value—is assigned a different wage on the balance sheet. The municipal theatre is usually a major municipal company and employer as well.

The model outlined (and somewhat simplified) here arose during the differentiation and disciplining of the arts in the early 19th century (see also Aggermann 2020), which materialised above all in the institutions dedicated to the various art forms (museums, concert halls, conservatories, theatres). The typical German municipal theatre, with its two or three departments (i.e., theatre, dance, music), is unique in that it unites various disciplines under one roof but must clearly distinguish them from one another. It is believed that only the strict disciplinary separation of the arts and their protective removal from the free market economy can guarantee art and the arts the freedom and autonomy defined within the scope of classical bourgeois aesthetics as a sterile, non-economic residue and as their defining characteristic.

The financial crisis in Frankfurt of the 1990s questioned this costly model. It rocked both the financial foundations of the bourgeois community (that is, municipal government) and the political (or, if you will, ideological) model of theatre, particularly in Frankfurt, where politicians and citizens were presented with a functional, prestigious alternative in the form of the TAT.

Frankfurt provided fertile ground for new and innovative aesthetics in the performing arts. With participation (Mitbestimmung) the main mode of administrating and organising municipal theatres from 1972 to 1980, autonomy and responsibility were not clichés but established practices amongst staff. At the same time, unconventional aesthetics and the breaking of audience routines and expectations received strong support from politics and, what is more, were even demanded by Hilmar Hoffman, councillor for culture and the arts from 1970 to 1990 (see Hoffmann 1980, 11). After a quite glorious decade, with almost yearly invitations of Schauspiel performances to the prestigious Theatertreffen festival in Berlin, municipal theatres scaled back to a conventional form of organisation and management from 1980 on. However, the TAT strongly relied on this already-tested and approved political mandate to promote experimental aesthetics and to enable new modes of organising, producing, and distributing performances.

Its aesthetic output was indeed exceptional. Most of the examples that Hans Thies Lehmann cites in his book *Postdramatisches Theater* were part of the TAT programme of the time (see Lehmann 1999). New modes in performing arts production—mainly electronic technologies such as sampling and hybridisation, which emphasised adaptation and recombination—blurred the boundaries between conventional genres and styles and the techniques on which they were based. As a consequence, different forms of artistic expression became increasingly emancipated from trained skills and disciplinary virtuosity, their established hierarchies, and their accompanying formats and genres, as did the various artists and technical staff involved. Postdramatic performance, therefore, gained new

status not only as a model for the interplay between media (see Meyer 2001, 52), but also as an essential laboratory that fostered the development of aesthetic genres and means. Lehmann highlights this new kind of aesthetics mainly created by co-production: 'This theatre is experimental in its very nature. It seeks to combine and integrate different working methods, institutions, places, and people' (Lehmann 1999, 36). Still, what Lehmann fails to acknowledge is that this aesthetic development was not just brought about by new (electronic/digital) technologies and artistic creativity. Lehmann misses a point that is revealed if we focus on the economic premises of these experimental and postdramatic aesthetics:

> The 'interdisciplinarity' of experimental art-making cannot ignore the fact that artists are often 'disciplined' by previous training and, as a result, do not always share the same standards in craft, image-making, acting. . . . At the same time, it is often the case that experimental artists find themselves treading on the expert territory of other art fields.
>
> (Jackson 2009, 14)

The *Kulturgesellschaft* (and similar organisations) provided a means of dealing with the substantial differences that did not fit within the standardised production processes of the municipal theatre. Its organisational and economic structure made it possible to draw on the skills and abilities of a wide range of specialists. Their independence and expertise in heterogeneous fields provided an opportunity to test and reflect upon aesthetic techniques, to examine the aesthetic potentialities of the very different elements used in theatre. This gave rise to a new mode of artistic development and new modes of spectating. This new pop-culturally informed aesthetic did, indeed, have an emancipatory quality, a new taste, compared to bourgeois aesthetics. The act of spectating was no longer carried out in a state of amazement, nor was it bound to background knowledge or the concomitant habitus. This new taste was, according to Christoph Menke, no longer determined by discipline or autonomy, by skill or practice (which shaped the different genres of art as well as the aesthetic subject of the 18th and 19th centuries), but by adaptation and commodification, which were first and foremost creative and emancipatory acts (see Menke 2010, 233). Overall these popcultural, postdramatic, and experimental aesthetics point strongly in the direction of a significant change in the economic nature of the arts and their relationship to the social sphere. While at the end of the 20th century, subjects and their everyday commodities were being increasingly saturated by aesthetics (see Reckwitz 2015, 30), art was becoming more and more subject to economic principles. Moreover, and especially in postdramatic performance, both producing and receiving subjects increasingly became evaluators, who primarily evaluated each other (cf. van Eikels 2013, 332). Postdramatic and pop-cultural emancipation—that is, the increasing significance of specific, sometimes periphery aesthetic elements in performing arts (like light or the amplification of sound or the mechanics of the stage, scenery, and props) was accompanied by a process that can be described using the economic term *valorisation*. In macroeconomics, this term is used to

define the assurance and stabilisation of the value of goods. However, here the concept refers less to the material and pecuniary requirements for the production of art than to a sociological and, above all, praxeological approach. Thus, valorisation draws attention to how objects and subjects are removed from their 'normal', functional context and are instead assigned their own value within the scope of the late-modern economy of attention (cf. Reckwitz 2017, 79).

Although in the concept of valorisation, the principles of the market economy encroach upon the sociocultural field and, not least, upon that of art (cf. Franck 2005), the term is not primarily used here to designate the commercialisation of the arts in general and performance in particular (see Diederichsen 2008, 82), but to describe the adjustment of values within an economic system in order to enable exchange and circulation. Value in art and the peculiar economy of arts can only be characterised via valorisation, because value is foremost a metonymic phenomenon: 'Value is constitutively relational and becomes manifest in the relation of commodity to commodity' (Graw 2012, 40). The focus on valorisation finally makes it possible to describe the process of differentiation and the advancement of aesthetic genres not from an intrinsically aesthetic perspective, but from a socio-economic standpoint. If we follow Boris Groys, aesthetic innovation comes, above all, from adapting and transgressing well-known (i.e., defined) values: 'The reassessment of values is the general form of innovation' (Groys 1992, 14).

A new economy in the arts

According to the theory of socio-economic values that Pierre Bourdieu presents in his extensive study on the arts, the value of an art work comprises more or less three dimensions: firstly, there is the price of its consumption; secondly, the symbolic capital that art can generate; and thirdly, the balance between production and distribution or, rather, its profit margin (Bourdieu 2001, 189–190f.). Specific genres of art and aesthetical means are differentiated not only by their forms of expression and their perceptual qualities, but also due to the way that they create value: the cost of their production, their typical mode of/medium for representation and its necessary expense, and their promise of symbolic capital. However, what Bourdieu overlooks in his model is that the nature of value is metonymic, and it is, above all, demand that plays a crucial role in defining the value of a commodity or artefact: i.e., its circulation in the (capital) market (see Franck 2005, 73). If we understand theatre as an economic system, we have to recognise that, within the scope of this aesthetic economy, the creation of secondary value and symbolic capital is potentially more important than material and quantifiable (countable) values. Furthermore, it is more revealing not to evaluate the singular elements and processes, but to focus on the circulation of expenditure and its ongoing utilisation as 'the relational nature of value presupposes exchange' (Graw 2012 40). In the case of the TAT, this circulation and exchange reveals unique characteristics.

In most TAT productions, different artistic genres and practices were treated equally, regardless of how much the various artistic methods and practices differed from one another in terms of the amount of work, skill, or financial effort required.

(Im)materially different art forms and art objects were treated in a similar way—not only with regard to their aesthetic impact, but also concerning their mode of production. This equal treatment of different materials and techniques, which is also one of the main characteristics of the white cube—which also guarantees the equality e.g., exchangeability, purchasability, and evaluability of different art objects (see Diederichsen 2017, 19)—had an inevitable impact on highly specialised, trained artists and their standing in the economy of arts. Musicians like Marie Goyette, John King, and Ensemble Modern and visual artists like Jan Fabre and Jana Sterbak, to name but a few, had access to the benefits of the performing and dramatic arts: the comparatively low prices charged to consume their art works; a rather profitable balance between production and distribution; a discerning audience; and critical appraisal in the cultural sections of newspapers, radio programmes, and television. To achieve roughly equal treatment and adjustment (regarding the levels of attention and, later on, purchasability), basic differences in artistic production had to be evened out. While in the theatre, distribution is bound to 'liveness' or the singularity of the event (the performance), rehearsals are one of the main ways to train and perpetuate different production processes. Music production is comparable, but improvisation plays a more vital role. In the fine arts, there is not usually a rehearsal (in the strict sense of the word), but rather sketching or modelling processes, mainly carried out on one's own. Equal treatment at the TAT was not merely a way to objectify different artistic genres and practices, it was, above all, an act of valorisation. The individual arts were conceived of and treated as if they were completely equal and, therefore, independently of the costs of their production. Under the idealistic, municipal roof (in this case, the Kulturgesellschaft), each artistic genre, each artefact, and each subject was accorded almost equal value.

This development did not necessarily contradict the constraints and competition of the free market economy and must be understood as a consequence not just of technical reproduction, but of digitisation (cf. Stalder 2016, 103) in particular, through which aesthetic and cultural artefacts and events have been made available on a sweeping, inflationary scale, predominantly split off from their real production costs. This becomes most evident by looking at tickets for TAT performances. The difference in ticket prices was no longer based on the artistic genre (opera, drama, ballet, or concert), but only on the location of the chosen seat.

In the TAT, the production of art works was no longer an individual and solitary event but had to be organised as a joint activity. Therefore, performers were not to be treated like virtuoso artists, highly trained experts, or interpreters within a dramaturgical grid. Instead, they were seen as investigators, operating from within the intrinsic logic of autonomous aesthetic play (see Sonderegger 2000, 20). In Heiner Goebbels's *Repetition*, for example, Marie Goyette and John King were no longer just musicians. They were treated as performers and even more as actors. They had to be on stage all the time. Furthermore, they had to be not only conducted, but also directed in a certain way. During the production process, they were required to offer up their individual creativity, especially in the modes and practices in which they were not trained or experienced, such as facial expression and gesticulatory eloquence. As their performance acquired a new presentational

framework, they needed a different mode of rehearsing—different from the mere repetition and presentation of music in classical (bourgeois) concerts or opera. Looking at the musicians and performers employed at the TAT shows that its productions, by contrast, were clearly based on the conventions and practices of jazz—an art form that oscillates between aesthetic autonomy and economic appraisal and exploitation, not least due to its defining characteristic: improvisation (see van Eikels 2013, 353).

This equal standing among the various elements and the valorisation of different practices and technical professions that took precise shape in the rather hybrid organisational structure of the Kulturgesellschaft even made it possible to sell a rehearsal like the one for *Repetition* in December 1994. The rehearsal was no longer a simple, practical necessity for the performance. Within the scope of valorisation, it became an original event that demonstrated a very specific theatrical form. The main distinguishing characteristic of the oeuvre of Heiner Goebbels, whose career received a boost during his time at the TAT and who can be considered a paradigm for its specific aesthetics, lies precisely within this valorisation of different art forms and the transfer and circulation of elements.

Due to this transfer, performance was increasingly understood as a mode of play that proved itself to be a way to question the specific characteristics of aesthetic elements and means of expression—the particularities of music, singing, image, sculptures, movement, speech (dialogue), and any other element used—in order to explore their possible representational modes. Heiner Goebbels in particular adapted an idiosyncratic mode of composing and directing that enabled different artistic practices to consolidate within a joint frame and, later on, to be transferred into other formats of representation. In the run-up to the very first performance of *Repetition* in April 1995, Heiner Goebbels claimed that his artistic working mode did not really correspond to that of a composer or director and that he instead saw himself 'more like an architect' (see Buchberger 1995, 70)—an approach that still shapes his works today.

This transformation of different artistic elements and art forms and their use as a kind of 'tool kit' is only possible if all the different artistic genres and all aesthetic means are valued similarly in terms of their production, their distribution, and even their promise of symbolic capital. In the idea of co-production, of which the TAT is a striking example, it was not only aesthetic development that became apparent, but also an alternative economy to that of the typical German (municipal) theatre company and its hierarchical, unionised order of competences, tasks, salaries, and wages. Heiner Goebbels, who has criticised the idea of conventional municipal theatre in a number of statements (see Goebbels 2015), is just one example of the valorisation of art forms, practices, and skills that occurred in several other TAT performances at that time. Although the different artistic methods and practices did not entirely lose their original institutional framing or organisational specificities, in most TAT productions, they were organised and treated as equals. Much of the symbolic capital that the TAT generated, as well as its quite successful financial management, had its foundations in the hybrid organisational structure of the TAT and the idea of production that the TAT offered.

Today, this idea of production continues to flourish and is now called 'curating' or 'curatorial aesthetics'. And with more than twenty years' hindsight, we are also able to detect the process of normalisation that this avant-garde mode of production has undergone. Co-production and its premise, the valorisation of the arts, are no longer exceptional in the organisation of the performing arts but have become a new standard or, at least, a common alternative to conventional theatre today. This development sets aside the complexity and traps of this production mode, as Hilmar Hoffmann had already foreseen: encompassing autonomy, responsibility, and the concomitant ideas of the originality and independence of all participants (and elements), participation

> must not single out the exponential and flamboyant; instead, it has to prove its ability to integrate as an opportunity the uncomfortable or even insane forces that disrupt norms and transgress boundaries, to claim the extraordinary as a general quality standard.
>
> (Hoffmann 1980, 15)

By focusing on the organisational level, we can clearly see the implications of this new mode of production, which was accompanied by difficulties in the cooperation among rather different technical professions, organisational units, and institutional frameworks. Several documents in the city archive of Frankfurt hint at the complex transformation processes necessary for co-production and their potential for conflict. Dealing with different national currencies and adapting different shows to venues abroad were only the very obvious problems raised by this kind of theatre organisation and distribution. Co-production only works if the institution is small and agile and can provide expertise in the production of different artistic genres playing virtuously with its framings—which is exactly what the Kulturgesellschaft did. One of the reasons for the artistic success and reputation of TAT productions was certainly the hybrid and diverse expertise of the Kulturgesellschaft. The TAT and its specific aesthetic outcomes can only be understood within this framework; co-production proves to be innovative above all when circulation and valorisation can be kept up through the deployment of a wide range of different elements and specialists. However, somebody must ultimately account for the material and quantifiable differences that arise in the production of art and, if possible, balance them out. In the end, there has to be one person ensuring a (financial) equilibrium by transferring money from one (organisational) unit to the other. Several documents show that Christoph Vitali, the general manager of the Kulturgesellschaft at the time, balanced the budget of the TAT using the profits of the Schirn Kunsthalle, which was no secret: 'This unusual institution operated like a company, dealing with the risks of profit and loss. The Council took on the role of the supervisory board' (Vitali 1994, 11). Vitali had programmed extremely successful exhibitions. It was therefore easy for him to balance the almost-permanent losses of the TAT against the profits of the Schirn. Moreover, he was even able to sell some objects used as scenery in TAT performances in order to make a profit on the art market—a rather smart

secondary use of theatre props. Furthermore, files from the Frankfurt city archive reveal a very peculiar system of accounting and calculating production costs in the Kulturgesellschaft: there were frequently two or three different calculations for the same production, depending on who the invoice was made out to.

However, it was not solely the TAT that implemented this new aesthetic economy, but also the Kulturgesellschaft, as an ensemble of quite different organisational units (a theatre, an exhibition space, workshops, an off-space), embedded within a cluster of collaboration partners, theatres, and festivals, which all helped to level the substantial economic differences in production. In fact, the TAT itself produced 30% of the performances in the programme, 20% were purchased as guest productions, and the other half were co-productions to quite varying degrees. Financial expenditure and artistic results in the TAT related extremely well to each other.

The *Kulturgesellschaft's* false promises

In the years following German reunification, a significant change took place in Frankfurt's cultural policy. Due to low business tax income—as important companies like Deutsche Bahn and others moved from Frankfurt to the new federal states or to the new capital of Berlin—and cuts in the federal budget—as a larger share of the federal budget was spent on the East—Frankfurt transformed from being one of the most prosperous cities to being the city with the highest debts, forcing politicians to restructure local cultural institutions. From 1993 onwards, after a number of very prosperous years, the city council had to spend more and more money on social benefits. Amongst other cultural institutions, the Städtische Bühnen, comprising drama, opera, and ballet, soon became the main target for noticeable budget cuts carried out by the city council due to its huge financial requirements and its lack of both commercial and artistic success (which was especially the case in the drama department). The Städtische Bühnen were supposed to contribute nearly 10% of the general savings the city had to make, and there were plans to curtail their budget by 30%.

In this context, the new, flexible economy of the Kulturgesellschaft gained fresh attention from the city government, and politicians stressed the model of the TAT as forward looking and something worth striving for. The TAT as an organisational model that guaranteed fewer expenses and higher quality than the municipal theatre seemed to point to a way out of the crisis. The TAT was not understood as part of the Kulturgesellschaft, but as a theatre in its own right. In order to adapt its mode of producing art to municipal theatres, politicians of all parties forced the organisational merging of the TAT with the Städtische Bühnen. This gave way to intense discussions in the news media. Making reference to financial crises, the politicians refused to define the contemporary role of the arts, culture, and in particular, the theatre in an increasingly international urban community. After two decades of a visionary and extremely generous cultural policy, the financial crisis revealed the limitations of municipal, bourgeois funding. However, the crisis did not lead to discussions about another, affordable theatre model.

Despite considerable opposition from stage directors, theatre managers, and artists, city officials started to put the merger into practice.

In a first step, the city government divided the Kulturgesellschaft into parts. The main venue that both gave its name to and housed the TAT, the building at Eschenheimer Turm, was sold. For one and a half seasons, the TAT worked separated from Schirn Kunsthalle and its profits, putting on its shows at the Bockenheimer Depot before eventually being integrated into the Städtische Bühnen as a fourth branch. As the TAT had already incurred a severe loss as part of the Kulturgesellschaft, after those one and a half years, it came as no surprise that the TAT had accrued more debt than ever before. The merger led to several conflicts between the TAT and the Städtische Bühnen—and between the TAT and the Schauspiel in particular. The managing director of the Schauspiel, Professor Eschberg, began to bluntly criticise and belittle the TAT and its productions:

> It decorates the image of our city. But it can't be compared with the Schauspiel and its political content, its aesthetic agenda, and its social task. The Schauspiel is part of the distinctive and essential system of German municipal theatre, which is due to its ensemble, its repertoire, and its local audience.
> (Press release Schauspiel Frankfurt, May 28, 1996)

The TAT was forced to take on the role of ornament, while the Schauspiel was considered essential to the municipal community.

The TAT's quite unorthodox mode of co-producing and rehearsing was no longer supported by the different technical professions, but rather by the more-or-less standardised workshops of the municipal theatre. The necessary hybrid expertise that the Kulturgesellschaft employees provided had to be bought in from outside while employees of the Städtische Bühnen were underemployed. Co-producing at the Städtische Bühnen became unattractive to external artists as they were no longer able to claim for themselves rights of use: i.e., the rights to their own performances and the rights to tour their productions. Furthermore, they were bound by rather inflexible contracts and the labour laws of municipal theatre as the Städtische Bühnen were not yet operating as an independent company but were still a municipal enterprise. Last but not least, an internal audit of the Städtische Bühnen prevented the 'creative accounting' that the TAT and the Kulturgesellschaft were used to. Due to this hostile environment, which was unreceptive to innovation and non-conformity, Tom Stromberg, who followed Christoph Vitali as artistic director of the TAT, turned his attention to new challenges and began curating the performing arts section of Documenta X, which was definitely more promising than the implementation of a rather bleak reform.

The merger of a German municipal theatre, well known for its participatory management (a decade earlier), with a small avant-garde venue without any ensemble, which established the now-common practice of co-production with European partners, created neither noticeable savings nor any added aesthetic value. On the contrary: it led involuntarily to the decline of the TAT and to its ultimate closure less than a decade later. The Städtische Bühnen were not able to

adapt the flexible and responsible mode of organising and distributing the performing arts (although Sylvain Cambreling, artistic director of the opera house, had developed a similar form of co-production with the Salzburg Festival and Theatre la Monnaie in Brussels as well). The Städtische Bühnen thus failed to participate in the emerging multimedia, more European, supra-nationally orientated aesthetics that the TAT pursued. From an economic and political point of view, the merger of the Städtische Bühnen and the TAT was a fundamental mistake. The Städtische Bühnen failed in their financial consolidation. Even though the TAT existed for eight more years, it was no longer seen as paradigmatic or avant-garde and lost its reputation as an innovative economic organisation.

What the Kulturgesellschaft and Städtische Bühnen had in common was that both organisations consisted of three units dedicated to different artistic genres: the Kunsthalle Schirn, the TAT, and the off-off TAT comprised the Kulturgesellschaft while the Städtische Bühnen were divided into the three classical genres of theatre: opera, drama, and ballet. Whereas there was an internal differentiation within the performing arts at the Städtische Bühnen, the Kulturgesellschaft was a hybrid mixture of artistic genres in general. Ignoring this fact was the main mistake in the idea of the reform. It is not difficult to see parallels between the discussions in Frankfurt in the 1990s and the current discussions around opening up traditional theatre spaces such as the Kammerspiele Munich and the Volksbühne Berlin (see the chapters by Michaels and Boenisch in this volume).

Furthermore, the Kulturgesellschaft was led by a general manager. Due to the restructuring in 1972 that abolished the role of the general director (Generalintendant) for all three sections (opera, drama, ballet), the Städtische Bühnen had no such director. Instead, every department had (and still has) its own manager (Intendant). Despite being labelled as a company dedicated to the avant-garde, and in contrast to the Städtische Bühnen and their policy of Mitbestimmung (participation as the main mode of administrating and organising), the Kulturgesellschaft was highly conventional in its organisational structure—not to say conservative: 'I'm completely against running a theatre in an anti-authoritarian manner', Tom Stromberg once commented in a journal (Boxberger 1994, 20). The success of the TAT and its model of co-production was mainly due to its flexibility, governed by a rigid (hierarchical) structure in terms of both the technical professions and the financial balancing of artistic production. Co-producers had to have a wide range of expertise, bookkeepers had to have a creative hand, and the general director had to have both at the same time. Moreover, lawyers had to be able to deal with ongoing legal conflicts concerning the debts of the different co-producing partners and the duties of artists. Christoph Vitali rolled all of that into one. We might conclude that the role model for a successful and recognised general director that Frankfurt's politicians had in mind regarding the turnaround of the municipal theatre in the early 1990s was possibly none other than the impresario of the 17th and early 18th centuries (see Walter 2016, 73–74f.). It is no wonder, then, that economisation failed.

Repetition did not end as a public rehearsal. Planned for the venue at Eschenheimer Turm, it finally premiered on the opening night of the TAT at Bockenheimer

Depot. In addition to the stage performance, *Repetition* later became an award-winning radio play, a film, a CD, and a concert. Some of its scenes even became models for a new performance more than 20 years later (*Mit einem Namen aus einem alten Buch*, Stadttheater Giessen 2018), once again bringing the TAT's characteristic aesthetics back to life. After producing another performance within the framework of the Städtische Bühnen—the legendary *Black on White*—Heiner Goebbels turned his back on the TAT and chose former co-production partner Theatre Vidy in Lausanne as the base for his further productions.

As Frankfurt's financial crisis drew to a close in the late 1990s, there was no need to further discuss the municipal theatre or to proclaim a new agenda in cultural politics. Was it this laxity of municipal politicians that caused the final transformation and exchange? While the TAT did not generate extraordinary attention from the late 1990s onwards, the city government appointed as artistic and managing director of the Schauspiel Elisabeth Schweeger (2001–09), who firmly pursued a postdramatic programme and corresponding production modes—without any severe financial worries.

Co-production in theatres and art festivals today is an established mode of organising and distributing the performing arts. Co-production and its non-standardised, valorised aesthetics have not superseded the idea of the municipal theatre, its highly trained artists, and its specialised technical professions, but they have extended the way that theatre is organised. Nevertheless, co-production has not become a new kind of normal but is still understood in opposition to and, even more emphatically, as an attack on municipal theatre. The current situation in Germany, the urgent demand for new structures for municipal (ensemble) theatres, and the performing arts in general seem in many respects to be revenants of the Frankfurt crisis in the 1990s.

References

Aggermann, Lorenz. 2020. "Singspiel: A proto European phenomenon?" *Forum Modernes Theater*, no. 31: 106–117.
Bourdieu, Pierre. 2001. *Die Regeln der Kunst*. Frankfurt a.M.: Suhrkamp.
Boxberger, Edith. 1994. "Der andere Blick. Jenseits der Sparten: die Arbeit des Frankfurter Theaters am Turm. Ein Gespräch mit Tom Stromberg." Ballett International/Tanz aktuell, May 1994, 20–23.
Buchberger, Stephan. 1995. "Eher wie ein Architekt. Ein Gespräch mit Heiner Goebbels." *Theaterschrift*, no. 9: 70–95.
Diederichsen, Diedrich. 2008. *On (Surplus) Value in Art: Mehrwert und Kunst: Meerwarde en Kunst*. Berlin: Sternberg Press.
Diederichsen, Diedrich. 2017. *Über Produktion und Eigenwert*. Berlin: Sternberg Press.
Elfert, Jennifer. 2009. *Theaterfestivals. Geschichte und Kritik eines kulturellen Organisationsmodells*. Bielefeld: Transcript.
Franck, Georg. 2005. *Mentaler Kapitalismus. Eine politische Ökonomie des Geistes*. Munich and Vienna: Hanser.
Goebbels, Heiner. 2015. *Aesthetics of Absence: Texts on Theatre*. Edited by Jane Collins. Translated by David Roesner and Christina M. Lagao. New York: Routledge.

Graw, Isabell. 2012. "The Value of the Art Commodity: Twelve Theses on Human Labor, Mimetic Desire and Aliveness." *Texte zur Kunst*, no. 88: 30–59.
Groys, Boris. 1992. *Über das Neue. Versuch einer Kulturökonomie*. Munich: Hanser.
Hoffmann, Hilmar. 1980. "Theater als organischer Teil der Gesellschaft." In *War da was? Theaterarbeit und Mitbestimmung am Theater Frankfurt 1972–1980*, edited by Gert Loschütz and Horst Laube, 11–16. Frankfurt a.M.: Syndikat.
Jackson, Shannon. 2009. *Social Works: Performing Arts, Supporting Publics*. London and New York: Routledge.
Lehmann, Hans Thies. 1999. *Postdramatisches Theater*. Frankfurt a.M.: Verlag der Autoren.
Menke, Christoph. 2010. "Ein anderer Geschmack. Weder Autonomie noch Massenkonsum." In *Kreation und Depression. Freiheit im gegenwärtigen Kapitalismus*, edited by Christoph Menke and Juliane Rebentisch, 226–239. Berlin: Kadmos.
Meyer, Petra Maria. 2001. *Intermedialität des Theaters. Entwurf einer Semiotik der Überraschung*. Düsseldorf: Parerga.
Reckwitz, Andreas. 2015. "Ästhetik und Gesellschaft—ein analytischer Bezugsrahmen." In *Ästhetik und Gesellschaft. Grundlagentexte aus Soziologie und Kulturwissenschaft*, edited by Andreas Reckwitz, Sophia Prinz, and Hilmar Schäfer, 23–52. Berlin: Suhrkamp.
Reckwitz, Andreas. 2017. *Die Gesellschaft der Singularitäten. Zum Strukturwandel der Moderne*. Berlin: Suhrkamp.
Ruger, Wolfgang, and Siegmund, Gerald 1992. "Das Theater um die Kulturpolitik." Ein Gespräch aus akutellem Anlaß mit Tom Stromberg. *Journal Frankfurt*, no. 25 (December): 38–42.
Sonderegger, Ruth. 2000. *Für eine Ästhetik des Spiels. Hermeneutik, Dekonstruktion und der Eigensinn der Kunst*. Frankfurt a.M.: Suhrkamp.
Stalder, Felix. 2016. *Kultur der Digitalität*. Berlin: Suhrkamp.
van Eikels, Kai. 2013. *Die Kunst des Kollektiven. Performance zwischen Theater, Politik und Ökonomie*. Munich and Paderborn: Fink.
Vitali, Christoph. 1994. "Interview." *Tagesanzeiger*, July 7: 11.
Walter, Michael. 2016. *Oper. Geschichte einer Institution*. Stuttgart: J.B. Metzler.

14 Potential, need, risk

On control and subjectification in contemporary production networks

Georg Döcker

I

'Once upon a time', writes former Advancing Performing Arts Project manager Koen Kwanten in a report from 2016,

> there were no networks in performing arts, perhaps some of us still remember this time. As a matter of fact, it is a quite recent phenomenon. At the same time, the field of contemporary (performing) arts cannot be imagined anymore without the existence of networks.
>
> (Kwanten 2016, 18)

Kwanten's rhetoric, particularly his allusion to the world of fairy tales at the beginning of his statement, could not be more fitting for a reflection on the current state of networks, and production networks in particular, in the performing arts scenes in Europe. Although a past without systematic collaborations among European theatre institutions is not very distant—it was only in the 1980s that first efforts were made toward international co-production, and only in the early 2000s were these relations formalised into recognised network bodies—the non-existence of connective structures today seems to equal a mere fiction, an impossibility. Production networks, within a very short time-span, have effectively become naturalised.

Perhaps the best proof of this contemporary condition is that even the *Theatertreffen*, a renowned festival presenting annually a best-of selection of ten productions from German municipal theatres, in 2019 featured six creations that were produced by two institutions or more (cf. Irmer 2019); for the longest time, Germany's city theatres had championed the 19th-century bourgeois model of in-house production that consolidated everything from finances to an ensemble of actors to stage design under one roof, yet these days they, too, seem to be transitioning to the cross-institutional production modes that the rest of Europe's theatres and the independent German scene accepted before. It is therefore plausible to say that, in the absence of a unifying aesthetics, theatre, dance, and performance in Europe are, in the fullest sense of the word, connected through the network, both in the independent milieus and in city or national theatres (cf. Frank 2006, 72; Balme 2019, 9).

The analysis in this chapter will centre on one particular aspect of increasing network integration: namely, the ways that the concerted efforts of production houses contribute to the subjectification of contemporary performing artists. While the most visible activities of institutional networks concern the economic and organisational frameworks that determine the making of a performance, the analysis will be used to demonstrate that the primary object of production is the performance-maker herself: the practitioner, not her practice. In other words, production is here understood as a process of the making and reconfiguring of the practitioner as a subject of the network—a network subject—who, once produced, retroactively serves as the very legitimating reason for the existence of the network.

In the following, it will be argued that production networks operate by means of three simultaneous yet logically separable power mechanisms constituting the network subject as a subject of potential, need, and risk; it is the implementation of risk that allows for the execution of control not only vis-à-vis the practitioners but across the entire network, and it is there that the network design shows how it is both reliant on and undermined by a momentum of crisis. This argument will be developed via a reading of reports from influential EU-funded networks, among them House on Fire (2012–17), NXTSTP (2007–12, 2012–17), Departures and Arrivals (DNA) (2014–18), and Life Long Burning (2013–18, 2018–22), each of which joined together theatre or festival institutions for production purposes and the instalment of support structures, including residencies and workshops. (Non-production networks such as IETM, which foster discourse, exchange, and lobbying, will not be considered.) Since most report documents are strategic papers communicating to the EU funding body of the Creative Europe programme (previously the Culture programme), they offer insight into the precise language of power that networks apply to talk about their relations to practitioners. Additionally, they provide information about the networks' economic data and infrastructural architectures. Supplementary materials include interview statements from artistic directors and theatre producers on co-production, which is the most conventional mode of network cooperation.

The methodology employed for the analysis is derived from a selective use of network theories: after roughly 20 years of 'network fever' (Galloway and Thacker 2007, 27), it seems necessary to scrutinise and, in some cases, abandon theories that unreflectingly affirm network concepts from cybernetics: that is, some of the very concepts that prefigured networks as systems of social dominance and control (for a similar criticism, cf. Franklin 2015, chapter 3). This problem concerns a general sociology of networks (cf. certain passages in Castells 2010, 2013), as well as existing evaluations of performance networks (cf. Fondazione Fitzcarraldo 2001). In the same vein, it is important to object to views that celebrate networks as inherently libertarian and egalitarian forms of organisation politically favourable to centralisation, such approaches equally failing to understand how decentralised or distributed network arrangements unfold their own mechanisms of power. For these reasons, the following investigation adopts the critical perspective of network theoreticians such as Steven Shaviro and Alexander Galloway and Eugene

Thacker, who continue Foucault's and Deleuze and Guattari's project of a microphysical analytic of power into the present. Correspondingly, the leitmotif will be Galloway and Thacker's network-critical slogan 'we're tired of rhizomes' (2007, 153), which is a reiteration of Deleuze and Guattari's famous dictum '[w]e're tired of trees' (1987, 15).

II

Before zeroing in on the details of artist subjectification in production networks, this section sketches out the networks' organisation structures, their inner force relations and dynamics, which build the foundation for their interactions with practitioners. Among their most deep-rooted features are those of connectivity and heterogeneity, the latter coming to bear in the networks' internal configurations, which entail both layers of horizontality and vertical chains of command. On the one hand, NXTSTP, House on Fire, and other weighty production networks each establish a horizontal plane of multiple partners who operate together on the basis of joint decision-making processes. In the case of NXTSTP, for example, first seven (2007–12), then eight festivals (2012–17) collaborated in such non-hierarchical fashion, among them *Kunstenfestivaldesarts* from Brussels, Alkantara Festival from Lisbon, and *steirischer herbst* from Graz, whilst DNA united 12 venues comprising, amongst others, Hebbel am Ufer from Berlin, Kunstencentrum Vooruit from Ghent, and Latvijas Jauna Teatra Instituts from Riga. However, in every network, one institution executes the extra task of overall coordination, and, more importantly, the entire network responds to the funding authority of the EU, both instances complicating the flat network design. Furthermore, the performing artists, once they get involved in the network, respond to one or more institutions from a position below, such that the network ultimately acts as an intermediary stratum from which hierarchical relations extend both to the top (EU) and the bottom (practitioners).

While this is mostly in line with Deleuze and Guattari's early emphasis on the plural character of rhizomes, which necessarily includes territorialisations and lines of segmentation (1987, 7–9), an oddity of EU-funded performance networks is that they are initiated from the top down and not from the bottom up, the Creative Europe programme first kick-starting the forming of alliances from above by providing guidelines and incentivising applications. EU networks thus tend to mirror a transcendent order in which the condition for the possibility of its existence is located in one autonomous superior place, countering effectively the 'collapse into immanence' that Shaviro (2003, 34) found to be the ontological innovation of the network principle. With respect to Galloway's network nomenclature derived from graph theory (2004, 11), performance networks can further be interpreted as consisting of, on the level of their participating theatre institutions, a distributed assembly in which all partners are connected to each other as equivalent nodes (leaving aside for a moment the exception of the network coordinator), whereas, from the angle of their dependence on the EU, they are all linked to one node that serves as a central hub. Again, for practitioners, the network represents not

a distributed or centralised but a decentralised order since the practitioners direct themselves to the multiple centres of the production houses.

This heterogeneous ensemble is put to work in an economy that is equally heterogeneous because it puts forward a value system of not one but two main currencies. First, networks depend on the financial value of monetary support, EU subsidies usually making up around 40% to 50% of the overall production budgets and doubling the means that co-production houses gather from regional or national funding—for the five-year implementation period of House on Fire, the EU granted roughly €2.5m in funding (House on Fire 2017, 9); DNA, for its four-year time span, was allocated €2m (DNA 2018). Second, though, networks are dependent on the theatrical capital of visibility, which refers to the symbolic recognition derived from being among those who produce ambitious artists and creations (cf. Cools 2004, 14) but also, and more elementarily, implies quantifiable audience turnout, which is supposed to justify the financial awards granted to them. Amelie Deuflhard, artistic director at Kampnagel in Hamburg, makes no secret of the worth of audience support when she discloses that 'if we don't have enough audience, we go bust' (in Deuflhard *et al.* 2006, 62).

Although monetary and theatrical values are of fundamentally different orders—financial input will not directly translate into a calculable measure of visibility or audience response—the network structure promises to mediate and accelerate this double economy. It is through its feature of connectivity—through its connective tissue, one might say—that the network projects a simultaneous increase in financial means and visibility rewards, a recursive reinforcement of the two categories. What is at work here is what Shaviro, borrowing from William Burroughs, calls the 'algebra of need' (2003, 11), a synonym for the logic of addiction, which, in networks, signifies the tendency of connections to reproduce themselves; if only for the initial purpose of pre-emptively safeguarding its further existence, the network is endowed with an inherent drive of constant growth: a drive to multiply its connections and to forge connections that always create further connections, thus generating a potentially infinite cycle. In performance networks, this process effectuates growing numbers of partners and productions, growing numbers of audiences, and ever-greater reasons to claim more subsidies in the next application round, which ideally supplies the material base for even further production activities and even greater audience response.

This excessive spiral is represented in the seemingly dry graphs and tables in EU network reports, whose numbers, as a matter of fact, happen to emanate an enticing, if not erotic, vibe: they tell the story of a compulsion towards expansion that comes to life, for instance, in the enlargement from 11 to 12 partners after the first cycle of the Life Long Burning project (cf. Life Long Burning 2013, 2018), in the aforementioned growth of NXTSTP from 7 to 8 partners, and in NXTSTP's leap from 36 to 39 creations and from 318 to 702 presentations between its first and second five years, with 76,455 tickets sold in the latter period (cf. NXTSTP 2012, 10–11; NXTSTP 2017, 6–8). Certainly, these numbers testify to the fact that almost every aspect of network production is rendered in quantifiable data—in co-production agreements, even the use of residencies' spaces tends to be output

in money amounts (cf. Cools 2004, 7)—which signals an aspect of control that networks inherit from their cybernetic conceptualisation and their reliance on mathematical and information-based communication channels (cf. Shaviro 2003, 10–11; Mersch 2013). But more importantly, perhaps, they show that the network 'algebra of need' performs an interlacing of what Andrew Culp, in his Deleuzian diagnostics of the present, targets as the two main regimes of capture in the contemporary social sphere—namely, 'connectivism' and 'productivism' (2016, 5, 10)—which, in the network, plays out as production through connection and vice versa, as the 'connectivism' of 'productivism' and its opposite.

III

Turning now to the mechanisms of power and subjectification in the contact between networks and practitioners, the networks' obsession to increase productive connections implies that practitioners need not fear the threat of exclusion, but rather the invitation to join in, to become part of the web; as Galloway and Thacker pointed out, networks pursue a politics of inclusion, in which inclusion equals a means of regulation, the calculus being that the more immediate and long lasting the relation with a process or person, the greater the possibilities for control (2007, 29). In the same vein, networks, again with Galloway and Thacker, can be termed '*many-to-many relationships*' (2007, 98; emphasis in original), which holds true for production networks, considering that they comprise several theatres or festivals and many more practitioners at the same time—House on Fire, to name one, having directly impacted the mobility of 3,000 professionals (2017, 17). Thus, there exists, strictly speaking, no single subject of the network; instead, it necessarily brings forth a plurality of subjects.

Despite the effort of plural inclusion, however, integration must never be complete, not in a single case—the reason for this peculiarity having to do with the first main step of artist subjectification in production networks: the configuration of performing artists as subjects of potential. As outlined in the introductory remarks, practitioners are turned into network subjects by three essential operations: their production as subjects of potential, as subjects of need, and as subjects of risk, all of them occurring simultaneously yet being logically distinct. The category of potential will not only illuminate the issue of incomplete inclusion but also lay the ground for the exploration of the functions of need and risk.

The performance-makers, not the performances, form the most important unit of production, curator Frie Leysen once explained in a statement on her work for *Kunstenfestivaldesarts*. 'For me', she emphasises, 'it's very important that in the festival it's not about productions but it's about artists' (2002). While Leysen argues that the primacy of the artists allows for flexibility in the choice of each creation's specific medium, the 'artist-driven approach' (cf. Suchy 2015), as it is also called, seems to be motivated by at least one other concern, the implications of which are more fundamental. This reason must be traced in what is so apparently absent from the discourse of networks and co-production, in what their documents strategically omit: namely, the very definition of what makes an artist

or practitioner, respectively, an artist or practitioner. Sifting through the network reports, it is striking that the profile of a practitioner is never outlined in any way, which is to say that, *ex negativo*, she is characterised precisely by her nothingness, by her being nothing, which inversely converts into pure potentiality, into the potential of being or creating everything. While everything else in the language of production networks is framed in explicit terms and numbers, the being of the practitioner remains entirely undefined, thus conjuring the virtual sphere of that which is yet to be named and yet to exist. Apart from the interesting detail that networks thus tend to confirm the modern mimetology of theatre and the actor, which Lacoue-Labarthe (1986) famously highlighted in his reading of Diderot's paradox—the paradox of the actor being that she must, by the virtue of technique or *techne*, become nothing in order to actualise the pure *physis* of nature and be able to embody anything—the take-away here is that networks rely on the person, not the product, because it is she who can be conceived of as a container of potentiality; it is she who can promise a connection that can manifest in not one but many potential performances; and it is she, therefore, to whom the networks commit in the form of 'long-term support' (cf. House on Fire 2017, 9; NXTSTP 2017, 25).

In hindsight, through the materialisation of the performing artists' capabilities in the form of performance creations, the potential can actually be named, as this passage from a NXTSTP report exemplifies: 'The artists we wanted to support within the framework of this project have proven their potential with their first artistic productions' (2012, 14–15). Except for the performance results, however, the creative potential of the practitioners stays elusive; it remains an external force; and, in fact, this alien quality is very much desired because the practitioners' difference makes them the networks' source of life, the resource that the networks can feed off, much like the vampire that, according to Marx, is capitalism. From one perspective, then, it is the network itself that produces the artists as subjects and carriers of potential, but in another sense, the artists and their potentials must, nevertheless, be situated outside so that the network can live off them. After all, if the artists were fully assimilated, they would no longer be a source, but rather a mere receiver within the network, or, differently put, if the artists were entirely devoured by the network, the network feeding itself the artists' potentials would structurally amount to cannibalism, leading eventually to the network's decline.

What might seem like a rhetorical fabrication or a hyperbolic condensation is truly the consequence of a cybernetic network logic according to which a system, in order not to suffer entropic collapse (cf. Dany 2013, 56–59), necessarily relies on foreign input from its environment; more complex cybernetic concepts accounting for this relation posit that the system, in addition to its difference from the environment, also denotes the functional relation of exchange between them (cf. Baecker 2004, 280). In performance networks, the practitioners embody exactly the role of the environment that the vitality of the system or network depends on, which is why it is in the interest of the network to be both connected to the practitioners and to keep a distance so that the practitioners maintain their environment status. This paradoxical quest for a certain purity of the artists' subjectivity resonates, for instance, in producer and dramaturge Guy Cools's recommendation to

devise the artistic proposal before addressing co-producers (2004, 4), but it also illustrates a fundamental lesson in power that Burroughs reveals when arguing that to control someone never means complete control '[b]ecause control also needs opposition or acquiescence; otherwise it ceases to be control' (1978, 38) and simply turns into ownership and use. Although Burroughs here speaks of control in a non-specific sense, which equals all sorts of power relations, it nonetheless offers insight into the strategic advantages of a certain letting go that characterises control—and network control in particular. Deleuze, one might speculate, had exactly this aspect in mind when referring to Burroughs as the inspiration behind his concept of the societies of control (1992, 4).

The practitioners thus occupy an interstice in the production network, an in-between space that, despite being created for strategic purposes, nevertheless seems to suggest a relative autonomy—were it not for the fact that the network develops a second angle of connection and subjectification in addition to that of potentiality: namely, that of need. In applying Foucault's concept of biopolitics to contemporary social relations, Shaviro suggests that network power is characterised by a deep commitment to care, to protecting its subjects very much for the network's own sake (2003, 34–35). This could not be more true of the way that networks offer to provide, as in the case of Life Long Burning, 'sustained quality support following the actual needs of artists', with a set of residency and mobility schemes, 'skill-set trainings', and 'on-the-job-learning' (2018, n.p.); or, to quote Leysen again: 'My way of working is determined by the artists and their specific needs' (2015, 38).

Although there is nothing to be said against helpful support, it is important to understand how catering to the needs of the practitioners serves the function of establishing an influence over them, precisely where addressing them only as carriers of potential is no longer enough. Potential, as going beyond recognisable form or activity, cannot be stirred into specific directions, but production nevertheless needs to be able to regulate, if necessary, the actualisation of potential. It needs to be able to orient potential towards creation, and the translation of potential into need fulfils this purpose. An uttered need is something that a network can respond to, something whose satisfaction can prove the network's benevolence; something, therefore, that can facilitate a pragmatic and material, a 'matrimonial relationship' to the artists, as Cools once defined co-production (2004, 10). In this way, the construction of network artists as subjects of need is an essential step towards securing that their potential will not be lost or wasted but actually invested in successful work that yields performance results.

But a risk always remains. In fact, a certain level of risk should remain, or, better yet: risk should be welcomed. It should be produced just like potential and need because risk is not only the third logical operation of artist subjectification but also the category that holds the network together more than potential and need alone could ever do, the resource that the network capitalises upon, both with respect to the ultimate legitimation of its own necessity and with regard to the dynamics of escalating production. Risk is everywhere in the network: it first emanates from the practitioner and her ability or inability to create, but

Potential, need, risk 201

from there, it spreads out into every corner and affects everyone and everything involved, from the producers and curators to the financial issue of spending to experimentation with modes of working and extra events. Cools, in a note which describes the artist as producer, underlines that 'the co-producer takes the risk of having a "blind date" with the producer and guarantees both money and performances at a stage when the production still has to be realized' (2004, 6). Similarly, in a passage that is more suggestive of the excitement of risk, a NXTSTP statement reads, '[b]y working together as a network of partners, NXTSTP embraces the opportunity for risk-taking, for developing an alternative way of co-producing and supporting the artist's trajectory' (2012, 17). And, as if to signal that risk could not possibly go too far, House on Fire makes metaphorical use of its own name in stating that they 'encouraged each of the curators to take more risks and to allow performing arts practices, performances, events and debates to set their own houses on fire' (2017, 14).

Its penetrating force makes risk the single greatest connector in the entire network, and if that is so, it is primarily because it streamlines all its actors and elements with respect to the temporal dimension of the uncertain future. As Elena Esposito maintains, the historical context of such an understanding of risk coincides with the time of early modernity, when the shock of contingency, the abolition of an absolute order, led to the fundamental openness of the future and the challenge of managing actions in the face of it (2007, 19–35; 79–85). However, while the modern invention of risk was coupled with the notion of probability and methods of statistical analysis—a relation that, as Foucault's studies on governmentality have shown, was also central to risk as a strategical instrument in *dispositifs* of security from the 18th century and beyond (Foucault 2009, 57–61)—today's risk calculus has replaced probability with mere possibility. Brian Massumi (2015), Louise Amoore (2013), and again Esposito (2011) all highlight how this reconfiguration of risk is, on a political and economic level, particularly tied to contemporary warfare and the internal workings of the digitised financial markets, in which highly unlikely and thus improbable events must be accounted for; in the case of networks in performance, it is the dependence on the practitioner's potentiality that first causes risk to be unpredictable. No matter how successful the establishment of systems of need is in safeguarding the practitioner's process, the possibility remains that the imaginative force will suddenly be blocked and not unfold at all.

But even if the performance makes it to the premiere, the production process encounters yet another source of risk, which is at least as important and hard to control as the practitioner and answers to the name of the audience. Deuflhard describes what is risked before an audience and their response to a show in concise words when she concludes: 'actually, one cannot calculate or anticipate it all' (in Deuflhard *et al.* 2006, 61). The programming of themed sections and a mix of renowned and upcoming artists might provide some stability (2006, 62), but in the end, it consistently remains unclear whether the audience will storm the theatre or stay at home instead. Deuflhard adds, then: 'this makes all the producing of dance and performance exciting' (2006, 61).

The thrill of production, one can infer, stems precisely from the unknown, from the two unknowns that are the practitioners and the spectators, and from the contingent bond between them that serves, ultimately, as the impulse for a veritable game of risk production. After all, the internal connectivity of the network enables and encourages the distribution of risk among all partners, and the promise that it generates is, paradoxically, that risk is best dealt with not when it is reduced, but when it is increased. The logic at play is very simply that the more the risk is shared, the more risk can and should be taken; thus, in a recursive manner that is again indebted to cybernetics, risk tends to create a reason for its own multiplication, with the extra advantage that once it has become self-referential, there seems to be nothing inhibiting it.

The fact that there remain, however, some ultimate limits, at least when ties to the material world still exist, was analysed on a larger level by Ulrich Beck in his research on the risk society (1999, 1992), in which he anticipated the drawbacks of grand-scheme recursive management that these days manifest themselves in the destruction of human and planet resources and the looming climate collapse. An analogy for performing arts would have to state that the escalation of the risk dynamism in production networks leads to the exhaustion of precisely the networks' others, who are the performing artists, by way of their potentials, and the audiences, by way of their attention. Practitioners are particularly vulnerable to this process, as even the best care management from the side of the networks cannot avert the dangers of psychological and physical burnout being triggered from years of having to maximise one's creative outputs (cf. particularly Kunst 2015; Cvejić *et al.* 2010 for their critiques of post-Fordist labour and performance). The practitioner as a subject of risk is pushed to risk her own potential, the very capacity that caused her to be of interest to the network in the first place. Overall, it can be said that the network brings together institutions, practitioners, and audiences via the all-uniting measure of risk, while the very application of risk via the network structure threatens the integrity of everyone involved—and, therefore, the existence of the network itself.

IV

It was the intention of this chapter to investigate the functioning of contemporary production networks in performing arts in Europe, particularly with respect to the power mechanisms that inform the subjectification of the performing artist or artists. The main argument can be summarised by stating that networks create a web of necessarily plural institutions and practitioners, who are bound together by a complex relation of potential, need, and risk: the practitioners are constructed as subjects of creative potential so as to serve as the life source of the network and performance production while their simultaneous construction as bearers of need and risk allows for the instalment of processes of management that legitimise the network and employ their connective grid as a means for a productivity in excess—at the possible expense of primarily the practitioners, whose materially

limited potentiality might not keep up with the network's risk calculations and desired outcomes. However, as indicated before, this eventuality is as much a threat to the network subjects as it is to the networks themselves; after all, there is simply no production without practitioners.

It would be wrong, nevertheless, to assume that the tendency towards destruction and self-destruction forms the constitutive outside or the blind spot of production networks; quite on the contrary, the creation of a radical state of insecurity must be understood as the most comprehensive overall manifestation of power in the network. As a concluding remark, it can be stated that the recipe for potential, need, and risk is really a recipe for the deliberate production of crisis, here understood not as the absence of order due to uncertainty but as the order of uncertainty itself, as executing control precisely via sustaining and perpetuating the ultimate danger of non-existence, vis-à-vis both the practitioners and the network as a whole. Dario Gentili (2013) and others like the Invisible Committee (2015, chapter 1) hold in their political theories that the concept of crisis is the central instrument of contemporary governmentality, the contemporary implementation of crises, according to them, consisting of the creation of existential circumstances, which are presented as being without an alternative, such that the only solution to combatting them is affirming them. Referencing Reinhart Koselleck's project of a history of the concept of crisis, Gentili specifically explains that, much like in modern politics, crisis is evoked in its ancient medical meaning as a moment of decision over life and death (cf. Koselleck 2006). However, in the modern configuration, the political decision was still to be one between alternatives, be it a choice between alternative ways to avoid political disintegration or the choice to actually let one political system die so as to establish a new one. In either case, modern crisis suggested an open future, whereas contemporary crisis, in discarding alternatives as fiction—or in discarding, as Gentili has it, even the fiction of alternatives (2013, 25)—makes into an absolute the status quo as a status of the constant fear of radical demise.

Production networks in performance activate this kind of crisis when they so deeply involve their practitioners and institutions in a sharing and multiplication of risk that, in the face of the possible actualisation of that risk, there is no other option available but to increase risk. Since the entire network is upheld by risk, any form of risk reduction, let alone the complete dismantling of risk, will more likely result in the damage or self-destruction of the network than the iterative reinforcement of given risk procedures. Put differently, the network guarantees its further existence by becoming more and more indebted to the possibility of its non-existence, having to ignore the fact that, at the same time, this possibility is more and more likely to become true. The question remains, then, whether production networks in performance are indeed destined to collapse under the weight of their own contradictions or are flexible enough to reconfigure themselves in different terms. A third option should not be excluded, though: a rise of resistance against the power of the networks, propelled by the practitioners themselves.

References

Amoore, Louise. 2013. *The Politics of Possibility*. Durham and London: Duke University Press.
Baecker, Dirk. 2004. "Rechnen lernen." In *Cybernetics: The Macy-Conferences 1946–1953*. Vol. 2, edited by Claus Pias, 277–298. Berlin and Zurich: Diaphanes.
Balme, Christopher. 2019. "Introduction." In *Res publica Europa*, edited by Christopher Balme and Axel Tangerding, 6–11. Berlin: Theater der Zeit.
Beck, Ulrich. 1992. *Risk Society*. Translated by Mark Ritter. London: Sage.
Beck, Ulrich. 1999. *World Risk Society*. No translator. Cambridge: Polity Press.
Burroughs, William S. 1978. "The Limits of Control." *Schizo-Culture*. Semiotext(e) 3, no. 2: 38–42.
Castells, Manuel. 2010. *The Rise of the Network Society*. 2nd ed. Chichester: Wiley-Blackwell.
Castells, Manuel. 2013. *Communication Power*. 2nd ed. Oxford: Oxford University Press.
Cools, Guy. 2004. "International Co-Production and Touring." *IETM*. Accessed July 13, 2019. www.ietm.org/en/system/files/publications/international_coproduction_and_touring.pdf.
Culp, Andrew. 2016. *Dark Deleuze*. Minneapolis, MN: Minnesota University Press.
Cvejić, Bojana, Ana Vujanović, Alice Chauchat, Virginie Bobin, Grégory Castéra, Bojan Djordjev, and Nataša Petrešin-Bachelez, eds. 2010. *Exhausting Immaterial Labour in Performance*. TkH 17. Belgrade: TkH.
Dany, Hans-Christian. 2013. *Morgen werde ich Idiot*. Hamburg: Nautilus.
Deleuze, Gilles. 1992. "Postscript on the Societies of Control." No translator. *October*, no. 59 (Winter): 3–7.
Deleuze, Gilles, and Félix Guattari. 1987. *A Thousand Plateaus*. Translated by Brian Massumi. Minneapolis: Minnesota University Press.
Deuflhard, Amelie, Christine Peters, Res Bosshart, and Matthias Lilienthal. 2006. "Lass uns Komplizen finden." Interview by Nina Peters and Nikolaus Merck. In *Spielräume produzieren*, edited by Amelie Deuflhard, 55–64. Berlin: Theater der Zeit.
DNA. 2018. "[DNA] Departures and Arrivals." *Creative Europe Project Results*. Accessed July 29, 2019. https://ec.europa.eu/programmes/creative-europe/projects/ce-project-details/#project/552290-CREA-1-2014-1-BE-CULT-COOP2.
Esposito, Elena. 2007. *Die Fiktion der wahrscheinlichen Realität*. Translated by Nicole Reinhardt. Berlin: Suhrkamp.
Esposito, Elena. 2011. *The Future of Futures*. Cheltenham and Northampton, MA: Edward Elgar Publishing.
Fondazione Fitzcarraldo. 2001. "How Networking Works." *IETM*. Accessed July 14, 2019. www.ietm.org/en/system/files/publications/how_networking_works.pdf.
Foucault, Michel. 2009. *Security, Territory, Population*. Translated by Graham Burchell. Basingstoke: Palgrave Macmillan.
Frank, Thomas. 2006. "Cross the Border, Close the Gap." In *Spielräume produzieren*, edited by Amelie Deuflhard, 72–74. Berlin: Theater der Zeit.
Franklin, Seb. 2015. *Control: Digitality as Cultural Logic*. London and Cambridge, MA: MIT Press.
Galloway, Alexander R. 2004. *Protocol*. Cambridge, MA: MIT Press.
Galloway, Alexander R., and Eugene Thacker. 2007. *The Exploit*. Minneapolis: Minnesota University Press.
Gentili, Dario. 2013. "Crisis as Art of Government." *iMex. México Interdisciplinario/Interdisciplinary Mexico* 2, no. 4: 21–29.
House on Fire. 2017. *Entering the Burning House*. Edited by Lonneke van Heughten. Lisboa: Maria Matos Teatro Municipal/EGEAC.

Invisible Committee. 2015. *To Our Friends*. Translated by Robert Hurley. South Pasadena, CA: Semiotext(e).
Irmer, Thomas. 2019. "Neuartige Produktionsverhältnisse." *Der Freitag*, March 17, 2019. Accessed April 3, 2019. www.freitag.de/autoren/der-freitag/neuartige-produktions verhaeltnisse.
Koselleck, Reinhart. [1985] 2006. "*Einige Fragen an die Begriffsgeschichte von 'Krise'.*" In *Begriffsgeschichten*, 203–217. Frankfurt a.M.: Suhrkamp.
Kunst, Bojana. 2015. *Artist at Work*. London and New York: Verso.
Kwanten, Koen. 2016. "A Network as a Web of Possibilities." In *Performing Europe 2011–2016*, edited by SZENE Salzburg. Salzburg: SZENE Salzburg.
Lacoue-Labarthe, Philippe. 1986. "Le paradoxe et la mimésis." In *L'imitation des Modernes. Typographies II*, 15–36. Paris: Galilée.
Leysen, Frie. 2002. "Searching for the Next Generation." Interview by Daniel Mufson. Accessed July 29, 2019. https://danielmufson.com/interviews/searching-for-the-next-generation-frie-leysen-the-kunstenfestival/.
Leysen, Frie. 2015. "Embracing the Elusive or, the Necessity of the Superfluous." In *How to Build a Manifesto for the Future of a Festival*, "Switch the Scene", edited by Silvia Bottiroli and Giulia Polenta, 38–44. Santarcangelo: Santarcangelo Festival.
Life Long Burning. 2013. "Life Long Burning." *Creative Europe Project Results*. Accessed July 29, 2019. https://ec.europa.eu/programmes/creative-europe/projects/ce-project-details/#project/536282-CU-1-2013-1-AT-CULTURE-VOL11.
Life Long Burning. 2018. "Life Long Burning: Towards a Sustainable Eco-System for Contemporary Dance in Europe." *Creative Europe Project Results*. Accessed July 29, 2019. https://ec.europa.eu/programmes/creative-europe/projects/ce-project-details/#project/597374-CREA-1-2018-1-AT-CULT-COOP2.
Massumi, Brian. 2015. "The Primacy of Preemption." In *Ontopower: Wars, Powers, and the State of Perception*, 3–19. Durham and London: Duke University Press.
Mersch, Dieter. 2013. *Ordo ab chao: Order from Noise*. Berlin and Zurich: Diaphanes.
NXTSTP. 2012. *What Is/Are the Main Challenge(s) for the Performing Arts in Europe in the Years to Come?*, edited by Christophe Slagmuylder, Ruth Collier, Jasper Nijsmans, and Elke Van Campenhout. Brussels: NXTSTP.
NXTSTP. 2017. *NXTSTP 2012–2017*. Brussels: Kunstenfestivaldesarts.
Shaviro, Steven. 2003. *Connected*. Minneapolis: Minnesota University Press.
Suchy, Melanie. 2015. "Campo ist überall." *Theater heute*, no. 11 (November): 48–53.

15 Theatre crisis, local farce, or institutional change?

The controversy surrounding the Munich Kammerspiele 2018 from an institutional logics perspective

Bianca Michaels

'The time for financial and artistic experiments is over', declared Richard Quaas, cultural policy spokesman of the Christian Social Union (CSU) faction of the Munich City Council (Karowski and Vick 2018; Schleicher 2018). What had happened? Two and a half years after the start of the planned five-year tenure of Matthias Lilienthal as artistic director of the municipal Munich Kammerspiele, the CSU parliamentary group decided and publicly announced that it would not be supporting an extension of Matthias Lilienthal's role as artistic director beyond 2020 (Hermanski 2018). What followed was a large-scale, heated public discussion about the renowned Munich city theatre,[1] until Lilienthal announced that he himself did not want to extend his contract beyond summer 2020 because he saw that there was no support for the continuation of the collaboration.[2] Richard Quaas not only declared that the time for financial and artistic experiments was over; in an open letter on his Facebook account on 27 March 2018, he stated:

> With the appointment of Lilienthal as artistic director we wanted to give the theatre a chance to move to new shores. But there can only be a chance if the audience is reached . . . if the Schauspielhaus . . . is at least predominantly used for its purpose of showing drama and does not often stand empty or must serve as an event location.
>
> (Quaas 2018)[3]

The remarks are just a small sample of the comparatively large response that the events surrounding the artistic direction of the Munich Kammerspiele triggered in spring 2018. The discussion about a profound crisis at the theatre had already begun in 2016, after the planned staging of *Plattform/Unterwerfung*, based on the novel *Platform* by the French author Michel Houellebecq, was cancelled on short notice, and it became publicly known that three extremely well-known and popular actresses from the ensemble would be leaving the Kammerspiele at the end of the 2017–18 season because the theatre had no use for them due to its current artistic orientation (Dössel 2016). In a roundtable discussion on the future of the Kammerspiele, which the theatre itself had organised in November 2016 ("What kind of theatre does Munich need?"), the extent to which the cultural

public sphere was occupied with the new course of the Kammerspiele was already apparent.[4]

Numerous comments from the various protagonists and the regional and national media were followed by a public demonstration, an extraordinary meeting of the cultural committee,[5] open letters, and petitions, as well as innumerable comments on various social media channels. In autumn 2016, following the announcement by the departing members of the ensemble, many media outlets had already discussed whether and to what extent the Munich Kammerspiele was in crisis. Leading theatre critic Christine Dössel set up an opposition between Lilienthal's advocacy of so-called 'performance-theatre' and 'classical' acting:

> The postdramatic discourse- and performance-theatre that Lilienthal is trying to establish no longer requires the classical actor, who can speak well and is endlessly versatile, but instead the "performer": as young and as "authentic" as possible with street credibility and that certain something, ideally with an interesting immigrant background and idiom.
>
> (Dössel 2016)

The theatre critic of the Munich-based newspaper *Süddeutsche Zeitung* drew a comparison with the world of football:

> If the Kammerspiele apparently has no need for an actor like Brigitte Hobmeier—despite the fact that this artist is capable of performance art—one has to ask oneself what the aim of this theatre is. It's as if FC Bayern were to leave Robert Lewandowski sitting on the subs' bench. That's not how you win the Champions League.
>
> (Dössel 2016)

The public comments about the extension of the artistic directorship in spring 2018 seamlessly followed from the crisis narrative formulated in the features pages in 2016.

One could characterise the discussions about the Munich Kammerspiele as local, intensive, but entirely normal public processes of negotiation. And they are. However, the example of the Kammerspiele—as shown next—points to institutional transformation processes, whose impact extends beyond Matthias Lilienthal, the city of Munich, and its municipal theatre.

Theatre as an institution

Although there is an overwhelming and sometimes confusing amount of mostly social-scientific literature on the concept of 'institution', so far, few studies have investigated theatre from the perspective of institutional theory. Here, I will apply the perspective of institutional logics, which is well established in sociology but has hitherto hardly been tested in the fields of theatre studies and the theatre.

The theoretical approach of institutional logics has experienced a meteoric rise in recent years. Its roots are to be found in the new institutionalism of Meyer and Rowan (1977) and DiMaggio and Powell (1983, 1991)—with Friedland and Alford (1991) as a direct point of reference—and further developed by Scott (2014); Thornton and Ocasio (2002); and Thornton, Ocasio, and Lounsbury (2012).

In the following, I draw on the concept of an institution elaborated by neo-institutional theory, which was developed in particular in the 1970s and 1980s in the USA in the field of organisational studies. The organisational theory referred to as neo-institutionalism subsequently became widespread in Europe as well. Within the scope of this theory, institutions are 'rules, expectations or belief systems or interpretation schemata', which can be regarded as 'firmly established structures of social expectation': 'In certain social situations it is thus expected that certain types of agents will act out defined behavioural scripts' (Walgenbach and Meyer 2008, 55).

While institutional theories frequently emphasise the regulative character of institutions, the social scientist W. Richard Scott also points out—in addition to the restrictions that institutions impose—the role of institutions with regard to social interaction and, thus, the ability of institutions to support and enable actions and agents: 'Institutions comprise regulative, normative, and cultural-cognitive elements that, together with associated activities and resources, provide stability and meaning to social life' (Scott 2014, 56).[6] Scott stresses the stabilising and meaning-making properties of institutions because of the processes set in motion by regulative, normative, and cultural-cognitive elements: 'These elements are the central building blocks of institutional structures, providing the elastic fibers that guide behavior and resist change' (Scott 2014, 57). For the present context and for dealing with institutions in general, these two apparently contrary aspects are thus both fundamental: the symbolic systems (rules, norms, and cultural-cognitive beliefs) as components of institutions are responsible for constancy and resistance to change and simultaneously form an elastic framework for social behaviour (Scott 2014, 57). Of particular relevance in the present context is Scott's observation that the analysis of institutions should not be restricted to symbolic systems (rules, norms, and belief or interaction systems) but must also consider the activities 'that produce, reproduce, and change them and to the resources that sustain them. Institutions are . . . inhabited by people and their interactions' (Scott 2014, 57). Thus, institutions coordinate 'interactions, distribute duties or roles and define the relationships of the agents to each other' (Walgenbach and Meyer 2008, 55).

Due to the lack of consideration given to the terms *institution* and *organisation* in theatre studies so far, it is necessary to consider, at least briefly, the relationship between institution and organisation. The oft-cited game metaphor of the economist Douglass C. North is particularly illuminating here. According to North: 'Institutions are the rules of the game in a society or, more formally, are the humanly devised constraints that shape human interaction' (North 1990, 3). As North states, using the analogy of competitive team sports, institutions represent

the formal written rules of the game, as well as its non-written codes of conduct, while organisations act as players that observe the rules of the game:

> The purpose of the rules is to define the way the game is played. But the objective of the team within that set of rules is to win the game—by a combination of skills, strategy, and coordination; by fair means and sometimes by foul means.
>
> (North 1990, 4–5)

Moreover, organisations also have an influence on the structure of the rules: for instance, by using political or other means to try to change them. As Hasse and Krücken state: 'institutions can be defined sociologically as social expectation structures that determine what is appropriate action and decision-making' (Hasse and Krücken 2009, 237).

Transferred to the field of theatre, this means that individual theatres such as the Munich Kammerspiele are organisations and thus players or teams that produce theatre under the prevailing institutional conditions (what is currently expected of publicly funded theatre in terms of action). Although individual theatre organisations differ significantly in terms of their artistic profiles, the composition of the ensemble, and the strategy used in programme planning, they all adhere to the prevailing rules of the game. One of the few examples of written rules in the field of publicly funded theatre in Germany is the articles of association. The articles of association of the city of Munich for the Munich Kammerspiele state the following:

> The task of the municipal enterprise is the promotion of acting. To this end, it engages in repertory theatre with its own ensemble. . . . The repertoire includes, on a regular basis, the theatre's own artistic productions, co-productions, guest performances and special events, and occasionally media productions.
>
> (Landeshauptstadt Muenchen 2003)

Here, it is also stated, for instance, that the theatre directly promotes and supports art and culture, it is an exclusively non-profit organisation, and the bodies responsible for the affairs of the municipal enterprise are—in addition to the artistic director and the managing director—the cultural committee, the full city council, and the mayor.[7] Although the approximately 140 publicly funded theatres in Germany represent a broad spectrum in terms of their repertoire, similar general institutional conditions apply to all such theatres.

Programme planning

Having outlined the concept of publicly funded theatre as an institution and some of its valid rules, I will now turn to the artistic orientation of theatre organisations. The artistic activities of a theatre not only appear at the level of production and individual performances, but also materialise particularly in the orientation of the

programme planning. Here, the individual theatres produce and reproduce the institutionalised rules, norms, and belief systems of what is considered legitimate for a publicly funded theatre. As the statements by the cultural policy spokesman Richard Quaas mentioned at the beginning of this chapter suggest, it seems that it was particularly the artistic orientation of the theatre—i.e., the general programme planning—that was a source of irritation, as can be seen, for example, in his statement that the Kammerspiele has other duties and responsibilities besides being just 'any old experimental theatre'. I want to pursue the thesis that the performances and events that Quaas described as 'nonsense' not only represent a central factor in the offence felt by the CSU faction in Munich but can also be drawn on as a significant indicator of institutional changes in the theatre landscape.

In the 2004–05 season, the *Deutscher Bühnenverein* (German Theatre and Orchestra Association), in its annual publication of theatre statistics, with figures on the income and expenditures, staff costs, audience numbers, venues, and events of the approximately 140 state theatres, municipal theatres, and regional theatres in Germany, made an adjustment to the data collected:[8] so-called 'theatre-related events' were introduced as a new category previously known just as 'other events'. 'Theatre-related events' cover educational programmes, introductions to plays, panel discussions, etc. for which the theatres generally charge little or no entry fee. The 'other events' included performances such as readings and song recitals. Thus, 'theatre-related events' and 'other events' are located outside the scope of what is usually recorded under the headings of drama, opera, and concert or children's and youth theatre.

The introduction of the 'theatre-related events' category in the 2004–05 season can itself be seen as a significant indicator of institutional change in the theatre. The annual theatre statistics can be regarded as a mirror of or a litmus test for the prevailing non-written institutionalised rules, expectations, and belief systems in the theatre because they make these overall trends visible.[9]

In addition to the introduction of the category itself, the figures listed under this category are also indicative of an ongoing process of change in programme planning in recent years. An analysis of the performance figures of all publicly funded theatres since 2004–05 shows that the number of performances under the two headings 'other events' and 'theatre-related events' has increased significantly in recent years (Figure 15.1).

While the 'other events', which were not divided into subcategories until 2004, accounted for 11.5% of all performances across the theatres for which figures were recorded in the 1991–92 season. The proportion of events summarised in this category was 17.4% in the 2004–05 season and 28.2% in 2017–18, thus representing more than a quarter of the total performances.[10] This significant increase of the number of events recorded in the categories of 'theatre-related events' and 'other events' is further proof that altered expectation structures have become firmly established in the field of theatre and are reflected in the programme planning of the publicly funded theatres.[11]

In the 2017–18 season of the Munich Kammerspiele, the third under the artistic direction of Lilienthal, 53% of all performances can be categorised as

Theatre crisis, farce, change? 211

number of events

[Bar chart showing three seasons:
- 1991/1992: 88.5% established divisions, 11.5% other
- 2004/2005: 82.6% established divisions, 17.4% other
- 2017/2018: 71.8% established divisions, 28.2% other
Y-axis: 0 to 90,000; X-axis: seasons]

☐ other performances and theatre related events

■ performances of 'established divisions' (opera, drama, children's theatre, concert etc.)

Figure 15.1 The growth of new forms in German public theatre.

Source: Author's diagram (Deutscher Bühnenverein 1993, 2006, 2019)

drama. 'Other events' account for 16% and 'theatre-related events' for 21% of the total performances (Figure 15.2). In addition, there are guest performances and concerts. It thus becomes apparent that in the programme planning of the Kammerspiele, many other forms can be found in addition to drama: concerts, guest performances, theatre-related events (panel discussions, welcome café for refugees, etc.). As the figure that follows shows, these often hard-to-define performances, which are listed in the theatre statistics under 'other events' and 'theatre-related events', together make up 37% of the total offerings. These events, together with guest performances and concerts, have almost as large a share of the programme as the performances categorised as drama do (53%).[12]

Thus, the programme planning of the Kammerspiele with regard to the proportion of 'other events' and 'theatre-related events' seems to be a particularly

Munich Kammerspiele

season 2017/2018

[Pie chart showing:
- drama: 399
- concert: 14
- other events: 124
- theatre-related events: 160
- guest performance: 60]

Figure 15.2 Programme of the Munich Kammerspiele, season 2017–2018.

Source: Author's diagram (Deutscher Bühnenverein 2019)

significant example. This also becomes apparent in a direct comparison with an overview of the performances of the Residenztheater, another renowned drama theatre located in Munich, which is funded by the State of Bavaria (Figure 15.3).

The comparison illustrates how big the differences in the programme planning are: the performances in the drama category make up 85% of the performances at the Residenztheater in the season in question, whereas 'other events' account for only 3.5% and 'theatre-related events' do not appear at all.

Institutional logics and the significance of legitimacy

In order to expand the perspective, I will use a neo-institutional approach and, in particular, the perspective of institutional logics to examine more closely the organisational field of publicly funded theatre in Germany and the processes of change that can currently be observed. The background is the finding mentioned

Bayerisches Staatsschauspiel /Residenztheater

season 2017/2018

[Pie chart showing:
- concert: 3
- other events: 21
- guest performance: 13
- children's theatre: 50
- drama: 499]

Figure 15.3 Programme of the Bayerisches Staatsschauspiel/Residenztheater, season 2017–2018.

Source: Author's diagram (Deutscher Bühnenverein 2019)

earlier: what Richard Quaas calls 'nonsense' can be identified as a significant diversification of the programme. This trend towards a more diverse program in terms of new (often participatory) formats can be observed in the programme planning of almost all 140 German municipal and state theatres, albeit mostly to

a lesser extent. An increase in the number of 'theatre-related' and 'other events' characterises all publicly funded municipal and state theatres throughout Germany.

According to the essay by Friedland and Alford (1991), in which the approach of institutional logics was first developed, higher-level institutional orders can be observed in Western societies (state, democracy, market, religion, and family). Each of these orders is, in turn, characterised by specific practices, systems of rules, and cultural symbolism, which together constitute a specific institutional logic: 'Each of the most important institutional orders of contemporary Western societies has a central logic—a set of material practices and symbolic constructions—which constitutes its organizing principles and which is available to organizations and individuals to elaborate' (Friedland and Alford 1991, 248). Institutional logics are thus understood as superordinate categorisations. They include rationales, belief patterns, and assumptions of the actors and always, as the basis of their legitimacy, have an effect on the attitudes and actions of individuals and organisations. Other scholars, such as Thornton and Ocasio, have applied and extended this approach to the analysis of institutional shifts within organisations:

> Institutional logics define the norms, values and beliefs that structure the cognition of actors in organizations and provide a collective understanding of how strategic interests and decisions are formulated. Shifts in institutional logics can affect which conditions are viewed as problematic and how they can be addressed by change in strategy and structure of an organization.
> (Thornton and Ocasio 2002, 82)

Friedland and Alford pointed out that each logic is linked to a particular type of rationality. For example, democracy is associated with equality and participation, and family is associated with unconditional loyalty (Friedland and Alford 1991). Thornton and Ocasio, however, differentiate ideal-typical categories of institutional orders: family, religion, state, market, profession, corporation, and community (Thornton, Jones, and Kury 2005, 128, 168–170; Thornton, Ocasio, and Lounsbury 2012, 52–53). Accordingly, on the social macro level, each of these institutional orders is characterised by an institutional logic as a bundle of norms and cultural and structural practices. Each bundle differs in various ways: for instance, in their sources of legitimacy and in the types of norms and control mechanisms. In processes of change, different institutional logics can come into conflict with each other. In this regard, Scott states that: 'Many of the most important tensions and change dynamics observed in contemporary organizations and organization fields can be fruitfully examined by considering the competition and struggle among various categories of actors committed to contrasting institutional logics' (Scott 2014, 91). The assumption is that the formation of interests and the perceptions of actors with regard to resources and organisational practices take place only within specific institutional contexts or logics.

At the same time, the role of the actors should not be underestimated in the approaches to institutional logics: 'Decisions and outcomes are a result of the

interplay between agency and institutional structure' (Thornton and Ocasio 2008, 103). Here, the approach presumes 'an interdependency of individuals' preferences or identities on the one hand and structural constraints or incentives on the other, which are understood in terms of "embedded agency"' (Thornton and Ocasio 2008, 103–104). Thus, institutional logics not only contribute to the stability of organisational settings, but also—as a cognitive orientation framework—structure new approaches to problems, thereby acting as a trigger for (organisational) innovations and institutional change (Thornton and Ocasio 2008, 108). They are, therefore, on the one hand, stabilising and, on the other hand, constitutive for processes of change.

In his study on changes in the organisation of higher education published in 2016, Albrecht Bluemel questions whether the taxonomy of institutional orders or logics postulated by Thornton and Ocasio in 2012 is really exhaustive and whether science and jurisprudence (subsumed under 'profession' by Thornton *et al.*) do not, in fact, represent further institutional orders or logics (Bluemel 2016, 83). Subsequently, one might discuss whether the field of art should also be categorised as an independent institutional order with its own logic, with closer consideration in the field of the arts/performing arts of other institutional orders, such as the logics of the market and the profession.

One significant context, which the debates outlined earlier about the Munich Kammerspiele illuminate, is the fact that organisations require legitimacy:

> legitimacy is not a commodity to be possessed or exchanged but a condition reflecting perceived consonance with relevant rules and laws or normative values, or alignment with cultural-cognitive frameworks. Like some other invisible properties such as oxygen, the importance of legitimacy becomes immediately and painfully apparent only if lost, suggesting that it is not a specific resource, but a fundamental condition of social existence.
> (Scott 2014, 72)

From the perspective of neo-institutionalism, theatres are, like all organisations, forced 'to present themselves in such a way that they can be recognised by their environment as legitimate agents' (Hasse and Krücken 2009, 246). This applies all the more to publicly funded theatres in Germany, which receive considerable financial support from the public purse: i.e., from the local authorities and the federal states. The amount of public funding is one of the reasons debates on cultural policy in Germany time and again enter the public sphere. For example, the planned operating grant from the city of Munich to the Munich Kammerspiele in 2019 was more than €35 million, which corresponds to 16% of the city's culture budget (*Landeshauptstadt Muenchen*).[13]

The importance of legitimacy[14] is particularly apparent in the field of publicly funded theatres in Germany because, due to the large amount of public money spent on culture, the legitimacy of municipal theatre organisations is implicitly and explicitly negotiated. In order to be perceived as legitimate (i.e., acceptable), new activities—and here one could certainly term the new artistic course of the

Kammerspiele undertaken by Matthias Lilienthal and his team in Munich as a new activity—must be accepted locally (i.e., not just by the audience and the employees but, ultimately, also by the city council). Although artistic freedom is rooted in Article 5 of the German Constitution, attempts to influence the content of art directly are rare. However, political and cultural public debates about theatre show the extent to which there are certainly negotiations—on the level of cultural policy—about questions of legitimacy and what is understood to be the role of the theatre. Nevertheless, cultural policy debates in Germany tend to concentrate on questions of financing and audience numbers, by which the degree of legitimacy of a theatre is measured. Financial arguments and questions about the popularity of the theatre with the audience are rarely linked to artistic issues as they were in the recent cultural policy debate in Munich.

As Langenohl notes, 'it is precisely in periods of institutional change and in the view of organisation members who are substantially affected by this change that such a change represents a more or less open conflict between different logics' (Langenohl 2005, 7). The perspective of institutional logics provides the following interpretation: in certain social situations, artistic directors are expected to act out specific behavioural scripts associated with publicly funded theatre, which are reflected, for example, in the programme planning. At the same time, there are explicit and implicit expectations of municipal and state theatres that, to some extent, contradict or seem to contradict each other. The example of the debate about 'any old experimental theatre' shows how these established expectation structures converge and lead to conflicts. Here, the conflicting logics can be relatively clearly assigned to the determining actors in the debate: i.e., the representatives of the CSU faction on the one hand and the artistic direction of the Kammerspiele on the other.[15] The case is particularly prolific because questions of theatre programming are normally not the subject of public political debate. In the conflict over the current artistic direction, institutionalised expectation structures of cultural policy actors regarding the programme become explicit and thus observable.

Conclusion

Nearly one and a half years after the debate in Munich, the renowned journal *Theater heute* published a survey of critics in its almanac in August 2019: 14 of the journal's 44 critics from Germany, Austria, and Switzerland voted for the Kammerspiele as theatre of the year 2019. In an interview with the Deutschlandfunk Kultur radio station, the editor of *Theater heute*, Franz Wille, said that this vote was in no way to be considered as belated congratulations to Lilienthal:

> I don't think that that's the sentimental answer. It's really a great show of appreciation for a great undertaking. Matthias Lilienthal and his team at the Munich Kammerspiele have tried to rethink German municipal theatre. The Kammerspiele was a laboratory and—as is the case in laboratories—a few test tubes blew up in their faces at first. They made mistakes; they corrected the

mistakes. And this is now the well-earned thanks for the really important work that extends far beyond Munich and provides an outlook for municipal theatre.
(Billerbeck 2019)

Here, Wille emphasises the experimental character of theatre, which is inscribed in the institutional logic of the theatre as a behavioural expectation. If institutional logics—as set out here—encompass rationales and assumptions of the actors and serve as a basis for legitimacy, it becomes apparent here, if not earlier, that the publicly funded theatres in Germany possibly find themselves, with regard to forms of performance ('theatre-related events', 'other events'), in a process of transformation which may change the norms and values as well as the basis for the legitimacy of theatre. Nevertheless, the fact that, in 2019, the Kammerspiele in Munich was not only voted theatre of the year, but also won prizes in numerous other categories (production of the year, actor of the year, etc.) also allows another conclusion to be drawn. Despite all the current processes of change, there has obviously been no change amongst theatre critics and their expectation structures towards theatre as a testing ground. Contrary to what Richard Quaas said, the time for artistic experiments does not seem to be over at all, and the artistic experiment still appears to represent the fundamental norm and, as part of the specific institutional logic of the theatre, a substantial pillar of legitimacy.

Regarding the omnipresent crisis narrative of the debate about Matthias Lilienthal and the Munich Kammerspiele, the following should be noted: although the term *crisis* appears repeatedly in the relevant reports on the Kammerspiele in 2016 and 2018, I would argue that the case shown here is not a theatre crisis. This is particularly because there is no indication that the Kammerspiele as an organisation is in question or that there are any doubts about its existence or its public sponsorship. Particularly, there is no indication that the legitimacy (i.e., the recognition) of the house would be called into question. Rather, the programmatic orientation under Matthias Lilienthal as artistic director of the house and thus responsible for the programming was called into question. The artistic orientation of the Munich Kammerspiele under the artistic direction of Matthias Lilienthal apparently did not correspond to the expectation structures of individual cultural policy actors. Thus, the decision-making situation was necessarily associated with a crisis related to the concrete constellation of actors, not to the Kammerspiele as an organisation or even to the institution of theatre itself.

The public debate with Councillor Quaas's quoted statement that the theatre of the city has other duties and responsibilities than being just any old experimental theatre shows that the Kammerspiele has, by no means, been called into question as an organisation, but, on the contrary, as the theatre of the city, it still has an unquestioned significance. Therefore, in this case, it is neither a theatre crisis nor a local farce. Rather, the debate described in this chapter makes the institutional logics of the respective actors (i.e., the respective cognitive orientation framework) clearly evident.

At the same time, the conflicting logics of the actors in Munich—even if they are certainly specific to the Bavarian city—also reveal and make tangible the

substantial institutional change in terms of programme planning currently taking place throughout Germany: i.e., the change of cultural-cognitive beliefs and expectation structures regarding the theatre.

Notes

1 In an open letter, members of the ensemble and numerous performers and artists associated with the Kammerspiele addressed the Munich City Council: 'It is incomprehensible to us why it's not possible to have, in the Kammerspiele, a theatre in Munich in which, in addition to the "classics" and contemporary dramas, other performative formats and interdisciplinary or international works are shown; a theatre that works together with the independent artistic scene, tries out new modes of production, and makes visual arts, concerts, dance, discourse and community work, such as the Welcome Café for newcomers to Munich and long-term Munich residents, an integral part of its programme. In other words: A theatre as an open space that is influenced by society and influences it in return' (Tillmans et al. 2018).
2 According to a report by the dpa (German Press Agency), due to the makeup of the city council, there might not have been a majority for an extension of the artistic direction without the agreement of the CSU (cf. dpa 2018).
3 *Schauspielhaus* refers to the Kammerspiele's famous art nouveau main stage while the term *event location* (*Eventbude*) has been used as a pejorative term and denotes a theatre where traditional ensemble structures are dissolved in favour of guest companies. In a post on the Facebook page of the Munich Kammerspiele, the councillor called the programme of the Kammerspiele under the artistic direction of Lilienthal 'nonsense'. On 20 March 2018, the politician made a very firm statement about his idea of a municipal theatre: A municipal theatre 'has other duties and responsibilities than being just any old experimental theatre' (@Richard Quaas, March 20, 2018). The post has since been deleted.
4 The panel discussion at the Munich Kammerspiele on 20 November 2016 took place in front of a full house. The public discussion was triggered to a large extent by the reporting in the Munich media, especially in the *Süddeutsche Zeitung*, where the loss of the ensemble spirit, the neglect of drama, the alienation of the audience, too much performance art, discussions, guest performances by independent groups, and the departures of top-class actresses were denounced (Weiser 2016).
5 In the extraordinary meeting, it was debated whether theatre could be conceived as a place of experimentation. Marian Offmann, a councillor belonging to the CSU faction, qualified the attitude of her party in comparison to the statements of the cultural policy spokesman of the CSU faction, Richard Quaas: 'Of course, the CSU also considers the theatre to be a place of experimentation, but only of artistic, not financial experimentation' (Leucht 2018). The background to this debate was the decline in audience numbers and the cancellations of subscriptions, although neither of these factors is unusual when there is a change of artistic director. The retiring director of the Municipal Department of Arts and Culture Hans-Georg Küppers, however, emphatically denied the suggestion that the Kammerspiele was in a 'financial crisis' (cf. Leucht 2018).
6 While various institutional theorists consider either the regulative, the normative, or the cultural-cognitive aspect as the most important component, Scott develops a three-pillar system, according to which the three elements together support institutions, although they are each based on varying assumptions (cf. Scott 2014, 59–71). For the field of art, we can assume that especially normative and cultural-cognitive aspects are of central importance in questions related to programme planning, while in other areas (e.g., in relation to working conditions) regulative aspects have more weight.
7 According to the articles of association, the full city council is responsible for major personnel issues, such as the appointment and dismissal of the artistic director.

8 The theatre statistics published by the *Deutscher Bühnenverein* include all state theatres, municipal theatres, and regional theatres and, thus, all publicly funded theatres in Germany. In contrast, festivals and private theatres are not fully included in the statistics. The theatre statistics are the only source that provides detailed information on the figures mentioned earlier with the most important economic data of theatres and orchestras. When using the theatre statistics as a source, one must bear in mind that the *Deutscher Bühnenverein* does not provide official statistical information as, for instance, the Federal Statistical Office does. Instead, as the interest group and employers' association for theatres and orchestras, its aim is to 'preserve, promote and develop the unique diversity of the German theatre and orchestra landscape and its contribution to cultural life' (*Deutscher Bühnenverein*, website). The theatres themselves report the figures for the theatre-related events to the *Bühnenverein*.
9 More detailed analyses of the theatre statistics are currently being carried out in the research project *Von Bürgerbühnen und Stadtprojekten* (Of Citizen's Theatres and City Projects) at LMU Munich within the framework of the research group *Krisengefüge der darstellenden Künste*. One question to be answered is to what extent a summary like the theatre statistics of the *Bühnenverein* not only produces and reproduces, but also changes theatre. It is not possible to go into detail here, but one question to be investigated is to what extent the introduction of the additional category not only reproduces the programme planning of the theatres, but also indicates an altered expectation and belief system: if one follows this perspective and the arguments cited here about the meaning-making dimension of institutions, one could interpret this change in the way in which the statistics are presented as an altered perception of theatre by the *Bühnenverein*. Accordingly, in the view of the *Bühnenverein*, it would therefore not only be justified, but possibly also appropriate for publicly funded theatres to include 'theatre-related events' in their programmes.
10 Cf. 2017–18: A total of 82,125 performances, 16,769 of which were 'theatre related' and 6,422 of which were 'other events': i.e., a total of 23,191 of 82,125 performances.
11 These conclusions are supported by numerous other pieces of evidence: for instance, one could mention changes to the advertising of the position of artistic director at municipal and state theatres, as well as the focus placed on certain areas of the performing arts by the German Federal Cultural Foundation through its funding programmes, such as the *Heimspiel* (Home Game) fund between 2006 and 2011. This programme awarded additional funding for projects at theatres that were characterised by a closer examination of the social and urban reality of the city in which the theatre was located and supported 63 projects all over Germany.
12 In the season before (2016–17), the share of 'theatre related events' and 'other events' together amounted to 43%; thus, the ratio between drama and all other categories together was 45% (drama) to 55%.
13 According to information about the municipal budget of the city of Munich, in 2018, €215 million (and thus 3% of the overall budget of the city of Munich) was paid out for culture through the Department of Arts and Culture (Landeshauptstadt Munich 2018). Of this, €35 million is budgeted for 2019 as an operating grant for the Munich Kammerspiele (Landeshauptstadt Munich 2019, 48).
14 Legitimacy is understood here, above all, as the legitimacy conviction of the public, including the political decision-makers: i.e., the recognition of a certain political order (cf. Braun and Schmitt 2009, 55).
15 An analysis of the role of the media would also be fruitful at this point, but it would go beyond the scope of this chapter.

References

Billerbeck, Liane von. 2019. "Voller Erfolg für die Muenchner Kammerspiele." Interview with Franz Wille. *Deutschlandfunk Kultur*. Accessed September 7, 2019. www.

deutschlandfunkkultur.de/theater-des-jahres-gekuert-voller-erfolg-fuer-die-muenchner.1008.de.html?dram:article_id=457488.
Bluemel, Albrecht. 2016. *Von der Hochschulverwaltung zum Hochschulmanagement.* Wiesbaden: Springer VS.
Braun, Daniela, and Hermann Schmitt. 2009. "Politische Legitimität." In: *Politische Soziologie*, edited by Viktoria Kaina and Andrea Römmele, 53–81, Wiesbaden: VS Verlag für Sozialwissenschaften.
Deutscher Bühnenverein. 1993. *Theaterstatistik 1991/92: Die wichtigsten Wirtschaftsdaten der Theater, Orchester und Festspiele.* Köln: Deutscher Bühnenverein.
Deutscher Bühnenverein. 2006. *Theaterstatistik 2004/05: Die wichtigsten Wirtschaftsdaten der Theater, Orchester und Festspiele.* Köln: Deutscher Bühnenverein.
Deutscher Bühnenverein. 2019. *Theaterstatistik 2017/18: Die wichtigsten Wirtschaftsdaten der Theater, Orchester und Festspiele.* Köln: Deutscher Bühnenverein.
DiMaggio, Paul J., and Walter W. Powell. 1983. "The Iron Cage Revisited: Institutional Isomorphism and Collective Rationality in Organizational Fields." *American Sociological Review* 48, no. 2: 147–160.
DiMaggio, Paul J., and Walter W. Powell. 1991. "Introduction." In *The New Institutionalism in Organization Analysis*, edited by Walter W. Powell and Paul J. DiMaggio, 1–38. Chicago: University of Chicago Press.
Dössel, Christine. 2016. "Als ließe der FC Bayern Lewandowski auf der Ersatzbank hocken." *Sueddeutsche.de*, November 3, 2016. Accessed September 7, 2019. www.sueddeutsche.de/kultur/2.220/theater-als-liesse-der-fc-bayern-lewandowski-auf-der-ersatzbank-hocken-1.3231419.
dpa. 2018. "Kammerspiele: Intendant Lilienthal nimmt den Hut." *Muenchner Merkur*, March 19, 2018. Accessed September 7, 2019. www.merkur.de/kultur/kammerspiele-intendant-lilienthal-nimmt-hut-9709655.html.
Friedland, Roger, and Robert R. Alford. 1991. "Bringing Society Back in: Symbols, Practices, and Institutional Contradictions." In *The New Institutionalism in Organizational Analysis*, edited by Walter W. Powell and Paul J. DiMaggio, 232–263. Chicago and London: Chicago Press.
Hasse, Raimund, and Georg Krücken. 2009. "Neo-institutionalistische Theorie." Accessed September 7, 2019. www.uni-kassel.de/einrichtungen/fileadmin/datas/einrichtungen/incher/K35_Hasse_Kruecken_2009.pdf.
Hermanski, Susanne. 2018. "Avanti dilettanti." *Süddeutsche Zeitung*, March 24, 2018. DIZDigital.
Karowski, S., and K. Vick. 2018. "Lilienthal macht 2020 Schluss." *Münchner Merkur*, March 20, 2018.
Landeshauptstadt München. 2003. "Betriebssatzung des Eigenbetriebs Münchner Kammerspiele 566." Accessed September 7, 2019. www.muenchen.de/rathaus/Stadtrecht/vorschrift/566.
Landeshauptstadt München. 2018. "Der Stadthaushalt 2018." Accessed September 7, 2019. www.muenchen.de/rathaus/dam/jcr:c27f8e06-8c17-411b-8503-a2350b46867b/180329_lhm_haushalt_2018.pdf.
Landeshauptstadt München. 2019. "Teilhaushalt Kulturreferat 2019." Accessed September 7, 2019. www.muenchen.de/rathaus/dam/jcr:5cdb5d7b-f261-42d7-94da-e011f2de87e4/06_kultur.pdf.
Landeshauptstadt München. n.d. "Zahlen, Daten, Fakten." Accessed September 7, 2019. www.muenchen.de/rathaus/Stadtverwaltung/Kulturreferat/Wir-ueber-uns/Zahlen_Daten_Fakten.html.

Langenohl, Andreas. 2005. "Neo-Institutionalismus und Konstruktivismus: Zur qualitativen Rekonstruktion konfligierender institutioneller Logiken in Unternehmen der Finanzwirtschaft." Working Paper, Justus-Liebig-University Gießen. Accessed September 7, 2019. www1.uni-giessen.de/erinnerungskulturen/home/_download.php?type=termin_material&id=8.

Leucht, Sabine. 2018. "Sündenböcke und der Stoff, aus dem Legenden sind." *Nachtkritik.de*, April 13, 2018. Accessed September 7, 2019. https://nachtkritik.de/index.php.

Meyer, John W., and Brian Rowan. 1977. "Institutionalized Organizations: Formal Structure as Myth and Ceremony." *The American Journal of Sociology* 83, no. 2: 340–363.

North, Douglass C. 1990. *Institutions, Institutional Change and Economic Performance*. Cambridge: Cambridge University Press.

Quaas, Richard (@Richard Quaas). 2018. "Offener Brief an die SZ-Muenchenkultur-Chefin zu ihrem Kommentar 'Wer hat eine Vision für Muenchen." *Facebook*, March 27, 2018. Accessed September 7, 2019. www.facebook.com/Stadtrat.Richard.Quaas/posts/1809452025778367.

Schleicher, Michael. 2018. "Stadt Will Lilienthal-Nachfolger bis Jahresende." *Muenchner Merkur*, April 13, 2018. Accessed September 7, 2019. www.merkur.de/kultur/stadt-will-lilienthal-nachfolger-bis-jahresende-9776388.html.

Scott, W. Richard. 2014. *Institutions and Organizations: Ideas, Interests and Identities*. Thousand Oaks: Sage Publications.

Thornton, Patricia H., Candace Jones, and Kenneth Kury. 2005. "Institutional Logics and Institutional Change in Organizations: Transformation in Accounting, Architecture, and Publishing." *Transformation of Cultural Industries: Research in the Sociology of Organizations* 23: 125–170.

Thornton, Patricia H., and William Ocasio. 2002. "The Rise of the Corporation in a Craft Industry: Conflict and Conformity in Institutional Logics." *Academy of Management Journal* 45, no. 1: 81–101.

Thornton, Patricia H., and William Ocasio. 2008. "Institutional Logics." In *Handbook of Organizational Institutionalism*, edited by Royston Greenwood, Christine Oliver, Roy Suddaby, and Kerstin Sahlin, 99–129. Thousand Oaks, CA: Sage.

Thornton, Patricia H., William Ocasio, and Michael Lounsbury. 2012. *The Institutional Logics Perspective: A New Approach to Culture, Structure and Process*. Oxford: Oxford University Press.

Tillmans, Wolfgang, David Kermani, Hortensia Völckers, Okwui Enwezor, Ulrich Wilmes, Kasper König, Armin Nassehi, *et al*. 2018. "Offener Brief an den Muenchner Stadtrat." Accessed July 30, 2019. http://docs.dpaq.de/13455-offener_brief_muenchner_kammerspiele.pdf.

Walgenbach, Peter, and Renate Meyer. 2008. *Neoinstitutionalistische Organisationstheorie*. Stuttgart: Kohlhammer.

Weiser, Michael. 2016. "Hier sitze ich und will nicht anders." *kultur-vollzug.de*, November 24, 2016. Accessed September 7, 2019. www.kultur-vollzug.de/article-61324/2016/11/24/hier-sitze-ich-und-will-nicht-anders/.

Index

Agamben, Giorgio 72
Al Attar, Mohammed 33, 36
All Together Now! 174
Alston, Adam 59
anagnorisis 9
assembly 16
Autonomous Cultural Centre Metelkova Mesto 175

Ballhaus Naunynstrasse (theatre) 30
Balme, Christopher 59, 110, 151
Baumol, William 108
Beck, Ulrich 46, 202
Benjamin, Walter 8, 58
Berlant, Lauren 76, 79
Berliner Ensemble 29
Berlin Volksbühne 2, 11, 15, 27, 41, 166, 176, 191
Bildung 27, 32, 96
Boenisch, Peter M. 15, 27, 191
Bogotá 49
Bogusz, Tanja 59
Boltanski, Luc 17, 18, 84, 94, 120
Bourdieu, Pierre 84, 157, 185
Bulc, Mare 174
Burroughs, William S. 197
Burzyńska, Anna 147
Butler, Judith 16, 46

Cabaret Rhizome 160
Castorf, Frank 27, 166
Catholic Church 143
Celtic Tiger 83
Charmatz, Boris 33, 36
Chiapello, Eve 17, 84, 120
Chul Han, Byung 28
Clata, Jan 148
Cools, Guy 199
Croatian National Theatre 143

Crouch, Colin 56
Curse, The 148

D'Amico, Silvio 108
Days of Marko Marulić 145
De Keersmaeker 36
Delgado, Maria 5, 6
Dercon, Chris 2, 11, 15, 27, 41, 59, 166
Deuflhard, Amelie 197
Deutscher Bühnenverein 126
Diawara, Manthia 32
Diederichsen, Diedrich 32
Dirks, Nicholas 50
Documenta 190
Donato, Fabio 106
Dössel, Christine 206

Edmondson, George 67
Eikhof, Doris R. 123
Embros Theatre 14, 70
enculturative breakdown 2, 15, 22, 119
Ensemble Modern 181
Ensemble-Netzwerk 126
Enwezor, Okwui 28, 32
Esposito, Elena 201
Etchels, Tim 36
Eurokaz 144
Exile Ensemble 30

Fisher, Tony 64
Florida, Richard 90
Foster, Hal 44
Foucault, Michel 3
Free Stage 160
Freud, Sigmund 7
Fried, Michael 44
Frljić, Oliver 19, 30, 143, 170

Galloway, Alexander 195
General Assembly 16, 56

Index

Gentili, Dario 203
Ghent Manifesto 16, 59
Globe Theatre 11
Goebbels, Heiner 181
Goldhill, Simon 56
Goodhart, David 15
Goyette, Marie 181
Gramsci, Antonio 17, 69, 71
Grassi, Paolo 108
Grotowski, Jerzy 144
Groys, Boris 27, 31, 185

Habermas, Jürgen 8, 10, 11, 12, 14, 16, 47, 151
Hamlet 8
Harney, Stefano 78
HATE Radio 58
Haunschild, Axel 18, 44, 46, 119
Haus der Kunst Munich 27
Havel, Vaclav 19
Hayes, Sharon 42
Hebbel-Theater 20, 182, 196
Hegel, G.W.F. 4, 8
Hegemann, Carl 27, 31
Hillje, Jens 30, 38
Houellebecq, Michel 206
Huntington, Samuel 28
Husserl, Edmund 10
hyperculture 28, 37

Image Snatchers 174
Ingvartsen, Mette 36
institutional change 3
Intendant 31
Invisible Committee 203
Iphigenia 33

Jarry, Alfred 20

Kaai-Theater 20, 182
Kampnagel (Hamburg) 197
Kantor, Tadeusz 144
Kennedy, Susanne 36
King, John 181
Klaic, Dragan 6
kleinkunst 170
Knörer, Ekkehard 36
Königsmark, Václav 137
Koselleck, Reinhardt 1, 4, 6, 7, 16, 41, 107, 203
Král, Karel 140
Kugler, Ema 174
Kulturgesellschaft 181
Kunst, Bojana 27, 166, 176

Kunstenfestivaldesart 196
Kwanten, Koen 194

Langhoff, Shermin 30, 38
Last Days of the Ceauşescus, The 58, 60
Lavender, Andy 57
Lebenswelt 10, 14
Lébl, Petr 140
Lehmann, Hans-Thies 9, 183
legitimation crisis 8
Levitow, Roberta 20, 169
Leysen, Frie 198
Leysen, Johan 181
Life Long Burning 195
Lilienthal, Matthias 2, 11, 21, 36, 206
Lorenci, Jernej 20

Mladinsko Theatre 170, 175
Maribor Theatre festival 176
Marincola, Paula 42
Marx, Karl 4, 7, 8, 199
Mason, Paul 36
Mavili Collective 17, 70
May, Theresa 15
Maxim Gorki Theater 29, 36, 38
McGrath, John 66
Menke, Christoph 184
Meritis, Felix 20
Mitbestimmung 183
Mladek, Klaus 67
Moten, Fred 78
Mouffe, Chantal 63, 71
Mukarovsky, Jan 19, 139
Müller, Heiner 1, 2
Munich Kammerspiele 2, 11, 21, 36, 191, 206

National Theatres 72, 74, 75, 105, 114–115, 143–146, 167, 169, 171–173, 176
neoliberalism 2, 3, 12, 15, 19, 28, 30, 44, 57, 59, 66, 69, 83, 85, 87, 108, 173
North, Douglass C. 208
Nova pošta (*New Post Office*) 175
NTGent 16, 36, 59

Ostermeier, Thomas 30
Our Violence and Your Violence 145

Piaget, Jean 10
Piccolo Teatro di Milano 112
Pitínský, Jan Antonín 140
Pollesch, René 30, 38
Polygon Theatre 161

Powszechny Theatre 143
public sphere 2, 56–58, 59, 64, 91, 149, 151, 207
Puchner, Martin 62
Pullmann, Michael 133

Quaas, Richard 206

Rajković, Nataša 147
Rancière, Jacques 37, 79
Rau, Milo 16, 36, 56
Reckwitz, Andreas 15, 28, 30, 37
re-enactment 56
Regietheater 35, 37
repetition 181
Rice, Emma 11
Rodrigues, Tiago 36
Rois, Sophie 31, 34
Roitman, Janet 3, 4
Ronen, Yael 30
Rosanvallon, Pierre 57
Roselt, Jens 173
Ruto Killakund 158

Schaubühne (Berlin) 30, 61
Schauspielhaus Zürich 30
Schiller, Friedrich 7
Schillertheater 29
Schirn Kunsthalle 188
Schmitt, Carl 8
Schneider, Rebecca 58
Schößler, Franziska 123, 125
Scott, Richard W. 208, 214, 218
Sehgal, Tino 33, 36
self-exploitation 127
singularities 15, 28, 37
Shaviro, Steven 195
SNT Drama 20, 169
Städtische Bühnen 182
Stary Teater 148

Stegi/Onassis Cultural Centre 75
Stemann, Nicolas 30
Steyerl, Hito 32, 43
Storming of the Reichstag 16, 57
Svich, Caridad 5, 6
Szondi, Peter 56

Tartu New Theatre 160
Teatro Nacional D. Maria II 36
Teatro Valle 69
Teatr Polski 147
Tillmans, Wolfgang 43
Thacker, Eugene 195
Theater am Turm (TAT) 20, 181
Theatre Powszechny 148
Theatrum 157
Thévenot, Laurent 17, 84, 88, 94
Throsby, David 115
Tolstoy, Leo 12

Ubu the King 20, 167

Van Maanen, Hans 154
VAT Theatre 157
Velvet Revolution 133
Vitali, Christoph 182
Vodička, Libor 133
Von Krahl Theatre 157
Võru City Theatre 160

War and Peace 12
Weiss, Peter 146
Wiener Festwochen 20, 145, 182
Woolf, Brandon 44
Wu, Tim 53
Wuttke, Martin 31, 34

Zadara, Michal 147
Zagreb Theatre &TD 147
Žižek, Slavoj 30

Lightning Source UK Ltd.
Milton Keynes UK
UKHW021832080223
416660UK00020B/154